VASARI'S LIVES OF THE ARTISTS

Giotto, Masaccio, Fra Filippo Lippi,
Botticelli, Leonardo, Raphael,
Michelangelo, Titian

GIORGIO VASARI

Translated by Mrs. Jonathan Foster
Edited by Marilyn Aronberg Lavin

DOVER PUBLICATIONS, INC.
Mineola, New York

Bibliographical Note

This Dover edition, first published in 2005, is an original selection of eight excerpts from *Lives of the Most Eminent Painters,* published in two volumes by The Heritage Press, New York, 1967. The translation used as a basis for the Heritage edition first appeared in 1851. The work was originally published in Florence in 1550, and revised and extended for a second edition in 1568.

Library of Congress Cataloging-in-Publication Data

Vasari, Giorgio, 1511–1574.
 [Vite de' più eccellenti pittori, scultori et architettori. English. Selections]
 Vasari's lives of the artists : Giotto, Masaccio, Fra Filippo Lippi, Botticelli, Leonardo, Raphael, Michelangelo, Titian / Giorgio Vasari ; translated by Mrs. Jonathan Foster ; edited by Marilyn Aronberg Lavin.
 p. cm.
 "This is an original selection of eight excerpts from Lives of the most eminent painters, published in 2 vols. by The Heritage Press, New York, 1967."
 ISBN 0-486-44180-6
 1. Artists—Italy—Biography—Early works to 1800. 2. Art, Renaissance—Italy—Early works to 1800. 3. Art, Italian—Early works to 1800. I. Foster, Jonathan, Mrs. II. Lavin, Marilyn Aronberg. III. Title.

N6922.V2213 2005
709'.2'245—dc22
[B]
 2005041273

Manufactured in the United States of America
Dover Publications, Inc., 31 East 2nd Street, Mineola, N.Y. 11501

Introduction

GIORGIO VASARI (1511–1574), born in the Tuscan town of Arezzo, was already a painter and architect of considerable prestige when he set out to write the first complete history of modern art. He gives credit for the idea to the scholar Paolo Giovio, who had himself planned to write such a history. One evening, after a lecture on the subject, Vasari criticized Giovio for not having "put things in their proper order." It was then that Cardinal Alexander Farnese suggested to Vasari that he take over the project. Objecting that literature was not his field, Vasari at first refused. Only after much encouragement by the Cardinal and other intellectuals was he finally persuaded. He made it clear, however, that he felt this work would take his time away from "more important things," meaning his painting and architecture, and to escape responsibility he planned to sign the *Lives* with a pseudonym.

Yet the project could have been no new idea to Vasari, nor he so reluctant as he makes himself appear, for, as he explains in his own *Life*, he was able to turn immediately to "notes and memoranda, which I had prepared even from my boyhood, for my own recreation, and because of a certain affection which I preserved toward the memory of our artists, every notice respecting whom had always been most interesting to me." This occurred in 1546; Vasari was thirty-five. Within two years, in 1547, he reports his book as "brought almost to its conclusion," and by 1550 the first edition was published. It included the lives of more than two hundred painters, sculptors, and architects, from Cimabue to his own day. A few attempts at this subject had been made before by, among others, Ghiberti in his *Commentaries,* and Leonardo da Vinci and Raphael, both of whom left manuscript notes on lives of artists. But nothing of the scope and magnitude of Vasari's work had ever been conceived. Had he had assistance in collecting material or in putting it in order (a thing he does not mention), or had he devoted ten or twenty years of continuous work to it (which he did not), the *Lives* would still represent an incredi-

ble feat of research and writing. The publication met with deserved success; and several years later—in 1568, when the expanded second edition was unveiled—it became, as it has remained, the fundamental source for Italian Renaissance art.

One of the reasons Vasari gives for allowing himself to be talked into undertaking the *Lives* was that he felt a painter and not a scholar should do the job. His opinion stemmed from the belief that while a scholar would fill his work with erudite knowledge, he might say little about works of art as such. No such accusation can be leveled at Vasari, for the bulk of his text is composed of minute descriptions of thousands of paintings, statues, and buildings. These descriptions, which may seem elementary to us, are in fact of fundamental importance for the field of the history of art. They laid the groundwork for precise scientific recording of artistic data, for observing the development of compositional structure and the manipulation of color, and for the analysis of the meaning of changes in style and subject matter.

His interest in matter-of-fact recording of works of art was also important for the genesis of the modern museum. Institutions of this sort did not exist until after Vasari's time, but he foreshadowed their function in a figurative sense at least; through his text he sought the objective preservation and display of works of art to a general public. In addition to this, Vasari was an art collector. His collection differed from the pattern usual at his time in that it brought together neither curiosities nor keepsakes. His was a collection of drawings chosen to illustrate the styles of the artists whose lives he was writing. The "book of drawings" (frequently mentioned in the text) was, in the early stages of the project, apparently meant to be consulted by his readers. When the *Lives* began to circulate in printed form the idea obviously became impractical, and had to be abandoned.

Furthermore, Vasari saw himself as something of an art impresario. In the Prefatory Letter "To the Artists of Design" he tells his brother artists that another reason he was moved to take on the project was that he felt a "generous indignation that so much talent should remain concealed for so long a time, and still continue buried." Thus not only was it his genius to recognize the need to record for posterity the Italian patrimony of art; he also wished to publicize new works by lesser-known artists. In this way he prefigured the modern art gallery. And by his inclusion and praise for certain artists, and exclusion or condemnation of others, he is also the ancestor of the modern art critic.

Vasari's opinion that he could outdo a scholar in writing the *Lives* was well sustained. He was empowered to contribute to the intellectual side of the fine arts through his position as a professional creative artist. Yet, on a literary level he was irrevocably bound to the humanist tradition: his

form is basically that of ancient biographical writing. He sought the spirit of the artist in the man rather than in his works. In the brief introductions that open each *Life* the usual point of departure is some distinctive facet of the artist's personality, either documented or known through word-of-mouth tradition. Thus he characterizes Baldovinetti as avaricious, Fra Filippo Lippi as unscrupulous, Perugino as irreligious, Raphael as eclectic, Parmigianino as dedicated to alchemy, Sebastiano del Piombo as lazy, Michelangelo as divine. Such adjectives play through the *Lives* as leit-motifs, giving each its own flavor. Through these distinctions, Vasari gains literary variety and avoids the monotony of merely cataloguing facts.

In certain ways, however, he went beyond ordinary biography. His idea (or *concetto*) of each artist frequently coincides with a real insight into the artist's style. For example, the piety of Fra Angelico is historically a fact, and it also emanates from his every painting. These insights occur even in cases where the local tradition has been proven untrue by later scholarship. The most flagrant case is that of Andrea del Castagno; by describing his character as brutal and ill-tempered, Vasari justified tales of murder, and condemned Castagno as a criminal for centuries. Exoneration came only when it was shown that his alleged victim, Domenico Veneziano, outlived him by four years at least. Still, Castagno's style is harsh and powerful, and no doubt Vasari accepted the malicious legends because he saw the same qualities in the paintings.

Nevertheless, the reader will come away from many a *Life* with only a vague notion of the individual artist's style. Stylistic remarks are for the most part appraisals based on the artist's ability to achieve realistic effects, with artists as different as Pollaiuolo and Andrea del Sarto both receiving praise for finishing their work "with infinite care" and for the life-like quality of their figures. This does not mean that Vasari failed to articulate stylistic differences. On the contrary, he was the very first to distinguish between the styles of the Late Gothic, the Early Renaissance, and the High Renaissance. In fact, although he does not use the actual terms, he divides the *Lives* into three sections according to these "manners," and it is in the prefaces to the three sections that his discussions of style as such are to be found.

Yet we must remember that for Vasari the stylistic periods showed a progression in quality. Art for him moved from bad to good, from Gothic to Classic. His history of Italian art starts as if from a vacuum, claiming that the "rude and uncouth Greek" (meaning Byzantine) style was rejected out of hand. From Cimabue onward, with the help of classical antiquity, art started a slow but steady climb to the perfection of the High Renaissance. At a moment of high-pitched enthusiasm, Vasari cries out to his fellow artists, "Be thankful to Heaven [for Michelangelo] and strive

to imitate [him] in all things." Man had reached his peak of cultural achievement; there was no need to try for more. With the vantage point of four hundred years we may tend to disagree; but we should not overlook the fact that out of Vasari's dynamic concept of progress upward, grew our modern concept of artistic evolution.

Vasari also had a particular view of Florentine art. For him this Tuscan town was endowed by heaven with a special muse. Any art that was Florentine was good; anything that was not, was *ipso facto* of a lower order. This opinion had the practical result that Vasari's selection of artists was by no means objective. Florentine artists are treated in full. Artists from other areas of Italy are sketchily traced, with a larger margin of error and omission. Non-Florentine artists too "good" to be put down are drawn into the Florentine orbit. Thus Cavallini the Roman and Simone Martini the Sienese are named as students of Giotto, Pisanello of Verona is listed as trained in Florence, and Giorgione, the Venetian *par excellence,* is said to have been influenced by Leonardo da Vinci. Yet it is easy to see that in Vasari's chauvinism lay the roots of our own notion of regional or local "schools" of art. Moreover, the fact that he included as many outlanders as he did, often treating them quite decently, is a tribute to Vasari's nascent scholarly objectivity.

The literary merit of the *Lives* may cause some comment. Working as he did, almost without precedent, Vasari employed a vocabulary that is often experimental or blurred. He had no strict chronology on which to rely. And he worked fast. The reader frequently feels that once Vasari had the material before him, he just sat down and wrote. When he later discovered a mistake, he did not rewrite or reorganize but simply added his corrections wherever he happened to be in the narrative. The same is true of material he learned about after writing the paragraphs to which it might pertain. These arbitrary additions keep the text quite personal and lively, but they do not make for exact historical clarity.

It must also be admitted that the issue of some of his ideas was negative. Because of his opening remarks about medieval "Greek" art, Italy's deep debt to the refined and splendid art of Byzantium was ignored for centuries. Though many may still share Vasari's partiality toward Florentine art, his attitude was parochial, and he unfairly slanted much of the taste, development of style, and aesthetic theory that were developing in western Europe. Nevertheless, we have in Vasari's *Lives* an undisputed classic. The vast scope of their legacy is not to be denied. Throughout the sixteenth, seventeenth, and eighteenth centuries, when lives of the artists were continually produced for later periods and for geographical areas other than Florence, inside and outside Italy, they all took their point of departure as well as their form from Vasari. His selection, arrangement, and appraisal of the artists remained standard for

centuries, and his chronologies, descriptions, and attributions unchallenged. Even today it is frequently impossible to understand our own preconceptions—and even our misconceptions—of many Renaissance artists without consulting Vasari. Wherever the modern student of Italian Renaissance art begins, there is Vasari behind him, a guide and a challenge.

Vasari's critical fortune as an artist has fared less well. Long in the service of Duke Cosimo de' Medici (to whom both editions of the *Lives* were dedicated), he was busy and prosperous his entire career. But since then, while his architecture has been widely acclaimed, his painting has never received a sympathetic consideration. He is accused of following his own dictum of imitating Michelangelo in all things, and blamed for some of the driest, least spontaneous painting of the sixteenth century. Vasari himself, for all his apparent self-confidence, seems to have been aware of this shortcoming. When Luca Signorelli (in his *Life*) prophesies for his young relative a future of greatness as a painter, Vasari declares it is an opinion "I know that I have been far from justifying." Signorelli was wrong, and Vasari was right. Let us praise him for accepting the goad to write the *Lives*, and believe that despite the deprecations he heaped on his literary project, he recognized its value and knew wherein his own greatest contribution truly lay.

Contents

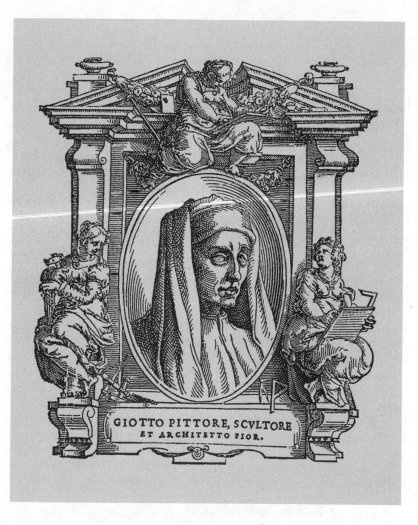

GIOTTO PITTORE, SCVLTORE
ET ARCHITETTO FIOR.

GIOTTO
Painter, Sculptor, and Architect, of Florence
[1266/76–1337]

THE gratitude which the masters in painting owe to nature—who is ever the truest model of him who, possessing the power to select the brightest parts from her best and loveliest features, employs himself unweariedly in the reproduction of these beauties—this gratitude, I say, is due, in my judgment, to the Florentine painter, Giotto, seeing that he alone—although born amidst incapable artists, and at a time when all good methods in art had long been entombed beneath the ruins of war—yet, by the favor of Heaven, he, I say, alone succeeded in resuscitating art, and restoring her to a path that may be called the true one. And it was in truth a great marvel that, from so rude and inapt an age, Giotto should have had strength to elicit so much that the art of design, of which the men of those days had little, if any, knowledge, was by his means effectually recalled into life.

The birth of this great man took place in the hamlet of Vespignano, fourteen miles from the city of Florence, in the year 1276. His father's name was Bondone, a simple husbandman, who reared the child, to whom he had given the name of Giotto, with such decency as his condition permitted. The boy was early remarked for extreme vivacity in all his childish proceedings, and for extraordinary promptitude of intelligence; so that he became endeared, not only to his father, but to all who knew him in the village and around it. When he was about ten years old, Bondone gave him a few sheep to watch, and with these he wandered about the vicinity—now here and now there. But induced by nature herself to the arts of design, he was perpetually drawing on the stones, the earth, or the sand some natural object that came before him or some fantasy that presented itself to his thoughts.

It chanced one day that the affairs of Cimabue took him from Florence to Vespignano, when he perceived the young Giotto, who, while his sheep fed around him, was occupied in drawing one of them from the life, with a stone slightly pointed, upon a smooth clean piece of rock—and that without any teaching whatever, but such as nature herself had imparted. Halting in astonishment, Cimabue inquired of the boy if he would accompany him to his home, and the child replied he would go willingly if his father were content to permit it. Cimabue therefore

requesting the consent of Bondone, the latter granted it readily, and suffered the artist to conduct his son to Florence, where, in a short time, instructed by Cimabue and aided by nature, the boy not only equalled his master in his own manner, but became so good an imitator of nature that he totally banished the rude Greek manner—restoring art to the better path adhered to in modern times, and introducing the custom of accurately drawing living persons from nature, which had not been used for more than two hundred years. Or if some had attempted it, as said above, it was not by any means with the success of Giotto.

Among the portraits by this artist, and which still remain, is one of his contemporary and intimate friend, Dante Alighieri, who was no less famous as a poet than Giotto as a painter, and whom Messer Giovanni Boccaccio has lauded so highly in the introduction to his story of Messer Forese da Rabatta, and of Giotto the painter himself. This portrait is in the chapel of the palace of the Podestà in Florence; and in the same chapel are the portraits of Ser Brunetto Latini, master of Dante, and of Messer Corso Donati, an illustrious citizen of that day.

The first pictures of Giotto were painted for the chapel of the high altar, in the Abbey of Florence, where he executed many works considered extremely fine. Among these, an Annunciation is particularly admired; the expression of fear and astonishment in the countenance of the Virgin, when receiving the salutation of Gabriel, is vividly depicted; she appears to suffer the extremity of terror, and seems almost ready to take flight. The altar-piece of that chapel is also by Giotto; but this has been, and continues to be, preserved, rather from the respect felt for the work of so distinguished a man than from any other motive.

There are four chapels in Santa Croce also painted by Giotto: three between the sacristy and the principal chapel, and one on the opposite side of the church. In the first of the three, which belongs to Messer Ridolfi de' Bardi, and wherein are the bell-ropes, is the life of St. Francis. In this picture are several figures of monks lamenting the death of the saint: the expression of weeping is very natural. In the second chapel, which belongs to the family of Peruzzi, are two passages from the life of St. John the Baptist, to whom the chapel is dedicated, wherein the dancing of Salome, and the promptitude with which certain servants are performing the service of the table, are depicted with extreme vivacity. Two other paintings in the same chapel, also exceedingly fine, are events from the life of St. John the Evangelist—that wherein he restores Drusiana to life, and his own ascension into heaven. The third chapel belongs to the Giugni family: it is dedicated to the Apostles; and Giotto has painted in it various scenes from the martyrdom of many of them.

In the fourth chapel, which is on the other side of the church to the north, belonging to the families of Tosinghi and Spinelli, and dedicated

to the Assumption of Our Lady, he has depicted the following passages from the life of the Virgin: her birth, her marriage, her annunciation, the adoration of the Magi, and the presentation of Christ in the Temple. This last is a most beautiful thing; for not only is the warmest expression of love to the child to be perceived on the face of the old man Simeon, but the act of the infant, who, being afraid of him, stretches its arms timidly and turns towards its mother, is depicted in a manner inexpressibly touching and exquisite. The Apostles and Angels, with torches in their hands, who surround the death-bed of the Virgin, in a succeeding picture, are also admirably well done. In the same church, and in the chapel of the Baroncelli family, is a picture in distemper, by the hand of Giotto: it represents the coronation of the Virgin, with a great number of small figures, and a choir of saints and angels, very carefully finished. On this work, the name of the master and the date are written in letters of gold.

Artists who reflect on the period at which Giotto, without any light to guide him towards better methods, could make so happy a commencement, whether as respects design or coloring, will be compelled to regard him with great respect and admiration. There are, moreover, in the same church of Santa Croce, and above the marble tomb of Carlo Marsuppini of Arezzo, a Crucifix, a figure of the Virgin, a St. John and the Magdalen at the foot of the Cross, all by the hand of Giotto; and on the other side of the church, exactly opposite to the latter, and above the burial-place of Leonardo Aretino, is an Annunciation, near the high altar, which has been restored with very little judgment by the hand of some modern painter: a great discredit to those who had the custody of these works. In the refectory is a Tree of the Cross,[1] with scenes from the life of St. Louis, and a Last Supper, by the same master. On the presses or wardrobes of the sacristy, also, are passages from the life of Christ and that of St. Francis. Giotto likewise painted in the church of the Carmine, depicting the life of St. John the Baptist, for the chapel of that saint, in a series of pictures; and in the Guelphic Palace of Florence there is a painting of the Christian Faith, admirably executed in fresco, wherein he has placed the portrait of Clement IV, who founded the society, conferring on it his own arms, which it has borne ever since.

After these works were finished, Giotto departed from Florence, and went to Assisi, to complete the paintings commenced by Cimabue. Passing through Arezzo, he painted one of the chapels of the capitular church, that of St. Francis, which is above the baptistery; and on a round column, which stands beside a very beautiful antique Corinthian capital, are portraits of St. Francis and St. Dominic, by his hand, both taken from nature.[2] In the cathedral without Arezzo, he further executed the Martyrdom of St. Stephen, in one of the larger chapels; of which the com-

position is fine. Having finished these things, he proceeded to Assisi, a city of Umbria, being invited thither by Fra Giovanni of Muro in the Marches, who was then general of the fraternity of St. Francis. Here, in the upper church, and under the corridor which traverses the windows, he painted a series of thirty-two frescoes, representing passages from the life and acts of the saint; namely, sixteen on each side; a work which he executed so perfectly as to acquire great fame from it. And, of a truth, there is singular variety in these frescoes; not only in the gestures and attitudes of each figure, but also in the composition of all the stories: the different costumes of those times are also represented; and, in all the accessories, nature is most faithfully adhered to. Among other figures, that of a thirsty man stooping to drink from a fountain is worthy of perpetual praise: the eager desire with which he bends towards the water is portrayed with such marvelous effect that one could almost believe him to be a living man actually drinking.

There are many other parts of this work that well merit remark, but I refrain from alluding to them, lest I become too discursive. Let it suffice to say that it added greatly to the fame of Giotto, for the beauty of the figures, the good order, just proportion, and life of the whole, while the facility of execution, which he had received from nature and afterwards perfected by study, was made manifest in every part of the work. Giotto has indeed well merited to be called the disciple of nature rather than of other masters, having not only studiously cultivated his natural faculties, but being perpetually occupied in drawing fresh stores from nature, which was to him the never-failing source of inspiration.

When the stories above described were finished, Giotto continued to labor in the same place, but in the lower church, where he painted the upper part of the walls beside the high altar, together with the four angles of the vault, beneath which the remains of St. Francis repose. All of these display rich and original invention. In the first angle is St. Francis glorified in heaven, and surrounded by those virtues which are essential to him who desires fully to partake of the grace of God. On one side is Obedience, placing a yoke on the neck of a friar who kneels before her, the bands of the yoke being drawn towards heaven by hands above. The finger on the lip of Obedience imposes silence, while her eyes are fixed on Jesus, from whose side the blood is flowing: beside this Virtue stand Prudence and Humility to show that where there is true obedience there are also humility and prudence directing every action towards the right and good. In the second angle is Chastity, who, firm on a well-defended fortress, refuses to yield to any of the kingdoms, crowns, and glories that are offered her on all sides. At the feet of Chastity is Purity, washing certain naked figures, while Force is conducting others towards her, to be also washed and purified. On one side of Chastity stands Penitence,

driving away Love with the cord of discipline, and putting Incontinence to flight.

The third compartment exhibits Poverty walking barefoot amidst thorns: a dog follows her, barking, and a boy throws stones at her, while a second gathers the thorns about her, and presses them into her legs with a stick. This Poverty is here seen to be espoused by St. Francis, while Christ himself is holding her hand; and Hope, not without significance, is present, together with Charity. In the fourth and last of these angles is a St. Francis, also glorified, as in the first compartment. He is dressed in the white tunic of the deacon, and is triumphant in heaven, attended by a multitude of angels, who form a choir around him; they hold a standard, on which is a cross with seven stars; and over all is the Holy Spirit. In each of these angles are certain Latin words, explanatory of the events depicted.

Besides the paintings in these four compartments, those on the walls are extremely fine, and well deserve our admiration, not only for their beauty, but also for the care with which they were executed, which was such that they have retained their freshness even to this day. The portrait of Giotto himself, very well done, may be seen in one of these pictures; and over the door of the sacristy is a fresco, also by him, representing St. Francis at the moment when he receives the Stigmata; the expression of the saint being so full of love and devotion, that to me this seems to be the best picture that Giotto has produced in this work, which is nevertheless all truly beautiful and admirable.[3]

When Giotto had at length completed this St. Francis, he returned to Florence, where, immediately after his arrival, he painted a picture to be sent to Pisa. This is also a St. Francis, standing on the frightful rocks of La Verna, and is finished with extraordinary care: it exhibits a landscape with many trees and precipices, which was a new thing in those times. In the attitude and expression of St. Francis, who is on his knees receiving the Stigmata, the most eager desire to obtain them is clearly manifest, as well as infinite love towards Jesus Christ, who from heaven above, where he is seen surrounded by the seraphim, grants these Stigmata to his servant with looks of such lively affection that it is not possible to conceive any thing more perfect. Beneath this picture are three others, also from the life of St. Francis, and very beautiful. The picture of the Stigmata, just described, is still in the church of San Francesco in Pisa, close beside the high altar. It is held in great veneration for the sake of the master; and caused the Pisans to entrust him with the decoration of their Campo Santo. The edifice was scarcely completed, from the design of Giovanni Pisano, when Giotto was invited to paint a portion of the internal walls.

This magnificent fabric, being encrusted externally with rich marbles

and sculptures, executed at immense cost, the roof covered with lead, and the interior filled with antique monuments and sepulchral urns of pagan times brought to Pisa from all parts of the world, it was determined that the inner walls should be adorned with the noblest paintings. To that end Giotto repaired to Pisa, and on one of the walls of the Campo Santo he painted the history of Job, in six large frescoes; but, as he judiciously reflected, the marble of that part of the building where he went to work, being turned towards the sea and exposed to the southeast winds, was always humid and gave out a certain saline moisture, as do nearly all the bricks of Pisa, which fades and corrodes the colors and pictures; so he caused a coating or intonaco to be made for every part whereon he proposed to paint in fresco, that his work might be preserved as long as possible. This intonaco was composed of lime, chalk, and powdered bricks, all so well mingled together, that the paintings which he afterwards executed on the surface thus prepared remain in tolerable preservation to this day. Nay, they might have been in much better condition if the neglect of those who ought to have taken care of them had not suffered them to sustain injury from the damp: but this not having been guarded against, as it might easily have been, has caused some of the paintings to be spoiled in certain places, the flesh tints having become blackened and the plaster fallen off. It is, besides, the nature of chalk when mingled with lime to become corroded and peel off with time, when it inevitably ruins the colors; although at first it seems to bind and secure them.

In these stories, beside the portrait of Messer Farinata degli Uberti,[4] there are many admirable figures, more particularly those of certain villagers, who bring the grievous news of his losses to Job: no faces could be more eloquently demonstrative of the grief they feel for the lost cattle and other calamities than are these. There is likewise extraordinary grace in the figure of a servant, who, with a fan of branches in his hand, stands near the suffering Job, now abandoned by all else. Every part of his figure is beautiful; but most of all to be admired is his attitude—as, driving the flies from his leprous and ill-odored master with one hand, he guards himself from the pungent scents, from which he obviously shrinks, with the other. The remaining figures of these paintings, and the heads, those of the men as well as the women, are exceedingly beautiful; the draperies also are painted with infinite grace; nor is it at all surprising that this work acquired so much fame for its author as to induce Pope Benedict IX[5] to send one of his courtiers from Treviso to Tuscany for the purpose of ascertaining what kind of man Giotto might be, and what were his works, that Pontiff then proposing to have certain paintings executed in the church of St. Peter.

The messenger, when on his way to visit Giotto and to inquire what other good masters there were in Florence, spoke first with many artists

in Siena—then, having received designs from them, he proceeded to Florence, and repaired one morning to the workshop where Giotto was occupied with his labors. He declared the purpose of the Pope and the manner in which that Pontiff desired to avail himself of his assistance, and finally requested to have a drawing that he might send it to His Holiness. Giotto, who was very courteous, took a sheet of paper, and a pencil dipped in a red color; then, resting his elbow on his side, to form a sort of compass, with one turn of the hand he drew a circle so perfect and exact that it was a marvel to behold. This done, he turned, smiling to the courtier, saying, "Here is your drawing." "Am I to have nothing more than this?" inquired the latter, conceiving himself to be jested with. "That is enough and to spare," returned Giotto: "Send it with the rest, and you will see if it will be recognized." The messenger, unable to obtain any thing more, went away very ill-satisfied and fearing that he had been fooled. Nevertheless, having dispatched the other drawings to the Pope, with the names of those who had done them, he sent that of Giotto also, relating the mode in which he had made his circle, without moving his arm and without compasses; from which the Pope, and such of the courtiers as were well versed in the subject, perceived how far Giotto surpassed all the other painters of his time. This incident becoming known gave rise to the proverb, still used in relation to people of dull wits—"Tu sei più tondo che l'O di Giotto"[6]—the significance of which consists in the double meaning of the word *tondo,* which is used in the Tuscan for slowness of intellect and heaviness of comprehension, as well as for an exact circle. The proverb has besides an interest from the circumstance which gave it birth.

Giotto was then invited by the above-named Pope to Rome, where his talents were at once appreciated by that Pontiff, and himself treated very honorably. He was instantly appointed to paint a large picture in the sacristy of St. Peter's, with five others in the church itself—these last being passages from the life of Christ; all which he executed with so much care that no better work in distemper ever proceeded from his hands: so that he well deserved the reward of 600 gold ducats, which the Pope, considering himself well served, commanded to be paid him, besides conferring on him so many favors that there was talk of them throughout all Italy.

At this time there lived in Rome—to omit nothing relative to art that may be worthy of commemoration—a certain Oderigi of Agobbio, an excellent miniature painter of those times, with whom Giotto lived on terms of close friendship; and who was therefore invited by the Pope to illuminate many books for the library of the palace: but these books have in great part perished in the lapse of time.

In my book of ancient drawings, I have some few remains from the

hand of this artist, who was certainly a clever man, although much sur-
passed by Franco of Bologna, who executed many admirable works in
the same manner for the same Pontiff (and which were also destined
for the library of the palace) at the same time with those of Oderigi.
From the hand of Franco also I have designs, both in painting and illu-
minating, which may be seen in my book above cited: among others, are
an eagle, perfectly well done, and a lion tearing up a tree, which is most
beautiful. Of these two excellent miniaturists, Dante makes mention in
the eleventh canto of the *Purgatorio,* in the following lines:

> "Oh!" diss'io lui, "non se' tu Oderisi
> L'onor d'Agobbio e l'onor di quell'arte
> Ch'alluminare chiamata è in Parisi?"
> "Frate," diss'egli, "più ridon le carte,
> Che pennelleggia Franco bolognese:
> L'onor è tutto or suo, e mio in parte."[7]

The Pope having seen these works of Giotto, whose manner pleased
him infinitely, commanded that he should paint subjects from the Old
and New Testaments entirely around the walls of St. Peter's; and, for a
commencement, the artist executed in fresco the Angel, seven braccia
high, which is now over the organ: this was followed by many other pic-
tures, of which some have been restored in our own days, while more
have been either destroyed in laying the foundations of the new walls, or
have been taken from the old edifice of St. Peter's, and set under the
organ; as is the case with a Madonna, which was cut out of the wall that
it might not be totally destroyed, and, being supported by beams and bars
of iron, was thus carried away and secured for its beauty in the place
wherein the pious love, which the Florentine doctor, Messer Niccolò
Acciaiuoli, has ever borne to the excellent in art, desired to see it en-
shrined, and where he has richly adorned this work of Giotto with a
framework composed of modern pictures and of ornaments in stucco.

The picture in mosaic, known as the Navicella, and which stands
above the three doors of the portico in the vestibule of St. Peter's, is also
from the hand of Giotto—a truly wonderful work, and deservedly eulo-
gized by all enlightened judges; and this not only for the merit of the
design, but also for that of the grouping of the apostles, who labor in var-
ious attitudes to guide their boat through the tempestuous sea, while the
winds blow in a sail which is swelling with so vivid a reality that the
spectator could almost believe himself to be looking at a real sail. Yet it
must have been excessively difficult to produce the harmony and inter-
change of light and shadows, which we admire in this work, with mere
pieces of glass, and that in a sail of such magnitude—a thing which, even
with the pencil, could only be equalled by great effort. There is a fisher-

man, also, standing on a rock and fishing with a line, in whose attitude the extraordinary patience proper to that occupation is most obvious, while the hope of prey and his desire for it are equally manifest in his countenance. Beneath this work are three small arches painted in fresco; but as they are almost entirely destroyed, I will say no more of them; but the praises universally bestowed by artists on the mosaic above described were without doubt fully merited.

Giotto afterwards painted a large picture of the Crucifixion, in distemper, for the church of Minerva, belonging to the Preaching Friars, which was very highly praised at the time: he then returned to his native Florence, whence he had been absent six years. No long time after this, Benedict IX (XI) being dead, Clement V was elected Pope at Perugia, when Giotto was obliged to depart again with that Pontiff, who removed his court to Avignon, where our artist produced many admirable works; and not there only, but in many other parts of France he painted many beautiful pictures and frescoes which infinitely delighted the Pontiff and his whole court, insomuch that, when all were finished, Giotto was graciously dismissed with many presents, so that he returned home no less rich than honored and renowned. Among other things, he brought back with him the portrait of the Pontiff, which he afterwards presented to his disciple Taddeo Gaddi.

The return of Giotto to Florence took place in the year 1316; but he was not long permitted to remain in that city, being invited to Padua by the Signori della Scala, for whom he painted a most magnificent chapel in the Santo,[8] a church just then erected. From Padua he proceeded to Verona, where he painted certain pictures for Messer Cane, the father of Francesca di Rimini, in the palace of that noble, more particularly the portrait of Cane himself: he also executed a picture for the Fraternity of St. Francis. Having completed these works, Giotto departed for Tuscany, but was compelled to halt at Ferrara, where he painted certain works for the Signori d'Este, as well in their palace as in the church of Sant'Agostino, where they are still to be seen. Meanwhile, as it had come to the ears of Dante that Giotto was in Ferrara, he so contrived that the latter was induced to visit Ravenna, where the poet was then in exile, and where Giotto painted some frescoes, which are moderately good, in the church of San Francesco, for the Signori da Polenta. He then proceeded from Ravenna to Urbino, where he also painted some pictures. After this, as he was passing through Arezzo, he could not refuse to comply with the wishes of Piero Saccone, who had ever treated him with great kindness, and therefore painted a fresco for him in the principal chapel of the episcopal church. The subject is St. Martin dividing his mantle in half and bestowing one of the portions on a beggar, who stands before him almost entirely naked. Having then executed a large

Crucifixion, in distemper, on panel, for the abbey of Santa Fiore, which is still in the middle of that church, he returned at length to Florence, where, among many other works, he painted pictures, both in distemper and fresco, for the convent of the nuns of Faenza, all of which have been lost in the destruction of that convent.

In the year 1322, his most intimate friend, Dante, having died, to his great sorrow, the year preceding, Giotto repaired to Lucca, and, at the request of Castruccio, then lord of that city, which was the place of his birth, he executed a picture, in the church of San Martino, representing Christ hovering in the air over the four saints, protectors of Lucca, namely, San Piero, San Regolo, San Martino, and San Paolino; they appear to be recommending to him a Pope and an Emperor, who, as many believe, are Frederick of Bavaria and the Antipope, Nicholas V. Many also maintain that at San Frediano, in this same city of Lucca, Giotto likewise designed the castle and fortress of Giusta, which is impregnable.

Some time after this, and when Giotto had returned to Florence, Robert, King of Naples, wrote to his eldest son Charles, King of Calabria, who was then in Florence, desiring that he would, by all means, send Giotto to him at Naples, he having just completed the convent and church of Santa Clara, which he desired to see adorned by him with noble paintings. Giotto, therefore, being thus invited by so great and renowned a monarch, departed with the utmost readiness to do him service, and being arrived he painted various subjects from the Old and New Testaments in the different chapels of the building. It is said that the passages from the Apocalypse, which he has painted in one of these chapels, were inventions of Dante, as were probably those so highly eulogized of Assisi, respecting which we have already spoken at sufficient length. It is true that Dante was then dead, but it is very probable that these subjects may have been discussed between Giotto and him: a thing which so frequently happens among friends.

But to return to Naples. Giotto executed many works in the Castel dell'Uovo, particularly in the chapel, which greatly pleased the King, by whom Giotto was indeed so much beloved that while at his work he was frequently held in conversation by that monarch, who took pleasure in watching the progress of his labors and in hearing his remarks. Now Giotto had always a jest ready, and was never at a loss for a witty reply, so that he amused the King with his hand while he painted and also by the acuteness of his pleasant conversation. Thus, one day, the King telling him that he would make him the first man in Naples, Giotto replied that he already was the first man in Naples, "for to that end it is that I dwell at the Porta Reale," where the first houses of the city stand. Another time, the King saying to him, "Giotto, if I were in your place, now that it is so hot, I would give up painting for a time and make my rest." "And

so I would do, certainly," replied Giotto, "if I were in your place." Giotto, being thus so acceptable to King Robert, was employed by him to execute numerous paintings in a hall (which King Alfonso afterwards destroyed to make room for the castle) and also in the church of the Incoronata.[9] Among those of the hall were many portraits of celebrated men, Giotto himself being of the number. One day the King, desiring to amuse himself, requested Giotto to depict his kingdom, when the painter, as it is said, drew an ass, bearing a pack saddle loaded with a crown and sceptre, while a similar saddle lay at his feet, also bearing the ensigns of sovereignty: these last were all new; and the ass scented them with an expression of desire to change them for those he then bore. The King inquired what this picture might signify; when Giotto replied, "Such is the kingdom, and such the subjects, who are every day desiring a new lord."

Leaving Naples to proceed to Rome, Giotto was detained at Gaeta, where he was persuaded to paint certain subjects from the New Testament for the church of the Annunciation. These works are now greatly injured by time, but not to such a degree as to prevent us from clearly distinguishing the portrait of Giotto himself, which will be found near a large and very beautiful crucifix. These works being completed, he passed some days in Rome, in the service of the Signor Malatesta, to whom he could not refuse this favor; he then repaired to Rimini, of which city the said Malatesta was lord, and painted numerous pictures in the church of San Francesco; but these works were afterwards destroyed by Gismondo, son of Pandolfo Malatesta, who rebuilt the entire edifice.

He also painted a fresco on the cloisters in front of the church. This was the history of the Beata Michelina,[10] one of the best and most beautiful works that Giotto ever produced; for to say nothing of the grace and life of the heads, which are nevertheless wonderful, or of the draperies, which are admirably done, there is the evidence of so much varied thought in the composition, and care in the execution, that it cannot be too highly praised. The principal figure is a young woman, lovely as it is possible to conceive that a woman can be, and who is in the act of freeing herself by oath from the calumnious charge of adultery. She takes the oath on a book, while she keeps her eyes fixed on her husband in an attitude of inexpressible grace, and with the expression of the most assured innocence; he having compelled her to make oath, from doubts respecting a black infant to which she had given birth, and which he can by no means persuade himself to believe his own. The distrust and indignation of the husband are clearly evident from his countenance; while that of the wife makes her innocence and purity equally obvious. None can regard that candid brow and those truthful eyes with attention but must perceive the wrong her husband does her in compelling her to affirm her

innocence, and in publicly accusing her of unchastity. There is also extreme vividness of expression in a group, comprising a man suffering from various wounds, while all the women around him, offended by the exhalations emitted from these wounds, turn away in disgust with various contortions, but all with the most graceful attitudes. The foreshortenings which are to be observed in another picture, wherein is a crowd of lame beggars, have also great merit, and must have been highly appreciated by the artists of those days, since it was from these works that the commencement and first methods of foreshortening were derived; besides which they cannot be considered badly done, considering them as the first.

But, more than all other parts of these frescoes, the gestures which the above-named Michelina makes towards certain usurers, who are paying her the price of her possessions, which she has given to the poor, are the most wonderful. The contempt she feels for riches and all other earthly wealth is most manifest—nay, she seems to hold them in disgust and abhorrence, while the usurers present the very personification of human avarice and greed. The figure of one, who, while counting the money, is making signs to the notary, who is writing, is extremely fine; for though he has his eyes on the notary, he yet holds his hands over his money, betraying his love of it, his avarice, and his mistrust in every feature. Again, the three figures personating Obedience, Patience, and Poverty, which are hovering in the air and upholding the vestments of St. Francis, are worthy of infinite praise, and more particularly because there is a grace in the flow of the draperies which makes it obvious that Giotto was born to be the light of painting. He has, besides, given the portrait of Malatesta in this work: he is in a boat, and so truly natural that he might be thought to breathe. Other mariners also, and other figures, in the vivacity of their actions, the grace of their attitudes, and the life of their expression, make manifest the excellence of the master; one most especially, who, speaking with others, holds his hand before his face while he spits into the sea, deserves to be remembered. And without doubt this may be called one of the best of the works of Giotto; for though the number of figures is so great, there is not one which does not display great perfection of art, and which has not a character peculiar to itself. It is not wonderful therefore that the Signor Malatesta should praise the painter highly and reward him magnificently.

Having finished his labors for this noble, Giotto executed a painting at the request of a Florentine prior, who was then at San Cataldo of Rimini: the subject is St. Thomas Aquinas reading to his monks; and the work is without the door of the church. He then departed and returned to Ravenna, where he painted a chapel in fresco in the church of St. John the Evangelist, which was highly celebrated. After this, Giotto returned

to Florence, rich in honors, and with sufficient worldly wealth. He there
painted a Crucifix in wood, larger, than the natural size, in distemper, on
a ground of gold, for the church of St. Mark, and which was placed in
the south aisle of the church. He executed a similar work for the church
of Santa Maria Novella, being aided in this last by Puccio Capanna, his
scholar: it may still be seen over the principal door of the church, on the
right as you enter, and over the tomb of the Gaddi family. In the same
church he painted a St. Louis, for Paolo di Lotto d'Ardinghelli, at the feet
of which is the portrait of the donor and his wife, taken from nature.

In the year 1327, Guido Tarlati da Pietramala, Bishop and Lord of
Arezzo, died at Massa di Maremma, when returning from Lucca, whither
he had gone to visit the emperor, and his body was carried to Arezzo,
where it received the honor of a most solemn and magnificent funeral.
It was then resolved by Piero Saccone, and Dolfo da Pietramala, brother
of the bishop, that a sepulchral monument in marble, worthy of the
greatness of a man who had been lord spiritual and temporal of the city,
as well as chief of the Ghibelline Party in Tuscany, should be raised to
his memory. They wrote accordingly to Giotto, requesting him to pre-
pare designs for a very splendid tomb, adorned with whatever might
most worthily enrich it, and sending him the required measurements.
They prayed him, at the same time, to procure them a sculptor, the most
excellent according to his opinion that could be found in Italy, they re-
ferring the whole affair entirely to his judgment. Giotto, who was very
obliging, made the design and sent it them, when the monument was
erected accordingly.

Now the talents of Giotto were very highly appreciated by Piero
Saccone, and he, having taken the Borgo di San Sepolcro, no long time
after he had received the above-named design, took a picture thence,
which had been formerly painted by Giotto, and which he carried to
Arezzo. The figures were small, and the work afterwards fell to pieces,
but the fragments were diligently sought by Baccio Gondi, a Florentine
gentleman, and lover of the fine arts, who was Commissioner of Arezzo:
having recovered some of them, he took them to Florence, where he
holds them in high estimation, and preserves them carefully, together
with other works of the same artist, who produced so many that, were
all enumerated, their amount would seem incredible.

And not many years since, when I was myself at the hermitage of
Camaldoli, where I executed many works for the reverend fathers, I saw
a small Crucifix by Giotto, in one of the cells, which had been brought
thither by the very Reverend Don Antonio of Pisa, then general of the
congregation of Camaldoli. This work, which is on a gold ground and
has the name of Giotto inscribed on it by himself, is very beautiful and
is still preserved, as I was told by the Reverend Don Silvano Razzi, a

monk of Camaldoli, in the Monastery degli Angeli, at Florence, where it is kept in the cell of the prior, together with a most exquisite picture by Raphael, as a rare and valuable relic of the master.

A chapel and four pictures were painted by Giotto for the fraternity of the Umiliati d'Ognissanti, in Florence; among these works is a figure of the Virgin, surrounded by angels and holding the Child in her arms, with a large crucifix on panel, the design of which last being taken by Puccio Capanna, he executed great numbers in the same manner (having intimate knowledge of Giotto's method), which were afterwards scattered through all Italy.

When this book of the *Lives of the Most Eminent Painters, Sculptors, and Architects* was first published, there was a small picture, in distemper, in the transept of the church belonging to the Umiliati, which had been painted by Giotto with infinite care. The subject was the Death of the Virgin, with the Apostles around her, and with the figure of Christ, who receives her soul into his arms. This work has been greatly prized by artists, and was, above all, valued by Michelangelo Buonarroti, who declared, as we have said before, that nothing in painting could be nearer to the life than this was, and it rose still higher in the general estimation after these *Lives* had appeared; but has since been carried away from the church, perhaps from love of art and respect to the work, which may have seemed to the robber to be not sufficiently reverenced, who thus out of piety became impious, as our poet saith. It may with truth be called a miracle that Giotto attained to so great an excellence of manner, more particularly when we consider that he acquired his art in a certain sense without any master.

After completing these works, and on the 9th of July, 1334, Giotto commenced the campanile of Santa Maria del Fiore; the foundations were laid on massive stone, sunk twenty braccia beneath the surface, on a site whence gravel and water had previously been excavated: then having made a good concrete to the height of twelve braccia, he caused the remainder, namely eight braccia, to be formed of masonry. The Bishop of the city, with all the clergy and magistrates, was present at the foundation, of which the first stone was solemnly laid by the Bishop himself. The edifice then proceeded on the plan before mentioned and in the Gothic manner of those times; all the historical representations which were to be the ornaments being designed with infinite care and diligence by Giotto himself, who marked out on the model all the compartments where the friezes and sculptures were to be placed, in colors of white, black, and red. The lower circumference of the tower is of one hundred braccia; twenty-five, that is, on each of the four sides. The height is one hundred and forty-four braccia.

And if that which Lorenzo di Cione Ghiberti has written be true, as

I fully believe it is, Giotto not only made the model of the campanile, but even executed a part of the sculptures and reliefs—those representations in marble, namely, which exhibit the origin of all the arts. Lorenzo also affirms that he saw models in relief from the hand of Giotto, and more particularly those used in these works: an assertion that we can easily believe; for design and invention are the parents of all the arts and not of one only. This campanile, according to the design of Giotto, was to have been crowned by a spire or pyramid of the height of fifty braccia: but as this was in the old Gothic manner, the modern architects have always advised its omission, the building appearing to them better as it is. For all these works, Giotto was not only made a citizen of Florence, but also received a pension of a hundred golden florins yearly—a large sum in those times—from the Commune of Florence. He was also appointed superintendent of the work, which he did not live to see finished, but which was continued after his death by Taddeo Gaddi.

While this undertaking was in progress, Giotto painted a picture for the nuns of San Giorgio, and in the abbey of Florence, within the church, and on an arch over the door, he executed three half-length figures, which were afterwards whitewashed over, to give more light to the church. In the great hall of the Podestà in Florence, Giotto painted a picture, the idea of which was afterwards frequently borrowed. In this he represented the Commune seated, in the character of a judge, with a sceptre in the hand, and equally poised scales over the head to intimate the rectitude of her decisions. The figure is surrounded by four Virtues: these are Force with generosity, Prudence with the laws, Justice with arms, and Temperance with the word. This is a very beautiful picture, of appropriate and ingenious invention.

About this time, Giotto once more repaired to Padua, where he painted several pictures and adorned many chapels; but more particularly that of the Arena, where he executed various works, from which he derived both honor and profit. In Milan also he produced many paintings, which are scattered throughout that city and are held in high estimation even to this day. Finally, and no long time after he had returned from Milan, having passed his life in the production of so many admirable works, and proved himself a good Christian as well as excellent painter, Giotto resigned his soul to God in the year 1336,[11] not only to the great regret of his fellow citizens, but of all who had known him, or even heard his name. He was honorably entombed, as his high deserts had well merited that he should be, having been beloved by all in his life, but more especially by the eminent men of all professions. Of Dante we have already spoken as his intimate friend; his character and talents were equally admired by Petrarch, insomuch that this last poet, as we read in his testament, bequeathed to Francesco da Carrara, Lord of Padua, among other

things which he highly valued, a picture of the Virgin by Giotto, as a rare
and acceptable gift, which is thus distinguished in that clause of the will
which relates to it:

> Transeo ad dispositionem aliarum rerum; et prædicto igitur
> domino meo Paduano, quia et ipse per Dei gratiam non eget, et ego
> nihil aliud habeo dignum se, mitto tabulam meam sive historiam
> Beatæ Virginis Mariæ, opus Jocti pictoris egregii, quæ mihi ab
> amico meo Michaele Vannis de Florentia missa est, in cujus pul-
> chritudinem ignorantes non intelligunt, magistri autem artis stu-
> pent: hanc iconem ipsi domino lego, ut ipsa Virgo benedicta sibi sit
> propitia apud filium suum Jesum Christum, etc.[12]

Petrarch further remarks, in a Latin epistle to be found in the fifth
book of his familiar letters, to the following effect:

> Atque (ut a veteribus ad nova, ab externis ad nostra transgrediar)
> duos ego novi pictores egregios, nec formosos, Jottum Florentinum
> civem, cujus inter modernos fama ingens est, et Simonem
> Senensem, novi scultores aliquot, etc.[13]

Giotto was buried in Santa Maria del Fiore, where an inscription on
white marble to the memory of this great man was placed on the wall to
the left of the entrance. The commentator of Dante, who was contem-
porary with Giotto, has spoken of him, as we have related in the life of
Cimabue, in the following words: "Giotto was and is the most eminent
of all the painters in the city of Florence, and to this his works bear tes-
timony in Rome, Naples, Avignon, Florence, Padua, and many other
parts of the world."

That Giotto drew extremely well for his day, may be proved from the
various sketches on vellum, some in water color, others in ink, and in
chiaroscuro, with the lights in clear white, which are collected into our
book of drawings before alluded to, and which are a veritable wonder,
when compared with the drawings of the masters who preceded him.

Giotto, as we have said before, was of an exceedingly jocund humor,
and abounded in witty and humorous remarks, which are still well re-
membered in Florence. Examples of these may be found not only in the
writings of Messer Giovanni Boccaccio, but also in the three hundred
stories of Franco Sacchetti, who cites many amusing instances of his tal-
ent in this way. And here I will not refuse the labor of transcribing some
of these stories, giving them in Franco's own words, that my readers may
be made acquainted with the peculiar phraseology and modes of speech
used in those times, together with the story itself. He says, then, in one
of these, to set it forth with its proper title:

*To Giotto, the great painter, is given a buckler to paint, by a man of small
account. He, making a jest of the matter, paints it in such sort, that the owner
is put out of countenance.*

THE TALE

Every one has long since heard of Giotto, and knows how greatly he
stood above all other painters. Hearing the fame of this master, a rude ar-
tizan, who desired to have his buckler painted, perhaps because he was
going to do watch and ward in some castle, marched at once to the
workshop of Giotto, with one bearing the shield behind him. Having got
there, he speedily found Giotto, to whom he said, "God save thee, mas-
ter! I would fain have thee paint me my arms on this shield." Giotto, hav-
ing examined the man and considered his manner, replied nothing more
than—"When wilt thou have it finished?" which the other having told
him, he answered, "Leave the matter to me"; and the fellow departed.
Then Giotto, being left alone, began to think within himself, "What may
this mean? Hath some one sent this man to make a jest of me? However
it be, no man ever before brought me a buckler to paint; yet here is this
simple fellow, who brings me his shield, and bids me paint his arms upon
it, as though he were of the royal family of France. Of a verity, I must
make him arms of a new fashion." Thinking thus within himself, he
takes the said buckler, and having designed what he thought proper,
called one of his scholars, and bade him complete the painting. This was
a tin skullcap, a gorget, a pair of iron gauntlets, with a cuirass, cuishes and
gambadoes, a sword, a dagger, and a spear. Our great personage, of whom
nobody knew any thing, having returned for his shield, marches forward
and inquires, "Master, is this shield painted?" "To be sure it is," replied
Giotto; "bring it down here." The shield being brought, our wise gen-
tleman that-would-be, began to open his eyes and look at it, calling out
to Giotto, "What trumpery is this that thou hast painted me here?" "Will
it seem to thee a trumpery matter to pay for it?" answered Giotto. "I will
not pay five farthings for it all," returned the clown. "And what didst
thou require me to paint?" asked Giotto. "My arms." "And are they not
here," rejoined the painter; "is there one wanting?" "Good, good!"
quoth the man. "Nay, verily, but 'tis rather bad, bad!" responded Giotto.
"Lord help thee, for thou must needs be a special simpleton: why, if a
man were to ask thee, 'Who art thou?' 'twould be a hard matter for thee
to tell him; yet here thou comest and criest, 'paint me my arms.' If thou
wert of the house of the Bardi, that were enough; but thou!—what arms
dost thou bear? who art thou? who were thy forefathers? Art thou not

ashamed of thyself! Begin at least to come into the world before thou talkest of arms, as though thou wert Dusnam of Bavaria at the very least. I have made thee a whole suit of armor on thy shield: if there be any other piece, tell me, and I'll put that too." "Thou hast given me rough words, and hast spoiled my shield," declared the other; and going forth, he betook himself to the justice, before whom he caused Giotto to be called. The latter forthwith appeared; but on his side summoned the complainant for two florins, the price of the painting, and which he demands to be paid. The pleadings being heard on both sides, and Giotto's story being much better told than that of our clown, the judges decided that the latter should take away his buckler, painted as it was, and should pay six livres to Giotto, whom they declared to have the right. Thus the good man had to pay and to take his shield; whereupon he was bidden to depart, and not knowing his place, had it taught to him on this wise.

It is said that Giotto, when he was still a boy and studying with Cimabue, once painted a fly on the nose of a figure on which Cimabue himself was employed, and this so naturally that, when the master returned to continue his work, he believed it to be real, and lifted his hand more than once to drive it away before he should go on with the painting. Many other jests and witty retorts might be recorded of Giotto; but these which appertain to art shall suffice me to tell in this place; and for the rest I refer my reader to Franco and other writers.

The memory of Giotto is not only preserved in his own works, but is also consecrated in the writings of the authors of those times, he being the master by whom the true art of painting was recovered, after it had been lost during many years preceding his time: wherefore, by a public decree and by command of the elder Lorenzo de' Medici, of glorious memory, who bore him a particular affection and greatly admired the talent of this distinguished man, his bust was placed in Santa Maria del Fiore, being sculptured in marble by Benedetto da Majano, an excellent sculptor; and the following verses by that divine poet, Messer Angelo Poliziano,[14] were engraved thereon, to the end that all who should distinguish themselves in any profession might have hope of receiving such memorials at the hands of others, his successors, as Giotto deserved and received from the hands of Lorenzo:

> Ille ego sum, per quem pictura extinta revixit,
>> Cui quam recta manus, tam fuit et facilis
> Naturæ deerat nostræ quod defuit arti:
>> Plus licuit nulli pingere, nec melius
> Miraris turrim egregiam sacro aere sonantem?
>> Hæc quoque de modulo crevit ad astra meo,

Denique sum Jottus, quid opus fuit illa referre?
Hoc nomen longi carminis instar erit.[15]

And that those who shall come after, may better know the excellence of
this great man, and may judge him from drawings by his own hand, there
are some that are wonderfully beautiful preserved in my book above-
mentioned, and which I have collected with great diligence, as well as
with much labor and expense.

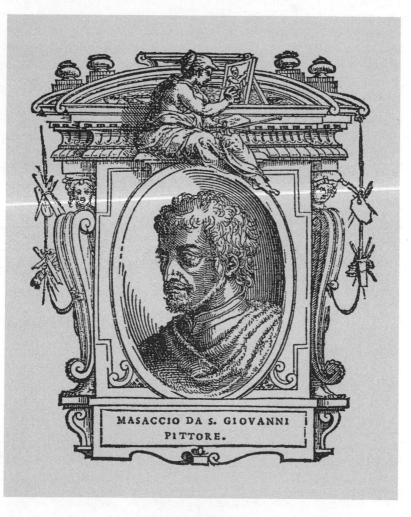

MASACCIO DA S. GIOVANNI
PITTORE.

MASACCIO
Painter, of Castel San Giovanni, in Valdarno
[1401–1428]

WHEN nature has called into existence a genius of surpassing excellence in any vocation, it is not her custom to leave him alone: on the contrary, she for the most part gives life to another, created at the same time and in the same locality, whence the emulation of each is excited and they mutually serve as stimulants one to the other. And this, in addition to the great advantage derived from it by them who, thus united, make their efforts in common, has the further effect of awakening the minds of those who come after them, and who are excited to labor with the utmost zeal and industry for the attainment of that glorious reputation and those honors which they daily hear ascribed to their distinguished predecessors; and that this is true we find proved by the fact that Florence produced at one and the same time Filippo, Donato, Lorenzo,[1] Paolo Uccello, and Masaccio, each most excellent in his peculiar walk, and all contributing to banish the coarse and hard manner which had prevailed up to the period of their existence; nor was this all, for the minds of those who succeeded these masters were so effectually inflamed by their admirable works that the modes of production in these arts were brought to that grandeur and height of perfection which are made manifest in the performances of our own times.

We then, of a truth, have the greatest obligation to those masters who by their labors first taught us the true path by which to attain the highest summit of perfection; and as touching the good manner in painting, most especially are we indebted to Masaccio, since it was he who, eager for the acquirement of fame, first attained the clear perception that painting is no other than the close imitation, by drawing and coloring simply, of all the forms presented by nature, exhibiting them as they are produced by her, and that whosoever shall most perfectly effect this may be said to have most nearly approached the summit of excellence. The conviction of this truth formed by Masaccio was the cause, I say, of his attaining to so much knowledge, by means of perpetual study, that he may be accounted among the first by whom art was in a great measure delivered from rudeness and hardness: he it was who taught the method of overcoming many difficulties, and led the way to the adoption of those beautiful attitudes and movements never exhibited by any painter before his day, while he also imparted a life and force to his figures with a cer-

tain roundness and relief which render them truly characteristic and natural. Possessing extreme rectitude of judgment, Masaccio perceived that all figures, not sufficiently foreshortened to appear standing firmly on the plane whereon they are placed, but reared up on the points of their feet, must needs be deprived of all grace and excellence in the most important essentials, and that those who so represent them prove themselves unacquainted with the art of foreshortening.

It is true that Paolo Uccello had given his attention to this subject, and had done something in the matter, which did to a certain extent lessen the difficulty; but Masaccio, differing from him in various particulars, managed his foreshortenings with much greater ability, exhibiting his mastery of this point in every kind and variety of view, and succeeding better than any artist had done before him. He moreover imparted extreme softness and harmony to his paintings, and was careful to have the carnations of the heads and other nude parts in accordance with the colors of the draperies, which he represented with few and simple folds, as they are seen in the natural object. This has been of the utmost utility to succeeding artists, and Masaccio deserves to be considered the inventor of that manner, since it may be truly affirmed that the works produced before his time should be called paintings; but that his performance, when compared with those works, might be designated life, truth, and nature.

The birthplace of this master was Castello San Giovanni, in the Valdarno, and it is said that some figures are still to be seen there which were executed by Masaccio in his earliest childhood. He was remarkably absent and careless of externals, as one who, having fixed his whole mind and thought on art, cared little for himself or his personal interests, and meddled still less with the affairs of others; he could by no means be induced to bestow his attention on the cares of the world and the general interests of life, insomuch that he would give no thought to his clothing, nor was he ever wont to require payment from his debtors, until he was first reduced to the extremity of want; and for all this, instead of being called Tommaso, which was his name, he received from every one the cognomen of Masaccio,[2] by no means for any vice of disposition, since he was goodness itself, but merely from his excessive negligence and disregard of himself; for he was always so friendly to all, so ready to oblige and do service to others, that a better or kinder man could not possibly be desired.

Masaccio's first labors in art were commenced at the time when Masolino da Panicale was working at the chapel of the Brancacci, in the church of the Carmine, at Florence: and he sought earnestly to follow in the track pursued by Donatello and Filippo Brunelleschi (although their branch of art, being sculpture, was different from his own), his efforts

being perpetually directed to the giving his figures a life and animation which should render them similar to nature. The outlines and coloring of Masaccio are so different from those of the masters preceding him that his works may be safely brought in comparison with the drawing and coloring of any produced in later times. Studious and persevering in his labors, this artist successfully coped with the difficulties of perspective, which he overcame most admirably and with true artistic skill, as may be seen in a story representing Christ curing a man possessed by a demon, which comprises a number of small figures and is now in the possession of Ridolfo del Ghirlandaio.

In this work are buildings beautifully drawn in perspective, and so treated that the inside is seen at the same time, the artist having taken the view of these buildings not as presented in front, but as seen in the sides and angles, to the great increase of the difficulty. Masaccio gave much more attention than had ever been bestowed by previous masters to the foreshortening of his figures and the treatment of the naked form: he had great facility of handling, and his figures, as we have said, were of the utmost simplicity. There is a picture in distemper by this master, representing Our Lady reposing in the lap of St. Anna, and holding the Divine Child in her arms: it is now in Sant'Ambrogio, in Florence, in the chapel which stands next to the door leading to the parlor of the nuns. In the church of St. Nicholas, beyond the Arno, is also a picture by Masaccio: it is in distemper and represents the Annunciation, with a house and many columns, admirably painted in perspective. The design and coloring are alike perfect, and the whole is so managed that the colonnade gradually recedes from view in a manner which proves Masaccio's knowledge of perspective.

In the Abbey of Florence, Masaccio painted a fresco on a pillar opposite to one of those which support the arch of the high altar; this represents St. Ivo of Brittany, whom the master figures as standing within a niche, that the feet might appear duly foreshortened to the spectator viewing it from below: a thing which obtained him no small commendation, as not having been so successfully practiced by other masters. Beneath St. Ivo, and on the cornice below, is a crowd of beggars, widows, and orphans, to whom the saint affords help in their necessity. In the church of Santa Maria Novella, there is likewise a fresco, painted by Masaccio; it represents the Trinity, with the Virgin on one side, and St. John the Evangelist on the other, who are in contemplation of Christ crucified. This picture is over the altar of St. Ignatius, and on the side walls are two figures, supposed to be the portraits of those who caused the fresco to be painted; but they are little seen, having been concealed by some gilded decorations appended over them. But perhaps the most beautiful part of this work, to say nothing of the excellence of the fig-

ures, is the coved ceiling, painted in perspective, and divided into square compartments, with a rosette in each compartment; the foreshortening is managed with so much ability, and the whole is so judiciously treated that the surface has all the appearance of being perforated.

In the church of Santa Maria Maggiore, and in a chapel near the side door which leads towards San Giovanni, is a picture painted by Masaccio, and representing the Madonna, with Santa Caterina, and San Giuliano. On the predella are various stories from the life of Santa Caterina, the figures being very small; with that of San Giuliano killing his father and mother. The Birth of Christ is also depicted here with that simplicity and life-like truth which were peculiar to the manner of this master. In Pisa, moreover, and in one of the chapels in the church of the Carmine, is a picture by this master, representing Our Lady with the Child, and at their feet are angels sounding instruments of music; one of whom is giving the most rapt attention to the harmony he is producing. St. Peter and St. John the Baptist are on one side of the Virgin, with San Giuliano and San Niccolò on the other. These figures are all full of truth and animation.

On the predella beneath are stories from the lives of the above named saints in small figures, and in the center of these is the Adoration of Christ by the Magi. This part of the work presents horses full of life, and so beautiful that nothing better could be desired. The persons composing the court of the three kings are clothed in different vestments customary at that time; and over all, as a completion to the work, are various saints, in several compartments, placed around a crucifix. It is moreover believed that the figure of a saint, wearing the robes of a bishop, and painted in fresco, in the same church, beside the door which leads into the convent, is also by the hand of Masaccio; but I am fully convinced that this is the work of Masaccio's disciple, Fra Filippo.

Having returned from Pisa to Florence, Masaccio there painted a picture, which is now in the Palla Rucellai palace: it presents two naked figures, male and female, of the size of life. But not finding himself at his ease in Florence, and stimulated by his love and zeal for art, the master resolved to proceed to Rome, that he might there learn to surpass others, and this he effected. In Rome, Masaccio acquired high reputation, and in a chapel of the church of San Clemente, he painted a Crucifixion in fresco, with the thieves on their crosses, and also stories from the life of St. Catherine the Martyr. This work he executed for the Cardinal of San Clemente.[3] He likewise painted many pictures in distemper; but in the troubled times of Rome, these have all been destroyed or lost. There is one remaining in the church of Santa Maria Maggiore, and in a small chapel near the sacristy, wherein are four saints so admirably done that they seem rather to be executed in relief than on the plain surface: in the

midst of these is Santa Maria della Neve. The portrait of Pope Martin, taken from nature, is also by this master: the Pontiff is represented holding a spade in his hand, with which he is tracing out the foundations of the church; near the Pope stands the figure of the Emperor Sigismund II.[4]

I was one day examining that work with Michelangelo Buonarroti, when he praised it very highly, remarking at the same time that the two personages depicted had both lived in Masaccio's day. Whilst this master was in Rome he was appointed to adorn the walls of the church of San Giovanni in that city, Pisanello and Gentile da Fabriano being also employed by Pope Martin to decorate the walls of the same edifice with their paintings. But Masaccio, having received intelligence that Cosimo de' Medici, from whom he had received favor and protection, had been recalled from exile, again repaired to Florence; there, Masolino da Panicale being dead, Masaccio was appointed to continue the paintings of the Brancacci chapel, in the church of the Carmine, left unfinished, as we have said, by the death of Masolino.[5] Before entering on this work, our artist painted, as if by way of specimen, and to show to what extent he had ameliorated his art, that figure of St. Paul which stands near the place of the bell-ropes; and it is certain that the master displayed great excellence in this work; for the figure of the saint, which is the portrait of Bartolo di Angiolino Angiolini, taken from the life, has something in it so impressive, and is so beautiful and life-like, that it seems to want nothing but speech; insomuch that he who has not known St. Paul has but to look at this picture, when he will at once behold the noble deportment of him who conjoined the Roman culture and eloquence with that invincible force which distinguished the exalted and devout character of this apostle, whose every care and thought were given to the affairs of the faith.

In this picture, Masaccio also afforded further proof of his mastery over the difficulties of foreshortening: the powers of this artist as regards that point were indeed truly wonderful, as may be seen even now in the feet of this apostle, where he has overcome the difficulty in a manner that may well be admired when we consider the rude ancient fashion of placing all the figures on the points of their feet; and this manner was persisted in even to his day, not having been fully corrected by the older artists; he it was who (earlier than any other master) brought this point of art to the perfection which it has attained in our own times.

While Masaccio was employed on this work, it chanced that the aforesaid church of the Carmine was consecrated, and in memory of that event Masaccio painted the whole ceremony of the consecration as it had occurred, in chiaroscuro, over the door within the cloister which leads into the convent. In this work, which was in terra verde, the mas-

ter painted the portraits of a great number of the citizens who make part of the procession, clothed in hoods and mantles; among these figures were those of Filippo di Ser Brunellesco, in "zoccoli,"[6] Donatello, Masolino da Panicale, who had been his master, Antonio Brancacci,[7] for whom it was that the above-mentioned chapel was painted, Niccolò da Uzzano, Giovanni di Bicci de' Medici, and Bartolommeo Valori, all of whose portraits, painted by the same artist, are also in the house of Simon Corsi, a Florentine gentleman. Masaccio likewise placed the portrait of Lorenzo Ridolfi, who was then ambassador from the Florentine republic to the republic of Venice, among those of the picture of the consecration; and not only did he therein depict the above-named personages from the life, but the door of the convent is also portrayed as it stood, with the porter holding the keys in his hand.

This work has, of a truth, much in it that is very excellent, Masaccio having found means to marshal his figures so admirably well on the level space of that piazza, in ranges of five or six in a file, and they are gradually diminished to the eye with such judgment and truth of proportion that it is truly wonderful. There is also to be remarked that he has had the forethought to make these men not all of one size, but differing, as in life; insomuch that one distinguishes the short and stout man from the tall and slender figures, as one would if they were living. The feet of all are planted firmly on the plane they occupy, and the foreshortening of the files is so perfect that they could not look otherwise in the actual life.

After this Masaccio returned to the works of the Brancacci chapel, wherein he continued the stories from the life of St. Peter, commenced by Masolino da Panicale, of which he completed a certain part: the installation of St. Peter as first Pontiff, that is to say, the healing of the sick, the raising to life of the dead, and the making the halt sound by the shadow of the apostle falling on them as he approaches the temple with St. John. But remarkable above all the rest is the story which represents St. Peter, when, by command of Christ, he draws money to pay the tribute from the mouth of the fish; for besides that we have here the portrait of Masaccio himself, in the figure of one of the apostles (the last painted by his own hand, with the aid of a mirror, and so admirably done that it seems to live and breathe); there is, moreover, great spirit in the figure of St. Peter as he looks inquiringly towards Jesus, while the attention given by the apostles to what is taking place, as they stand around their master awaiting his determination, is expressed with so much truth, and their various attitudes and gestures are so full of animation, that they seem to be those of living men. Saint Peter, more particularly, bent forward and making considerable effort as he draws the money from the mouth of the fish, has his face reddened with the exertion and position. When he pays the tribute also, the expression of his face as he carefully counts the

money, with that of him who receives it, and which last betrays an excessive eagerness to become possessed of it: all this is depicted with the most vivid truth, the latter regarding the coins which he holds in his hand with the greatest pleasure.

Masaccio also depicted the restoration to life of the king's son by St. Peter and St. Paul, but this last work remained unfinished at the death of Masaccio, and was afterwards completed by Filippino. In the picture which represents St. Peter administering the rite of Baptism, there is a figure which has always been most highly celebrated: it is that of a naked youth, among those who are baptized, and who is shivering with the cold. This is in all respects so admirable and in so fine a manner that it has ever since been held in reverence and admiration by all artists, whether of those times or of a later period.

This chapel has indeed been continually frequented by an infinite number of students and masters for the sake of the benefit to be derived from these works, in which there are still some heads so beautiful and life-like that we may safely affirm no artist of that period to have approached so nearly to the manner of the moderns as did Masaccio. His works do indeed merit all the praise they have received, and the rather as it was by him that the path was opened to the excellent manner prevalent in our own times; to the truth of which we have testimony in the fact that all the most celebrated sculptors and painters since Masaccio's day have become excellent and illustrious by studying their art in this chapel. Among these may be enumerated Fra Giovanni da Fiesole,[8] Fra Filippo, Filippino, who completed the work; Alesso Baldovinetti, Andrea del Castagno, Andrea del Verrocchio, Domenico del Ghirlandaio, Sandro di Botticello, Leonardo da Vinci, Pietro Perugino, Fra Bartolommeo di San Marco, Mariotti Albertinelli, and the sublime Michelangelo Buonarroti. Raphael of Urbino also made his first commencement of his exquisite manner in this place, and to these must be added Granaccio, Lorenzo di Credi, Ridolfo del Ghirlandaio, Andrea del Sarto, Rosso, Francia Bigio (or Franciabigio), Baccio Bandinelli, Alonzo Spagnolo, Jacopo da Pontormo, Pierino del Vaga, and Toto del Nunziata; all, in short, who have sought to acquire their art in its perfection have constantly repaired to study it in this chapel, there imbibing the precepts and rules necessary to be followed for the ensurance of success, and learning to labor effectually from the figures of Masaccio.

And if I have here made mention of but few among the foreigners who have frequented this chapel for purposes of study, let it suffice to say that where the heads go, there the members are certain to follow. But although the works of Masaccio have ever been held in such high estimation, yet it is nevertheless the opinion, or rather the firm belief, of many that he would have done still greater things for art had not death, which

tore him from us at the age of twenty-six,[9] so prematurely deprived the world of this great master. Whether it were from envy, or because the best things have but rarely a long duration, so it was that he died in the fairest flower of his youth; and so sudden was his decease that there were not wanting persons who ascribed it to poison rather than to any other cause (*accidente*).

It is said that when Filippo di Ser Brunellesco heard of this event, he remarked, "We have suffered a very great loss in the death of Masaccio," and that it grieved him exceedingly, the rather as he had himself long labored to instruct the departed painter in matters touching the rules of perspective and architecture. Masaccio was buried in the above-named church of the Carmine in the year 1443,[10] and although no memorial was placed over his sepulchre at the time—he having been but little esteemed while in life—yet there were not wanting those who honored him after his death by the following epitaphs:

> Pinsi et la mia pittura al ver fu pari;
>> L'atteggiai, l'avvivai, le diedi il moto
>> Le diedi affetto. Insegui il Bonarroto
>> A tutti gli altri e da me solo impari.[11]
>> (by Annibal Caro)

> Invida cur, Lachesis, primo sub flore juventæ
>> Pollice discindis stamina funereo?
> Hoc uno occiso, innumeros occidis Apelles:
>> Picturæ omnis obit, hoc obeunte lepos.
> Hoc sole extincto, extinguuntur sydera cuncta.
>> Heu! decus omne perit, hoc pereunte simul.[12]
>> (by Fabio Segni)

FRA FILIPPO LIPPI
The Florentine Painter
[1406–1469]

THE Carmelite monk, Fra Filippo di Tommaso Lippi, was born at Florence in a bye street called Ardiglione, under the Canto alla Cuculia, and behind the convent of the Carmelites. By the death of his father he was left a friendless orphan at the age of two years, his mother having also died shortly after his birth. The child was for some time under the care of a certain Mona Lapaccia, his aunt, the sister of his father, who brought him up with very great difficulty till he had attained his eighth year, when, being no longer able to support the burden of his maintenance, she placed him in the above-named convent of the Carmelites. Here, in proportion as he showed himself dexterous and ingenious in all works performed by hand, did he manifest the utmost dulness and incapacity in letters, to which he would never apply himself, nor would he take any pleasure in learning of any kind.

The boy continued to be called by his worldly name of Filippo, and being placed with others, who like himself were in the house of the novices, under the care of the master, to the end that the latter might see what could be done with him, in place of studying, he never did any thing but daub his own books, and those of the other boys, with caricatures, whereupon the prior determined to give him all means and every opportunity for learning to draw. The chapel of the Carmine had then been newly painted by Masaccio, and this being exceedingly beautiful, pleased Fra Filippo greatly, wherefore he frequented it daily for his recreation, and, continually practising there, in company with many other youths, who were constantly drawing in that place, he surpassed all the others by very much in dexterity and knowledge; insomuch that he was considered certain to accomplish some marvelous thing in the course of time. For not only in his youth, but when almost in his childhood, he performed so many praiseworthy labors that it was truly wonderful.

While still very young he painted a picture in terra verde, in the cloister, near Masaccio's painting of the Consecration, the subject of which was a Pope confirming the Rule of the Carmelites, with others in fresco on several of the walls in different parts of the church: among these was a figure of St. John the Baptist, with stories from the life of that saint. Proceeding thus, and improving from day to day, he had so closely followed the manner of Masaccio, and his works displayed so much simi-

larity to those of the latter that many affirmed the spirit of Masaccio to have entered the body of Fra Filippo. On one of the pillars of the church, near the organ, he depicted the figure of San Marziale, a work by which he acquired great fame, seeing that it was judged to bear a comparison with those executed by Masaccio. Whereupon, hearing himself so highly commended by all, he formed his resolution at the age of seventeen, and boldly threw off the clerical habit.[1]

Some time after this event, and being in the March of Ancona, Filippo was one day amusing himself with certain of his friends in a boat on the sea, when they were all taken by a Moorish galley, which was cruising in that neighborhood, and led captives into Barbary,[2] where he remained, suffering many tribulations, for eighteen months. But, having frequent opportunities of seeing his master, it came into his head one day to draw his portrait; and finding an opportunity, he took a piece of charcoal from the fire, and with that delineated his figure at full length on a white wall, robed in his Moorish vestments. This being related to the master by the other slaves, to all of whom it appeared a miracle, the arts of drawing and painting not being practiced in that country, the circumstance caused his liberation from the chains in which he had so long been held. And truly that was greatly to the glory of that noble art; for here was a man to whom belonged the right of condemning and punishing, but who, in place of inflicting pains and death, does the direct contrary, and is even led to show friendship, and restore the captive to liberty.

Having afterwards executed certain works in painting for his master, he was then conducted safely to Naples, where he painted a picture on panel for King Alfonso, then Duke of Calabria, which was placed in the chapel of the castle, where the guard-room now is. But after no long time he conceived a wish to return to Florence, where he remained some months, during which time he painted an altar-piece for the nuns of Sant'Ambrogio, a most beautiful picture,[3] by means of which he became known to Cosimo de' Medici, who was thereby rendered his most assured friend. He likewise executed a painting in the chapter-house of Santa Croce, with a second, which was placed in the chapel of the Medici Palace, and on which he depicted the Nativity of Christ. Fra Filippo likewise painted a picture for the wife of the above-named Cosimo, the subject of which is also a Nativity of Christ, with a figure of St. John the Baptist; this work was intended for one of the cells in the hermitage of Camaldoli, which she had caused to be constructed as a mark of devotion, and had dedicated to St. John the Baptist. Other pictures by the same master, containing stories in small figures, were sent as a gift to Pope Eugenius IV, who was a Venetian, by Cosimo de' Medici, and these works caused Fra Filippo to be in great favor with that Pontiff.

It is said that Fra Filippo was much addicted to the pleasures of sense,

insomuch that he would give all he possessed to secure the gratification of whatever inclination might at the moment be predominant; but if he could by no means accomplish his wishes, he would then depict the object which had attracted his attention in his paintings, and endeavor by discoursing and reasoning with himself to diminish the violence of his inclination. It was known that, while occupied in the pursuit of his pleasures, the works undertaken by him received little or none of his attention; for which reason Cosimo de' Medici, wishing him to execute a work in his own palace, shut him up, that he might not waste his time in running about; but having endured this confinement for two days, he then made ropes with the sheets of his bed, which he cut to pieces for that purpose, and so having let himself down from a window, escaped, and for several days gave himself up to his amusements.

When Cosimo found that the painter had disappeared, he caused him to be sought, and Fra Filippo at last returned to his work, but from that time forward Cosimo gave him liberty to go in and out at his pleasure, repenting greatly of having previously shut him up, when he considered the danger that Fra Filippo had incurred by his folly in descending from the window; and ever afterwards, laboring to keep him to his work by kindness only, he was by this means much more promptly and effectually served by the painter, and was wont to say that the excellencies of rare genius were as forms of light and not beasts of burden.

For the church of Santa Maria Primerana, on the piazza of Fiesole, Fra Filippo painted a picture, wherein he depicted Our Lady receiving the Annunciation from the Angel. This work exhibits extraordinary care, and there is so much beauty in the figure of the angel that it appears to be indeed a celestial messenger. This master executed two pictures for the nuns of the Murate; one, an Annunciation, is placed on the high altar; the other, presenting stories from the lives of San Benedetto and San Bernardo, is on another altar of the same church. In the palace of the Signoria, Fra Filippo likewise painted a picture of the Annunciation, which is over a door, with another representing San Bernardo placed over another door in the same palace. In the sacristy of Santo Spirito, in Florence, is a painting by this master, representing the Virgin surrounded by angels, and with saints on either hand, a work of rare excellence, which has ever been held in the highest esteem by men versed in our arts.

In the church of San Lorenzo, Fra Filippo executed a picture, also representing the Annunciation, which is in the chapel of the Superintendents of Works, with a second for the Della Stufa Chapel, which is not finished. For Sant'Apostolo, in the same city, he painted a picture in panel for one of the chapels; it presents the Virgin surrounded by different figures. And in Arezzo he executed one for Messer Carlo

Marsuppini, to be placed in the chapel of San Bernardo, belonging to the monks of Monte Oliveto, wherein he depicted the Coronation of the Virgin, surrounded by numerous saints. This work has maintained itself in so remarkable a degree of freshness that one might suppose it to have but just left the hands of the master. With respect to this picture, the latter was exhorted by Carlo Marsuppini to give particular attention to the hands, his painting of which, in many of his works, had been much complained off; whereupon Fra Filippo, wishing to avoid such blame for the future, ever afterwards sought to conceal the hands of his figures, either by the draperies or by some other contrivance. In the painting we are now describing, the master has given the portrait of Messer Carlo Marsuppini from the life.

In Florence, Fra Filippo painted the picture of a Nativity, for the nuns of Annalena, and some of his works are also to be seen in Padua. He sent two stories in small figures to Rome for Cardinal Barbo; they were admirably executed, and finished with extraordinary care. This master certainly displayed most wonderful grace in his works, blending his colors with the most perfect harmony, qualities for which he has ever been held in the highest esteem among artists, and for which he is extolled by modern masters with unlimited commendation; nay, there can be no doubt, that so long as his admirable labors can be preserved from the voracity of time his name will be held in veneration by all coming ages. In Prato, near Florence, where Fra Filippo had some relations, he took up his abode for some months, and there executed various works for the whole surrounding district, in company with the Carmelite, Fra Diamante, who had been his companion in novitiate.

Having then received a commission from the nuns of Santa Margherita to paint a picture for the high altar of their church, he one day chanced to see the daughter of Francesco Buti, a citizen of Florence, who had been sent to the convent, either as a novice or boarder. Fra Filippo, having given a glance at Lucrezia, for such was the name of the girl, who was exceedingly beautiful and graceful, so persuaded the nuns that he prevailed on them to permit him to make a likeness of her for the figure of the Virgin in the work he was executing for them. The result of this was that the painter fell violently in love with Lucrezia, and at length found means to influence her in such a manner that he led her away from the nuns, and on a certain day, when she had gone forth to do honor to the Cintola[4] of Our Lady, a venerated relic preserved at Prato and exhibited on that occasion, he bore her from their keeping. By this event the nuns were deeply disgraced, and the father of Lucrezia was so grievously afflicted thereat that he never more recovered his cheerfulness, and made every possible effort to regain his child.[5] But Lucrezia, whether retained by fear or by some other cause, would not return, but remained

with Filippo, to whom she bore a son, who was also called Filippo, and who eventually became a most excellent and very famous painter like his father.[6]

In the church of San Domenico, in this same Prato, are two pictures by this master, and in the transept of the church of San Francesco is another, a figure of the Virgin namely. Desiring to remove this work from its original place, the superintendents, to save it from injury, had the wall on which it was depicted cut away, and having secured and bound it with wood-work, thus transported it to another wall of the church, where it is still to be seen. Over a well, in the courtyard of the Ceppo of Francesco di Marco, there is a small picture on panel by this master, representing the portrait of the above-named Francesco di Marco, the author and founder of that pious establishment.

In the capitular church of Prato, on a small tablet which is over the side door as one ascends the steps, Fra Filippo depicted the death of San Bernardo, by the touch of whose bier many lame persons are restored to health. In this work are monks bewailing the loss of their master; and the exquisite grace of their heads, the truth and beauty with which their grief and the plaintive expression of their weeping are conveyed to the spectator is a thing marvelous to behold. Some of the hoods and draperies of these monks have most beautiful folds, and the whole work merits the utmost praise for the excellence of its design, composition, and coloring, as well as for the grace and harmony of proportion displayed in it, completed as it is by the most delicate hand of Filippo. He was also appointed by the wardens of the same church, who desired to retain a memorial of him, to paint the chapel of the high altar, and here we have likewise good evidence of his power, for besides the excellence of the picture as a whole, there are certain heads and draperies in it which are most admirable. In this work Fra Filippo made the figures larger than life, and hereby instructed later artists in the mode of giving true grandeur to large figures. There are likewise certain figures clothed in vestments but little used at that time, whereby the minds of others were awakened, and artists began to depart from that sameness which should rather be called obsolete monotony than antique simplicity.

In the same work are stories from the life of Santo Stefano, to whom the church is dedicated; they cover the wall on the right side, and consist of the Disputation, the Stoning and the Death of the Protomartyr. In the first of these, where St. Stephen is disputing with the Jews, the countenance of the saint exhibits so much zeal and fervor that it is difficult even to imagine how much more could give it expression: while, in the faces and attitudes of these Jews, their hatred and rage, with the anger they feel at finding themselves vanquished by the saint, are equally manifest. Still more forcibly has he depicted the brutal rage of those who slew

the martyr with stones, which they grasp, some large, others smaller ones, with grinding teeth, horrible to behold, and with gestures of demoniac rage and cruelty. St. Stephen, calm and steadfast in the midst of their terrible violence, is seen with his face towards heaven, imploring the pardon of the Eternal Father for those who thus attack him, with the utmost piety and fervor. This variety of expression is certainly very fine, and is well calculated to teach students of art the value of imitative power, and the importance of being able to express clearly the affections and emotions of the characters represented. Fra Filippo devoted the most earnest attention to this point, as is seen in this work; he has given the disciples who are burying St. Stephen attitudes so full of dejection, and faces so deeply afflicted, so drowned in tears, that it is scarcely possible to look at them without feeling a sense of sorrow.

On the other side of the chapel is the history of St. John the Baptist, his Birth, that is to say, his Preaching in the Wilderness, his Baptism, the Feast of Herod, and the Decapitation of the Saint. In the picture of the Preaching, the Divine Spirit inspiring the speaker is most clearly manifest in his face, while the different emotions of hope, anxiety, gladness, and sorrow of the crowd, women as well as men, who are listening around him, charmed and mastered by the force of his words, are equally well expressed. In the Baptism are beauty and goodness exemplified, and in the Feast of Herod, the splendor of the banquet, the address of Herodias, the astonishment of the guests, and their inexpressible sorrow when the head is presented on the charger are rendered with admirable truth and effect. Among those present at the banquet are numerous figures in fine attitudes, exhibiting beautiful draperies and exquisite expressions of countenance.

A portrait of Fra Filippo himself, taken with his own hand by help of a mirror, is one of them, and among the persons who bewail the death of St. Stephen, is the portrait of his disciple, Fra Diamante, in a figure robed in black and bearing the vestments of a bishop. This work is indeed the best of all that he produced, as well for the many fine qualities displayed in it as for the circumstance that having made the figures somewhat larger than life he encouraged those who came after him to enlarge their manner. Fra Filippo was indeed so highly estimated for his great gifts that many circumstances in his life, which were very blamable, received pardon, and were partly placed out of view in consideration of his extraordinary abilities. In the work just described is the portrait of Messer Carlo, natural son of Cosimo de' Medici, who was rector of the church wherein it was executed, which had received large benefactions both from him and his house.

In the year 1463, when Fra Filippo had completed this undertaking, he painted a picture in tempera for the church of San Jacopo, in Pistoia.

The subject of this work, which is a very fine one, is the Annunciation, and contains the portrait of Messer Jacopo Bellucci, taken from the life, and depicted with great animation. There is also a picture representing the Birth of the Virgin, by this master, in the house of Pulidoro Bracciolini; and in the hall of the Council of Eight, in Florence, is a picture of the Virgin with the Child in her arms, painted in tempera, on a half circle. In the house of Ludovico Capponi, likewise, there is another picture of the Virgin, which is exceedingly beautiful; and a work of the same master is in the possession of Bernardo Vecchietti, a Florentine noble, of so much integrity and excellence that my words cannot do justice to his merits. The picture is small, the subject Sant'Agostino occupied with his studies; an exceedingly beautiful painting.[7]

But still finer is a figure of St. Jerome doing penance, of similar size, and by the same hand, which is now in the Guardaroba of Duke Cosimo: for if Fra Filippo displayed excellence in his paintings generally, still more admirable were his smaller pictures; in these he surpassed himself, imparting to them a grace and beauty than which nothing finer could be imagined: examples of this may be seen in the predellas of all the pictures painted by him. He was indeed an artist of such power that in his own time he was surpassed by none, and even in our days there are very few superior to him: therefore it is that he has not only been always eulogized by Michelangelo, but in many things has been imitated by that master.

For the church of San Domenico-vecchio, in Perugia, Fra Filippo painted a picture, which has since been placed on the high altar; it represents the Virgin, with San Piero, San Paolo, San Ludovico, and Sant'Antonio the Abbot. The Cavaliere, Messer Alessandro degli Alessandri, also a friend of Fra Filippo, caused him to paint a picture for the church of his country palace at Vincigliata, on the heights of Fiesole, the subject a San Lorenzo and other saints. In this work he depicted the portraits of Alessandro degli Alessandri and his two sons. Fra Filippo was very partial to men of cheerful character, and lived for his own part in a very joyous fashion.

This master instructed Fra Diamante in the art of painting, and the latter executed many works in the church of the Carmine at Prato. He attained to great perfection in the imitation of his master's manner, and thereby obtained much credit for himself. Among those who studied with Fra Filippo were Sandro Botticelli, Pisello, and Jacopo del Sellajo, a Florentine, who painted two pictures for the church of San Friano, and one in distemper for that of the Carmine, with many other artists whom he always instructed in the most friendly manner. He lived creditably by his labors, and expended very large sums on the pleasures to which he continued to addict himself even to the end of his life. Fra Filippo was requested by the Commune of Spoleto, through the medium of Cosimo

de' Medici, to paint the chapel in their principal church—that of Our Lady—and this work, with the assistance of Fra Diamante, he was conducting to a successful termination, when, being overtaken by death, he was prevented from completing it. It was said that the libertinism of his conduct occasioned this catastrophe, and that he was poisoned by certain persons related to the object of his love.

Fra Filippo finished the course of his life in the year 1438 being then fifty-seven years old.[8] He left Filippo his son to the guardianship of Fra Diamante, with whom the child, then ten years old,[9] returned to Florence, and was by him instructed in the art of painting. Fra Diamante took three hundred ducats with him from Spoleto, which remained to be received from the Commune for the work performed there, and with this sum he purchased a certain property for himself, appropriating but little of it to the child. The latter was placed with Sandro Botticelli, who was at that time considered an excellent master in painting, and the old man was buried in a tomb of red and white marble, which the people of Spoleto caused to be erected for him in the church which he was painting.

The death of Fra Filippo caused much regret to many among his friends, more particularly to Cosimo de' Medici[10] and Pope Eugenius IV. The latter had offered in his lifetime to give him a dispensation that he might make Lucrezia di Francesco Buti his legitimate wife; but Fra Filippo, desiring to retain the power of living after his own fashion, and of indulging his love of pleasure as might seem good to him, did not care to accept that offer.[11]

During the pontificate of Sixtus IV, Lorenzo de' Medici was sent ambassador from the Florentines, and took the journey to Spoleto, for the purpose of demanding the remains of Fra Filippo from that Commune, to the end that they might be deposited in the Florentine cathedral, Santa Maria del Fiore. But the Spoletines replied that they were but poorly provided with ornaments, above all with distinguished men; they consequently begged permission as a favor to retain them, that they might honor themselves therewith, adding that, since they possessed so many great men in Florence as almost to have a superfluity, they might content themselves without this one, and that reply was all that Lorenzo received.

But being still resolved to do all the honor that he possibly could to Fra Filippo, he sent Filippino, the son of the latter, to Rome, to the Cardinal of Naples, that he might paint a chapel for that prelate, and on this occasion Filippino, passing through Spoleto, was commissioned by Lorenzo to construct a sepulchre of marble over the sacristy and beneath the organ. On this work he expended two hundred ducats, which were paid by Nofri Tornabuoni, master of the bank to the Medici. Lorenzo

likewise caused the following epigram to be made by Messer Agnolo Poliziano, which was engraved on the tomb in letters after the antique:

> Conditus hic ego sum picturæ fama Philippus
> Nulli ignota meæ est gratia mira manus;
> Artefices potui digitis animare colores
> Sperataque animos fallere voce diu:
> Ipsa meis stupuit natura expressa figuris,
> Meque suis fassa est artibus esse parem.
> Marmoreo tumulo Medices Laurentius hic me
> Condidit, ante humili pulvere tectus eram.[12]

Fra Filippo drew exceedingly well, as may be seen in our book of the drawings of the most famous painters, more particularly in certain specimens wherein the picture of Santo Spirito is delineated, with others, which present drawings of the works in the chapel of Prato.

SANDRO BOTTICELLI PITT.
FIORENTINO

SANDRO BOTTICELLI
The Florentine Painter
[1444–1510]

IN the same time with the illustrious Lorenzo de' Medici the elder, which was truly an age of gold for men of talent, there flourished a certain Alessandro, called after our custom Sandro, and further named Di Botticello, for a reason which we shall presently see. His father, Mariano Filipepi, a Florentine citizen, brought him up with care, and caused him to be instructed in all such things as are usually taught to children before they choose a calling. But although the boy readily acquired whatever he wished to learn, yet was he constantly discontented; neither would he take any pleasure in reading, writing, or accounts, insomuch that the father, disturbed by the eccentric habits of his son, turned him over in despair to a gossip of his, called Botticello, who was a goldsmith, and considered a very competent master of his art, to the intent that the boy might learn the same.

There was at that time a close connection and almost constant intercourse between the goldsmiths and the painters, wherefore Sandro, who possessed considerable ingenuity, and was strongly disposed to the arts of design, became enamored of painting, and resolved to devote himself entirely to that vocation. He acknowledged his purpose at once to his father, and the latter, who knew the force of his inclinations, took him accordingly to the Carmelite monk, Fra Filippo, who was a most excellent painter of that time, with whom he placed him to study the art, as Sandro himself had desired.

Devoting himself thereupon entirely to the vocation he had chosen, Sandro so closely followed the directions and imitated the manner of his master, that Fra Filippo conceived a great love for him, and instructed him so effectually that Sandro rapidly attained to such a degree in art as none would have predicted for him. While still a youth he painted the figure of Fortitude, among those pictures of the Virtues which Antonio and Pietro Pollaiuolo were executing in the Mercatanzia, or Tribunal of Commerce, in Florence. In Santo Spirito, a church of the same city, he painted a picture for the chapel of the Bardi family: this work he executed with great diligence, and finished it very successfully, depicting certain olive and palm trees therein with extraordinary care. Sandro also painted a picture in the convent of the Convertites, with another for the nuns of San Barnaba.

In the church of Ognissanti he painted a Sant'Agostino, in fresco, for the Vespucci: this is in the middle aisle, near the door which leads into the choir; and here Sandro did his utmost to surpass all the masters who were painting at the time, but more particularly Domenico Ghirlandaio, who had painted a figure of St. Jerome on the opposite side. Sparing no pains, he thus produced a work of extraordinary merit. In the countenance of the saint he has clearly manifested that power of thought and acuteness of perception which is, for the most part, perceptible in those reflective and studious men who are constantly occupied with the investigation of exalted subjects and the pursuit of abstruse inquiries. This picture, as we have said in the life of Domenico Ghirlandaio, has this year (1561) been removed entire and without injury from the place where it was executed.

Having, in consequence of this work, obtained much credit and reputation, Sandro was appointed by the Guild of Porta Santa Maria to paint a picture in San Marco, the subject of which is the Coronation of Our Lady, who is surrounded by a choir of angels, the whole extremely well designed, and finished by the artist with infinite care. He executed various works in the Medici Palace for the elder Lorenzo, more particularly a figure of Pallas on a shield wreathed with vine branches, whence flames are proceeding: this he painted of the size of life. A San Sebastiano was also among the most remarkable of the works executed for Lorenzo. In the church of Santa Maria Maggiore, in Florence, is a Pietà with small figures by this master: this is placed beside the chapel of the Panciatichi, and is a very beautiful work. For different houses in various parts of the city, Sandro painted many pictures of a round form, with numerous figures of women undraped. Of these there are still two examples at Castello, a villa of the Duke Cosimo, one representing the birth of Venus, who is borne to earth by the Loves and Zephyrs: the second also presenting the figure of Venus crowned with flowers by the Graces; she is here intended to denote the Spring, and the allegory is expressed by the painter with extraordinary grace.[1]

In the Via de' Servi, in the palace of Giovanni Vespucci, which now belongs to Piero Salviati, this master painted numerous pictures around one of the chambers: they are enclosed within a richly decorated framework of walnut wood, and contain many beautiful and animated figures. In Casa Pucci, likewise, Sandro painted Boccaccio's Novella of Nastagio degli Onesti, in four compartments: the figures are small, but the work is very graceful and beautiful. He also depicted an Adoration of the Magi in the same place. For the monks of Cestello this master painted a picture of the Annunciation in one of their chapels, and in the church of San Pietro he executed one for Matteo Palmieri, with a very large number of figures. The subject of this work, which is near the side door, is

the Assumption of Our Lady, and the zones or circles of heaven are there painted in their order. The Patriarchs, the Prophets, the Apostles, the Evangelists, the Martyrs, the Confessors, the Doctors, the Virgin, and the Hierarchies: all which was executed by Sandro according to the design furnished to him by Matteo, who was a very learned and able man.

The whole work was conducted and finished with the most admirable skill and care: at the foot of it was the portrait of Matteo kneeling, with that of his wife. But although this picture is exceedingly beautiful and ought to have put envy to shame, yet there were found certain malevolent and censorious persons who, not being able to affix any other blame to the work, declared that Matteo and Sandro had erred gravely in that matter, and had fallen into grievous heresy.

Now, whether this be true or not, let none expect the judgment of that question from me: it shall suffice me to note that the figures executed by Sandro in that work are entirely worthy of praise, and that the pains he took in depicting those circles of the heavens must have been very great, to say nothing of the angels mingled with the other figures, or of the various foreshortenings, all which are designed in a very good manner.

About this time Sandro received a commission to paint a small picture with figures three parts of a braccio high, the subject an Adoration of the Magi; the work was placed between the two doors of the principal façade of Santa Maria Novella, and is on the left as you enter by the central door. In the face of the oldest of the kings, the one who first approaches, there is the most lively expression of tenderness as he kisses the foot of the Savior, and a look of satisfaction also at having attained the purpose for which he had undertaken his long journey. This figure is the portrait of Cosimo de' Medici, the most faithful and animated likeness of all now known to exist of him. The second of the kings is the portrait of Giuliano de' Medici, father of Pope Clement VII; and he offers adoration to the Divine Child, presenting his gift at the same time, with an expression of the most devout sincerity. The third, who is likewise kneeling, seems to be offering thanksgiving as well as adoration, and to confess that Christ is indeed the true Messiah: this is the likeness of Giovanni, the son of Cosimo.

The beauty which Sandro has imparted to these heads cannot be adequately described, and all the figures in the work are represented in different attitudes: of some, one sees the full face; of others, the profile; some are turning the head almost entirely from the spectator, others are bent down; and to all, the artist has given an appropriate and varied expression, whether old or young, exhibiting numerous peculiarities also, which prove the mastery that he possessed over his art. He has even distinguished the followers of each king in such a manner that it is easy to

see which belongs to one court and which to another. It is indeed a most admirable work: the composition, the design, and the coloring are so beautiful that every artist who examines it is astonished, and at the time, it obtained so great a name in Florence and other places for the master that Pope Sixtus IV, having erected the chapel built by him in his palace at Rome,[2] and desiring to have it adorned with paintings, commanded that Sandro Botticelli should be appointed superintendent of the work. He accordingly executed various pictures there: among them the Temptation of Christ in the Wilderness, Moses slaying the Egyptian, Moses receiving drink from the Daughters of Jethro the Midianite, and the Descent of Fire from heaven when the Sons of Aaron offer Sacrifice; with several figures of holy Popes in the niches above the paintings.

By these works, Botticelli obtained great honor and reputation among the many competitors who were laboring with him, whether Florentines or natives of other cities, and received from the Pope a considerable sum of money; but this he consumed and squandered totally during his residence in Rome, where he lived without due care, as was his habit. Having completed the work assigned to him, he returned at once to Florence, where, being whimsical and eccentric, he occupied himself with commenting on a certain part of Dante, illustrating the *Inferno* and executing prints, over which he wasted much time; and neglecting his proper occupation, he did no work, and thereby caused infinite disorder in his affairs. He likewise engraved many of the designs he had executed, but in a very inferior manner, the work being badly cut.

The best attempt of this kind from his hand is the Triumph of Faith, by Fra Girolamo Savonarola, of Ferrara, of whose sect our artist was so zealous a partisan that he totally abandoned painting, and not having any other means of living, he fell into very great difficulties. But his attachment to the party he had adopted increased; he became what was then called a *Piagnone*,[3] and abandoned all labor, insomuch that, finding himself at length become old, being also very poor, he must have died of hunger had he not been supported by Lorenzo de' Medici, for whom he had worked at the small hospital of Volterra and other places, who assisted him while he lived, as did other friends and admirers of his talents.

In San Francesco, outside the gate of San Miniato, Botticelli painted a Madonna, the size of life, surrounded by angels, which was considered a very beautiful picture. Now Sandro was fond of jesting, and often amused himself at the expense of his disciples and friends. In allusion to this habit, it is related that one of his scholars, named Biagio, had copied the above-mentioned picture very exactly, for the purpose of selling it: this Sandro did for him, having bargained with a citizen for six gold florins. When Biagio appeared, therefore, his master said to him, "Well, Biagio, I've sold thy picture for thee at last, but the buyer wishes to see it in a

good light, so it must be hung up this evening at a favorable height, and do thou go to the man's house to-morrow morning and bring him here, that he may see it in its place; he will then pay thee the money." "Oh, master," quoth Biagio, "how well you have done"; and having suspended the picture at the due height, he went his way.

Thereupon Sandro and Jacopo, who was another of his disciples, prepared eight caps of pasteboard, such as those worn by the Florentine citizens, and these they fixed with white wax on the heads of the eight angels, who, in the painting in question, were depicted around the Madonna. The morning being come, Biagio appears with the citizen who had bought the painting, and who was aware of the jest. Raising his eyes on entering the workshop, Biagio beholds his Madonna, not surrounded by angels, but in the midst of the Signoria of Florence, and seated among those caps. He was about to break forth into outcries and excuse himself to the citizen, but as the latter made no observation on the circumstance, and began to praise the picture, he remained silent himself. Ultimately, the citizen took him home to his house and paid him the six florins, which the master had bargained for, wherewith Biagio returned to the bottega (workshop), where he arrived just as Sandro and Jacopo had taken off the pasteboard head-dresses, and saw his angels as veritable angels again, and no longer citizens in their caps.

Altogether astonished at what he beheld, the disciple turned to his master and said, "Master mine, I know not whether I am dreaming, or whether the thing be really so, but when I came in just now, these angels had red caps on their heads, and now they have none! What may this mean?" "Thou art out of thy wits, Biagio," quoth Sandro; "this money hath made thy brain turn round. If the thing were as thou hast said, dost thou think this citizen would have bought thy picture?" "That is true," replied Biagio, "and he certainly said nothing about it, but for all that it seems a very strange matter." At last, all the other scholars, getting round him, said so much that they made him believe the whole an imagination of his own.

A weaver of cloth once came to live close to Sandro, and this man erected full eight looms, which, when all were at work, not only caused an intolerable din with the trampling of the weavers and the clang of the shuttles, insomuch that poor Sandro was deafened with it, but likewise produced such a trembling and shaking throughout the house, which was none too solidly built, that the painter, what with one and the other, could no more continue his work, nor even remain in the house. He had frequently requested his neighbor to put an end to this disturbance, but the latter had replied that he both could and would do what he pleased in his own house. Being angered by this, Sandro had an enormous mass of stone of great weight, and more than would fill a wagon, placed in

exact equilibrium on the wall of his own dwelling, which was higher than that of his neighbor, and not a very strong one: this stone threatened to fall at the slightest shake given to the wall, when it must have crushed the roof, floors, frames, and workmen of the weaver to atoms. The man, terrified at the danger, hastened to Sandro, from whom he received back his own reply in his own words, namely, that he both could and would do what he pleased in his own house; whereupon, not being able to obtain any other answer, he was compelled to come to reasonable terms, and to make the painter a less troublesome neighbor.

We find it further related that Sandro Botticelli once went to the vicar of his parish, and, in jest, accused a friend of his own of heresy. The person inculpated, having appeared, demanded to know by whom he was accused and of what. Being told that Sandro had declared him to hold the opinion of the Epicureans, to wit, that the soul dies with the body, he required that his accuser should be confronted with him before the judge. Sandro was summoned accordingly, when the accused man exclaimed, "It is true that I hold the opinion stated respecting the soul of this man, who is a blockhead; nay, does he not appear to you to be a heretic also; for, without a grain of learning, scarcely knowing how to read, has he not undertaken to make a commentary on Dante, and does he not take his name in vain?"

This master is said to have had an extraordinary love for those whom he knew to be zealous students in art, and is affirmed to have gained considerable sums of money; but being a bad manager and very careless, all came to nothing. Finally, having become old, unfit for work, and helpless, he was obliged to go on crutches, being unable to stand upright, and so died, after long illness and decrepitude, in his seventy-eighth year.[4] He was buried at Florence, in the church of Ognissanti, in the year 1510.

In the Guardaroba of the Signor Duke Cosimo are two very beautiful female heads in profile by this master, one is said to be the portrait of an inamorata of Giuliano de' Medici, brother of Lorenzo; the other that of Madonna Lucrezia Tornabuoni, Lorenzo's wife.[5] In the same place, and also by the hand of Sandro, is a Bacchus, raising a wine flask to his lips with both hands, a truly animated figure. In the Cathedral of Pisa was an Assumption of the Virgin, with a Choir of Angels, commenced by Botticelli for the chapel of the Impagliata, but the work not pleasing him, he left it unfinished. He also painted the picture of the high altar in the church of San Francesco, at Montevarchi; and in the capitular church of Empoli he depicted two Angels, on the same side with the St. Sebastian of Rossellino. It was by Sandro Botticelli that the method of preparing banners and standards in what is called inlaid work was invented; and this he did that the colors might not sink through, showing the tint of the cloth on each side. The Baldachino of Orsanmichele is by this master

and is so treated; different figures of Our Lady are represented on it, all of which are varied and beautiful. This work serves to show how much more effectually that mode of proceeding preserves the cloth than do those mordants, which, corroding the surface, allow but a short life to the work; but as the mordants cost less, they are nevertheless more frequently used in our day than the first-named method.

Sandro Botticelli drew remarkably well, insomuch that, for a long time after his death, artists took the utmost pains to procure examples of his drawings, and we have some in our book which are executed with extraordinary skill and judgment; his stories were exceedingly rich in figures, as may be seen in the embroidered ornaments of the Cross borne in procession by the monks of Santa Maria Novella, and which were executed entirely after his designs. This master was, in short, deserving of the highest praise for all such works as he chose to execute with care and good-will, as he did the Adoration of the Magi, in Santa Maria Novella, which is exceedingly beautiful. A small round picture by his hand, which may be seen in the apartments of the prior, in the monastery of the Angeli at Florence, is also very finely done; the figures are small, but singularly graceful, and finished with the most judicious care and delicacy.

Similar in size to that of the Magi just mentioned is a picture, now in the possession of the Florentine noble, Messer Fabio Segni. The subject of this work is the Calumny of Apelles, and nothing more perfectly depicted could be imagined. Beneath this picture, which was presented by Sandro himself to Antonio Segni, his most intimate friend, are now to be read the following verses, written by the above-named Messer Fabio:

> Indicio quemquam ne falsa lætere tentent
> Terrarum reges, parva tabella monet
> Huic similem Ægypti regi donavit Apelles:
> Rex fuit et dignus munere, manus eo.[6]

LEONARDO DA VINCI
The Florentine Painter and Sculptor
[1452–1519]

THE richest gifts are occasionally seen to be showered, as by celestial influence, on certain human beings; nay, they sometimes supernaturally and marvelously congregate in one sole person; beauty, grace, and talent being united in such a manner that, to whatever the man thus favored may turn himself, his every action is so divine as to leave all other men far behind him, and manifestly to prove that he has been specially endowed by the hand of God himself, and has not obtained his preeminence by human teaching, or the power of man.

This was seen and acknowledged by all men in the case of Leonardo da Vinci,[1] in whom, to say nothing of his beauty of person, which yet was such that it has never been sufficiently extolled, there was a grace beyond expression, which was rendered manifest without thought or effort in every act and deed; and who had besides so rare a gift of talent and ability that, to whatever subject he turned his attention, however difficult, he presently made himself absolute master of it. Extraordinary power was in his case conjoined with remarkable facility, a mind of regal boldness and magnanimous daring; his gifts were such that the celebrity of his name extended most widely, and he was held in the highest estimation, not in his own time only, but also, and even to a greater extent, after his death; nay, this has continued, and will continue to be by all succeeding ages.

Truly admirable, indeed, and divinely endowed was Leonardo da Vinci; this artist was the son of Ser Piero da Vinci. He would without doubt have made great progress in learning and knowledge of the sciences, had he not been so versatile and changeful, but the instability of his character caused him to undertake many things which having commenced he afterwards abandoned. In arithmetic, for example, he made such rapid progress in the short time during which he gave his attention to it that he often confounded the master who was teaching him, by the perpetual doubts he started, and by the difficulty of the questions he proposed. He also commenced the study of music, and resolved to acquire the art of playing the lute, when, being by nature of an exalted imagination and full of the most graceful vivacity, he sang to that instrument most divinely, improvising at once the verses and the music.

But, though dividing his attention among pursuits so varied, he never

abandoned his drawing, and employed himself much in works of relief, that being the occupation which attracted him more than any other. His father, Ser Piero, observing this, and considering the extraordinary character of his son's genius, one day took some of his drawings and showed them to Andrea del Verrocchio, who was a very intimate friend of his, begging him earnestly to tell him whether he thought that Leonardo would be likely to secure success if he devoted himself to the arts of design. Andrea Verrocchio was amazed as he beheld the remarkable commencement made by Leonardo, and advised Ser Piero to see that he attached himself to that calling, whereupon the latter took his measures accordingly, and sent Leonardo to study in the bottega, or workshop, of Andrea.

Thither the boy resorted therefore, with the utmost readiness, and not only gave his attention to one branch of art, but to all the others, of which design made a portion. Endowed with such admirable intelligence, and being also an excellent geometrician, Leonardo not only worked in sculpture (having executed certain heads in terra-cotta, of women smiling, even in his first youth, which are now reproduced on gypsum, and also others of children which might be supposed to have proceeded from the hand of a master); but in architecture likewise he prepared various designs for ground plans and the construction of entire buildings. He too it was who, though still but a youth, first suggested the formation of a canal from Pisa to Florence, by means of certain changes to be effected on the river Arno.[2]

Leonardo likewise made designs of mills, fulling machines,[3] and other engines, which were to be acted on by means of water; but as he had resolved to make painting his profession, he gave the larger portion of time to drawing from nature. He sometimes formed models of different figures in clay, on which he would arrange fragments of soft drapery dipped in plaster; from these he would then set himself patiently to draw on very fine cambric or linen that had already been used and rendered smooth. These he executed in black and white with the point of the pencil in a most admirable manner, as may be seen by certain specimens from his own hand which I have in my book of drawings. He drew on paper also with so much care and so perfectly that no one has ever equalled him in this respect. I have a head by him in chiaroscuro, which is incomparably beautiful. Leonardo was indeed so imbued with power and grace by the hand of God, and was endowed with so marvelous a facility in reproducing his conceptions, and his memory also was always so ready and so efficient in the service of his intellect, that in discourse he won all men by his reasonings, and confounded every antagonist, however powerful, by the force of his arguments.

This master was also frequently occupied with the construction of

models and the preparation of designs for the removal or the perforation of mountains, to the end that they might thus be easily passed from one plain to another. By means of levers, cranes, and screws, he likewise showed how great weights might be raised or drawn, in what manner ports and havens might be cleansed and kept in order, and how water might be obtained from the lowest deeps. From speculations of this kind he never gave himself rest, and of the results of these labors and meditations there are numberless examples in drawings, &c., dispersed among those who practice our arts. I have myself seen very many of them.

Besides all this he wasted not a little time to the degree of even designing a series of cords, curiously intertwined, but of which any separate strand may be distinguished from one end to the other, the whole forming a complete circle. A very curiously complicated and exceedingly difficult specimen of these coils may be seen engraved; in the midst of it are the following words: *Leonardus Vinci Academia*. Among these models and drawings there is one, by means of which Leonardo often sought to prove to the different citizens—many of them men of great discernment—who then governed Florence, that the church of San Giovanni in that city could be raised, and steps placed beneath it, without injury to the edifice. He supported his assertions with reasons so persuasive that while he spoke the undertaking seemed feasible, although every one of his hearers, when he had departed, could see for himself that such a thing was impossible.

In conversation Leonardo was indeed so pleasing that he won the hearts of all hearers, and though possessing so small a patrimony that it might almost be called nothing, while he yet worked very little, he still constantly kept many servants and horses, taking extraordinary delight in the latter. He was indeed fond of all animals, ever treating them with infinite kindness and consideration; as a proof of this it is related that, when he passed places where birds were sold, he would frequently take them from their cages, and having paid the price demanded for them by the sellers, would then let them fly into the air, thus restoring to them the liberty they had lost. Leonardo was in all things so highly favored by nature that, to whatever he turned his thoughts, mind, and spirit, he gave proof in all of such admirable power and perfection, that whatever he did bore an impress of harmony, truthfulness, goodness, sweetness and grace, wherein no other man could ever equal him.

Leonardo, with his profound intelligence of art, commenced various undertakings, many of which he never completed, because it appeared to him that the hand could never give its due perfection to the object or purpose which he had in his thoughts, or beheld in his imagination; seeing that in his mind he frequently formed the idea of some difficult enterprise, so subtle and so wonderful that, by means of hands, however

excellent or able, the full reality could never be worthily executed and entirely realized. His conceptions were varied to infinity; philosophizing over natural objects, among others, he set himself to investigate the properties of plants, to make observations on the heavenly bodies, to follow the movements of the planets, the variations of the moon, and the course of the sun.

Having been placed, then, by Ser Piero in his childhood with Andrea Verrocchio, as we have said, to learn the art of the painter, that master was engaged on a picture the subject of which was San Giovanni baptizing Jesus Christ. In this, Leonardo painted an angel holding some vestments; and although he was but a youth, he completed that figure in such a manner that the angel of Leonardo was much better than the portion executed by his master, which caused the latter never to touch colors more, so much was he displeased to find that a mere child could do more than himself.

Leonardo received a commission to prepare the cartoon for the hangings of a door, which was to be woven in silk and gold in Flanders, thence to be despatched to the King of Portugal; the subject was the sin of our first parents in Paradise. Here the artist depicted a meadow in chiaroscuro, the high lights being in white lead, displaying an immense variety of vegetation and numerous animals, respecting which it may be truly said that, for careful execution and fidelity to nature, they are such that there is no genius in the world, however god-like, which could produce similar objects with equal truth. In the fig tree, for example, the foreshortening of the leaves and the disposition of the branches are executed with so much care that one finds it difficult to conceive how any man could have so much patience. There is besides a palm tree, in which the roundness of the fan-like leaves is exhibited to such admirable perfection and with so much art that nothing short of the genius and patience of Leonardo could have effected it. But the work for which the cartoon was prepared was never carried into execution, the drawing therefore remained in Florence, and is now in the fortunate house of the illustrious Ottaviano de' Medici, to whom it was presented, no long time since, by the uncle of Leonardo.

It is related that Ser Piero da Vinci, being at his country house, was there visited by one of the peasants on his estate, who, having cut down a fig tree on his farm, had made a shield from part of it with his own hands, and then brought it to Ser Piero, begging that he would be pleased to cause the same to be painted for him in Florence. This the latter very willingly promised to do, the countryman having great skill in taking birds and in fishing, and being often very serviceable to Ser Piero in such matters. Having taken the shield with him to Florence therefore, without saying any thing to Leonardo as to whom it was for, he desired the

latter to paint something upon it. Accordingly, he one day took it in hand, but finding it crooked, coarse, and badly made, he straightened it at the fire, and giving it to a turner, it was brought back to him smooth and delicately rounded, instead of the rude and shapeless form in which he had received it. He then covered it with gypsum, and having prepared it to his liking, he began to consider what he could paint upon it that might best and most effectually terrify whomsoever might approach it, producing the same effect with that formerly attributed to the head of Medusa.

For this purpose therefore, Leonardo carried to one of his rooms, into which no one but himself ever entered, a number of lizards, hedgehogs, newts, serpents, dragon-flies, locusts, bats, glow-worms, and every other sort of strange animal of similar kind on which he could lay his hands; from this assemblage, variously adapted and joined together, he formed a hideous and appalling monster, breathing poison and flames, and surrounded by an atmosphere of fire. This he caused to issue from a dark and rifted rock, with poison reeking from the cavernous throat, flames darting from the eyes, and vapors rising from the nostrils in such sort that the result was indeed a most fearful and monstrous creature: at this he labored until the odors arising from all those dead animals filled the room with a mortal fetor, to which the zeal of Leonardo and the love which he bore to art rendered him insensible or indifferent.

When this work, which neither the countryman nor Ser Piero any longer inquired for, was completed, Leonardo went to his father and told him that he might send for the shield at his earliest convenience, since so far as he was concerned, the work was finished. Ser Piero went accordingly one morning to the room for the shield, and having knocked at the door, Leonardo opened it to him, telling him nevertheless to wait a little without, and having returned into the room he placed the shield on the easel, and shading the window so that the light falling on the painting was somewhat dimmed, he made Ser Piero step within to look at it. But the latter, not expecting any such thing, drew back, startled at the first glance, not supposing that to be the shield, or believing the monster he beheld to be a painting, he therefore turned to rush out, but Leonardo withheld him, saying: "The shield will serve the purpose for which it has been executed; take it therefore and carry it away, for this is the effect it was designed to produce."

The work seemed something more than wonderful to Ser Piero, and he highly commended the fanciful ideal of Leonardo; but he afterwards silently bought from a merchant another shield, whereon there was painted a heart transfixed with an arrow, and this he gave to the countryman, who considered himself obliged to him for it to the end of his life. Some time after Ser Piero secretly sold the shield painted by Leonardo to certain merchants for one hundred ducats, and it subse-

quently fell into the hands of the Duke of Milan, sold to him by the same merchants for three hundred ducats.

No long time after, Leonardo painted an admirable picture of Our Lady, which was greatly prized by Pope Clement VII; among the accessories of this work was a bottle filled with water in which some flowers were placed, and not only were these flowers most vividly natural, but there were dewdrops on the leaves, which were so true to nature that they appeared to be the actual reality. For Antonio Segni, who was his intimate friend, Leonardo delineated on paper a Neptune in his chariot drawn by sea-horses, and depicted with so much animation that he seems to be indeed alive. The turbulent waves also, the various phantasms surrounding the chariot, with the monsters of the deep, the winds, and admirable heads of marine deities, all contribute to the beauty of the work, which was presented by Fabio Segni, the son of Antonio, to Messer Giovanni Gaddi, with the following lines:

Pinxit Virgilius Neptunum, pinxit Homerus;
Dum maris undisoni per vada flectit equos.
Mente quidem vates illum conspexit uterque,
Vincius ast oculis; jureque vincit eos.[1]

Leonardo also had a fancy to paint the head of a Medusa in oil, to which he gave a circlet of twining serpents by way of head-dress, the most strange and extravagant invention that could possibly be conceived. But as this was a work requiring time, so it happened to the Medusa as to so many other of his works, it was never finished. The head here described is now among the most distinguished possessions in the palace of the Duke Cosimo, together with the half-length figure of an angel raising one arm in the air; this arm, being foreshortened from the shoulder to the elbow, comes forward, while the hand of the other arm is laid on the breast.

It is worthy of admiration that this great genius, desiring to give the utmost possible relief to the works executed by him, labored constantly, not content with his darkest shadows, to discover the ground tone of others still darker. Thus he sought a black that should produce a deeper shadow, and be yet darker than all other known blacks, to the end that the lights might by these means be rendered still more lucid, until he finally produced that totally dark shade, in which there is absolutely no light left, and objects have more the appearance of things seen by night, than the clearness of forms perceived by the light of day; but all this was done with the purpose of giving greater relief, and of discovering and attaining to the ultimate perfection of art.

Leonardo was so much pleased when he encountered faces of extraordinary character, or heads, beards, or hair of unusual appearance, that

he would follow any such, more than commonly attractive, through the whole day, until the figure of the person would become so well impressed on his mind that, having returned home, he would draw him as readily as though he stood before him. Of heads thus obtained, there exist many, both masculine and feminine; and I have myself several of them drawn with a pen by his own hand, in the book of drawings so frequently cited. Among these is the head of Amerigo Vespucci, which is a very beautiful one of an old man, done with charcoal, as also that of the Gypsy Captain Scaramuccia, which had been left by Gianbullari to Messer Donato Valdambrini, of Arezzo, Canon of San Lorenzo. A picture representing the Adoration of the Magi was likewise commenced by Leonardo, and is among the best of his works, more especially as regards the heads; it was in the house of Amerigo Benci, opposite the loggia of the Peruzzi, but like so many of the other works of Leonardo, this also remained unfinished.

On the death of Giovanni Galeazzo, Duke of Milan, in the year 1493, Ludovico Sforza was chosen in the same year to be his successor, when Leonardo was invited with great honor to Milan by the Duke,[5] who delighted greatly in the music of the lute, to the end that the master might play before him. Leonardo therefore took with him a certain instrument which he had himself constructed almost wholly of silver, and in the shape of a horse's head, a new and fanciful form calculated to give more force and sweetness to the sound. Here Leonardo surpassed all the musicians who had assembled to perform before the Duke. He was besides one of the best *improvisatori* in verse existing at that time, and the Duke, enchanted with the admirable conversation of Leonardo, was so charmed by his varied gifts that he delighted beyond measure in his society, and prevailed on him to paint an altar-piece, the subject of which was the Nativity of Christ, which was sent by the Duke as a present to the Emperor.

For the Dominican monks of Santa Maria delle Grazie at Milan, he also painted a Last Supper, which is a most beautiful and admirable work; to the heads of the Apostles in this picture the master gave so much beauty and majesty that he was constrained to leave that of Christ unfinished, being convinced that he could not impart to it the divinity which should appertain to and distinguish an image of the Redeemer. But this work, remaining thus in its unfinished state, has been ever held in the highest estimation by the Milanese, and not by them only, but by foreigners also. Leonardo succeeded to perfection in expressing the doubts and anxiety experienced by the Apostles, and the desire felt by them to know by whom their Master is to be betrayed; in the faces of all appear love, terror, anger, or grief and bewilderment, unable as they are to fathom the meaning of their Lord. Nor is the spectator less struck with

admiration by the force and truth with which, on the other hand, the master has exhibited the impious determination, hatred, and treachery of Judas. The whole work indeed is executed with inexpressible diligence even in its most minute part. Among other things may be mentioned the tablecloth, the texture of which is copied with such exactitude that the linen cloth itself could scarcely look more real.

It is related that the prior of the monastery was excessively importunate in pressing Leonardo to complete the picture. He could in no way comprehend wherefore the artist should sometimes remain half a day together absorbed in thought before his work, without making any progress that he could see; this seemed to him a strange waste of time, and he would fain have had him work away as he could make the men do who were digging in his garden, never laying the pencil out of his hand. Not content with seeking to hasten Leonardo, the prior even complained to the Duke, and tormented him to such a degree that the latter was at length compelled to send for Leonardo, whom he courteously entreated to let the work be finished, assuring him nevertheless that he did so because impelled by the importunities of the prior.

Leonardo, knowing the Prince to be intelligent and judicious, determined to explain himself fully on the subject with him, although he had never chosen to do so with the prior. He therefore discoursed with him at some length respecting art, and made it perfectly manifest to his comprehension that men of genius are sometimes producing most when they seem to be laboring least, their minds being occupied in the elucidation of their ideas, and in the completion of those conceptions to which they afterwards give form and expression with the hand. He further informed the Duke that there were still wanting to him two heads, one of which, that of the Savior, he could not hope to find on earth, and had not yet attained the power of presenting it to himself in imagination, with all that perfection of beauty and celestial grace which appeared to him to be demanded for the due representation of the Divinity incarnate.

The second head still wanting was that of Judas, which also caused him some anxiety, since he did not think it possible to imagine a form of feature that should properly render the countenance of a man who, after so many benefits received from his Master, had possessed a heart so depraved as to be capable of betraying his Lord and the Creator of the world. With regard to that second, however, he would make search, and after all, if he could find no better, he need never be at any great loss, for there would always be the head of that troublesome and impertinent prior. This made the Duke laugh with all his heart; he declared Leonardo to be completely in the right, and the poor prior, utterly confounded, went away to drive on the digging in his garden, and left Leonardo in peace. The head of Judas was then finished so successfully that it is indeed the true image of

treachery and wickedness; but that of the Redeemer remained, as we have said, incomplete.

The admirable excellence of this picture, the beauty of its composition, and the care with which it was executed, awakened in the King of France[6] a desire to have it removed into his own kingdom, insomuch that he made many attempts to discover architects, who might be able to secure it by defences of wood and iron, that it might be transported without injury. He was not to be deterred by any consideration of the cost that might be incurred, but the painting, being on the wall, his Majesty was compelled to forego his desire, and the Milanese retained their picture.

In the same refectory, and while occupied with the Last Supper, Leonardo painted the portrait of the above-named Duke Ludovico, with that of his first-born son, Maximilian: these are on the wall opposite to that of the Last Supper, and where there is a Crucifixion painted after the old manner. On the other side of the Duke is the portrait of the Duchess Beatrice, with that of Francesco, their second son: both of these princes were afterwards Dukes of Milan: the portraits are most admirably done.[7]

While still engaged with the paintings of the refectory, Leonardo proposed to the Duke to cast a horse in bronze of colossal size, and to place on it a figure of the Duke,[8] by way of monument to his memory: this he commenced, but finished the model on so large a scale that it never could be completed, and there were many ready to declare (for the judgments of men are various, and are sometimes rendered malignant by envy) that Leonardo had begun it, as he did others of his labors, without intending ever to finish it. The size of the work being such, insuperable difficulties presented themselves, as I have said, when it came to be cast; nay, the casting could not be effected in one piece, and it is very probable that, when this result was known, many were led to form the opinion alluded to above from the fact that so many of Leonardo's works had failed to receive completion. But of a truth, there is good reason to believe that the very greatness of his most exalted mind, aiming at more than could be effected, was itself an impediment, perpetually seeking to add excellence to excellence, and perfection to perfection; this was, without doubt, the true hindrance, so that, as our Petrarch has it, the work was retarded by desire.[9]

All who saw the large model in clay, which Leonardo made for this work, declared that they had never seen anything more beautiful or more majestic; this model remained as he had left it until the French, with their King Louis, came to Milan, when they destroyed it totally. A small model of the same work, executed in wax, and which was considered perfect, was also lost, with a book containing studies of the anatomy of the horse, which Leonardo had prepared for his own use. He afterwards gave his attention, and with increased earnestness, to the anatomy of the human

frame, a study wherein Messer Marcantonio della Torre, an eminent philosopher, and himself did mutually assist and encourage each other.

Messer Marcantonio was at that time holding lectures in Pavia, and wrote on the same subject; he was one of the first, as I have heard say, who began to apply the doctrines of Galen to the elucidation of medical science, and to diffuse light over the science of anatomy, which, up to that time, had been involved in the almost total darkness of ignorance. In this attempt, Marcantonio was wonderfully aided by the genius and labor of Leonardo, who filled a book with drawings in red crayons, outlined with the pen, all copies made with the utmost care from bodies dissected by his own hand. In this book he set forth the entire structure, arrangement, and disposition of the bones, to which he afterwards added all the nerves, in their due order, and next supplied the muscles, of which the first are affixed to the bones; the second give the power of cohesion or holding firmly; and the third impart that of motion. Of each separate part he wrote an explanation in rude characters, written backwards and with the left hand, so that whoever is not practiced in reading cannot understand them, since they are only to be read with a mirror.

Of these anatomical drawings of the human form, a great part is now in the possession of Messer Francesco da Melzi, a Milanese gentleman, who, in the time of Leonardo, was a child of remarkable beauty, much beloved by him, and is now a handsome and amiable old man, who sets great store by these drawings, and treasures them as relics, together with the portrait of Leonardo of blessed memory. To all who read these writings it must appear almost incredible that this sublime genius could, at the same time, discourse, as he has done, of art, and of the muscles, nerves, veins, and every other part of the frame, all treated with equal diligence and success.

There are, besides, certain other writings of Leonardo, also written with the left hand, in the possession of N.N., a painter of Milan;[10] they treat of painting, of design generally, and of coloring. This artist came to see me in Florence no long time since; he then had an intention of publishing this work, and took it with him to Rome, there to give this purpose effect, but what was the end of the matter I do not know.

But to return to the labors of Leonardo. During his time the King of France came to Milan, whereupon he (Leonardo) was entreated to prepare something very extraordinary for his reception. He therefore constructed a lion, and this figure, after having made a few steps, opened its breast, which was discovered to be entirely filled full of lilies. While in Milan, Leonardo took the Milanese Salai for his disciple;[11] this was a youth of singular grace and beauty of person, with curled and waving hair, a feature of personal beauty by which Leonardo was always greatly pleased. This Salai he instructed in various matters relating to art, and

certain works still in Milan, and said to be by Salai, were retouched by Leonardo himself.

Having returned to Florence,[12] he found that the Servite monks had commissioned Filippino to paint the altar-piece for the principal chapel in their church of the Nunziata, when he declared that he would himself very willingly have undertaken such a work. This being repeated to Filippino, he, like the amiable man that he was, withdrew himself at once, when the monks gave the picture to Leonardo. And to the end that he might make progress with it, they took him into their own abode with all his household, supplying the expenses of the whole; and so he kept them attending on him for a long time, but did not make any commencement. At length, however, he prepared a cartoon, with the Madonna, Sant'Anna, and the infant Christ, so admirably depicted that it not only caused astonishment in every artist who saw it, but, when finished, the chamber wherein it stood was crowded for two days by men and women, old and young; a concourse, in short, such as one sees flocking to the most solemn festivals, all hastening to behold the wonders produced by Leonardo, and which awakened amazement in the whole people.

Nor was this without good cause, seeing that in the countenance of that Virgin there is all the simplicity and loveliness which can be conceived as giving grace and beauty to the Mother of Christ, the artist proposing to show in her the modesty and humility of the Virgin, filled with joy and gladness as she contemplates the beauty of her Son, whom she is tenderly supporting in her lap. And while Our Lady, with eyes modestly bent down, is looking at a little San Giovanni, who is playing with a lamb, Sant'Anna, at the summit of delight, is observing the group with a smile of happiness, rejoicing as she sees that her terrestrial progeny have become divine; all which is entirely worthy of the mind and genius of Leonardo. This cartoon was subsequently taken to France, as will be related hereafter.

Leonardo then painted the portrait of Ginevra, the wife of Amerigo Benci, a most beautiful thing, and abandoned the commission entrusted to him by the Servite monks, who once more confided it to Filippino; but neither could the last-named master complete it, because his death supervened before he had time to do so.

For Francesco del Giocondo, Leonardo undertook to paint the portrait of Mona Lisa, his wife, but, after loitering over it for four years, he finally left it unfinished. This work is now in the possession of King Francis of France, and is at Fontainebleau. Whoever shall desire to see how far art can imitate nature may do so to perfection in this head, wherein every peculiarity that could be depicted by the utmost subtlety of the pencil has been faithfully reproduced.

The eyes have the lustrous brightness and moisture which is seen in

life, and around them are those pale, red, and slightly livid circles, also proper to nature, with the lashes, which can only be copied, as these are, with the greatest difficulty. The eyebrows also are represented with the closest exactitude, where fuller and where more thinly set, with the separate hairs delineated as they issue from the skin, every turn being followed, and all the pores exhibited in a manner that could not be more natural than it is. The nose, with its beautiful and delicately roseate nostrils, might be easily believed to be alive. The mouth, admirable in its outline, has the lips uniting the rose tints of their color with that of the face, in the utmost perfection, and the carnation of the cheek does not appear to be painted, but truly of flesh and blood. He who looks earnestly at the pit of the throat cannot but believe that he sees the beating of the pulses, and it may be truly said that this work is painted in a manner well calculated to make the boldest master tremble, and astonishes all who behold it, however well accustomed to the marvels of art.

Mona Lisa was exceedingly beautiful, and while Leonardo was painting her portrait, he took the precaution of keeping some one constantly near her, to sing or play on instruments, or to jest and otherwise amuse her, to the end that she might continue cheerful, and so that her face might not exhibit the melancholy expression often imparted by painters to the likenesses they take. In this portrait of Leonardo's on the contrary, there is so pleasing an expression, and a smile so sweet, that while looking at it one thinks it rather divine than human, and it has ever been esteemed a wonderful work, since life itself could exhibit no other appearance.

The excellent productions of this divine artist had so greatly increased and extended his fame that all men who delighted in the arts (nay, the whole city of Florence) were anxious that he should leave behind him some memorial of himself; and there was much discussion everywhere in respect to some great and important work to be executed by him, to the end that the commonwealth might have the glory, and the city the ornament, imparted by the genius, grace, and judgment of Leonardo to all that he did. At that time the great Hall of the Council had been constructed anew, the architecture being after designs by Giuliano di Sangallo, Simone Pollaiuoli, called Cronaca, Michelangelo Buonarroti, and Baccio d'Agnolo, as will be related in the proper place. The building having been completed with great rapidity, as was determined between the Gonfaloniere and the more distinguished citizens, it was then commanded by public decree that Leonardo should depict some fine work therein.

The said hall was entrusted, accordingly, to that master by Piero Soderini, then Gonfaloniere of Justice, and he, very willing to undertake the work, commenced a cartoon in the Hall of the Pope, an apartment

so called, in Santa Maria Novella. Herein he represented the history of Niccolò Piccinino, captain-general to the Duke Filippo of Milan, in which he depicted a troop of horsemen fighting around a standard, and struggling for the possession thereof; this painting was considered to be a most excellent one, evincing great mastery in the admirable qualities of the composition, as well as in the power with which the whole work is treated. Among other peculiarities of this scene, it is to be remarked that not only are rage, disdain, and the desire for revenge apparent in the men, but in the horses also; two of these animals, with their fore-legs intertwined, are attacking each other with their teeth, no less fiercely than do the cavaliers who are fighting for the standard.

One of the combatants has seized the object of their strife with both hands, and is urging his horse to its speed, while he, lending the whole weight of his person to the effort, clings with his utmost strength to the shaft of the banner, and strives to tear it by main force from the hands of four others, who are all laboring to defend it with uplifted swords, which each brandishes in the attempt to divide the shaft with one of his hands, while he grasps the cause of contention with the other. An old soldier, with a red cap on his head, has also seized the standard with one hand, and raising a curved scimitar in the other, is uttering cries of rage, and fiercely dealing a blow, by which he is endeavoring to cut off the hands of two of his opponents, who, grinding their teeth, are struggling in an attitude of fixed determination to defend their banner. On the earth, among the feet of the horses, are two other figures foreshortened, who are obstinately fighting in that position; one has been hurled to the ground, while the other has thrown himself upon him, and, raising his arm to its utmost height, is bringing down his dagger with all his force to the throat of his enemy; the latter, meanwhile, struggling mightily with arms and feet, is defending himself from the impending death.

It would be scarcely possible adequately to describe the skill shown by Leonardo in this work, or to do justice to the beauty of design with which he has depicted the warlike habiliments of the soldiers, with their helmets, crests, and other ornaments, infinitely varied as they are, or the wonderful mastery he exhibits in the forms and movements of the horses. These animals were, indeed, more admirably treated by Leonardo than by any other master; the muscular development, the animation of their movements, and their exquisite beauty are rendered with the utmost fidelity.

It is said that, for the execution of this cartoon, Leonardo caused a most elaborate scaffolding to be constructed, which could be increased in height by being drawn together, or rendered wider by being lowered: it was his intention to paint the picture in oil, on the wall, but he made a composition for the intonaco, or ground, which was so coarse that, after

he had painted for a certain time, the work began to sink in such a manner as to induce Leonardo very shortly to abandon it altogether, since he saw that it was becoming spoiled.

Leonardo da Vinci was a man of very high spirit, and was very generous in all his actions: it is related of him that, having once gone to the bank to receive the salary which Piero Soderini caused to be paid to him every month, the cashier was about to give him certain paper packets of pence, but Leonardo refused to receive them, remarking, at the same time, "I am no penny-painter." Not completing the picture, he was charged with having deceived Piero Soderini, and was reproached accordingly; when Leonardo so wrought with his friends, that they collected the sums which he had received and took the money to Piero Soderini with offers of restoration, but Piero would not accept them.

On the exaltation of Pope Leo X to the chair of St. Peter, Leonardo accompanied the Duke Giuliano de' Medici to Rome.[13] The Pontiff was much inclined to philosophical inquiry, and was more especially addicted to the study of alchemy; Leonardo, therefore, having composed a kind of paste from wax, made of this, while it was still in its half-liquid state, certain figures of animals, entirely hollow and exceedingly slight in texture, which he then filled with air. When he blew into these figures, he could make them fly through the air, but when the air within had escaped from them they fell to the earth.

One day the vine-dresser of the Belvedere found a very curious lizard, and for this creature Leonardo constructed wings, made from the skins of other lizards, flayed for the purpose; into these wings he put quicksilver, so that when the animal walked, the wings moved also, with a tremulous motion. He then made eyes, horns, and a beard for the creature, which he tamed and kept in a case; he would then show it to the friends who came to visit him, and all who saw it ran away terrified.

He more than once, likewise, caused the intestines of a sheep to be cleansed and scraped until they were brought into such a state of tenuity that they could be held within the hollow of the hand; having then placed in a neighboring chamber a pair of blacksmith's bellows, to which he had made fast one end of the intestines, he would blow into them until he caused them to fill the whole room, which was a very large one, insomuch that whoever might be therein was compelled to take refuge in a corner. He thus showed them transparent and full of wind, remarking that, whereas they had previously been contained within a small compass, they were now filling all space, and this, he would say, was a fit emblem of talent or genius. He made numbers of these follies in various kinds, occupied himself much with mirrors and optical instruments, and made the most singular experiments in seeking oils for painting, and varnishes to preserve the work when executed.

About this time, he painted a small picture for Messer Baldassare Turini, of Pescia, who was Datary to Pope Leo: the subject of this work was Our Lady, with the Child in her arms, and it was executed by Leonardo with infinite care and art; but whether from the carelessness of those who prepared the ground, or because of his peculiar and fanciful mixtures for colors, varnishes, &c., it is now much deteriorated. In another small picture, he painted a little Child, which is graceful and beautiful to a miracle. These paintings are both in Pescia, in the possession of Messer Giulio Turini. It is related that Leonardo, having received a commission for a certain picture from Pope Leo, immediately began to distil oils and herbs for the varnish, whereupon the Pontiff remarked, "Alas! the while, this man will assuredly do nothing at all, since he is thinking of the end before he has made a beginning to his work."

There was perpetual discord between Michelangelo Buonarroti and Leonardo, and the competition between them caused Michelangelo to leave Florence, the Duke Giuliano framing an excuse for him, the pretext for his departure being that he was summoned to Rome by the Pope for the façade of San Lorenzo. When Leonardo heard of this, he also departed and went to France, where the King, already possessing several of his works, was most kindly disposed towards him, and wished him to paint the cartoon of Sant'Anna; but Leonardo, according to his custom, kept the King a long time waiting with nothing better than words.

Finally, having become old, he lay sick for many months, and, finding himself near death, wrought diligently to make himself acquainted with the Catholic ritual, and with the good and holy path of the Christian religion: he then confessed with great penitence and many tears, and although he could not support himself on his feet, yet, being sustained in the arms of his servants and friends, he devoutly received the Holy Sacrament, while thus out of his bed. The King, who was accustomed frequently and affectionately to visit him, came immediately afterwards to his room, and he, causing himself out of reverence to be raised up, sat in his bed describing his malady and the different circumstances connected with it, lamenting, besides, that he had offended God and man, inasmuch as that he had not labored in art as he ought to have done. He was then seized with a violent paroxysm, the forerunner of death, when the King, rising and supporting his head to give him such assistance and do him such favor as he could, in the hope of alleviating his sufferings, the spirit of Leonardo, which was most divine, conscious that he could attain to no greater honor, departed in the arms of the monarch,[14] being at that time in the seventy-fifth[15] year of his age.

The death of Leonardo caused great sorrow to all who had known him, nor was there ever an artist who did more honor to the art of painting. The radiance of his countenance, which was splendidly beautiful,

brought cheerfulness to the heart of the most melancholy, and the power of his word could move the most obstinate to say, "No," or "Yes," as he desired. He possessed so great a degree of physical strength that he was capable of restraining the most impetuous violence, and was able to bend one of the iron rings used for the knockers of doors, or a horse-shoe, as if it were lead. With the generous liberality of his nature, he extended shelter and hospitality to every friend, rich or poor, provided only that he were distinguished by talent or excellence. The poorest and most insignificant abode was rendered beautiful and honorable by his works; and as the city of Florence received a great gift in the birth of Leonardo, so did it suffer a more than grievous loss at his death.

To the art of painting in oil, this master contributed the discovery of a certain mode of deepening the shadows, whereby the later artists have been enabled to give great force and relief to their figures. His abilities in statuary were proved by three figures in bronze, which are over the north door of San Giovanni; they were cast by Gio. Francesco Rustici, but conducted under the advice of Leonardo, and are, without doubt, the most beautiful castings that have been seen in these later days, whether for design or finish.

We are indebted to Leonardo for a work on the anatomy of the horse, and for another, much more valuable, on that of man; wherefore, for the many admirable qualities with which he was so richly endowed, although he labored much more by his word than in fact and by deed, his name and fame can never be extinguished.[16] For all these things, Messer Gio. Battista Strozzi has spoken to his praise in the following words:

> Vince costui pur solo
> Tutti altri, e vince Fidia, e vince Apelle,
> E tutto il lor vittorioso stuolo.[17]

The Milanese artist, Gio. Antonio Boltraffio, was a disciple of Leonardo; he was an intelligent and able master, and, in the year 1500, he painted a picture in oil in the church of the Misericordia, outside the city of Bologna. The subject of this work is Our Lady, with the Child in her arms; there are besides figures of San Giovanni Battista, San Bastiano (Sebastian), a nude figure, and that of the person for whom the work was executed, painted in a kneeling position; a truly admirable picture, on which the artist inscribed his name, with the fact of his being a disciple of Leonardo. The same painter executed many other works in Milan and elsewhere, but it shall suffice me to have mentioned this one, which is his best. Marco Uggioni[18] was likewise a disciple of Leonardo, and painted the Assumption of Our Lady in the church of Santa Maria della Pace, with the Marriage at Cana of Galilee, also in the same church.

VITA DI RAFFAELLO DA VRB.
PIT. ARCHITETTO.

Raphael Sanzio of Urbino
The Florentine Painter and Architect
[1483–1520]

THE large and liberal hand wherewith Heaven is sometimes pleased to accumulate the infinite riches of its treasures on the head of one sole favorite, showering on him all those rare gifts and graces, which are more commonly distributed among a large number of individuals, and accorded at long intervals of time only, has been clearly exemplified in the well-known instance of Raphael Sanzio of Urbino.

No less excellent than graceful, he was endowed by nature with all that modesty and goodness which may occasionally be perceived in those few favored persons who enhance the gracious sweetness of a disposition, more than usually gentle, by the fair ornament of a winning amenity, always ready to conciliate, and constantly giving evidence of the most refined consideration for all persons and under every circumstance. The world received the gift of this artist from the hand of nature when, vanquished by Art in the person of Michelangelo, she deigned to be subjugated in that of Raphael, not by art only but by goodness also.

And of a truth, since the greater number of artists had up to that period derived from nature a certain rudeness and eccentricity, which not only rendered them uncouth and fantastic, but often caused the shadows and darkness of vice to be more conspicuous in their lives than the light and splendor of those virtues by which man is rendered immortal; so was there good cause wherefore she should, on the contrary, make all the rarest qualities of the heart to shine resplendently in her Raphael, perfecting them by so much diffidence, grace, application to study, and excellence of life that these alone would have sufficed to veil or neutralize every fault, however important, and to efface all defects however glaring they might have been. Truly may we affirm that those who are the possessors of endowments so rich and varied as were assembled in the person of Raphael are scarcely to be called simple men only; they are rather, if it be permitted so to speak, entitled to the appellation of mortal gods. And further are we authorized to declare that he who by means of his works has left an honored name in the records of fame here below may also hope to enjoy such rewards in heaven as are commensurate to and worthy of his labors and merits.

Raphael was born at Urbino, a most renowned city of Italy, on Good

Friday of the year 1483, at three o'clock of the night. His father was a certain Giovanni de' Santi, a painter of no great eminence in his art,[1] but a man of sufficient intelligence nevertheless, and perfectly competent to direct his children into that good way which had not for his misfortune been laid open to himself in his younger days. And first, as he knew how important it is that a child should be nourished by the milk of its own mother, and not by that of the hired nurse, so he determined, when his son Raphael (to whom he gave that name at his baptism, as being one of good augury) was born to him, that the mother of the child,[2] he having no other, as indeed he never had more,[3] should herself be the nurse of the child.

Giovanni further desired that in his tender years the boy should rather be brought up to the habits of his own family, and beneath his paternal roof, than be sent where he must acquire habits and manners less refined, and modes of thought less commendable, in the houses of the peasantry, or other untaught persons. As the child became older, Giovanni began to instruct him in the first principles of painting, perceiving that he was much inclined to that art and finding him to be endowed with a most admirable genius. Few years had passed therefore before Raphael, though still but a child, became a valuable assistant to his father in the numerous works which the latter executed in the state of Urbino.[4]

At length this good and affectionate parent, knowing that his son would acquire but little of his art from himself, resolved to place him with Pietro Perugino,[5] who, according to what Giovanni had been told, was then considered to hold the first place among the painters of the time. Wherefore, proceeding to Perugia for that purpose, and finding Pietro to be absent from the city, he occupied himself, to the end that he might await the return of the master, with the less inconvenience, in the execution of certain works for the church of San Francesco in that place. But when Pietro had returned to Perugia, Giovanni, who was a person of very good manners and pleasing deportment, soon formed an amicable acquaintanceship with him, and when the proper opportunity arrived, made known to him the desire he had conceived, in the most suitable manner that he could devise. Thereupon Pietro, who was also exceedingly courteous, as well as a lover of fine genius, agreed to accept the care of Raphael. Giovanni then returned to Urbino; and having taken the boy, though not without many tears from his mother, who loved him tenderly, he conducted him to Perugia; when Pietro no sooner beheld his manner of drawing, and observed the pleasing deportment of the youth, than he conceived that opinion of him which was in due time so amply confirmed by the results produced in the after life of Raphael.

It is a well-known fact that, while studying the manner of Pietro, Raphael imitated it so exactly at all points that his copies cannot be dis-

tinguished from the original works of the master, nor can the difference between the performances of Raphael and those of Pietro be discerned with any certainty. This is proved clearly by certain figures still to be seen in Perugia, and which the former executed in a picture painted in oil in the church of San Francesco, for Madonna Maddalena degl' Oddi. The subject of this work is the Assumption of the Virgin, and the figures here alluded to are those of Our Lady and of the Savior himself, who is in the act of crowning her; beneath them and around the tomb are the Apostles, who contemplate the celestial glory, and at the foot of the painting, in a predella divided into three stories, is the Virgin receiving the Annunciation from the Angel, the Adoration of the Magi, and the Infant Christ in the Temple, with Simeon who receives the Divine Child into his arms. This painting is without doubt executed with extraordinary diligence, and all who have not a thorough knowledge of the manner of Pietro will assuredly take it to be a work of that master, whereas it is most certainly by the hand of Raphael.

After the completion of this picture, Pietro repaired for certain of his occasions to Florence, when Raphael departed from Perugia and proceeded with several of his friends to Città di Castello, where he painted a picture in the same manner for the church of Sant'Agostino, with one representing the crucified Savior for that of San Domenico; which last, if it were not for the name of Raphael written upon it, would be supposed by every one to be a work of Pietro Perugino. For the church of San Francesco in the same city, he painted a small picture representing the Espousals of Our Lady, and in this work the progress of excellence may be distinctly traced in the manner of Raphael, which is here much refined, and greatly surpasses that of Pietro.[6] In the painting here in question, there is a church drawn in perspective with so much care that one cannot but feel amazed at the difficulty of the problems which the artist has set himself to solve.

While Raphael was thus acquiring the greatest fame by the pursuit of this manner, the painting of the library belonging to the Cathedral of Siena had been entrusted by Pope Pius II to Bernardino Pinturicchio, who was a friend of Raphael's, and, knowing him to be an excellent designer, took the latter with him to Siena. Here Raphael made Pinturicchio certain of the designs and cartoons for that work:[7] nor would the young artist have failed to continue there, but for the reports which had reached him concerning Leonardo da Vinci, of whose merits he heard many painters of Siena speak in terms of the highest praise. They more especially celebrated the cartoon which Leonardo had prepared in the Sala del Papa at Florence, for a most beautiful group of horses which was to be executed for the Great Hall of the palace. They likewise mentioned another cartoon, representing nude figures, and made

by Michelangelo Buonarroti, in competition with Leonardo, whom he had on that occasion greatly surpassed. These discourses awakened in Raphael so ardent a desire to behold the works thus commended that, moved by the love he ever bore to excellence in art, and setting aside all thought of his own interest or convenience, he at once proceeded to Florence.[8]

Arrived in that place, he found the city pleased him equally with the works he had come to see, although the latter appeared to him divine; he therefore determined to remain there for some time, and soon formed a friendly intimacy with several young painters, among whom were Ridolfo Ghirlandaio, Aristotile da Sangallo, and others. He was, indeed, much esteemed in that city but, above all, by Taddeo Taddei, who, being a great admirer of distinguished talent, desired to have him always in his house and at his table. Thereupon Raphael, who was kindliness itself, that he might not be surpassed in generosity and courtesy, painted two pictures for Taddeo, wherein there are traces of his first manner, derived from Pietro, and also of that much better one which he acquired at a later period by study, as will be related hereafter. These pictures are still carefully preserved by the heirs of the above-named Taddeo. Raphael also formed a close friendship with Lorenzo Nasi; and the latter, having taken a wife at that time, Raphael painted a picture for him, wherein he represented Our Lady with the Infant Christ, to whom San Giovanni, also a child, is joyously offering a bird, which is causing infinite delight and gladness to both the children. In the attitude of each, there is a childlike simplicity of the utmost loveliness: they are besides so admirably colored, and finished with so much care, that they seem more like living beings than mere paintings. Equally good is the figure of the Madonna: it has an air of singular grace and even divinity, while all the rest of the work— the foreground, the surrounding landscape, and every other particular are exceedingly beautiful.

This picture was held in the highest estimation by Lorenzo Nasi so long as he lived, not only because it was a memorial of Raphael, who had been so much his friend, but on account of the dignity and excellence of the whole composition. But on the 9th of August, in the year 1548, the work was destroyed by the sinking down of the hill of San Giorgio, when the house of Lorenzo was overwhelmed by the fallen masses, together with the beautiful and richly decorated dwelling of the heirs of Marco del Nero, and many other buildings. It is true that the fragments of the picture were found among the ruins of the house, and were put together in the best manner that he could contrive, by Battista the son of Lorenzo, who was a great lover of art.

After having completed these works, Raphael was himself compelled to leave Florence and repair to Urbino, where, his mother and Giovanni

his father having both died, his affairs were in much confusion. While thus abiding in Urbino, he painted two pictures of the Madonna for Guidobaldo of Montefeltro, who was then captain-general of the Florentines; these pictures are both small, but are exceedingly beautiful examples of Raphael's second manner; they are now in the possession of the most illustrious and most excellent Guidobaldo, Duke of Urbino. For the same noble, the master executed another small picture, representing Christ praying in the garden, with three of the Apostles, who are sleeping at some distance, and which is so beautifully painted that it could scarcely be either better or otherwise were it even in miniature. After having been long in the possession of Francesco Maria, Duke of Urbino, this picture was presented by the most illustrious lady, his consort, the Duchess Leonora, to the Venetians, Don Paolo Giustiniano and Don Pietro Quirini, brothers of the Holy Hermitage of Camaldoli, and was placed by them, like a relic or sacred thing, in the apartments of the principal of that Hermitage, where it remains, honored both as a memorial of that illustrious lady and as being from the hand of Raphael of Urbino.

Having completed these works and arranged his affairs, Raphael returned to Perugia, where he painted a picture of Our Lady with San Giovanni Battista and San Niccolò, for the chapel of the Ansidei family, in the church of the Servites; and at the monastery of San Severo, a small convent of the order of Camaldoli, in the same city, he painted a fresco for the chapel of Our Lady. The subject of this work is Christ in Glory, with God the Father, surrounded by Angels, and six figures of Saints seated, three on each side: San Benedetto, San Romualdo, and San Lorenzo, on the one side namely; with San Girolamo, San Mauro, and San Placido, on the other. Beneath this picture, which, for a work in fresco, was then considered very beautiful, Raphael wrote his name in large and clearly legible letters.[9]

In the same city, Raphael was commissioned to paint a picture of Our Lady by the nuns of Sant'Antonio of Padua; the Infant Christ is in the lap of the Virgin and is fully clothed, as it pleased those simple and pious ladies that he should be: on each side of Our Lady are figures of saints, San Pietro namely, with San Paolo, Santa Cecilia, and Santa Caterina. To these two holy virgins, the master has given the most lovely features and most graceful attitudes; he has also adorned them with the most fanciful and varied head-dresses that could be imagined—a very unusual thing at that time. In a lunette above this picture, he painted a figure of the Almighty Father, which is extremely fine, and on the predella are three scenes from the history of Christ, in very small figures. The first of these represents the Savior praying in the garden; in the second he is seen bearing the cross, and here the movements and attitudes of certain soldiers, who are dragging him along, are singularly beautiful; the third shows him

lying dead in the lap of the Madonna. The whole work is without doubt very admirable: it is full of devout feeling, and is held in the utmost veneration by the nuns for whom it was painted. It is very highly commended by all painters likewise.

But I will not omit to mention in this place that, after Raphael had been to Florence, he is known to have much changed and improved his manner, from having seen the many works by excellent masters to be found in that city; nay, the manner afterwards adopted by him was so little in common with his earlier one that the works executed in the latter might be supposed to be by a different hand, and one much less excellent in the art.

Before Raphael had left Perugia, he had been requested by Madonna Atalanta Baglioni to paint a picture for her chapel in the church of San Francesco, but as he could not at that time comply with her wishes, he promised that on his return from Florence, whither he was then obliged to proceed for certain affairs, he would not fail to do so. While in Florence, therefore, where he devoted himself with indescribable energy and application to the studies connected with his art, he prepared the cartoon for this chapel, with the intention of proceeding to execute it in San Francesco on the first opportunity that might present itself for doing so, a work which he afterwards accomplished.

While Raphael was thus sojourning in Florence, Agnolo Doni was dwelling in that city. Now Agnolo was averse to spending money for other things, but for paintings or sculptures, in which he greatly delighted, he would willingly pay, although he still did so as frugally as was possible. By him, therefore, Raphael was commissioned to paint a portrait of himself, as well as that of his wife, and both were executed, as we now see them; they are in the possession of Agnolo's son, Giovanni Battista, in the house which Agnolo built most handsomely and commodiously, at the corner of the Alberti, in the street of the Dyers, in Florence.

For Domenico Canigiani, Raphael also painted a picture wherein he represented the Madonna with the Infant Christ: the Divine Child is caressing the little San Giovanni, who is brought to him by St. Elizabeth; and the latter, while holding the boy, looks with a most animated countenance at St. Joseph, who stands leaning with both hands on his staff. He bends his head towards her with an expression of astonishment and of praise to God, whose greatness had bestowed this young child on a mother already so far advanced in years. All appear to be amazed at the manner in which the two cousins treat each other at an age so tender, the one evincing his reverence for the Savior, the other affectionately caressing his companion. Every touch of the pencil in the heads, hands, and feet of this work has produced such effect that the parts seem rather to

be of the living flesh than the mere colors of the painter, however able a master of his art. This most noble picture is now in the possession of the heirs of Domenico Canigiani, by whom it is held in all that esteem which is due to a work of Raphael of Urbino.

While in the city of Florence, this most excellent painter studied the ancient works of Masaccio, and what he saw in the labors of Leonardo and Michelangelo caused him still more zealously to prosecute his studies; he consequently attained to an extraordinary amelioration of manner, and made still further progress in art. Among other artists, Raphael formed a close intimacy with Fra Bartolommeo di San Marco, during his abode in Florence, the manner of that master pleasing him greatly, wherefore he took no small pains to imitate his coloring, teaching that good father, on his part, the rules of perspective, to which the monk had not previously given his attention.

But just when this intercourse was most frequent and intimate, Raphael was recalled to Perugia; here the first work which he performed was that in the church of San Francesco, where he completed the painting promised to the above-named Madonna Atalanta Baglioni, for which he had prepared the cartoon in Florence, as we have said. In this most divine picture, there is a Dead Christ, whom they are bearing to the sepulchre, the body painted with so much care and freshness that it appears to have been only just completed. When occupied with the composition of this work, Raphael had imagined to himself all the grief and pain with which the nearest and most affectionate relatives see, borne to the tomb, the corpse of one who has been most dear to them, and on whom has, in truth, depended all the honor and welfare of the entire family.

Our Lady is seen to be sinking insensible, and the heads of all the weeping figures are exceedingly graceful; that of San Giovanni more particularly, his hands are clasped together and he bends his head with an expression which cannot but move the hardest heart to compassion. Truly may we say that whoever shall consider the diligence and love, the art and grace exhibited in this work, has good reason to feel astonishment, and it does indeed awaken admiration in all who behold it, not only for the expression of the heads, but for the beauty of the draperies, and in short for the perfection of excellence which it displays in all its parts.

When Raphael, having completed his work, had returned to Florence, he received a commission from the Dei, Florentine citizens, to paint the altarpiece for their chapel in the church of Santo Spirito: this painting the master commenced and made considerable progress with the sketch for it. He likewise prepared a picture at the same time, which was afterwards sent to Siena, but had first to be left with Ridolfo Ghirlandaio, on the departure of Raphael, to the end that he might finish an azure vestment which was still wanting when Raphael left Florence. And this last

event happened from the circumstance that Bramante of Urbino, being in the service of Pope Julius II, for some little relationship that he had with Raphael, and because they were of the same place, had written to the latter, informing him that he had prevailed with the Pope to entrust certain rooms which the Pontiff had caused to be built in the Vatican to his care, and that therein he might give evidence of his ability.

The proposal gratified Raphael, and he left his works in Florence unfinished, the picture for the Dei family among the rest, but this last was in such a state that Messer Baldassare da Pescia afterwards, on the death of Raphael that is to say, caused it to be placed in the chapter-house of his native city. The master then proceeded to Rome, where he found on his arrival that a large part of the rooms in the palace had already been painted, or were in process of being painted, by different masters. In one of these apartments, for example, there was an historical picture completed by Piero della Francesca; Luca da Cortona had made considerable progress in the painting of one side of another; Don Pietro della Gatta, abbot of San Clemente in Arezzo, had also commenced certain works in the same place, and Bramantino of Milan had painted numerous figures there, the greater part of which were portraits from the life, which were considered to be exceedingly beautiful.

On his arrival in Rome, Raphael was received with much kindness by Pope Julius, and commenced a picture in the chamber of the Segnatura, the subject of which is Theologians engaged in the reconciliation of Philosophy and Astrology with Theology.[10] In this work are depicted all the sages of the world, arranged in different groups, and occupied with various disputations. There are certain astrologers, standing apart, who have made figures and characters of geomancy[11] and astrology on tablets which they send by beautiful angels to the Evangelists, who explain them.[12] Among the figures in this painting is Diogenes with his cup; he is lying on the steps, an extremely well-imagined figure, wrapt in his own thoughts, and much to be commended for the beauty of the form and characteristic negligence of the garments. There are likewise Aristotle and Plato in this work, the one with the Timæus, the other with the Ethics, in his hand; around them is gathered in a circle a large school of philosophers. The dignity of those astrologers and geometricians, who are drawing various figures and characters with the compasses on a tablet, is not to be described. Among these is the figure of a youth of the most graceful beauty, who extends his arms in admiration and inclines his head; this is the portrait of Federigo, second Duke of Mantua, who was at that time in Rome.

There is also a figure stooping to the ground and drawing lines with a pair of compasses which he holds in his hand; this is said to be the architect Bramante, and is no less life-like than that of Federigo previously

described, or than it would be if it were indeed alive. Beside him is one whose back is turned towards the spectator, and who holds a globe of the heavens in his hand: this is the representation of Zoroaster. And near to this figure stands that of Raphael himself, the master of this work, drawn by his own hand with the aid of a mirror; a youthful head of exceedingly modest expression wearing a black cap or barret, the whole aspect infinitely pleasing and graceful.

It would not be possible to describe the beauty and nobility of character which the master has imparted to the heads and figures of the Evangelists; there is a certain air of meditative thought and attentive consideration on the countenances, more especially of those who are writing, which is depicted with the utmost truth. This may be more particularly remarked in a St. Matthew, who is copying the characters from the tablet which an angel holds before him; these he is setting down in a book. Behind him is an old man who has placed a paper on his knee, and in this he is inserting what St. Matthew[13] writes, as the latter makes his extracts from the tablet: intent on his occupation, he remains in this inconvenient attitude, and seems to be twisting his head and jaws as if to accompany the movements of his pen.

And to say nothing of all these well-considered minutiæ, of which there are nevertheless very many, the composition of the whole work displays so much beauty of proportion, and such perfection of arrangement in every part, that the master did indeed give a notable example of his capabilities therein, and clearly proved himself to be one who had resolved to maintain the undisputed possession of the field against all who handled the pencil. Furthermore the artist adorned this work with fine perspective views of magnificent buildings and with numerous figures, all finished in a manner so delicate and harmonious that the excellence of the work caused Pope Julius to have all the stories of the other masters, whether old or new, destroyed at once, resolving that Raphael alone should have the glory of seeing his works preferred to all that had been done in paintings of that description up to his own time.

Above the painting by Raphael, here described, was a work by Giovanni Antonio Sodoma, of Vercelli, and which ought to have been destroyed in obedience to the commands of the Pope. But Raphael nevertheless determined to retain the compartments as he found them, and to use the arabesques which Giovanni Antonio had employed as decorations. There were besides four circular divisions, and in each of these Raphael depicted a figure, having relation to the picture which was immediately beneath it. In the first of these circular compartments, which is above the picture wherein the painter has delineated Philosophy, Astrology, Geometry, and Poetry, forming a union with Theology, is a female figure representing Knowledge: on each side of this figure, which is

seated, is a statue of the goddess Cybele, with the form of breast usually attributed by the ancients to Diana Polymastes. The vestments are of four colors, to indicate the four elements; from the head downwards they are flame color, to intimate fire; beneath the girdle is the color of the air; from the lap to the knees is that of earth; and the remainder to the feet has the color of water. These figures are accompanied by very beautiful boys.

In another circle, that turned towards the window which looks upon the Belvedere, is depicted Poetry, represented under the form of Polyhymnia. She is crowned with laurel; in one hand she holds the antique lyre, and has a book in the other; the limbs are crossed, and the face, which is of superhuman beauty, is turned upwards with the eyes raised to heaven. This figure also is accompanied by two boys, who are full of life and spirit; these children assist to form with her, as do those attending on the other figures, a group of richly varied beauty. And on this side, Raphael afterwards painted the Mount Parnassus over the above-mentioned window.

In the circle which is over the picture wherein the holy doctors are reading mass is a figure of Theology, with books and other objects around her, accompanied in like manner by the boys, which are no less beautiful than those before referred to. Above the other window, which looks towards the court, is placed the figure of Justice, in the fourth circle namely; she bears the balance in one hand and holds the sword raised aloft in the other; the boys are with her as with the previously cited figures, and are of supreme beauty. On the wall beneath is represented the delivery of the civil and canon law, as will be related in its due place.

In the angels of the ceiling, Raphael likewise executed four historical pictures, designed and colored with extraordinary care, but the figures are not of a large size. In one of these, that next the Theology, the master had depicted the sin of Adam in eating the apple, and this he has executed in a very graceful manner. In the second, which is above the Astrology, is the figure of that science; she is assigning their due places to the planets and fixed stars. In the one belonging to the Mount Parnassus is the figure of Marsyas, fastened to a tree, and about to be flayed by Apollo; and near the picture which represents the promulgation of the Decretals is the judgment of Solomon, when he decides that the infant shall be divided between the contending mothers. All these four delineations exhibit much thought and feeling; they are admirably drawn, and the coloring is pleasing and graceful.

But having now finished the description of the vaulting or ceiling of that apartment, it remains that we declare what was executed on each wall consecutively, and beneath the works indicated above. On the side towards the Belvedere, where are the Mount Parnassus and the Fountain

of Helicon, the master depicted a laurel grove of very deep shadows, and the verdure of the foliage is so finely painted that the spectator almost fancies himself to perceive each separate leaf trembling in the gentle breeze. Innumerable figures of naked Loves, with inexpressibly beautiful countenances, are hovering in the air. They are gathering branches of the laurel wherewith they weave garlands, which they then throw down and scatter on the mount, over which there does of a truth seem to be the spirit of the divinity breathing, such is the beauty of the figures, and the noble and elevated character of the whole picture, which awakens admiration and astonishment in all who behold it, when they consider that the human mind and mortal hand, with only the simple means of imperfect colors, and by the help of excellent drawing, has made a picture which appears as if it were alive.

The figures of the Poets also, distributed over the mount, are all most truly animated. Some are standing, others seated; some are writing, or speaking, or singing; others are conversing together in groups of four or six, accordingly as it has seemed good to the master to arrange them. In this portion of the work, there are portraits of the most renowned poets, ancient and modern, including among the latter several who had lived or were living at Raphael's own time. Some of the older poets were taken from statues, some from medals, many from old pictures; and others, who had lived in his own day, were taken from nature by Raphael himself. To begin with the one end, we have here the portraits of Ovid, Virgil, Ennius, Tibullus, Catullus, Propertius, and Homer: the last named, blind and with the head elevated, is pouring forth his verses, while there is a youth seated at his feet who writes them as he sings.

There is also in one group Apollo with the Nine Muses; and in all these figures there is so much beauty, their countenances have an air of so much divinity, that grace and life seem to breathe from every feature. There is here portrayed the learned Sappho, and the most divine Dante; the graceful Petrarch, and the gay Boccaccio, who are all most truly animated and life-like. Tebaldero is also here, with many other modern writers, who are grouped with infinite grace and painted with extraordinary care.

On one of the other sides, the master has depicted heaven, with Christ and the Virgin, San Giovanni Battista, the Apostles, the Evangelists, and the Martyrs, all enthroned amid the clouds. And above them is the figure of God the Father, who sends forth his Holy Spirit over them all, but more particularly on a vast company of Saints, who are celebrating the mass below, and some of whom are in disputation respecting the Host, which is on the altar.[14] Among these are the four Doctors of the Church, who are surrounded by numerous saints, San Domenico namely, with San Francesco, St. Thomas Aquinas, SS. Bonaventura, Scotus, and

Nicolaus of Lyra. Dante, Fra Girolamo Savonarola of Ferrara, and all the Christian theologians are also depicted, with a vast number of portraits from the life.

In the air above are four Children, who are holding open the four Gospels; these are figures which it would not be possible for any painter to surpass, such is their grace and perfection. The Saints are seated in a circle in the air, and not only does the beauty of the coloring give them all the appearance of life, but the foreshortenings, and the gradual receding of the figures, are so judiciously managed that they could not appear otherwise if they were in relief. The draperies and vestments are richly varied, and the folds are of infinite grace; the expression of the countenances moreover is celestial rather than merely human. This is more particularly to be remarked in that of the Savior, which exhibits all the mildness and clemency of the divine nature that could possibly be presented to the human eyes by a mere painting.

Raphael was indeed largely endowed with the power of imparting the most exquisite expression to his faces, and the most graceful character to the heads of his pictures: of this we have an instance in the Virgin, who with her hands crossed on her bosom, is regarding her Divine Son, whom she contemplates with an expression which implies her perfect assurance that he will not refuse forgiveness. There is, moreover, a certain dignity in the figures of this master, with a characteristic propriety, which is without doubt most beautiful; to the holy Patriarchs he gives the reverence of age, to the Apostles the earnest simplicity which is proper to their character, and the faces of his Martyrs are radiant with the faith that is in them.

But still more richly varied are the resources of art and genius which this master has displayed in the holy Doctors, who are engaged in disputation, and are distributed over the picture in groups of six, four, or two. Their features give token of a certain eager curiosity, but also of the earnest desire they feel to discover the precise truth of the matter in question. This is made further manifest by the action of the hands and by various movements of the person; they bend the ear with fixed attention; they knit the brow in thought, and offer evidence, in their looks, of surprise or other emotions, as the contending propositions are presented; each in his own peculiar manner, but all with most appropriate as well as beautiful and varied expression. Distinguished from the rest are the four Doctors of the Church, who, being illuminated by the Holy Spirit, resolve and explain, by the aid of the Holy Scriptures, all the difficulties presented by the gospels, which the boys who are hovering in the air hold before them.

On the third side of the apartment, that namely wherein is the other window which looks upon the court, Raphael painted, on the one part,

Justinian, who is giving the laws to the Doctors for revisal, with figures of Temperance, Fortitude, and Prudence above; on the other, the Pope,[15] who delivers the Decretals or canon laws, and in this Pontiff, Raphael has depicted the portrait of Pope Julius II. He has likewise executed portraits from the life of the Cardinal-Vicar, Giovanni de' Medici, who was afterwards Pope Leo X; of Cardinal Antonio de' Monte, and the Cardinal Alessandro Farnese, who ultimately became Pope Paul III, with those of many other personages.

The Pope was highly satisfied with all that was done; and to the end that the wood-work of the apartment should be worthy of the paintings, he caused Fra Giovanni of Verona to be summoned from the convent of Monte Oliveto di Chiusuri, a monastery in the territory of Siena. Fra Giovanni was a renowned master in works representing perspective views of buildings, formed of woods inlaid; and he not only prepared the wainscot around the room, but also made very beautiful doors and seats, richly decorated in the perspective ornaments for which he was famed, and which acquired for him very great honor, with much favor from the Pope, who rewarded him very liberally.

It is indeed certain that in works of this kind there has never been a more able master than Fra Giovanni, a fact to which we have testimony still in his native city of Verona. This is presented by the sacristy of Santa Maria-in-Organo, which is most beautifully adorned with inlaid work representing views in perspective. The choir of Monte Oliveto di Chiusuri affords another proof of his skill, as does that of San Benedetto di Siena. The sacristy of Monte Oliveto di Napoli was in like manner adorned by Fra Giovanni, and in the same place is the chapel of Paolo da Tolosa, which that master also decorated in wood-work. By all these labors he obtained much honor from those of his order, by whom he was ever held in the highest estimation until his death, which took place in 1537, when he had attained the age of sixty-eight.

Now of this master, as of a person who was truly excellent and remarkable in his art, I have thought it well to make mention thus far, for it appears to me that his talent has well merited so much, seeing that we are indebted to it for the fine works that were afterwards executed by many other masters, to whom Fra Giovanni laid open the way.

But to return to Raphael. His powers now became developed to the utmost, and he received a commission from the Pope to paint a second room in the Vatican, that towards the great hall namely. At this time, also, our artist, who had now acquired a very great name, depicted the portrait of Pope Julius himself. This is an oil painting of so much animation and so true to the life that the picture impresses on all beholders a sense of awe as if it were indeed the living object: this portrait is now preserved in the church of Santa Maria del Popolo, together with a very beautiful

Madonna, executed at the same time by the same master. In the last-named picture, which represents the Nativity of Christ, the Virgin is covering with a veil her Divine Child, the expression of whose countenance is of such wonderful beauty, and his whole person so clearly demonstrates the divinity of his origin that all must perceive him to be truly the Son of God. Nor are the attitude and countenance of the Madonna less beautiful; they exhibit the perfection of grace with an expression of mingled piety and gladness. There is also a St. Joseph, standing with both his hands supported on a staff, and contemplating the King and Queen of Heaven, with the adoration of a most righteous old man. Both these pictures are exhibited to the people on all occasions of solemn festival.

Raphael had at this time acquired much fame in Rome; but although he had the graceful manner which was held by every one to be most beautiful, and saw continually before his eyes the numerous antiquities to be found in that city, and which he studied continually, he had, nevertheless, not yet given to his figures that grandeur and majesty which he always did impart to them from that time forward. For it happened, at the period to which we now refer, that Michelangelo, as we shall furthermore set forth in his life, had made such clamors in the Sistine Chapel, and given the Pope such alarms, that he was compelled to take flight, and sought refuge in Florence. Whereupon Bramante, having the key of the chapel, and being the friend of Raphael, permitted him to see it, to the end that he might understand Michelangelo's modes of proceeding.[16] The sight thus afforded to him caused Raphael instantly to paint anew the figure of the prophet Isaiah, which he had executed in the church of Sant'Agostino, above the Sant'Anna of Andrea Sansovino, although he had entirely finished it; and in this work he profited to so great an extent by what he had seen in the works of Michelangelo that his manner was thereby inexpressibly ameliorated and enlarged, receiving thenceforth an obvious increase of majesty.

But when Michelangelo afterwards saw the work of Raphael, he thought, as was the truth, that Bramante had committed the wrong to himself, of which we have here spoken, for the purpose of serving Raphael, and enhancing the glory of that master's name.

No long time after this, Agostino Chigi, a very rich merchant of Siena, who was a great admirer of all distinguished men, gave Raphael a commission to paint a chapel. This he did because, some short time previously, the master had produced a fresco of the most exquisite beauty, in a loggia of his palace, in the Trastevere, now called the Chigi;[17] the subject of this is Galatea in a car on the sea drawn by two dolphins and surrounded by Tritons and different marine deities. Having made the cartoon for a chapel, which is at the entrance of the church of Santa

Maria della Pace, on the right as one enters by the principal door, the master executed it in fresco, and in his new manner, which was somewhat grander and more majestic than the earlier one. In this picture Raphael painted some of the Prophets and Sibyls, before Michelangelo had thrown open the chapel, which he had nevertheless seen, as has been related; and of a truth, these figures are considered to be the best, and among so many beautiful the most beautiful, seeing that in the women and children represented, there is the very perfection of truth and animation; the coloring, moreover, is faultless.

This work caused the master to be most highly extolled, both during his life and after his death, being, as it was, the most remarkable and most excellent one that Raphael ever executed. Raphael being earnestly entreated by a chamberlain of Pope Julius II,[18] to paint the picture for the high altar of the chapel of the Ara Cœli, he therein depicted the Madonna, reposing on the clouds of heaven, and with San Giovanni, San Francesco, and San Girolamo, robed in the vestments of a Cardinal, in a beautiful landscape beneath. In this Virgin there is the expression of a modesty and humility truly worthy of the Mother of Christ: the Divine Child, in an attitude of exquisite beauty, is playing with the mantle of Our Lady. The form of San Giovanni gives clear proof of the fasting to which his penitential discipline has subjected him; while in the expression of his countenance, one reads the sincerity of his soul, together with a frank and cheerful serenity, proper to those who, far removed from the influence of the world, look down on it with contempt, and in their commerce with mankind, abhorring all duplicity, devote themselves to the promulgation of truth.

The head of San Girolamo is raised; his eyes are fixed on the Virgin, whom he is regarding earnestly. And in the eyes thus raised, there are to be perceived all that learning and wisdom which are made manifest in his writings. With a movement of both the hands, he is in the act of recommending the chamberlain to the protection of Our Lady; and the figure of that chamberlain in actual life is scarcely more animated than the one here painted. Nor is there less of truth and nature in the San Francesco; he is kneeling on the earth, with one arm extended, and the head raised as he turns his gaze aloft, towards the Madonna; he is depicted with a glow of pious affection in his countenance, every line of which is beaming with the holiest emotion. The features and complexion show that the saint is consuming away in pious resignation, but is receiving comfort and life from the most gentle and beautiful looks of the Mother, as well as from the sovereign loveliness of the Divine Child.

In the center of the picture, and immediately beneath the Virgin, is a boy; his head is raised towards Our Lady, and he bears a tablet in his hands. It is not possible to imagine any thing more graceful or more

beautiful than this child, whether as regards the head or the rest of the person. There is besides a landscape of singular beauty, and which is executed to the highest perfection in every part.

Raphael then continued his work in the chambers of the Vatican, where he depicted the Miracle of the Sacrament, or the Corporal of Bolsena, whichever it may be called. In this story, the priest who is reading the mass is seen to have his face glowing with the shame which he felt, when in consequence of his own unbelief, he beheld the Host bleeding on the Corporal, as a reproof for his want of faith.[19] Terrified at the looks of his hearers, he has lost all self-possession, and is as a man beside himself; he has the aspect of one utterly confounded; the dismay that has seized him is manifest in his attitude; and the spectator almost perceives the trembling of his hands, so well are the emotions inevitable from such a circumstance expressed in the work.

Around the priest are many figures of varied character; some are serving the mass; others kneel, in beautiful attitudes, on a flight of steps and, moved by the novelty of the occurrence, exhibit their astonishment and emotion in divers gestures; some giving evidence of a desire to acknowledge themselves guilty of error, and this is perceived in men as well as in women. Among the latter is one at the lower part of the picture, seated on the earth and holding a child in her arms; she is listening while another relates the circumstance that has just happened to the priest; full of wonder she turns towards the speaker with a feminine grace and animation that is truly characteristic and life-like. On the other side is the Pope, Julius II, who is hearing the mass, an admirable part of the work; and here Raphael has depicted the portrait of the Cardinal di San Giorgio,[20] with a vast number of other personages, also from the life.

The break caused by the window was turned to account by the master, who, having there represented an ascent in the form of a flight of stairs, thus makes the paintings on each side into one sole picture; nay, he has even made it appear that, if this opening caused by the window had not been there, the scene could not have been so well arranged. It may indeed with truth be said of Raphael here, as elsewhere, that as respects invention and the graces of composition, whatever the story may be, no artist has ever shown more skill, more readiness of resource, or a more admirable judgment than himself; a fact of which he has given further proof in this same place, where in the opposite picture he has represented San Pietro thrown into a prison by Herod, and guarded by soldiers. The architectural details here depicted, and the simple delineation of the prison, are treated with so much ingenuity that the works of other artists, when compared with those of Raphael, seem to exhibit as much of confusion as do that master's of grace and beauty.

Raphael constantly endeavored to represent the circumstances which

he depicted as they are described or written, and to assemble only the most appropriate and characteristic objects in his works, as for example in the picture before us, where he reveals to us the wretchedness of the prison. Bound with chains, that aged man is seen extended between two soldiers; the deep and heavy sleep of the guards is rendered fully manifest, as the resplendent light proceeding from the Angel illumines the darkness of night, and causes the most minute particulars of the prison to be clearly discerned. The arms of the sleepers shine so brilliantly, that their burnished lustre seems rather to belong to things real and palpable, than to the merely painted surface of a picture.

No less remarkable are the art and ingenuity displayed in another part of the same picture; that namely where, freed from his chains, the Apostle walks forth from his prison, accompanied by the Angel. In the countenance of St. Peter there is evidence that he is as a man who feels himself to be acting in a dream, and not as one awake. Equally well expressed are the terror and dismay of those among the guards, who, being outside the prison, hear the clang of the iron door; a sentinel, with a torch in his hand, awakens his sleeping companions; the light he holds is reflected from their armor, and all that lies within the place which the torch has not reached is lighted by the Moon. This admirably conceived picture Raphael has placed over the window, at the darkest part of the room. It thus happens that, when the spectator regards the painting, the light of day strikes on his eyes, and the beams of the natural light mingle and contend with the different lights of the night as seen in the picture.

The observer fancies himself really to behold the smoke of the torch, and the splendor of the Angel, all which, with the dark shadows of the night, are so natural and so true that no one would ever affirm it to be painted, but must believe it to be real, so powerfully has our artist rendered this most difficult subject. The play of the shadows on the arms, the flickering reflections of the light, the vaporous haloes thrown around the torches, the dim uncertain shade prevailing in certain parts, all are painted in such a manner that, contemplating this work, one cannot but declare Raphael to be indeed the master of all masters. Never has painting which purports to counterfeit the night been more truly similar to the reality than is this, which is of a truth a most divine work, and is indeed admitted by common consent to be the most extraordinary and most beautiful of its kind.

On one of the unbroken walls of the chamber, Raphael then depicted the worship of God as practiced among the Hebrews, with the Ark and golden Candlesticks. Here also is the figure of Pope Julius, who is driving the avaricious intruders from the Temple.[21] In this work, which is of similar beauty and excellence to the night piece described above, several portraits of persons then living are preserved to us in the persons of the

bearers who support the chair wherein Pope Julius is borne along; the figure of the Pontiff is most life-like. While the populace, among whom are many women, make way for His Holiness to pass, they give to view the furious approach of an armed man on horseback. He is accompanied by two others who are on foot, and together they smite and overthrow the haughty Heliodorus, who, by the command of Antiochus, is about to despoil the Temple of all the treasures deposited for the widows and orphans.[22]

The wares and treasures are already in process of being borne away; but the terror awakened by the new occurrence of Heliodorus, struck down and scourged by the three figures above mentioned, who are seen and heard by himself alone, being only a vision, causes those who are bearing the spoils away to let all drop from their hands, while they themselves fall stumbling over each other, possessed as they are by a sudden affright and horror which had fallen on all the followers of Heliodorus. Apart from these stands the High Priest, Onias, in his pontifical robes, his hands and eyes are raised to heaven, and he is praying most fervently, being moved to compassion for the poor, whom he has beheld on the point of being despoiled of their possessions, but is yet rejoiced at the succor which he feels that heaven has sent to them. With felicitous invention, Raphael has placed various figures about the different parts of the building, some of whom climb on the socles of the columns, and clasping the shaft, thus stand, maintaining themselves with difficulty in their inconvenient position, to obtain a better view of the scene passing before them. The mass of the people meanwhile, astounded at what they behold, remain in divers attitudes awaiting the result of the wondrous event.

The whole of this work was so admirably executed in every part that even the cartoons were very highly estimated. Messer Francesco Massini, a gentleman of Cesena, who, without any master, but impelled from childhood by the love of art, has produced many paintings and works in design, has certain pieces of the cartoon which Raphael prepared for this story of Heliodorus still in his possession. They are treasured with all the esteem which they so truly merit, among the various antiquities in marble, reliefs and others, which he has collected. His own pictures and designs are also of such merit that many, well acquainted with art, have bestowed on them the highest commendations. Nor will I omit to mention that Messer Niccolò Massini, from whom it is that I have received intelligence of these things, is himself a sincere lover of our arts, as he is the friend of all other good and praiseworthy endeavors.

But to return to Raphael. In the ceiling above these works, he delineated four pictures: the subject of the first being the appearance of the Almighty Father to Abraham, to whom he promises the continuation of

his race; that of the second, the sacrifice of Isaac; and of the third, Jacob's dream; while the fourth represents Moses standing before the burning bush. In this work, the knowledge of art, rich power of invention, correct design, and exquisite grace, which distinguish our artist, are no less manifest than in the others whereof we have made mention.

And now, when the happy genius of the master was effecting such wonders, the envy of fortune deprived of life that Pontiff who was the especial protector and support of such talent, while he was the zealous promoter of every other good and useful work. Julius II died, but was succeeded by Leo X, who forthwith commanded that the labors commenced should be continued. The genius of Raphael was now exalted to heaven, and he received innumerable proofs of favor from the new Pontiff, fortunate in having encountered a prince so great, and one on whom the love of art had devolved by hereditary descent.

Thus encouraged, Raphael devoted himself with all his heart to the work, and on another wall of the same apartment, he represented the Approach of Attila towards Rome, and his encounter with Pope Leo III, by whom he is met at the foot of Monte Mario,[23] and who repulses him by the power of his word alone. In this picture, Raphael has shown San Pietro and San Paolo appearing in the air with swords in their hands, with which they come to defend the Church. It is true that the history of Leo III says nothing of such an occurrence, but so Raphael has chosen to represent it, perhaps as a mere fancy; for we know that painters and poets frequently permit themselves a certain degree of freedom for the more effectual decoration of their works; and this they may do without any undue departure from the propriety of the original thought.

In the two apostles thus depicted, there is all that holy zeal and dignity which the Divine Justice frequently imparts to the countenances of those among God's servants whom it has commissioned to become the defenders of the most holy faith. The effect of this expression on Attila is manifest in his face. He is riding on a fiery black horse, having a star on the forehead, and beautiful as it is possible that a horse could be; the attitude of the animal also betrays the utmost terror; its head is thrown aloft, and the body is turning in the act of flight.

There are other magnificent horses in the same work, among them a Spanish jennet, ridden by a figure which has all the parts usually left nude covered with scales in the manner of a fish. This is copied from the column of Trajan, the figures of the people around that column being armed in this fashion; such defences being made, as is conjectured, from the skins of crocodiles. Monte Mario is seen burning, as an intimation that, on the departure of soldiery, the dwellings are constantly given as a prey to the flames. Certain mace-bearers belonging to the papal retinue are painted with extraordinary animation, as are the horses which they

are riding: the same may be said of the court of Cardinals, and of the grooms who bear the canopy over the head of the Pontiff. The latter, Pope Leo X, is on horseback, in full pontificals, and is no less truthfully portrayed than are the figures before mentioned. He is followed by numerous courtiers, the whole scene presenting an extremely beautiful spectacle, in which all is finely appropriate to its place; and these details are exceedingly useful to those who practice our art, more particularly to such as are unprovided with the objects here represented.

About the same time, a picture was executed by Raphael for Naples, and this was placed in the church of San Domenico, and in that chapel wherein is the crucifix which spoke to St. Thomas Aquinas. In this work, Raphael depicted Our Lady, San Girolamo, clothed in the vestments of a Cardinal, and the Angel Raphael, who is serving as the guide of the youthful Tobit. For Leonello da Carpi, Lord of Meldola, who is still living, and has attained the age of more than ninety years, he painted a picture, the coloring of which is most admirable, and the beauty of the whole work very remarkable; it is indeed executed with so much force, and in a manner so exquisitely graceful withal, that I do not think the art could possibly produce or exhibit a finer work.

There is a divinity in the countenance of Our Lady, and a modest humility in her attitude, than which it would not be possible to conceive anything more beautiful. The master has depicted her with folded hands, in adoration of the Divine Child, who is seated on her lap, and is caressing a little St. John; the latter is also adoring the Redeemer. The figures of St. Joseph and St. Elizabeth complete the group. This picture was formerly in the possession of the most reverend Cardinal da Carpi, son of the above-named Signor Leonello, a very zealous admirer of our arts; it must now be in that of his heirs.

When Lorenzo Pucci, Cardinal of Santi Quattro, was created High Penitentiary, he caused Raphael, who was in great favor with him, to paint a picture for San Giovanni-in-Monte, at Bologna. This is now placed in that chapel wherein are deposited the relics of the Beata Elena dall'Olio, and serves to show what grace united with art could effect, when acting by the most accomplished and most delicate hand of Raphael. The subject of the work is Santa Cecilia, listening in ecstasy to the songs of the angelic choir, as their voices reach her ear from heaven itself. Wholly given up to the celestial harmony, the countenance of the saint affords full evidence of her abstraction from the things of this earth, and wears that rapt expression which is wont to be seen on the faces of those who are in ecstasy.

Musical instruments lie scattered around her, and these do not seem to be merely painted, but might be taken for the real objects represented. The same thing may be affirmed of the veil and vestments, formed of

cloth of gold and silver, with which Santa Cecilia is clothed, and beneath which is a garment of hair-cloth, also most admirably painted. In the figure of St. Paul likewise, the power and thought of the master are equally obvious: the saint is resting the right arm on his naked sword, the head is supported by the left hand, and the pride of his aspect has changed to a dignified gravity. The vestments of St. Paul consist of a simple cloth mantle, the color of which is red, with a green tunic beneath, after the manner of the apostles; his feet are bare.

St. Mary Magdalene also forms part of the group, and holds a vase, made of a very fine marble, in her hand. The attitude of this figure is singularly graceful, as is the turn of her head; she seems to rejoice in her conversion, and I do not think it would be possible that any work of the kind could be more perfectly executed. The heads of St. Augustine and of St. John the Evangelist, which are both in this picture, are of equal excellence. It may indeed with truth be declared that the paintings of other masters are properly to be called paintings, but those of Raphael may well be designated the life itself, for the flesh trembles, the breathing is made obvious to sight, the pulses in his figures are beating, and life is in its utmost animation through all his works.

This picture secured the author many commendations and a great increase of fame, insomuch that numerous verses, both in Latin and the vulgar tongue, were composed to his honor. Of these I will but insert the following, that I may not make a longer story than is needful:

> Pingant sola alii, referantque coloribus ora;
> Cæciliæ os Raphael atque animum explicuit.[24]

At a later period, our artist painted a small picture, which is now at Bologna, in the possession of the Count Vincenzio Ercolani. The subject of this work is Christ enthroned amid the clouds, after the manner in which Jupiter is so frequently depicted. But the Savior is surrounded by the four Evangelists, as described in the Book of Ezekiel: one in the form of a man, that is to say; another in that of a lion; the third as an eagle; and the fourth as an ox. The earth beneath exhibits a small landscape, and this work, in its minuteness—all the figures being very small—is no less beautiful than are the others in their grandeur of extent.

To Verona, Raphael sent a large picture of no less excellence, for the Counts of Canossa. The subject is the Nativity of Our Lord, admirably treated: the daybreak in particular, as here portrayed, has been highly commended, and the same may be said of the figure of Sant'Anna, and indeed of the whole work, which one could not extol more effectually than by the simple assertion that it is by the hand of Raphael da Urbino. The Counts hold this picture in the highest estimation, as it well de-

serves. Very great sums have been offered to them for it by different princes, but they have never been prevailed on to part with it.

For Bindo Altoviti, Raphael executed a portrait of himself when he (Bindo) was still young, and this work also has obtained, as it merits, the highest admiration. He also painted a picture of the Madonna for the same person, who despatched it to Florence. This is now preserved in the palace of the Duke Cosimo; it has been placed in the chapel of the new apartments, which have been built and painted by myself, where it serves as the altar-piece. The subject is Sant'Anna, a woman much advanced in years, who is seated with the Infant Christ in her arms; she is holding him out to the Virgin, and the beauty of his nude figure, with the exquisite loveliness of the countenance which the master has given to the Divine Child, is such that his smile rejoices the heart of all who behold him.

To Our Lady also, Raphael has imparted all the beauty which can be imagined in the expression of a virgin; in the eyes there is modesty, on the brow there shines honor, the nose is one of very graceful character, and the mouth betokens sweetness and excellence. In the vestments also, there is an indescribable simplicity with an attractive modesty, which I do not think could possibly be surpassed; there cannot, indeed, be anything better of its kind than is this whole work. There is a beautiful figure of the little San Giovanni undraped, in this picture, with that of another saint, a female, which is likewise very beautiful. The background represents a dwelling, in which there is a window partially shaded, through which light is given to the chamber wherein the figures are seated.

In Rome, Raphael likewise painted a picture of good size, in which he represented Pope Leo, the Cardinal Giulio de' Medici, and the Cardinal de' Rossi. The figures in this work seem rather to be in full relief, and living, than merely feigned, and on a plane surface. The velvet softness of the skin is rendered with the utmost fidelity. The vestments in which the Pope is clothed are also most faithfully depicted, the damask shines with a glossy lustre; the furs which form the linings of his robes are soft and natural, while the gold and silk are copied in such a manner that they do not seem to be painted, but really appear to be silk and gold. There is also a book in parchment decorated with miniatures, a most vivid imitation of the object represented, with a silver bell, finely chased, of which it would not be possible adequately to describe the beauty.

Among other accessories, there is, moreover, a ball of burnished gold on the seat of the Pope, and in this—such is its clearness—the divisions of the opposite window, the shoulders of the Pope, and the walls of the room are faithfully reflected; all these things are executed with so much care, that I fully believe no master ever has done or ever can do any thing better. For this work, Raphael was richly rewarded by Pope Leo. It is now in Florence, in the Guardaroba of the Duke. He also painted the portraits

of the Duke Lorenzo and of the Duke Giuliano, whom he depicted with that perfection and that grace of coloring which is to be seen in no other than himself. These works belong to the heirs of Ottaviano de' Medici, and are now in Florence.

The fame of Raphael continued to increase largely, as did the rewards conferred on him; wherefore, desiring to leave a memorial of himself in Rome, he caused a palace to be erected in the Borgo Nuovo, which was decorated with stucco-work by Bramante. The renown of this most noble artist having been carried, by the fame of these and other works, into France and Flanders, Albert Dürer, a most admirable German painter, and the engraver of most beautiful copperplates, sent a tribute of respect to Raphael from his own works—a head, namely, which was his own portrait, executed on exceedingly fine linen, which permitted the picture to appear equally on both sides, the lights not produced by the use of whites, but transparent, and the whole painted in water colors. This work was much admired by Raphael, who sent a number of his own drawings to Albert Dürer, by whom they were very highly estimated. The head sent by the German artist, Albert Dürer, to Raphael was subsequently taken to Mantua among the other possessions inherited from the last-named master, by Giulio Romano.

Raphael, having been thus made acquainted with the mode of proceeding adopted in his engravings by Albert Dürer, was desirous of seeing his own works treated after that manner. He therefore caused Marco Antonio of Bologna,[25] who was well practiced in that branch of art, to prepare numerous studies from them; and in this Antonio succeeded so well that Raphael commissioned him to engrave many of his earliest works, namely, the Slaughter of the Innocents, a Last Supper, the Neptune, and the Santa Cecilia, when she is being boiled in oil.[26] Marco Antonio subsequently executed a number of engravings, which were afterwards given by Raphael to Il Baviera, his disciple, who was the guardian of a certain lady, to whom Raphael was attached till the day of his death, and of whom he painted a most beautiful portrait, which might be supposed alive.

This is now at Florence, in the possession of the good and worthy Botti, a Florentine merchant of that city, who is the friend and favorer of all distinguished men, but more especially of painters; by him the work is treasured as if it were a relic, for the love which he bears to the art, but more especially to Raphael. Nor less friendly to artists than himself is his brother, Simon Botti, who, to say nothing of the fact that he is held by us all to be one of the most friendly among those who benefit our arts, is to myself in particular, the best and truest friend that ever the long experience of many years made dear to man; he has besides given proof of very good judgment in all things relating to our own art.

But to return to the copperplate engravings. The favor which Raphael had shown to Il Baviera was afterwards the cause which induced Marco of Ravenna, and many others, to labor in that branch of art; insomuch, that what was formerly the great dearth of engravings on copper, became eventually that large supply of them which we now find. Hugo da Carpi, moreover, whose fine powers of invention were turned to the discovery of many ingenious and fanciful devices, found out that of carving in wood, in which, by means of three blocks, the light, shadow, and middle tint can equally be given, and drawings in chiaroscuro imitated exactly. Without doubt a very beautiful and fanciful invention, which has since been largely extended.

For the monks of Monte Oliveto, Raphael executed a picture of Christ bearing his Cross, to be placed in their monastery at Palermo, called Santa Maria dello Spasmo. This is considered to be a most admirable work, and is remarkable, among other characteristics, for the force with which the master has rendered the cruelty of the executioners, who are dragging the Redeemer to his death on Mount Calvary, with all the evidences of a furious rage. The Savior himself, grievously oppressed by the torment of the death towards which he is approaching, and borne down by the weight of the Cross, has fallen to the earth faint with heat and covered with blood; he turns towards the Maries who are weeping bitterly. Santa Veronica is also among those who surround him, and, full of compassion, she extends her arms towards the Sufferer, to whom she presents a handkerchief with an expression of the deepest sympathy.[27] There are, besides, vast numbers of armed men on horseback and on foot, who are seen pouring forth from the gate of Jerusalem, bearing the ensigns of justice in their hands, and all in attitudes of great and varied beauty.

This picture was entirely finished, but had not yet been fixed in its place, when it was in great danger and on the point of coming to an unhappy end. The matter was on this wise: The painting, according to what I have heard related, was shipped to be taken to Palermo, but a frightful tempest arose which drove the vessel on a rock, where it was beaten to pieces, men and merchandise being lost together, this picture alone excepted, which, secured in its packings, was carried by the sea into the Gulf of Genoa. Here it was picked up and borne to land, when, being seen to be so beautiful a thing, it was placed in due keeping, having maintained itself unhurt and without spot or blemish of any kind; for even the fury of the winds and the waves of the sea had had respect to the beauty of so noble a work. The fame of this event was bruited abroad, and the monks to whom the picture belonged took measures to obtain its restoration: in this they eventually succeeded, though not without great difficulty and only by aid of the Pope, when they largely re-

warded those who had effected its recovery from the waves. Being then embarked anew, the picture was ultimately landed in Sicily; the monks then deposited the work in the city of Palermo, where it has more reputation than the Mount of Vulcan itself.[28]

While Raphael was thus engaged with the works above described, which he could not decline doing, partly because commissioned to execute them by great and important personages, but partly, also, because a due regard for his interest would not permit him to refuse them—while thus occupied, I say, he did not on that account neglect to continue the works which he had commenced in the papal halls and chambers. On the contrary, he kept people constantly employed therein, and by them the work was continued from drawings made by his own hand, every part being minutely superintended by himself, and the more important portions of the whole executed by him, so far as was possible in a work of such magnitude. No long time elapsed, therefore, before he gave to view the apartment of the Torre Borgia, on every wall of which he had placed a painting—two over the windows namely, and two on the sides wherein there are no windows.

In one of these pictures, the master has depicted the Conflagration of the Borgo Vecchio of Rome, which could not be extinguished until Pope Leo IV presented himself at the loggia of the palace, and extinguished it entirely by the power of his benediction. In this work is the representation of many perilous incidents; on one side are women bearing vases of water on their heads and in their hands wherewith to extinguish the flames; the hair and clothing of these figures are blown about by the fury of a tempestuous wind; others, who are attempting to throw water on the burning masses, are blinded by the smoke, and appear to be in a state of bewilderment. At another part of the picture is a group, resembling that described by Virgil, of Anchises borne out of danger by Æneas. An old man, being sick, is exhausted by his infirmity and the heat of the fire, and is carried by a youth in whose form the determination and power to save are manifest, as is the effort made by every member to support the dead weight of the old man helplessly hanging in utter abandonment upon his back.

He is followed by an old woman barefoot and with loosened garments, who is rushing in haste from the fire—a naked child goes before them. From the top of a ruined building, also, is seen a woman naked and with dishevelled hair, who has an infant in her hands which she is about to throw down to one of her family; just escaped from the flames, the last-mentioned person stands in the road below, raised on the points of his feet and stretching forth his arms to receive the child—an infant in swathing bands, which the woman holds out to him. And here the anxious eagerness of the mother to save her child is no less truthfully ex-

pressed than is the suffering which she is herself enduring from the devouring flames, glowing around and threatening to destroy her.

In the figure of the man who is receiving the child also, there is as clearly to be perceived the anxiety which he suffers in his desire to rescue it, with the fear he entertains for his own life. Equally remarkable is the power of imagination displayed by this most ingenious and most admirable artist in a mother, who, driving her children before her, with bare feet, loosened vestments, girdle unbound, and hair dishevelled, bears a part of her clothing in her hands, and smites her children to hasten their flight from the falling ruins and from the scorching fury of the flames. There are besides other women, who, kneeling before the Pope, appear to be entreating that His Holiness will cause the fire to be staid.

The second picture also represents an incident from the life of Pope Leo IV: here the master has depicted the Port of Ostia occupied by the fleet of the Turks, who had come to make His Holiness prisoner. On the sea without are seen the Christians engaged in combat with the Turkish Armada, and numerous prisoners are already observed to be entering the harbor; the latter are seen to issue from a boat whence they are dragged by soldiers, the attitudes and countenances of whom are exceedingly spirited and beautiful. The prisoners are clothed in a variety of vestments proper to seamen, and are led before St. Leo, whose figure is a portrait of the then reigning Pontiff, Leo X. His Holiness, who is in full pontificals, is enthroned between the Cardinal of Santa Maria-in-Portico, Bernardo Divizio da Bibbiena namely, and Cardinal Giulio de' Medici, who was afterwards Pope Clement VII. It would not be possible minutely to describe the admirable thought with which this most inventive artist has depicted the countenances of the prisoners, in whose expression all necessity for speech is superseded, so eloquently does it set forth their grief, their terror, and the bitter foretaste which they are enduring of the death preparing for them.

In the other two pictures is, first, Leo X consecrating the most Christian King, Francis I of France. He is chanting the mass robed in full pontificals, and is blessing the oils wherewith to anoint the monarch at the same time that he likewise blesses the royal crown; a vast body of Cardinals and Bishops, also in their episcopal robes, are serving the mass, and there are, moreover, numerous ambassadors and other personages portrayed from nature, with several figures dressed in the French manner of that period. The second picture represents the Coronation of the above-named King,[29] and here the Pope and Francis are both drawn from the life, the King in armor, the Pope in his pontifical robes. The College of Cardinals, a large number of Bishops, chamberlains, shield-bearers, and grooms of the chamber, all in their appropriate robes and

dresses of ceremony, are placed in their due position and proper order as is usual in the papal chapel.

Among them are many portraits from the life, as, for example, that of Giannozzo Pandolfini, Bishop of Troy, and the most intimate friend of Raphael, with those of many other persons holding eminent positions at that time. Near the King is a boy kneeling, who bears the crown in his hands: this is the portrait of Ippolito de' Medici, who was afterwards a Cardinal and became Vice-Chancellor—a highly esteemed prelate, and the firm friend, not of these arts only, but of all others—one too, whose memory I am myself bound to hold in the most grateful respect, and do indeed acknowledge myself deeply obliged to him, since my own commencement in art, such as it may have been, had its origin with that noble prelate.

To describe all the minute particulars of Raphael's works, wherein every object seems to be eloquently speaking in its silence, would not be possible. I must yet not omit to mention that beneath each of the pictures above described is represented a socle or basement, wherein are depicted the figures of various benefactors and defenders of the Church, separated from each other by terminal figures of various character, but all executed in such a manner that every part gives evidence of the utmost thought and care; all are full of spirit, with a propriety and harmony of color that could not possibly be better. The ceiling of this apartment had been painted by Pietro Perugino, Raphael's master, and this the latter, from respect to his memory and from the affection that he bore him, would not destroy, seeing that by his instructions it was that Raphael himself was first conducted to the path which had led him to so high a position in art.

So comprehensive and extended were the views of Raphael in all things relating to his works that he kept designers employed in all parts of Italy, at Pozzuolo and even in Greece, to the end that he might want nothing of that which appertained to his art; and for this he spared neither labor nor cost.

Pursuing his works in the Vatican, Raphael decorated one of the halls in *terretta,* depicting several of the Apostles and numerous Saints, whom he has represented standing in niches or tabernacles. There also he caused his disciple, Giovanni da Udine, who had not his equal in the delineation of animals, to paint all those then in the possession of Pope Leo X: the chameleon, for example, the civet cat, the apes, the parrots, the lions, the elephants, and other animals from distant lands. He also adorned many of the floors and other parts of the palace with *grottesche* and other embellishments; and gave the design for certain of the staircases, as well as for the loggias commenced by the architect Bramante, but which remained incomplete at the death of that master, when they

were continued after a new design, and with many changes in the architecture, by Raphael himself, who prepared a model in wood, the arrangement and decoration of which were richer and more beautiful than that proposed by Bramante.

Pope Leo, desiring to show the greatness of his magnificence and generosity, caused Raphael to make designs for the ornaments in stucco, which he had resolved to have placed between the paintings[30] executed in the loggias, as well as for those in other parts. And as superintendent of all these *grottesche* in stucco, he appointed Giovanni da Udine, Giulio Romano being commissioned to prepare the figures; but the latter did not work at them to any great extent. The Pontiff also commissioned Giovanni Francesco, Il Bologna,[31] Perino del Vaga, Pellegrino da Modena, Vincenzio of San Gimignano, and Polidoro da Caravaggio, with many other artists, to execute historical pictures, separate figures and many other portions of the works, all which Raphael caused to be completed with so much care that he even suffered the pavement to be procured in Florence from Luca della Robbia,[32] inasmuch that, whether for the paintings, the stucco-work, the architecture, or other beautiful inventions, a more admirable performance could not be executed, nay, could scarcely be imagined. Its perfection was indeed the cause of Raphael's receiving the charge of all the works in painting and architecture that were to be executed in the palace.

It is said that Raphael was so courteous and obliging that, for the convenience of certain among his friends, he commanded the masons not to build the walls in a firm uninterrupted range, but to leave certain spaces and apertures among the old chambers on the lower floors, to the end that they might store casks, pipes, firewood, &c., therein. But these hollows and spaces weakened the base of the walls, so that it has since become needful to fill them in, seeing that the whole work began to show cracks and other signs of deterioration. For all the doors, wainscots, and other portions ornamented in wood-work, Raphael caused fine carvings to be prepared, and these were executed and finished in a very graceful manner by Gian Barile.

The architectural designs for the Vigna[33] of the Pope and for several houses in the Borgo, but more particularly for the palace of Messer Giovanni Battista dall'Aquila, which was a very beautiful edifice, were likewise prepared by Raphael. He also designed one for the Bishop of Troy, who caused him to construct it in the Via di Sangallo at Florence.

For the Black Friars of San Sisto in Piacenza, Raphael painted a picture intended to form the altar-piece for the high altar of their church; the subject of this work is the Virgin with St. Sixtus and Santa Barbara, a truly admirable production.[34] Raphael painted many pictures to be sent into France, but more particularly one for the King, St. Michael namely,

in combat with the Archfiend; this also is considered singularly beauti-
ful. A rock, whence flames are issuing, represents the center of the earth,
and from the clefts of this rock fires and sulphurous flames are proceed-
ing, while Lucifer, whose limbs, scorched and burning, are depicted of
various tints, exhibits every emotion of rage that pride, envenomed and
inflated, can awaken against the Oppressor of his greatness, by whom he
is deprived of his kingdom, and at whose hands he may never hope for
peace, but is certain to receive heavy and perpetually enduring punish-
ment. In direct contrast with this figure is that of the Archangel San
Michele; his countenance is adorned with celestial beauty; he wears
armor formed of iron and gold; fearlessness, force, and terror are in his
aspect; he has cast Lucifer to the earth, and compels him to lie prone be-
neath his uplifted spear.

The work was performed in so admirable a manner at all points that
Raphael obtained, as he had well merited, a large and honorable reward
for it from the King. This master also painted the portrait of Beatrice of
Ferrara, with those of other ladies; that of his own inamorata is more par-
ticularly to be specified, but he also executed many others. He was much
disposed to the gentler affections and delighted in the society of women,
for whom he was ever ready to perform acts of service. But he also per-
mitted himself to be devoted somewhat too earnestly to the pleasures of
life, and in this respect was perhaps more than duly considered and in-
dulged by his friends and admirers.

We find it related that his intimate friend, Agostino Chigi, had com-
missioned him to paint the first floor of his palace,[35] but Raphael was at
that time so much occupied with the love which he bore to the lady of
his choice that he could not give sufficient attention to the work.
Agostino therefore, falling at length into despair of seeing it finished,
made so many efforts by means of friends and by his own care that after
much difficulty he at length prevailed on the lady to take up her abode
in his house, where she was accordingly installed in apartments near
those which Raphael was painting; in this manner the work was ulti-
mately brought to a conclusion.

For these pictures Raphael prepared all the cartoons, painting many of
the figures also with his own hand in fresco. On the ceiling he repre-
sented the Council of the Gods in Heaven, and in the forms of these
deities many of the outlines and lineaments may be perceived to be from
the antique, as are various portions of the draperies and vestments, the
whole admirably drawn and exhibiting the most perfect grace. In a man-
ner equally beautiful, Raphael further depicted the Marriage of Psyche,
with the attendants ministering to Jupiter and the Graces scattering flow-
ers. In the angles of the ceiling also he executed other stories, represent-
ing in one of them a figure of Mercury with his flute; the god in his

graceful movements appears really to be descending from heaven. In a second is the figure of Jupiter depicted with an aspect of the most sublime dignity; near him is Ganymede, whom with celestial gravity he is caressing. And on the remaining angles are other mythological representations. Lower down is the chariot of Venus, wherein Psyche is borne to heaven in a car which is drawn by the Graces, who are aided by Mercury.

In those compartments of the vaulting which are above the arches and between the angles are figures of boys most beautifully foreshortened; they are hovering in the air and bear the various attributes proper to the different deities. One has the thunderbolts of Jove for example; others bear the helmet, sword, and shield of Mars, or the hammers of Vulcan; some are laden with the club and lion-skin of Hercules; one carries the caduceus of Mercury; another the pipe of Pan; while others again have the agricultural implements of Vertumnus. All are accompanied by the animals appropriate to their various offices, and the whole work, whether as painting or poetry, is of a truth eminently beautiful. All these representations Raphael further caused Giovanni da Udine to surround with a bordering of flowers, fruits, and foliage in the richest variety, disposed in festoons and all as beautiful as it is possible that works of the kind can be.

This master likewise gave a design for the stables of the Chigi Palace, with that for the chapel belonging to the same Agostino Chigi in the church of Santa Maria del Popolo. This he painted also, and furthermore made preparations for the construction of a magnificent sepulchral monument, for which he caused the Florentine sculptor Lorenzetti to execute two figures. These are still in his house situate in the Macello de Corvi in Rome.[36] But the death of Raphael, and afterwards that of Agostino, caused the execution of the sepulchre to be made over to Sebastiano Veniziano.[37]

Raphael had now attained to such high repute that Leo X commanded him to commence the painting of the great hall on the upper floor of the papal palace, that namely wherein the victories of Constantine are delineated, and this work he accordingly began. The Pope also desired to have certain very rich tapestries in silk and gold prepared, whereupon Raphael made ready the cartoons, which he colored also with his own hand, giving them the exact form and size required for the tapestries. These were then despatched to Flanders to be woven, and when the cloths were finished they were sent to Rome. This work was so admirably executed that it awakened astonishment in all who beheld it, as it still continues to do; for the spectator finds it difficult to conceive how it has been found possible to have produced such hair and beards by weaving, or to have given so much softness to the flesh by means of thread, a work which certainly seems rather to have been performed by

miracle than by the art of man, seeing that we have here animals, buildings, water, and innumerable objects of various kinds, all so well done that they do not look like a mere texture woven in the loom, but like paintings executed with the pencil. This work cost 70,000 crowns, and is still preserved in the papal chapel.

For the Cardinal Colonna, Raphael painted a San Giovanni on canvas, which was an admirable work and greatly prized for its beauty by the Cardinal; but the latter being attacked by a dangerous illness, and having been cured of his infirmity by the physician Messer Jacopo da Carpi, the latter desired to be presented with the picture of Raphael as his reward. The Cardinal, therefore, seeing his great wish for the same, and believing himself to be under infinite obligation to his physician, deprived himself of the work, and gave it to Messer Jacopo. It is now at Florence in the possession of Francesco Benintendi.

Raphael also painted a picture for the Cardinal and Vice-Chancellor Giulio de' Medici, a Transfiguration namely, which was destined to be sent into France. This he executed with his own hand, and laboring at it continually, he brought it to the highest perfection, depicting the Savior transfigured on Mount Tabor, with eleven of the disciples awaiting him at the foot of the mount. To these is meanwhile brought a youth possessed of a spirit, who is also awaiting the descent of Christ, by whom he is to be liberated from the demon. The possessed youth is shown in a distorted attitude stretching forth his limbs, crying, rolling his eyes, and exhibiting in every movement the suffering he endures. The flesh, the veins, the pulses, are all seen to be contaminated by the malignity of the spirit; the terror and pain of the possessed being rendered further manifest by his pallid color and writhing gestures.

This figure is supported by an old man in whose widely open eyes the light is reflected. He is embracing and seeking to comfort the afflicted boy; his knitted brow and the expression of his face show at once the apprehension he feels, and the force with which he is laboring to combat his fears; he looks fixedly at the apostles as if hoping to derive courage and consolation from their aspect. There is one woman among others in this picture who is the principal figure therein, and who, kneeling before the two just described, turns her head towards the apostles, and seems by the movement of her arms in the direction of the possessed youth to be pointing out his misery to their attention. The apostles also, some of whom are standing, some seated, and others kneeling, give evidence of the deep compassion they feel for that great misfortune.

In this work the master has, of a truth, produced figures and heads of such extraordinary beauty, so new, so varied, and at all points so admirable that, among the many works executed by his hand, this, by the common consent of all artists, is declared to be the most worthily renowned, the

most excellent, the most divine. Whoever shall desire to see in what manner Christ transformed into the Godhead should be represented, let him come and behold it in this picture. The Savior is shown floating over the mount in the clear air; the figure, foreshortened, is between those of Moses and Elias, who, illumined by his radiance, awaken into life beneath the splendor of the light. Prostrate on the earth are Peter, James, and John, in attitudes of great and varied beauty.

One has his head bent entirely to the ground; another defends himself with his hands from the brightness of that immense light which proceeds from the splendor of Christ, who is clothed in vestments of snowy whiteness, his arms thrown open and the head raised towards heaven, while the essence and Godhead of all the three persons united in himself are made apparent in their utmost perfection by the divine art of Raphael.

But as if that sublime genius had gathered all the force of his powers into one effort, whereby the glory and the majesty of art should be made manifest in the countenance of Christ, having completed that, as one who had finished the great work which he had to accomplish, he touched the pencils no more, being shortly afterwards overtaken by death.

Having now described the works of this most excellent artist, I will not permit myself to consider it a labor to say somewhat, for the benefit of those who practice our calling, respecting the manner of Raphael, before proceeding to the relation of such particulars as remain to be specified in regard to other circumstances of his life, and to those which relate to his death. In his childhood he had imitated the manner of his master, Pietro Perugino, but had greatly ameliorated the same, whether as regarded design, coloring, or invention. Having done this, it then appeared to him that he had done enough; but when he had attained to a riper age he perceived clearly that he was still too far from the truth of nature. On becoming acquainted with the works of Leonardo da Vinci, who in the expression which he gave to his heads, whether male or female, had no equal, and who surpassed all other painters in the grace and movement which he imparted to his figures—seeing these works, I say— Raphael stood confounded in astonishment and admiration. The manner of Leonardo pleased him more than any other that he had ever seen, and he set himself zealously to the study thereof with the utmost zeal.

By degrees therefore, abandoning, though not without great difficulty, the manner of Pietro Perugino, he endeavored as much as was possible to imitate that of Leonardo. But whatever pains he took, and in spite of all his most careful endeavors, there were some points and certain difficulties of art in which he could never surpass the last-named master. Many are without doubt of opinion that Raphael surpassed Leonardo in

tenderness and in a certain natural facility; but he was assuredly by no means superior in respect of that force of conception and grandeur which is so noble a foundation in art, and in which few masters have proved themselves equal to Leonardo. Raphael has nevertheless approached him more nearly than any other painter, more particularly in the graces of coloring.

But to speak more exclusively of Raphael himself. In the course of time he found a very serious impediment in that manner which he had acquired from Pietro in his youth, and which he had at the first so readily adopted. Dry, minute, and defective in design, he could not completely divest himself of all recollection thereof, and this caused him to find the utmost difficulty in learning to treat worthily the beauties of the nude form, and to master the methods of those difficult foreshortenings which Michelangelo Buonarroti executed in his cartoon for the Hall of the Council in Florence.

Now any artist, who might have lost courage from believing that he had been previously throwing away his time, would never, however fine his genius, have accomplished what Raphael afterwards effected. For the latter, having, so to speak, cured and altogether divested himself of the manner of Pietro, the better to acquire that of Michelangelo, which was full of difficulties in every part, may be said from a master to have almost become again a disciple, and compelled himself by incredible labors to effect that in a few months, now that he was become a man, which even in his youthful days, and at the time when all things are most easily acquired, would have demanded a period of many years for its attainment. It is by no means to be denied that he who is not early embued with just principles, or who has not entered from the first on that manner which he can be content to pursue, and who does not gradually obtain facility in the difficulties of the art, by means of experience (seeking fully to comprehend every part and to confirm himself by practice in the knowledge of all), will scarcely ever attain to perfection; or, if he do attain it, must do so at the cost of much longer time and greatly increased labor.

At the time when Raphael determined to change and ameliorate his manner, he had never given his attention to the nude form, with that degree of care and study which the subject demands, having drawn it from the life only after the manner which he had seen practiced by Pietro his master, adding nevertheless to all that he did that grace which had been imparted to him by nature. But he thenceforth devoted himself to the anatomical study of the nude figure, and to the investigation of the muscles in dead and excoriated bodies as well as in those of the living. For in the latter they are not so readily to be distinguished, because of the impediment presented by the covering of the skin, as in those from which the outer integuments have been removed; but thus examined, the

master learnt from them in what manner they acquire fulness and soft-
ness by their unity, each in its due proportion, and all in their respective
places, and how, by the due management of certain flexures, the perfec-
tion of grace may be imparted to various attitudes as seen in different
aspects. Thus also he became aware of the effects produced by the infla-
tion of parts, and by the elevation or depression of any given portion or
separate member of the body or of the whole frame.

The same researches also made him acquainted with the articulations
of the bones, with the distribution of the nerves, the course of the veins,
&c., by the study of all which he rendered himself excellent in every
point required to perfect the painter who aspires to be of the best, know-
ing, nevertheless, that in this respect he could never attain to the emi-
nence of Michelangelo. Like a man of great judgment as he was, he
considered that painting does not consist wholly in the delineation of the
nude form, but has a much wider field. He perceived that those who pos-
sess the power of expressing their thoughts well and with facility, and of
giving effective form to their conceptions, likewise deserve to be enu-
merated among the perfect painters. And that he who in the composi-
tion of his pictures shall neither confuse them by too much, nor render
them poor by too little, but gives to all its due arrangement and just dis-
tribution may also be reputed a judicious and able master.

But in addition to this, as Raphael rightly judged, the art should be
further enriched by new and varied inventions in perspective, by views
of buildings, by landscapes, by a graceful manner of clothing the figures,
and by causing the latter sometimes to be lost in the obscurity of shad-
ows, sometimes to come prominently forward into the clear light. Nor
did he fail to perceive the importance of giving beauty and animation to
the heads of women and children, or of imparting to all, whether male
or female, young or old, such an amount of spirit and movement as may
be suited to the occasion. He gave its due value, likewise, to the attitudes
of horses in battle scenes, to their movements in flight, and to the bold
bearing of the warriors.

The due representation of animals in all their varied forms did not es-
cape his consideration, still less did that of so portraying the likenesses of
men that they may appear to be alive and may be known for those whom
they are intended to represent. Raphael perceived in like manner that in-
numerable accessories of other kinds and of all sorts were equally to be
taken into account, as for example the ornament of the work by well-
arranged and beautiful draperies, and vestments of every kind; by due
attention to the helmets and other parts of armor, to the appropriate
clothing of the feet, and to the head-dresses of women. He saw that equal
care should be accorded to the hair and head of figures, to vases, trees,
grottoes, rocks, fires, the air, either turbid or serene, clouds, rains, tem-

pests, lightnings, dews, the darkness of night, the moonlight, the sunshine, and an infinite variety of objects besides, to every one of which attention is demanded by the requirements of painting.

All these things, I say, being well considered by Raphael, he resolved, since he could not attain to the eminence occupied by Michelangelo on the point after which he was then laboring, to equal, or perhaps to surpass him in those other qualities that we have just enumerated, and thus he devoted himself, not to the imitation of Buonarroti, lest he should waste his time in useless efforts, but to the attainment of perfection in those parts generally of which we have here made mention.

And well would it have been for many artists of our day if they had done the same, instead of pursuing the study of Michelangelo's works alone, wherein they have not been able to imitate that master, nor found power to approach his perfection. They would not then have exhausted themselves by so much vain effort, nor acquired a manner so hard, so labored, so entirely destitute of beauty, being, as it is, without any merit of coloring and exceedingly poor in conception. But instead of this, might very possibly, by the adoption of more extended views and the endeavor to attain perfection in other departments of the art, have done credit to themselves as well as rendered service to the world.

Having made the resolution above referred to, therefore, and learning that Fra Bartolommeo had a very good manner in painting, drew very correctly, and had a pleasing mode of coloring, although, with the intention of giving more relief to his figures, he sometimes made his shadows too dark—knowing all this, Raphael determined to adopt so much of the monk's manner as he should find needful or agreeable to him; to take a medium course that is, as regarded design and coloring. And mingling with what he obtained from the manner of Fra Bartolommeo other qualities selected from the best that he could find in other masters, of many manners, he thus formed one, which was afterwards considered his own, and which ever has been and ever will be highly esteemed by all artists.

Thus his manner was afterwards seen perfected in the Sibyls and Prophets of the work executed, as we have said, for the church of Santa Maria della Pace, and in the conduct of which he was greatly assisted by the circumstance of his having seen the work of Michelangelo in the chapel of the Pope. Nay, had Raphael remained constant to the manner as there seen, had he not endeavored to enlarge and vary it for the purpose of showing that he understood the nude form as well as Michelangelo, he would not have lost any portion of the good name he had acquired. But the nude figures in that apartment of the Torre Borgia, wherein is depicted the Conflagration of the Borgo Nuovo, although certainly good, are not by any means all excellent, or perfect in

every part. In like manner, those painted by this master on the ceiling of Agostino Chigi's palace in the Trastevere are not altogether satisfactory, since they want that grace and softness which were peculiar to Raphael.

But the cause of this was, in great part, his having suffered them to be painted after his designs by other artists, an error, which judicious as he was, he soon became aware of, and resolved to execute the picture of the Transfiguration in San Pietro-a-Montorio,[38] entirely with his own hand, and without any assistance from others. In this work, therefore, will be found all those qualities which, as we have said, a good picture demands, and should exhibit. Nay, had Raphael not used in this picture, almost as it were from caprice, the lamp black, or printer's black, which, as we have more than once remarked, does of its nature become evermore darker with time, and is thus injurious to the other colors used with it, had he not done this, I believe that the work would now be as fresh as when he painted it; whereas it is, on the contrary, not a little darkened.

I have thought proper to make these remarks at the close of this life, to the end that all may discern the labor, study, and care to which this honored artist constantly subjected himself; and with a view, more particularly, to the benefit of other painters, who may learn, from what has been said, to avoid those impediments from the influence of which the genius and judgment of Raphael availed to secure him. I will also add the further observation that every man should content himself with performing such works as he may reasonably be supposed to be capable of, and equal to, by his inclination and the gifts bestowed on him by nature, without seeking to contend for that which she has not qualified him to attain. And this let him do, that he may not uselessly spend his time fatiguing himself vainly, nay, not unfrequently, to his own injury as well as discredit.

Let it be observed, moreover, that, when what has been accomplished suffices, it is not good to make further efforts, merely in the hope of surpassing those who by some special gift of nature, or by the particular favor accorded to them by the Almighty, have performed, or are performing, miracles in the art. For it is certain that the man who has not the needful endowments, let him labor as he may, can never effect those things to which another, having received the gift from nature, has attained without difficulty. And of this we have an example among the old masters of Paolo Uccello, who, struggling against the natural bent of his faculties to make progress on a given path, went ever backwards instead. The same thing has been done in our own days, and but a short time since, by Jacopo da Pontormo; nay, examples have been seen in the experience of many others, as we have said before, and as will often be said again. And this is permitted to occur, perhaps, in order that when

Heaven has distributed its favors to mankind, each one may be content
with the portion which has fallen to his lot.

But I have now discoursed respecting these questions of art at more
length perhaps than was needful, and will return to the life and death of
Raphael. This master lived in the strictest intimacy with Bernardo
Divizio, Cardinal of Bibbiena, who had for many years importuned him
to take a wife of his selection, nor had Raphael directly refused compli-
ance with the wishes of the Cardinal, but had put the matter off by say-
ing that he would wait some three or four years longer. The term which
he had thus set approached before Raphael had thought of it, when he
was reminded by the Cardinal of his promise, and being, as he ever was,
just and upright, he would not depart from his word, and therefore ac-
cepted a niece of the Cardinal himself for his wife.

But as this engagement was nevertheless a very heavy restraint to him,
he put off the marriage from time to time, insomuch that several months
passed and the ceremony had not yet taken place. Yet this was not done
without a very honorable motive, for Raphael, having been for many
years in the service of the court, and being the creditor of Leo X for a
large sum of money, had received an intimation to the effect that, when
the hall with which he was then occupied was completed, the Pontiff in-
tended to reward him for his labors as well as to do honor to his talents
by bestowing on him the red hat,[39] of which he meant to distribute a
considerable number, many of them being designed for persons whose
merits were greatly inferior to those of Raphael.

The painter meanwhile did not abandon the light attachment by
which he was enchained, and one day, on returning to his house from
one of these secret visits, he was seized with a violent fever, which being
mistaken for a cold, the physicians inconsiderately caused him to be bled,
whereby he found himself exhausted, when he had rather required to be
strengthened. Thereupon he made his will, and, as a good Christian, he
sent the object of his attachment from the house, but left her a sufficient
provision wherewith she might live in decency. Having done so much,
he divided his property among his disciples: Giulio Romano, that is to
say, whom he always loved greatly, and Giovanni Francesco, with whom
was joined a certain priest of Urbino, who was his kinsman, but whose
name I do not know.

He furthermore commanded that a certain portion of his property
should be employed in the restoration of one of the ancient tabernacles
in Santa Maria Ritonda,[40] which he had selected as his burial-place, and
for which he had ordered that an altar with the figure of Our Lady in
marble should be prepared. All that he possessed besides he bequeathed
to Giulio Romano and Giovanni Francesco, naming Messer Baldassare
da Pescia, who was then Datary[41] to the Pope, as his executor. He then

confessed, and in much contrition completed the course of his life on the day whereon it had commenced, which was Good Friday. The master was then in the thirty-seventh year of his age; and as he embellished the world by his talents while on earth, so is it to be believed that his soul is now adorning heaven.

After his death, the body of Raphael was placed at the upper end of the hall wherein he had last worked, with the picture of the Transfiguration, which he had executed for Cardinal Giulio de' Medici, at the head of the corpse. He who, regarding that living picture, afterwards turned to consider that dead body felt his heart bursting with grief as he beheld them. The loss of Raphael caused the Cardinal to command that this work should be placed on the high altar of San Pietro-a-Montorio, where it has ever since been held in the utmost veneration for its own great value, as well as for the excellence of its author. The remains of this divine artist received that honorable sepulture which the noble spirit whereby they had been informed had so well deserved, nor was there any artist in Rome who did not deeply bewail the loss sustained by the departure of the master, or who failed to accompany his remains to their repose.

The death of Raphael was in like manner bitterly deplored by all the papal court, not only because he had formed part thereof, since he had held the office of chamberlain to the Pontiff, but also because Leo X had esteemed him so highly that his loss occasioned that sovereign the bitterest grief. Oh most happy and thrice blessed spirit, of whom all are proud to speak, whose actions are celebrated with praise by all men, and the least of those works left behind thee, is admired and prized!

When this noble artist died, well might Painting have departed also, for when he closed his eyes, she too was left as it were blind. But now to us, whose lot it is to come after him, there remains to imitate the good, or rather the excellent, of which he has left us the example, and, as our obligations to him and his great merits well deserve, to retain the most grateful remembrance of him in our hearts, while we ever maintain his memory in the highest honor with our lips. To him, of a truth, it is that we owe the possession of invention, coloring, and execution, brought alike and altogether to that point of perfection for which few could have dared to hope; nor has any man ever aspired to pass before him.

And in addition to the benefits which this great master conferred on art, being as he was its best friend, we have the further obligation to him of having taught us by his life in what manner we should comport ourselves towards great men, as well as towards those of lower degree, and even towards the lowest. Nay, there was among his many extraordinary gifts one of such value and importance that I can never sufficiently admire it, and always think thereof with astonishment. This was the power

accorded to him by Heaven of bringing all who approached his presence
into harmony, an effect inconceivably surprising in our calling, and con-
trary to the nature of our artists.

Yet all, I do not say of the inferior grades only, but even those who lay
claim to be great personages (and of this humor our art produces im-
mense numbers), became as of one mind, once they began to labor in the
society of Raphael, continuing in such unity and concord that all harsh
feelings and evil dispositions became subdued and disappeared at the
sight of him, every vile and base thought departing from the mind be-
fore his influence. Such harmony prevailed at no other time than his
own. And this happened because all were surpassed by him in friendly
courtesy as well as in art; all confessed the influence of his sweet and gra-
cious nature, which was so replete with excellence, and so perfect in all
the charities, that not only was he honored by men, but even by the very
animals, who would constantly follow his steps and always loved him.

We find it related that, whenever any other painter, whether known to
Raphael or not, requested any design or assistance of whatever kind at
his hands, he would invariably leave his work to do him service. He con-
tinually kept a large number of artists employed, all of whom he assisted
and instructed with an affection which was rather as that of a father to
his children than merely as of an artist to artists. From these things it fol-
lowed that he was never seen to go to court but surrounded and accom-
panied, as he left his house, by some fifty painters, all men of ability and
distinction, who attended him thus to give evidence of the honor in
which they held him. He did not, in short, live the life of a painter, but
that of a prince.

Wherefore, oh art of Painting! well mightest thou for thy part then es-
teem thyself most happy, having, as thou hadst, one artist among thy sons
by whose virtues and talents thou wert thyself exalted to heaven. Thrice
blessed indeed may'st thou declare thyself, since thou hast seen thy disci-
ples, by pursuing the footsteps of a man so exalted, acquire the knowl-
edge of how life should be employed, and become impressed with the
importance of uniting the practice of virtue to that of art. Conjoined as
these were in the person of Raphael, their force availed to constrain the
greatness of Julius II and to awaken the generosity of Leo X, both of
whom, high as they were in dignity, selected him for their most intimate
friend, and treated him with every kind of familiarity; insomuch that by
means of the favor he enjoyed with them and the powers with which
they invested him, he was enabled to do the utmost honor to himself and
to art.

Most happy also may well be called those who, being in his service,
worked under his own eye; since it has been found that all who took
pains to imitate this master have arrived at a safe haven, and attained to a

respectable position. In like manner, all who do their best to emulate his labors in art will be honored on earth, as it is certain that all who resemble him in the rectitude of his life will receive their reward in heaven.

The following epitaph was written on Raphael by the Cardinal Bembo:

D. O. M.

RAPHAELI • SANCTO • JOAN • F • VRBINATI.

PICTORI EMINENTISS • VETERVMQ • AEMVLO,

CVIVS SPIRANTEIS PROPE IMAGINEIS

SI CONTEMPLERE,

NATVRAE • ATQVE ARTIS FOEDVS

FACILE INSPEXERIS,

IVLII II • ET LEONIS X • PONT • MAX.

PICTVRAE ET ARCHITECT • OPERIBVS

GLORIAM AVXIT.

VIXIT • AN • XXXVII • INTEGER • INTEGROS.

QVO • DIE NATVS EST, EO ESSE DESIIT.

VII • ID • APRIL • MDXX.

ILLE HIC • EST • RAPHAEL, TIMVIT • QVO • SOSPITE • VINCI

RERUM • MAGNA • PARENS, ET MORIENTE • MORI.[42]

The Count Baldassare Castiglione also wrote respecting the death of this master in the manner following:

Quod lacerum corpus medica sanaverit arte,
 Hippolytum, Stygiis et revocarit aquis;
Ad Stygias ipse est raptus Epidaurius undas;
 Sic precium vitae mors fuit artifici.
Tu quoque dum toto laniatam corpore Romam
 Componis miro, Raphael, ingenio;
Atque Urbis lacerum ferro, igni, annisque cadaver,
 Ad vitam, antiquum jam revocasque decus.
Movisti superum invidiam, indignataque mors est,
 Te dudum extinctis reddere posse animam.
Et quod longa dies paullatim aboleverat, hoc te
 Mortali spreta lege parare iterum.
Sic miser heu, prima cadis intercepte juventa;
 Deberi et morti nostraque, nosque mones.[43]

MICHELAGNOLO BVONAR. PIT.
SCVLTORE ET ARCHITET.

MICHELANGELO BUONARROTI
The Florentine Painter, Sculptor, and Architect
[1475–1564]

WHILE the best and most industrious artists were laboring, by the light of Giotto and his followers, to give the world examples of such power as the benignity of their stars and the varied character of their fantasies enabled them to command, and while desirous of imitating the perfection of Nature by the excellence of Art, they were struggling to attain that high comprehension which many call intelligence, and were universally toiling, but for the most part in vain, the Ruler of Heaven was pleased to turn the eyes of his clemency towards earth, and perceiving the fruitlessness of so many labors, the ardent studies pursued without any result, and the presumptuous self-sufficiency of men, which is farther from truth than is darkness from light, He resolved, by way of delivering us from such great errors, to send to the world a spirit endowed with universality of power in each art, and in every profession, one capable of showing by himself alone what is the perfection of art in the sketch, the outline, the shadows, or the lights, one who could give relief to Paintings, and with an upright judgment could operate as perfectly in Sculpture; nay, who was so highly accomplished in Architecture, also, that he was able to render our habitations secure and commodious, healthy and cheerful, well proportioned, and enriched with the varied ornaments of art.

The Almighty Creator was also pleased to accompany the above with the comprehension of the true Philosophy and the adornment of graceful Poesy, to the end that the world might select and admire in him an extraordinary example of blamelessness in life and every action, as well as of perfection in all his works: insomuch that he might be considered by us to be of a nature rather divine than human. And as the Supreme Ruler perceived that in the execution of all these sublime arts, Painting, Sculpture, and Architecture, the Tuscan genius has ever been raised high above all others, the men of that country displaying more zeal in study, and more constancy in labor, than any other people of Italy, so did he resolve to confer the privilege of his birth on Florence, as worthy above all other cities to be his country, and as justly meriting that the perfections of every art should be exhibited to the world by means of one who should be her citizen.

In the Casentino, therefore, and in the year 1475, a son was born, under a fated and happy star, to the Signor Lodovico di Lionardo Buonarroti Simoni, who, as it is said, was descended from the most noble and most ancient family of the Counts of Canossa, the mother being also a noble as well as excellent lady. Lodovico was that year Podestà, or Mayor of Chiusi-e-Caprese, near the Sasso della Verna, where St. Francis received the Stigmata, and which is in the diocese of Arezzo. The child was born on a Sunday, the 6th of March namely, at eight of the night, and the name he received was Michelangelo, because, without further consideration, and inspired by some influence from above, the father thought he perceived something celestial and divine in him beyond what is usual with mortals, as was indeed afterwards inferred from the constellations of his nativity, Mercury and Venus exhibiting a friendly aspect, and being in the second house of Jupiter, which proved that his works of art, whether as conceived in the spirit or performed by hand, would be admirable and stupendous.

His office, or Podesteria, having come to an end, Lodovico returned to Florence, or rather to the villa of Settignano, about three miles from that city, where he had a farm which he had inherited from his ancestors. The place is rich in stone, more especially in quarries of the *macigno,*[1] which are constantly worked by stone-cutters and sculptors, for the most part natives of the place, and here Michelangelo was given to the wife of a stone-cutter to be nursed. Wherefore, jesting with Vasari one day, Michelangelo once said, "Giorgio, if I have anything good in me, that comes from my birth in the pure air of your country of Arezzo, and perhaps also from the fact that, with the milk of my nurse, I sucked in the chisels and hammers wherewith I make my figures."

Lodovico had many children, and, as he possessed but slender revenues, he placed his sons as they grew up with wool and silk weavers. When Michelangelo had attained the proper age, he was sent to the school of learning kept by Messer Francesco of Urbino. But the genius of the boy disposing him to drawing, he employed his leisure secretly in that occupation, although reproached for it, and sometimes beaten by his father and other elders, they, perhaps, not perceiving his ability, and considering the pursuit he had adopted an inferior one and unworthy of their ancient family.

At this time Michelangelo formed a friendship with Francesco Granacci, who, although also but a boy, had placed himself with Domenico Ghirlandaio to learn the art of painting; and being fond of Michelangelo, Granacci supplied him daily with the designs of Ghirlandaio, who was then reputed one of the best masters, not in Florence only but through all Italy. The desire of Michelangelo for art thus increased from day to day, and Lodovico, finding it impossible to di-

vert him from his drawings, determined to try if he could not derive benefit from this inclination, and being advised by certain friends, he decided on placing him with Domenico Ghirlandaio.

Michelangelo was now fourteen years old. His life has been written, since this book of mine was first published, by one who affirms that, for want of sufficient intercourse with him, many things have been related by me which are not true, and others omitted which should have been told, more especially respecting this point of time;[2] Domenico Ghirlandaio, for example, being accused of base envy by the said writer, and declared to have given Michelangelo no assistance in his studies. But that this is indeed false may be shown by certain entries which Lodovico, the father of Michelangelo, wrote with his own hand in one of Domenico's books, which book is now in the possession of his heirs.

The words in question are these: "1488, I acknowledge and record, this 1st day of April, that I, Lodovico di Lionardo di Buonarroti have engaged Michelangelo my son to Domenico and David di Tommaso di Currado, for the three years next to come, under the following conditions: That the said Michelangelo shall remain with the above-named during all the said time, to the end that they may teach him to paint and to exercise their vocation, and that the above-named shall have full command over him, paying him in the course of these three years twenty-four florins, as wages, in the first six namely, in the second eight, and in the third ten, being in all ninety-six lire." Beneath this entry is the following, also written by Lodovico: "The above-named Michelangelo has received two florins in gold this sixteenth day of April. I, his father, Lodovico di Lionardo, having received twelve lire and twelve soldi on his account."

These entries I have copied from the book itself, to show that what I then wrote, as well as what I now propose to write, is the truth, nor do I know any one that has had more intercourse with Michelangelo than myself, or who has been more truly his friend or a more faithful servant to him than I have been. Neither do I believe that any man can show a greater number of letters by his hand than he has written to me, or any written with more affection. This digression I have made for the sake of truth, and it shall suffice for all the rest of the Life. We will now return to the history.

The ability as well as the person of Michelangelo increased to such an extent, that Domenico was amazed thereat, since it appeared to him that Michelangelo not only surpassed his other disciples, of whom he had a large number, but even equalled himself, who was the master. One day for example, as one of Domenico's disciples had copied with the pen certain draped female figures by Ghirlandaio, Michelangelo took that sheet, and with a broader pen he passed over one of those women with new

lines drawn in the manner which they ought to have been in order to produce a perfect form. A wonderful thing it was then to see the difference of the two, and to observe the ability and judgment of one who, though so young, had yet so much boldness as to correct the work of his master. This sheet I now keep as a relic, having obtained it from Granacci, to put it in my book of designs with other drawings by Michelangelo. And in the year 1550, being in Rome, I showed it to Michelangelo, who knew it at once and was rejoiced to see it again, but remarked, out of his modesty, that he knew more when he was a boy than at that time when he had become old.

Now it chanced that when Domenico was painting the great chapel of Santa Maria Novella, he one day went out, and Michelangelo then set himself to draw the scaffolding, with some trestles, the various utensils of the art, and some of those young men who were then working there. Domenico having returned and seen the drawing of Michelangelo exclaimed, "This boy knows more than I do," standing in amaze at the originality and novelty of manner which the judgment imparted to him by Heaven had enabled a mere child to exhibit. For the work was, in truth, rather such as might have fully satisfied the artist, had it been performed by the hand of an experienced master. But if it was possible to Michelangelo to effect so much, that happened because all the gifts of nature were in him enhanced, and strengthened by study and exercise, wherefore he daily produced works of increased excellence, as began clearly to be made manifest in the copy which he made of a plate engraved by the German Martino,[3] and which procured him a very great name. This engraving was one which had just then been brought to Florence, and represented St. Anthony tormented by devils. It is a copperplate, and Michelangelo copied it with a pen in such a manner as had never before been seen. He painted it in colors also; and, the better to imitate the strange forms of some among those devils, he bought fish which had scales somewhat resembling those on the demons; in this painted copy also he displayed so much ability that his credit and reputation were greatly increased thereby.

He likewise copied plates from the hands of many old masters, in such sort that the copies could not be distinguished from the originals, for Michelangelo had tinged and given the former an appearance of age with smoke and other things, so that he had made them look old, and when they were compared with the original, no difference could be perceived. All this he did that he might give his own copies in the place of the old works, which he desired to possess from the hand of their authors, admiring in them the excellence of art and seeking to surpass them when engaged in the execution of his own works, by which he acquired a very great name.

Lorenzo the Magnificent retained at that time the sculptor Bertoldo at his garden on the Piazza, not so much as curator and guardian of the many fine antiquities collected there at great cost, as because Lorenzo desired to form a good School of Painters and Sculptors; wherefore he wished that the students should have for their chief and guide the above-named Bertoldo, who had been a disciple of Donatello. It is true that he was old and could not work, but he was an able and highly reputed artist, not only for the ability and diligence which he had shown in polishing the bronze pulpits of Donatello, his master, but also for the numerous casts in bronze of battle pieces and other smaller works, which he had executed for himself, and in the treatment of which there was then no one in Florence who could surpass him.

Having a true love for art, Lorenzo grieved that in his time there should be found no great and noble sculptors who could take rank with the many painters of high fame and merit then existing, and he resolved, as I have said, to form a School. To this end he requested Domenico Ghirlandaio to send to the garden any youth whom he might find disposed to the study of sculpture, when Lorenzo promised to provide for his progress, hoping thus to create, so to speak, such artists as should do honor to his city.

By Domenico, therefore, were presented to him among others, Michelangelo and Francesco Granacci, as excellent for this purpose. They went to the garden accordingly, and found there Torrigiano, a youth of the Torrigiani family, who was executing in clay certain figures in full relief which Bertoldo had given him. Seeing this, and aroused to emulation, Michelangelo began to attempt the same; when Lorenzo, perceiving his fine abilities, conceived great hope of his future success, and he, much encouraged, took a piece of marble, after having been there but a few days, and set himself to copy the head of an old Faun from the antique. The nose of the original was much injured, the mouth was represented laughing, and this Michelangelo, who had never before touched the chisel or marble, did in fact copy in such a manner that the Magnifico was utterly amazed.

Lorenzo, furthermore, perceived that the youth had departed to a certain extent from the original, having opened the mouth according to his own fancy, so that the tongue and all the teeth were in view. He then remarked in a jesting manner to the boy, "Thou shouldst have remembered that old folks never retain all their teeth; some of them are always wanting." Michelangelo, who loved that Signore as much as he respected him, believed in his simplicity that Lorenzo had spoken in earnest, and no sooner saw his back turned than he broke out a tooth, filing the gum in such sort as to make it seem that the tooth had dropped out. He then waited impatiently the return of the Signore. When the latter saw what

was done, he was much amazed, and often laughed at the circumstance with his friends, to whom he related it as a marvel, resolving meanwhile to assist Michelangelo and put him forward.

He sent for Lodovico, therefore, requesting the latter to entrust the youth to his care, and saying that he would treat him as a son of his own, to which Lodovico consented gladly; when Lorenzo gave orders that a room in his own house should be prepared for Michelangelo, and caused him to eat at his own table with his sons and other persons of worth and quality. This was in the second year of Michelangelo's engagement with Domenico, and when the youth was fifteen or sixteen years old. He remained in the house of Lorenzo the Magnificent four years, to the death of Lorenzo namely, which took place in 1492. During all this time, Michelangelo received from the Magnifico an allowance of five ducats per month, and was furthermore presented for his gratification with a violet-colored mantle. His father, likewise, had an office in the Customs conferred on him. But indeed all the young men who studied in the garden received stipends of greater or less amount from the liberality of that magnificent and most noble citizen, being constantly encouraged and rewarded by him while he lived.

At this time and by the advice of Politiano, Michelangelo executed a Battle of Hercules with the Centaurs in a piece of marble given to him by Lorenzo, and which proved to be so beautiful that whosoever regards this work can scarcely believe it to have been that of a youth, but would rather suppose it the production of an experienced master. It is now in the house of his family,[4] and is preserved by Michelangelo's nephew Lionardo, as a memorial of him, and as an admirable production, which it certainly is. Not many years since, this same Lionardo had a basso-relievo of Our Lady, also by Michelangelo, and which he kept as a memorial of his uncle; this is of marble and somewhat more than a braccio high. Our artist was still but a youth when it was done, and designing to copy the manner of Donatello therein, he was succeeded to such an extent that it might be taken for a work by that master, but exhibits more grace and higher powers of design than he possessed. That basso-relievo was afterwards given by Lionardo to Duke Cosimo, by whom it is highly valued, and the rather as there is no other basso-relievo by his hand.

But to return to the garden of Lorenzo the Magnificent. Of this place, adorned with valuable antiques and excellent pictures, collected there for study and pleasure, Michelangelo had the keys, and proved himself more careful as well as more prompt in all his actions than any of the other young men who frequented the place, giving proof of boldness and animation in all that he did. He labored at the pictures of Masaccio in the Carmine also for many months, copying them with so much judgment that the artists were amazed thereat. But envy now increased with his

fame. Respecting this we find it related that Torrigiano, having formed an intimacy with Michelangelo, and becoming envious of his distinction in art, one day, when jeering our artist, struck him so violent a blow in the face that his nose was broken and crushed in a manner from which it could never be recovered, so that he was marked for life; whereupon Torrigiano was banished from Florence.

On the death of Lorenzo, Michelangelo returned to his father's house in great sorrow for his loss. Here he bought a large piece of marble from which he made a Hercules, four braccia high, which was much admired and, after having remained for some years in the Strozzi Palace, was sent to France, in the year of the siege, by Giovan Battista della Palla. It is said that Piero de' Medici, the heir of Lorenzo, who had been long intimate with Michelangelo, often sent for him when about to purchase cameos or other antiques, and that, one winter, when much snow fell in Florence, he caused Michelangelo to make in his court a Statue of Snow, which was exceedingly beautiful. His father, seeing him thus honored for his abilities, and beginning to perceive that he was esteemed by the great, now began to clothe him in a more stately manner than he had before done.

For the church of Santo Spirito, in Florence, Michelangelo made a Crucifix in wood, which is placed over the lunette of the high altar. This he did to please the prior, who had given him a room wherein he dissected many dead bodies, and, zealously studying anatomy, began to give evidence of that perfection to which he afterwards brought his design.

Some weeks before the Medici were driven from Florence, Michelangelo had gone to Bologna, and thence to Venice, having remarked the insolence and bad government of Piero, and fearing that some evil would happen to himself as a servant of the Medici. But finding no means of existence in Venice, he returned to Bologna, where he had the misfortune to neglect the countersign, which it was needful to take at the gate, if one desired to go out again, Messer Giovanni Bentivogli having then commanded that all strangers who had not this protection should be fined fifty Bolognese lire. This fine Michelangelo had no means of paying, but he having, by chance been seen by Messer Giovan Francesco Aldovrandi, one of the sixteen members of the government, the latter, making him tell his story, delivered him from that peril, and kept him in his own house for more than a year.

One day, Aldovrandi took him to see the tomb of San Domenico, which is said to have been executed by the old sculptors, Giovanni Pisano[5] and Maestro Niccolò dell'Arca. Here, as it was found that two figures, of a braccio high, a San Petronio, and an Angel holding a candlestick namely, were wanting, Aldovrandi asked Michelangelo if he had courage to undertake them, when he replied that he had; and having se-

lected a piece of marble, he completed them in such sort that they are the best figures of the work; and he received thirty ducats for the two. He remained, as we have said, a year with Aldovrandi, and to have obliged him would have remained longer, the latter being pleased with his ability in design, and also with his Tuscan pronunciation in reading, listening with pleasure while Michelangelo read the works of Dante, Petrarch, Boccaccio, and other Tuscan authors.

But our artist, knowing that he was losing time at Bologna, returned to Florence, where he executed a San Giovanni in marble for Lorenzo di Pier Francesco de' Medici; after which he commenced a Sleeping Cupid, also in marble and the size of life. This being finished was shown as a fine work, by means of Baldassare del Milanese to Pier-Francesco, who having declared it beautiful, Baldassare then said to Michelangelo, "I am certain that, if you bury this statue for a time, and then send it to Rome so treated, that it may look old, you may get much more for it than could be obtained here"; and this Michelangelo is said to have done, as indeed he very easily could, that or more, but others declare that it was Milanese who, having taken this Cupid to Rome, there buried it, and afterwards sold it as an antique to the Cardinal San Giorgio for two hundred crowns. Others again affirm that the one sold to San Giorgio was made by Michelangelo for Milanese, who wrote to beg that Pier-Francesco would give Michelangelo thirty crowns, declaring that sum to be all he had obtained for it, thus deceiving both him and Michelangelo.

Cardinal San Giorgio had, meanwhile, discovered that the Cupid had been made in Florence, and having ascertained the whole truth, he compelled Milanese to return the money and take back the statue, which, having fallen into the hands of the Duke Valentino, was presented by him to the Marchioness of Mantua, who took it to that city, where it is still to be seen. San Giorgio, meanwhile, incurred no small ridicule and even censure in the matter, he not having been able to appreciate the merit of the work; for this consisted in its absolute perfection, wherein, if a modern work be equal to the ancient, wherefore not value it as highly? For is it not a mere vanity to think more of the name than the fact? But men who regard the appearance more than the reality are to be found in all times. The reputation of Michelangelo increased greatly from this circumstance, and he was invited to Rome, where he was engaged by the Cardinal San Giorgio, with whom he remained nearly a year, but that prelate, not understanding matters of art, did nothing for him.

At that time a barber of the Cardinal, who had been a painter, and worked tolerably in fresco, but had no power of design, formed an acquaintance with Michelangelo, who made him a cartoon of St. Francis receiving the Stigmata, and this was painted by the barber very carefully.

It is now in the first chapel of the church of San Pietro, in Montorio. The ability of Michelangelo was, however, clearly perceived by Messer Jacopo Galli, a Roman gentleman of much judgment, who commissioned him to make a Cupid, the size of life, with a Bacchus of ten palms high; the latter holds a cup in the right hand, and in the left he has the skin of a Tiger, with a bunch of grapes which a little Satyr is trying to nibble away from him. In this figure the artist has evidently brought to mingle beauties of a varied kind, laboring to exhibit the bold bearing of the youth united to the fulness and roundness of the female form; and herein did he prove himself to be capable of surpassing the statues of all other modern masters.

During his abode in Rome, Michelangelo made so much progress in art that the elevation of thought he displayed, with the facility with which he executed works in the most difficult manner, was considered extraordinary by persons practiced in the examination of the same, as well as by those unaccustomed to such marvels, all other works appearing as nothing in the comparison with those of Michelangelo. These things caused the Cardinal Saint Denis, a Frenchman, called Rovano,[6] to form the desire of leaving in that renowned city some memorial of himself by the hand of so famous an artist. He therefore commissioned Michelangelo to execute a Pietà of marble in full relief; and this, when finished, was placed in San Pietro, in the chapel of Santa Maria della Febbre namely, at the temple of Mars.[7] To this work I think no sculptor, however distinguished an artist, could add a single grace, or improve it by whatever pains he might take, whether in elegance and delicacy, or force, and the careful perforation of the marble; nor could any surpass the art which Michelangelo has here exhibited.

Among other fine things may be remembered—to say nothing of the admirable draperies—that the body of the Dead Christ exhibits the very perfection of research in every muscle, vein, and nerve; nor could any corpse more completely resemble the dead than does this. There is besides a most exquisite expression in the countenance, and the limbs are affixed to the trunk in a manner that is truly perfect. The veins and pulses, moreover, are indicated with so much exactitude that one cannot but marvel how the hand of the artist should in a short time have produced such a work, or how a stone, which just before was without form or shape, should all at once display such perfection as nature can but rarely produce in the flesh.

The love and care which Michelangelo had given to this group were such that he there left his name—a thing he never did again for any work—on the cincture which girdles the robe of Our Lady. For it happened one day that Michelangelo, entering the place where it was erected, found a large assemblage of strangers from Lombardy there, who

were praising it highly. One of these, asking who had done it, was told, "Our Hunchback of Milan";[8] hearing which, Michelangelo remained silent, although surprised that his work should be attributed to another. But one night he repaired to Saint Peter's with a light and his chisels to engrave his name, as we have said, on the figure, which seems to breathe a spirit as perfect as her form and countenance, speaking as one might think in the following words:

> Beauty and goodness, piety and grief,
> Dead in the living marble. Weep not thus;
> Be comforted, time shall awake the dead.
> Cease then to weep with these unmeasured tears,
> Our Lord, and thine, thy father, son, and spouse,
> His daughter, thou his mother and sole bride.

From this work, then, Michelangelo acquired great fame. Certain dullards do indeed affirm that he has made Our Lady too young, but that is because they fail to perceive the fact that unspotted maidens long preserve the youthfulness of their aspect, while persons afflicted as Christ was do the contrary. The youth of the Madonna, therefore, does but add to the credit of the master.

Michelangelo now received letters from friends in Florence advising him to return, since he might thus obtain that piece of marble which Pier Soderini, then Gonfaloniere of the city, had talked of giving to Leonardo da Vinci, but was now preparing to present to Andrea dal Monte Sansovino, an excellent sculptor who was making many efforts to obtain it. It was difficult to get a statue out of it without the addition of several pieces; and no one, Michelangelo excepted, had the courage to attempt it; but he, who had long wished for the block, no sooner arrived in Florence than he made every effort to secure the same. This piece of marble was nine braccia high, and, unluckily, a certain Maestro Simone da Fiesole[9] had commenced a colossal figure thereon. But the work had been so grievously injured that the superintendents had suffered it to remain in the house of works at Santa Maria del Fiore for many years, without thinking of having it finished, and there it seemed likely to continue.

Michelangelo measured the mass anew to ascertain what sort of figure he could draw from it, and accommodating himself to the attitude demanded by the injuries which Maestro Simone had inflicted on it, he begged it from the superintendents and Soderini, by whom it was given to him as a useless thing, they thinking that whatever he might make of it must needs be preferable to the state in which it then lay, and wherein it was totally useless to the fabric. Michelangelo then made a model in wax, representing a young David, with the sling in his hand, as the ensigns of the Palace,[10] and to intimate that, as he had defended his people

and governed justly, so they who were then ruling that city should defend it with courage and govern it uprightly.

He commenced his labors in the house of works, at Santa Maria del Fiore, where he formed an enclosure of planks and masonry, which surrounded the marble. There he worked perpetually, permitting no one to see him until the figure was brought to perfection. The marble, having been much injured by Simone, did not entirely suffice to the wishes of Michelangelo, who therefore permitted some of the traces of Simone's chisel to remain. These may be still perceived, and certainly it was all but a miracle that Michelangelo performed when he thus resuscitated one who was dead.

When the statue was completed, there arose much discussion as to how it should be transported to the Piazza Signoria, but Giuliano da Sangallo, and Antonio his brother, made a strong frame-work of wood, and, suspending the figure to this by means of ropes, to the end that it might be easily moved, they thus got it gradually forward with beams and windlasses, and finally placed it on the site destined to receive the same. The knot of the rope which held the statue was made in such sort that it ran easily, but became tighter as the weight increased, a beautiful and ingenious arrangement, which I now have in my book of designs: a secure and admirable contrivance it is for suspending great weights.

When the statue was set up, it chanced that Soderini, whom it greatly pleased, came to look at it while Michelangelo was retouching it at certain points, and told the artist that he thought the nose too short. Michelangelo perceived that Soderini was in such a position beneath the figure that he could not see it conveniently, yet to satisfy him, he mounted the scaffold with his chisel and a little powder gathered from the floor in his hand; when striking lightly with the chisel, but without altering the nose, he suffered a little of the powder to fall, and then said to the Gonfaloniere who stood below, "Look at it now." "I like it better now," replied Piero; "you have given it life." Michelangelo then descended, not without compassion for those who desire to appear good judges of matters whereof they know nothing.

The work fully completed, Michelangelo gave it to view, and truly may we affirm that this statue surpasses all others, whether ancient or modern, Greek or Latin. Neither the Marforio at Rome, the Tiber and the Nile in the Belvedere, nor the Giants of Monte Cavallo can be compared with it, to such perfection of beauty and excellence did our artist bring his work. The outline of the lower limbs is most beautiful. The connexion of each limb with the trunk is faultless, and the spirit of the whole form is divine. Never since has there been produced so fine an attitude, so perfect a grace, such beauty of head, feet, and hands; every part is replete with excellence; nor is so much harmony and admirable art to

be found in any other work. He that has seen this, therefore, need not care to see any production besides, whether of our own times or those preceding it. For this statue, Michelangelo received from Soderini the sum of four hundred crowns. It was placed on its pedestal in the year 1504, and the glory resulting to the artist therefrom became such as to induce the Gonfaloniere to order a David in bronze, which, when Michelangelo had completed, was sent to France.

About the same time our artist commenced, but did not finish, two Medallions in marble, one for Taddeo Taddei, which is now in his house; the other for Bartolommeo Pitti, which was presented to Luigi Guicciardini by Fra Miniato Pitti of Monte Oliveto, his great friend, and whose acquaintance with painting as well as with cosmography and other sciences is very extensive. These works also obtained high approbation, as did likewise a marble statue of St. Matthew, which Michelangelo then sketched for the superintendents of works at Santa Maria del Fiore; and which, merely sketched as it is, gives clear evidence of the perfection to which the finished performance would have attained, and serves well to teach the sculptor how figures are to be drawn from the marble in such sort that they shall not prove abortions, and also in a manner which leaves to the judgment all fitting opportunity for such alterations and ameliorations as may subsequently be demanded.

About this time Michelangelo cast a Madonna in bronze for certain Flemish merchants called Moscheroni, persons of much account in their own land, and who paid him a hundred crowns for his work, which they sent into Flanders.[11] The Florentine citizen, Agnolo Doni, likewise desired to have some production from the hand of Michelangelo, who was his friend, and he being as we have before said, a great lover of fine works in art, whether ancient or modern. Wherefore, Michelangelo began a circular painting of Our Lady for him; she is kneeling, and presents the Divine Child, which she holds in her arms, to Joseph, who receives him to his bosom. Here the artist has finely expressed the perfection of delight with which the mother regards the beauty of her Son, and which is clearly manifest in the turn of her head and fixedness of her gaze. Equally obvious is her wish that this contentment shall be shared by that pious old man who receives the Babe with infinite tenderness and reverence. Nor did this suffice to Michelangelo, since the better to display his art, he has assembled numerous undraped figures in the background of his picture, some upright, some half recumbent, and others seated. The whole work is, besides, executed with so much care and finish that of all his pictures, which indeed are but few, this is considered the best.

When the picture was completed, Michelangelo sent it, still uncovered, to Agnolo Doni's house, with a note demanding for it a payment of sixty ducats. But Agnolo, who was a frugal person, declared that a

large sum to give for a picture, although he knew it was worth more, and told the messenger that forty ducats which he gave him was enough. Hearing this, Michelangelo sent back his man to say that Agnolo must now send a hundred ducats or give the picture back. Whereupon Doni, who was pleased with the work, at once offered the sixty first demanded. But Michelangelo, offended by the want of confidence exhibited by Doni, now declared that, if he desired to have the picture, he must pay a hundred and forty ducats for the same, thus compelling him to give more than double the sun first required.

When the renowned painter, Leonardo da Vinci, was painting in the Great Hall of the Council, as we have related in his Life, Piero Soderini, who was then Gonfaloniere, moved by the extraordinary ability which he perceived in Michelangelo, caused him to be entrusted with one portion of that hall, when our artist finished a façade (whereon he represented the War of Pisa) in competition with Leonardo. For this work, Michelangelo secured a room in the hospital of the Dyers at Sant'Onofrio; and here he commenced a very large cartoon, but would never permit any one to see it in progress. The work exhibited a vast number of nude figures bathing in the river Arno, as men do in hot days, and at this moment the enemy is heard to be attacking the Camp. The soldiers, who were bathing, spring forth in haste to seize their arms, which many are portrayed by the divine hand of Michelangelo as hurriedly doing. Some are affixing their cuirasses or other portions of their armor, while others are already mounted and commencing the battle on horseback.

Among the figures in this work was that of an old man who, to shelter himself from the heat, has wreathed a garland of ivy round his head, and, seated on the earth, is laboring to draw on his stockings, but is impeded by the humidity of his limbs. Hearing the sound of the drums and the cries of the soldiers, he is struggling violently to get one of the stockings on; the action of the muscles and distortion of the mouth evince the zeal of his efforts, and prove him to be toiling all over, even to the points of his feet. There were drummers, and other figures also, hastening to the Camp with their clothes in their arms, all displaying the most singular attitudes; some were standing, others kneeling or stooping forward, or half suspended between all these positions; some were falling down, others springing high in the air and exhibiting the most difficult foreshortenings. There were innumerable groups besides, all sketched in different manners, some of the figures being merely outlined in charcoal, others shaded off, some with the features clearly defined, and lights thrown in, Michelangelo desiring to show the extent of his knowledge in that vocation.

And of a truth the artists were struck with amazement, perceiving, as

they did, that the master had in that cartoon laid open to them the very highest resources of art. Nay, there are some who still declare that they have never seen anything equal to that work, either from his own hand or that of any other; and they do not believe that the genius of any other man will ever more attain to such perfection. Nor does this appear to be exaggerated, since all who have designed from and copied that cartoon (as it was the habit for both natives and strangers to do) have finally become excellent in Art.

As proof of this may be cited Aristotile da Sangallo, the friend of Michelangelo, Ridolfo Ghirlandaio, Raphael of Urbino, Francesco Granaccio, Baccio Bandinelli, and the Spaniard, Alonzo Berughetta. These were followed by Andrea del Sarto, Franciabigio, Jacopo Sansovino, Il Rosso, Marturino, Lorenzetti, and Tribolo, who was at that time but a child, with Jacopo da Pontormo, and Perino del Vaga, all of whom were excellent masters.

The cartoon having thus become a study for artists, was removed to the Great Hall of the Medici Palace. But this caused it to be left with too little caution in the hands of the artists; insomuch that, at the time of Giuliano's sickness, and when no one was thinking of such things, it was torn to pieces, and scattered over different places; among others in Mantua, where certain fragments are still to be seen in the house of M. Uberto Strozzi, a Mantuan gentleman, by whom they are preserved with great reverence, as indeed they well deserve to be, for in looking at them one cannot but consider them rather of divine than merely human origin.

The fame of Michelangelo had now, by his Pietà, by the colossal statue in Florence, and by his cartoon, become so much bruited abroad that in 1503, when our artist was about twenty-nine years old, he was invited to Rome with great favor by Julius II, who had succeeded Alexander VI on the papal throne. Here His Holiness, who had caused one hundred crowns to be paid to Michelangelo by his agents for travelling expenses, commissioned him to prepare his sepulchral monument, but he had been several months in Rome before he was directed to make any commencement. Finally, it was determined that a design which he had made for that tomb should be adopted; and this work also bore ample testimony to the genius of the master, seeing that, in beauty, magnificence, superb ornament, and wealth of statues, it surpassed every other sepulchre, not excepting the Imperial tombs, or those of antiquity. Encouraged by this success, Pope Julius ultimately determined to rebuild the church of San Pietro, for the purpose of worthily installing the monument above mentioned within it.

Michelangelo then set hand to his work with great spirit, repairing for that purpose, with two of his disciples, to Carrara, to superintend the ex-

cavation of the marbles, having first received one thousand crowns in Florence from Alamanno Salviati on account of those works.

In those mountains, then, he spent eight months without receiving any additional stipend or supplies of any kind, amusing himself meanwhile by planning all manner of immense figures to be hewn in those rocks, in memorial of himself, as did certain of the ancients, invited thereto by the vast masses before him. Having finally selected all that he required, he loaded them on ships, which he despatched to Rome, where they filled the entire half of the Piazza, which is towards Santa Caterina, and the whole space between the church and the corridor leading to the Castello, where Michelangelo had his studio, and where he prepared the statues and all other things needful for the tomb. And to the end that His Holiness might come conveniently to see the artist at work, there was a drawbridge constructed between the corridor and the studio, a circumstance which gave rise to so close an intimacy that the favorable notice thus bestowed on Michelangelo, having awakened great envy among the artists of his own calling, occasioned him much vexation and even persecution. Of this work, Michelangelo finished four statues and commenced eight others, either during the life or after the death of Pope Julius; and as the arrangements made for this work give proof of extraordinary powers of invention, we will here describe the principal features thereof.

For the greater magnificence of the effect, it was decided that the tomb should be wholly isolated, a passage remaining entirely around it, the fabric being eighteen braccia in extent on two sides, and twelve on the other two, the dimensions thus presenting a square and a half. A range of niches passed entirely around it, and these were interchanged by terminal figures, clothed from the middle upwards, and bearing the first cornice on their heads, while to every one was bound a captive in a strange distorted attitude, the feet of these prisoners resting on the projection of a socle or basement. These captives were intended to signify the Provinces subjugated by Pope Julius, and brought by him into the obedience of the apostolic Church. There were other statues, also bound, and these represented the Fine Arts and Liberal Sciences, which were thus intimated to be subjected to death no less than was that Pontiff by whom they had been so honorably protected. On the angles of the first cornice were four large figures, representing Active Life and Contemplative Life, with St. Paul and Moses.

Above the cornice, the fabric gradually diminished, exhibiting a frieze of stories in bronze, with figures of angels in the form of boys, and other ornaments around them. And over all, at the summit of the work, were two figures, one of which, having a smiling aspect, represented Heaven, and bore a bier on the shoulder. The other represented Cybele, who ap-

peared to be weeping at her misfortune of being compelled to remain in a world deprived of all genius by the death of so great a man, while Heaven was smiling because his soul had passed to the celestial regions. The fabric was so arranged that a free passage remained between the niches, the spectator passing in or out by the ends of the quadrangular edifice, which was of an oval form, and resembled a temple in that part destined to receive the dead body of Julius. Finally, there were to be added forty statues in marble, to say nothing of the numerous stories, angels, and other ornaments, or of the richly carved cornices and architectural decorations.

To forward the progress of the work, moreover, Michelangelo had arranged that a portion of the marbles should be sent to Florence, where it was his custom to pass a part of the summer, by way of avoiding the malaria of Rome, and where he did in fact complete the several pieces required for one entire side of the monument. In Rome also, he finished two of the captives, which were indeed divine, with some other statues so good that better have never been seen. But as these figures were not used for the tomb, Michelangelo afterwards gave the two captives above mentioned to the Signor Roberto Strozzi, in whose house he lay sick, and by whom they were sent to King Francis. They are now at Cevan, in France. Our artist likewise commenced eight statues in Rome with five in Florence, and finished a figure of Victory, with a prisoner lying beneath her feet. This is now in the possession of Duke Cosimo, to whom the group was presented by Lionardo, the nephew of Michelangelo, and who has placed it in the Great Hall of his palace painted by Vasari.

The Moses, in marble, five braccia high, was also completed by Michelangelo, and never will any modern work approach the beauty of this statue; nay, one might with equal justice affirm that, of the ancient statues, none is equal to this. Seated in an attitude of imposing dignity, the Lawgiver rests one arm on the Tables, and with the other restrains the flowing beard that, descending softly, is so treated as to exhibit the hair (which presents so great a difficulty in sculpture) soft, downy, and separated hair from hair in such sort as might appear to be impossible, unless the chisel had become a pencil. The countenance is of the most sublime beauty, and may be described as that of a truly sacred and most mighty prince. But to say nothing of this, while you look at it, you would almost believe the figure to be on the point of demanding a veil wherewith to conceal that face, the beaming splendor of which is so dazzling to mortal gaze. So well, at a word, has the artist rendered the divinity which the Almighty had imparted to the most holy countenance of that great Lawgiver.

The draperies also are most effectively raised from the marble ground,

and are finished with beautiful foldings of the edges. The muscles of the arms, with the anatomical development and nerves of the hands, are exhibited to the utmost perfection; and the same may be said of the lower limbs, which, with the knees and feet, are clothed in admirably appropriate vestments. At a word, the sculptor has completed his work in such sort that Moses may be truly affirmed more than ever now to merit his name of the friend of God. Nay, the Jews are to be seen every Saturday, or on their Sabbath, hurrying like a flight of swallows, men and women, to visit and worship this figure, not as a work of the human hand but as something divine.

Having at length made all his preparations, and approached the conclusion of the same, Michelangelo erected one portion of the tomb, the shorter sides namely, at San Pietro in Vincoli. It is said that, while he was employed on that operation, a certain part of the marbles arrived from Carrara, where they had been suffered to remain; and as it was necessary to pay those who had delivered them, our artist repaired to the Pope, as was his custom. But finding His Holiness engaged with important intelligence just received from Bologna, he returned home, and paid with his own money, expecting to receive the order for it from the Pontiff immediately. He went to the palace a few days after therefore, but was again desired to wait and take patience, by a groom of the chambers, who affirmed that he was forbidden to admit him.

A Bishop who stood near observed to the attendant that he was perhaps unacquainted with the person of the man whom he refused to admit; but the groom replied that he knew him only too well. "I, however," he added, "am here to do as my superiors command, and to obey the orders of the Pope." Displeased with this reply, the master departed, bidding the attendant tell His Holiness when next he should inquire for Michelangelo that he had gone elsewhere. He then returned to his dwelling, and ordering two of his servants to sell all his movables to the Jews, and then follow him to Florence, he took post-horses that same night and left Rome.

Arrived at Poggibonsi, a town on the road to the first-named city, in the Florentine territory, and consequently in a place of safety, the master made a halt. Five couriers followed him one after another with letters from the Pope and orders to convey him back, but no entreaty and no threat of the disgrace that would await him in case of refusal would induce him to return. He was, however, finally prevailed on to write in reply, when he declared that His Holiness must excuse his returning to his presence, which he was resolved not to do, seeing that he, Julius, had driven him forth like a worthless person, which was a mode of treatment that his faithful service had not merited. He added that the Holy Father might seek elsewhere for some one who should serve him better.

Having reached Florence, Michelangelo set himself to complete the cartoon for the Great Hall, at which he worked during the three months of his stay in the city, Piero Soderini, the Gonfaloniere, being anxious to see it finished. The Signoria meanwhile received three briefs, with the request that Michelangelo might be sent back to Rome. But the latter, doubting what this eagerness of the Pope might portend, entertained, as it is said, some intention of going to Constantinople, there to serve the Grand Seigneur, who sought to engage him, by means of certain Franciscan monks, for the purpose of constructing a bridge to connect Constantinople with Pera. But the Gonfaloniere laboring to induce Michelangelo to repair to the Pope instead, and the master still refusing, Soderini at length prevailed on him to do so by investing him with the character of Ambassador from the Florentine Republic, and recommending him also to the care of his brother, the Cardinal Soderini, whom he charged to introduce Michelangelo to His Holiness. He then sent the artist to Bologna, in which city Pope Julius had already arrived from Rome.

But there are some who ascribe Michelangelo's departure from Rome, and his disputes with the Pope, to the following cause. The artist would never suffer any one to see his works while in progress, but he suspected that his people sometimes permitted strangers to inspect them in his absence. And one day when the Pope, having bribed Michelangelo's assistants, was entering the chapel of his uncle, Pope Sixtus, which he was causing our artist to paint, as will be related hereafter, the latter, who had that day hidden himself, because suspicious of his young men as we have said, rushed upon him with a plank of the scaffolding, and not perceiving whom it was that he was turning out, drove His Holiness forth in a fury. Let it suffice, however, that for one cause or another, Michelangelo fell into discord with the Pope, and then, beginning to fear for his safety, departed from Rome, as we have said.

Arrived at Bologna, his feet were scarcely out of the stirrups before he was conducted by the servants of the Pontiff to the presence of His Holiness, who was at the Palace of the Sixteen. He was accompanied by a Bishop, sent by Cardinal Soderini, who was himself too ill to fulfil that office. Having reached the presence, Michelangelo knelt down before His Holiness, who looked askance at him with an angry countenance, and said, "Instead of coming to us, it appears that thou hast been waiting till we should come to thee," in allusion to the fact that Bologna is nearer to Florence than is Rome. But with a clear voice and hands courteously extended, Michelangelo excused himself, having first entreated pardon, admitting that he had acted in anger, but adding that he could not endure to be thus ordered away; if he had been in error, His Holiness would doubtless be pleased to forgive him.

Now the Bishop who had presented Michelangelo, thinking to aid his excuses, ventured to remark that such men as he were always ignorant, knowing, and being worth, nothing whatever, once out of their vocation. But this threw the Pope into such a rage that he fell upon the Bishop with a stick which he had in his hand, exclaiming, "'Tis thou that art the ignoramus, with the impertinencies thou art pouring forth, and which are such as we should ourselves not think of uttering." He then caused the Bishop to be driven out by the usher in waiting, with blows of his fist.[12] This offender having departed, the Pope, his rage thus cooled upon the prelate, bestowed his benediction on Michelangelo, who was detained in Bologna by numerous gifts and promises, His Holiness ultimately giving him the commission for a statue in bronze, being a portrait of that Pontiff himself, five braccia high. In this work, our artist displayed high powers of art; the attitude is majestic and graceful, the draperies are rich and magnificent, while the countenance exhibits animation, force, resolution, and an imposing dignity.

This statue was placed in a niche over the gate of San Petronio, and it is said that while Michelangelo was engaged therewith he received a visit from the distinguished goldsmith and painter Francia, who had heard much of his fame and works, but had never seen any one of them. Measures were accordingly taken for obtaining permission, and Francia had leave to see the statue above mentioned. He was much struck by the knowledge of art displayed, but on being asked what he thought, he replied that it was a fine casting and a beautiful material. Hearing which, Michelangelo supposed that he was praising the bronze rather than the artist, and remarked to Francia: "I am as much obliged for it to Pope Julius, who gave it me, as you are to the shopkeepers, who supply you with your colors for painting." He furthermore added angrily, in the presence of all the gentlemen standing near, that Francia was a dunce. It was on this occasion that Michelangelo remarked to a son of Francia, who was a very beautiful youth, "The living figures made by thy father are handsomer than those that he paints."

Among the gentlemen present at this visit was one who asked Michelangelo which was the larger, the statue of that Pope or a pair of oxen. "That depends on what the animals may be," replied the artist; "for if they are Bolognese oxen, it is certain that our Florentines are not such great brutes as those are." The statue was finished in the clay model before Pope Julius left Bologna for Rome, and His Holiness went to see it. But the right hand being raised in an attitude of much dignity, and the Pontiff, not knowing what was to be placed in the left, inquired whether he were anathematizing the people or giving them his benediction. Michelangelo replied that he was admonishing the Bolognese to behave themselves discreetly, and asked His Holiness to decide whether it were

not well to put a book in the left hand. "Put a sword into it," replied Pope Julius, "for of letters I know but little."

The Pontiff left a thousand crowns in the bank of M. Antonmaria da Lignano for the purpose of completing the figure; and after Michelangelo had labored at it for sixteen months, it was placed over the door of San Petronio, as we have before mentioned when describing the size of the statue. The work was eventually destroyed by the Bentivogli, and the bronze was sold to the Duke Alfonso of Ferrara, who made a piece of artillery called the Julia; of the fragments, the head only was preserved, and this is now in the Duke's Guardaroba.

The Pope having returned to Rome, and Michelangelo being still engaged with the statue, Bramante, who was the friend and kinsman of Raphael, and but little disposed to befriend Michelangelo, availed himself of his absence to influence the mind of Julius, whom he saw to be much inclined to works of sculpture. And hoping so to contrive that, on the return of Michelangelo, His Holiness should no longer think of completing the sepulchre, Bramante suggested that for a man to prepare his tomb during life was an evil augury and a kind of invitation to death. At a word, the Pontiff was persuaded to employ Michelangelo, on his return, in the painting of that chapel, which had been constructed in the palace and at the Vatican in memory of his uncle, Pope Sixtus; Bramante and the other rivals of Michelangelo, thinking they should thus detach him from his sculpture, in which they saw that he was perfect, and throw him into despair, they being convinced that by compelling him to paint in fresco they should also bring him to exhibit works of less perfection (he having but little experience in that branch of art), and thus prove himself inferior to Raphael. Or even supposing him to succeed in the work, it was almost certain that he would be so much enraged against the Pope as to secure the success of their purpose, which was to rid themselves of his presence.

When Michelangelo returned to Rome, therefore, he found Julius no longer disposed to have the tomb finished, but desiring that Michelangelo should paint the ceiling of the chapel. This was a great and difficult labor, and our artist, aware of his own inexperience, did all he could to excuse himself from undertaking the work, proposing at the same time that it should be confided to Raphael. But the more he refused, the more Pope Julius insisted; impetuous in all his desires, and stimulated by the competitors of Michelangelo, more especially by Bramante, he was on the point of making a quarrel with our artist, when the latter, finding His Holiness determined, resolved to accept the task.

The Pope then ordered Bramante to prepare the scaffolding, which the latter suspended by ropes, perforating the ceiling for that purpose. Seeing this, Michelangelo inquired of the architect how the holes thus

made were to be filled in when the painting should be completed; to which Bramante replied that they would think of that when the time came, and that it could not be done otherwise. But Michelangelo, perceiving that the architect was either incapable or unfriendly towards himself, went at once to the Pope, whom he assured that such a scaffolding was not the proper one, adding that Bramante did not know how to construct it; and Julius, in the presence of Bramante, replied that Michelangelo might construct it himself after his own fashion. The latter then erected his scaffolding on props in such a manner that the walls were not injured. And this method has since been pursued by Bramante and others, who were hereby taught the best way in which preparations for the execution of pictures on ceilings and other works of the kind could be made. The ropes used by Bramante, and which Michelangelo's construction had rendered needless, the latter gave to the poor carpenter, by whom the scaffolding was rebuilt, and who sold them for a sum which enabled him to make up the dowry of his daughter.

Michelangelo now began to prepare the cartoons for the ceiling. His Holiness giving orders to the effect that all the paintings executed on the walls by older masters in the time of Pope Sixtus, should be destroyed.[13] It was furthermore decided that Michelangelo should receive fifteen thousand ducats for the work, an estimation of its value which was made by Giuliano da Sangallo. But the extent of the work now compelled Michelangelo to seek assistance. He therefore sent for men to Florence, resolving to prove himself the conquerer of all who had preceded him and to show modern artists how drawing and painting ought to be done. The circumstances of the case became a stimulus to his exertions, and impelled him forward, not for his own fame only, but for the welfare of Art also. He had finished the cartoons, but deferred commencing the frescoes until certain of the Florentine painters, who were his friends, should arrive in Rome, partly to decrease his labor by assisting in the execution of the work, but also in part to show him the processes of fresco painting, wherein some of them were well experienced. Among these artists were Granacci, Giuliano Bugiardini, Jacopo di Sandro, and the elder Indaco, with Agnolo da Donnino, and Aristotile da Sangallo.

These masters having reached the city, the work was begun, and Michelangelo caused them to paint a portion by way of specimen; but what they had done was far from approaching his expectations or fulfilling his purpose, and one morning he determined to destroy the whole of it. He then shut himself up in the chapel, and not only would he never again permit the building to be opened to them, but he likewise refused to see any one of them at his house. Finally therefore, and when the jest appeared to them to be carried too far, they returned, ashamed and mortified, to Florence. Michelangelo then made arrangements for perform-

ing the whole work himself, sparing no care nor labor, in the hope of bringing the same to a satisfactory termination, nor would he ever permit himself to be seen, lest he should give occasion for a request to show the work; wherefore there daily arose, in the minds of all around him, a more and more earnest desire to behold it.

Now Pope Julius, always greatly enjoyed watching the progress of the works he had undertaken, and more than ever desired to inspect anything that was purposely concealed from him. Thus it happened that he one day went to see the chapel, as we have related, when the refusal of Michelangelo to admit him occasioned that dispute which caused the master to leave Rome, as before described.

Michelangelo afterwards told me the cause of this refusal, which was as follows. When he had completed about one-third of the painting, the prevalence of the north wind during the winter months had caused a sort of mould to appear on the pictures. And this happened from the fact that in Rome the plaster, made of travertine and pozzolana, does not dry rapidly, and while in a soft state is somewhat dark and very fluent, not to say watery. When the wall is covered with this mixture, therefore, it throws out an efflorescence arising from the humid saltness which bursts forth; but this is in time evaporated and corrected by the air. Michelangelo was, indeed, in despair at the sight of these spots, and refused to continue the work, declaring to the Pope that he could not succeed therein; but His Holiness sent Giuliano da Sangallo to look at it, and he, telling our artist whence these spots arose, encouraged him to proceed by teaching him how they might be removed.

When the half was completed, Pope Julius, who had subsequently gone more than once to see the work (mounting ladders for that purpose with Michelangelo's aid), and whose temper was hasty and impatient, would insist on having the pictures opened to public view without waiting until the last touches had been given thereto. And the chapel was no sooner thrown open than all Rome hastened thither, the Pope being the first; he had, indeed, not patience to wait until the dust caused by removing the scaffold had subsided. Then it was that Raphael, who was very prompt in imitation, having seen this work, instantly changed his manner, and to give proof of his ability immediately executed the Prophets and Sibyls in the church of the Pace. Bramante also then labored to convince Pope Julius that he would do well to confide the second half of the chapel to Raphael. Hearing of this, Michelangelo complained to the Pope of Bramante, enumerating at the same time, without sparing him, many faults in the life, as well as errors in the works, of that architect; of the latter, indeed, he did himself become the corrector at a subsequent period. But Julius, who justly valued the ability of Michelangelo, commanded that he should continue the work, judging

from what he saw of the first half that our artist would be able to improve the second materially. And the master accordingly finished the whole, completing it to perfection in twenty months, without having even the help of a man to grind the colors.[14]

It is true that he sometimes complained of the manner in which the Pope hastened forward the work, seeing that he was thereby prevented from giving it the finish which he would have desired to bestow, His Holiness constantly inquiring when it would be completed. On one occasion, therefore, Michelangelo replied, "It will be finished when I shall have done all that I believe required to satisfy Art." "And we command," rejoined the Pontiff, "that you satisfy our wish to have it done quickly," adding, finally, that if it were not at once completed he would have him, Michelangelo, thrown headlong from the scaffolding.

Hearing this, our artist, who feared the fury of the Pope, and with good cause, desisted instantly without taking time to add what was wanting, and took down the remainder of the scaffolding, to the great satisfaction of the whole city, on All Saints' Day, when Pope Julius went into that chapel to sing mass. But Michelangelo had much desired to retouch some portions of the work *a secco,* as had been done by the older masters who had painted the stories on the walls. He would also gladly have added a little ultramarine to some of the draperies, and gilded other parts to the end that the whole might have a richer and more striking effect.

The Pope, too, hearing that these things were still wanting, and finding that all who beheld the chapel praised it highly, would now fain have had the additions made. But as Michelangelo thought reconstructing the scaffold too long an affair, the pictures remained as they were, although the Pope, who often saw Michelangelo, would sometimes say, "Let the chapel be enriched with bright colors and gold; it looks poor." When Michelangelo would reply familiarly, "Holy Father, the men of those days did not adorn themselves with gold; those who are painted here less than any, for they were none too rich; besides which, they were holy men, and must have despised riches and ornaments."

For this work Michelangelo received from the Pope, in various payments, the sum of three thousand crowns, and of these he may have spent twenty-five in colors. He worked with great inconvenience to himself, having to labor with his face turned upwards, and injuring his eyes so much in the progress of the work that he could neither read letters nor examine drawings for several months afterwards, except in the same attitude of looking upwards. I can myself bear full testimony to the effects of such work, having painted the ceilings of five large apartments in the palace of Duke Cosimo; and if I had not made a seat with a support for the head, and occasionally laid down to my work, I should never have been able to finish them. As it was, I weakened my sight, and injured my

head so much that I still feel the bad effects of that toil, and I wonder Michelangelo endured it so well. But his zeal for his art increased daily, while the knowledge and improvement, which he constantly perceived himself to make, encouraged him to such a degree that he grudged no labor, and was insensible to all fatigue.

The division of the work in the chapel is after this manner: There are five corbels on each side thereof, and one on the wall at each end. On these are figures of the Prophets and Sibyls; and in the center of the ceiling is the History of the World from the Creation to the Deluge, with the Inebriation of Noah. On the lunettes are the Genealogy of Christ. In these compartments, Michelangelo has used no perspective foreshortenings, nor has he determined any fixed point of sight, but has rather accommodated the division to the figures than the figures to the division. He has been satisfied with imparting the perfection of design to all his forms whether nude or draped; and this he has done effectually, insomuch that a finer work never has been, and never can be executed; nor will it be without difficulty that its excellence shall be imitated.

Of a truth, this chapel, as thus painted by his hand, has been and is the very light of our art, and has done so much for the progress thereof that it has sufficed to illumine the world, which had lain in darkness for so many hundreds of years. Nay, no man who is a painter now cares to seek new inventions, attitudes, draperies, originality, and force of expression, or variety in the modes of representation, seeing that all the perfection which can be given to each of these requisites in a work of this character by the highest powers of art are presented to him here, and have been imparted to this work by Michelangelo. Every beholder who can judge of such things now stands amazed at the excellence of the figures, the perfection of the foreshortenings, the astonishing roundness of the outlines, and the grace and flexibility, with the beautiful truth of proportion, which are seen in the exquisite nude forms here exhibited. And the better to display the resources of his art, Michelangelo has given them of every age, with varieties of expression and form as well as of countenance and feature; some are more slender, others fuller. The beautiful attitudes also differ in all; some are seated, others are in motion; while others again are supporting festoons of oak leaves and acorns, adopted as the device of Pope Julius,[15] and denoting that at that time, and under his government, there flourished the age of gold, seeing that Italy was not then in the condition of trouble and misery which she has since endured. Between them the figures bear medallions in relief, to imitate bronze and gold, the subjects being stories taken from the Book of Kings.

In addition to all this, and furthermore to display the perfection of his art as well as the greatness of God, Michelangelo likewise depicted a story exhibiting the division of the Light from the Darkness. The

majesty of the Supreme Creator is displayed in the awful dignity of his attitude; self-sustained, He stands with extended arms, and a countenance at once expressive of power and love. The second picture, evincing admirable judgment and ability, portrays the Almighty when He creates the Sun and Moon. His figure is here supported by numerous Angels in the form of Children, and there is infinite power of art displayed in the foreshortening of the arms and legs. Next follows the Benediction of the Earth, and the Creation of the animal races. Here the Creator is represented as a foreshortened figure on the ceiling, and this form appears to turn with you into whatever part of the chapel you may proceed. The same figure recurs in the story of the division of the Water from the Earth. Both are exceedingly beautiful; nay, they are such, and of invention so perfect, that no hand but that of the most divine Michelangelo could have been worthy to produce them.

Then next comes the Creation of Adam, God the Father being here borne by a group of Angels, represented by little boys of very tender age entirely nude. Yet these appear to sustain the weight, not of one figure only, but of the whole world, so imposing is the majesty of that most venerable form, and such is the effect produced by the peculiar manner of the movement imparted thereto. One arm is thrown around certain of the children, as if he were supporting himself thereby, and the other is extended towards Adam, a figure of extraordinary beauty, whether as regards the outline or details, and of such character that one might believe it to have been just newly created by the great Father of all, rather than the mere production of the mind and pencil even of such a man as Michelangelo.

The story beneath this is the Creation of our mother Eve; and herein are the two nude forms of our first parents, the one held captive in a sleep so profound that it resembles death, the other just awakened to the most animated life by the Benediction of God. And the pencil of this most admirable artist here has shown clearly not only the difference between sleep and wakeful vitality, but also the appearance of stability and firmness, which is presented, humanly speaking, by the Divine Majesty.

There next follows the story of Adam, yielding to the persuasions of a figure, half woman and half serpent, and taking his death as well as our own in the forbidden fruit; he is furthermore exhibited in this picture as driven, with Eve, out of Paradise. And here, in the figure of the Angel, is displayed with grandeur and dignity the execution of the mandate pronounced by an incensed Deity; while in Adam we have regret for his fault, together with the fear of death; and in the woman that shame, abasement, and desire to obtain pardon, which are expressed by the compression of the arms, the clasping of the hands, the sinking of the head towards the bosom, and the turn of her imploring countenance towards

the Avenging Angel: all showing, likewise, that her fear of God's justice predominates over her hope in the Divine Mercy.

Not less beautiful is the story of the Sacrifice of Cain and Abel, wherein there are figures in great variety of attitudes; one brings wood, another is bent down and seeking to kindle the fire into flame by his breath; some are cutting up the victim; and these figures are painted with all the care and forethought which distinguish the others.

Equally conspicuous are the art and judgment of the master in the story of the Deluge; wherein there are numerous dead corpses mingled with other figures, all betraying the terrors inspired by the fearful events of those days, and seeking in various manners to escape with their lives. Among these heads are many, the expression of which proves them to be in despair of redeeming their days from destruction; fear, horror, and disregard of all around them are legibly impressed on their features. In others again, compassion is seen to prevail over their fears, and they are aiding each other to attain the summit of a rock, by means of which they hope to escape the coming floods. There is one figure in particular, which is laboring to save another, already half dead, and the action of which is so perfect that nature herself could show nothing more life-like.

Nor would it be easy adequately to describe the story of Noah, lying inebriated before his sons, one of whom derides the helplessness of the Patriarch, while the other two throw their mantles over him. This is a work of incomparable excellence; it could be surpassed by none but the master himself, and as if encouraged by what he there perceived himself to have accomplished, he subsequently prepared for yet greater efforts, proving his superiority in art, more than ever indisputably, by the figures of the five Sibyls and seven Prophets, each of which is more than five braccia high. The variety of attitude, the beauty of the draperies, and every other detail, in short, exhibits astonishing invention and judgment; nay, to those who comprehend the full significance of these figures, they appear little less than miraculous.

The Prophet Jeremiah is seated with the lower limbs crossed, and holding the beard with one hand, the elbow of that arm being supported by the knee, while the other hand is laid on his lap. The head is bent down in a manner which indicates the grief, the cares, the conflicting thoughts, and the bitter regrets which assail the Prophet, as he reflects on the condition of his people. There is evidence of similar power in the two boys behind him; and in the first Sibyl, that nearest the door namely, in whom the artist has proposed to exhibit advanced age; and not content with enveloping the form in draperies, has been anxious to show that the blood has become frozen by time, and has furthermore placed the book which she is reading very close to her eyes, by way of intimating that her power of sight is weakened by the same cause.

After the first Sibyl follows the Prophet Ezekiel, a very old man, whose attitude is singularly noble and beautiful. He too is much wrapped in draperies; and holding a scroll of his prophecies in the one hand, he raises the other, and turns his head at the same time, as in the act of preparing to utter high and holy truths. Behind him are two boys, who hold his books. The Sibyl following Ezekiel is in an attitude exactly opposite to that of the Erythraean Sibyl first described. She is holding her book at great distance, that is to say, and is about to turn a leaf. Her limbs are crossed over each other. She is deeply pondering on what she is preparing to write, and a boy standing behind her is blowing at a brand of wood, with which he is about to light her lamp. The countenance of this figure has an expression of extraordinary beauty. The draperies and head-dress are finely arranged, and the arms, which are of equal perfection with the rest of the person, are nude. Next to this Sibyl is the Prophet Joel, who is profoundly absorbed in attention to a scroll which he holds in his hand and is reading with an expression of countenance which proves him to be perfectly satisfied with what he finds therein, and has all the effect that could be produced by the face of a living man, whose thoughts are firmly riveted on some question of moment.

Over the door of the chapel is the aged Prophet Zacharias, who, seeking through the written page for something which he cannot find, remains with one foot lifted, and the other dropped down, while the anxiety and eagerness with which he seeks what he requires, and cannot discover, have caused him to forget the inconvenience of the painful attitude which he has taken. The figure has the aspect of a beautiful old age; the form is somewhat full, and the drapery, of few and simple folds, is admirably arranged. The Sibyl opposite to Zacharias, and turning towards the altar, is putting forward certain writings, and with the boys, her attendants, deserves equal praise with those before described.

But he who examines the Prophet Isaiah shall see features truly borrowed from nature herself, the real mother of art. One of the limbs is crossed over the other. He has laid one hand within a book at the place where he has been reading, is resting the elbow of the other arm on the volume; and leaning his cheek on his hand, he replies to the call on his attention, made by one of the boys standing behind him, by a mere turn of the head, without disturbing himself further. From this figure, at a word, the observer, who studies it well in every part, may acquire all the rules demanded to constitute the guiding precepts of a good painter. The Sibyl next to the Prophet Isaiah is of great age, but also of extraordinary beauty. Her attitude, as she zealously studies the book before her, is singularly graceful, as are those of the boys who are ministering around her.

But not imagination herself could add anything to the beauty of a figure representing the Prophet Daniel, and which is that of a youth, who,

writing in a great book, is copying certain passages from other writings with indescribable eagerness of attention. The weight of the book is supported by a boy who stands before the Prophet, and the beauty of that child is such that no pencil, by whatever hand it may be borne, will ever equal it. As much may be said for the Libyan Sibyl, who, having completed the writing of a large book taken from other volumes, is on the point of rising with a movement of feminine grace, and at the same time shows the intention of lifting and putting aside the book, a thing so difficult that it would certainly have proved impossible to any other than the master of this work.

And what shall I say of the four pictures which adorn the angles of the corbels on this ceiling? In the first is David, exerting all his boyish force in the conquest of the gigantic Philistine, and depriving him of his head, to the utter amazement of numerous Soldiers, who are seen around the Camp. Equally beautiful are the attitudes in the picture of Judith, which occupies the opposite angle, and wherein there is the lifeless body of Holofernes, so recently decapitated that it seems yet to palpitate with life. Judith meanwhile is placing the head of the General in a basket, which is borne by an old servant, on her head. The handmaid is tall of stature, and is stooping to facilitate the due arrangement of her burden by the hands of her mistress. She is endeavoring at the same time to uphold, and also to conceal, what she bears, being impelled to the last-mentioned act by the sound arising in the tent from the body of Holofernes, which, although dead, has drawn up an arm and a leg, thereby causing the sound in question. The face of the servant betrays her fear of some one entering from the Camp, as well as the terror caused her by the dead body, a picture which is certainly most remarkable.

But more beautiful and more divine than even this, or indeed than any of those yet described, is the story of the Serpents of Moses, which Michelangelo has placed above the left side of the altar, and wherein there are represented the dropping of the Serpents on the people, their stings and the bites they inflict, as is also that Serpent of Brass, which Moses himself erected on a staff. In this picture the different modes in which death seizes the sufferers is rendered vividly apparent; many of those not yet dead are obviously hopeless of recovery; others die convulsed with the fear and horror which that acrid venom has caused them. Many are throwing up their arms in agony; some appear to be paralysed; unable to move, they await their coming doom; and in other parts are beautiful heads, giving utterance to cries of desperation, and cast backwards in the horrors of hopeless anguish.

Those who, looking towards the Serpent erected by Moses, perceive their pains to be alleviated are also admirably depicted. They turn their eyes on their deliverer with infinite emotion. And one of these groups

may more particularly be specified, that of a Woman namely, supported by one who sustains her in such a manner that the effectual assistance rendered by him who gives aid is no less manifest than is the pressing need of her who endures that fear and pain.

The story of Ahasuerus, reclining in his bed and causing the Chronicles to be read, has equal merit. The figures are very fine, and among them are three men, seated at a table eating, who represent the deliberation of those who sought to free the Jewish people and to compass the death of Haman. The figure of the latter is likewise seen foreshortened in a very extraordinary manner, the stake which supports his person and the arm which he stretches before him appearing not to be painted but really round and in relief, as does also the leg, which he projects outward, and the portions of the body which are bent inward. This is indeed a figure which, among all beautiful and difficult ones, is certainly the most beautiful and most difficult.

But it would lead me too far were I to describe all the admirable compositions to be admired in these stories; the Genealogy of the Patriarchs, for example, commencing with the sons of Noah, for the purpose of showing the descent of Our Savior Christ, and in which we have an indescribable variety of figures, vestments, expressions, and fantasies of various kinds, original as well as beautiful. All bear the impress of genius; many of the figures exhibit the most remarkable foreshortenings; and every one of the details is most admirable. Who could behold without astonishment the powerful figure of Josiah, which is the last in the chapel, and where, by the force of art, the vaulting, which in fact does here spring forward, is compelled by the bending attitude of that figure to assume the appearance of being driven backwards and standing upright? Such is the knowledge of design here displayed.

Oh, truly fortunate age, and thrice happy artists! Well may I call you so, since in your day you have been permitted to dispel the darkness of your eyes by the light of so illustrious a luminary and behold all that was difficult rendered clear to you by so wonderful and admirable a master! The renown of *his* labors renders *you* also known, and increases your honor, the rather, as his hand has removed that bandage which you had before the eyes of your minds, previously full of darkness, and has delivered the truth from that falsehood which was overshadowing your intellect. Be thankful to heaven therefore, and strive to imitate Michelangelo in all things.

When this work was completed, all the world hastened from every part to behold it, and having done so, they remained astonished and speechless. The Pope rewarded Michelangelo with rich gifts, and was encouraged by the success of this undertaking to project still greater works. Wherefore, the artist would sometimes remark, in respect to the extraor-

dinary favors conferred on him, that he saw well the Pope did esteem his abilities, and if he should now and then inflict some rudeness by a peculiar way of proving his amicable feeling towards him, yet he always cured the wound by gifts and distinguished favors.

On one occasion, for example, when Michelangelo requested leave from His Holiness to pass the festival of San Giovanni in Florence, and begged also to have some money for that purpose, Pope Julius said, "Well! but when will this chapel be finished?" "When I can, Holy Father," replied our artist, and the Pope, who had a staff in his hand, struck Michelangelo therewith, exclaiming, "When I can—when I can! I'll make thee finish it, and quickly, as thou shalt see." But the master had scarcely returned to his house to prepare for his journey to Florence, before the Pontiff sent Cursio, his chamberlain, with five hundred crowns to pacify him, having some fear lest Michelangelo should play him a prank, as he did before. The chamberlain excused Pope Julius moreover, declaring that these things must all be considered favors and marks of kindness. And as Michelangelo knew the disposition of the Pontiff, and was, after all, much attached to His Holiness, he laughed at what had happened, the more readily as things of this kind always turned to his profit, and he saw well that the Pope did his utmost to retain him as his friend.

The chapel being finished, Pope Julius, before he felt the approaches of death, commanded the Cardinals Santi Quattro and Aginense, his nephews, to see that his tomb (when he died) should be constructed after a simpler design than that at first adopted. And now Michelangelo set himself anew to the work of that sepulchre with all the better will, as he hoped at length to bring it to a conclusion, unimpeded by those fatiguing obstacles which had hitherto assailed him. But he was tormented, on the contrary, with increasing vexations and turmoils in that matter, which cost him more labor and trouble than any other work of his whole life; nay, for some time it caused him to be charged with ingratitude towards that Pontiff by whom he had been so highly valued and favored. Having returned to the chapel, Michelangelo worked at it continually, and arranged a part of the designs for the fronts of the fabric; but envious Fortune would not permit this monument to have a conclusion in harmony with the magnificence of its commencement.

Pope Julius died, and on the creation of Pope Leo that work was laid aside, for this Pontiff, no less enterprising and splendid in his undertakings than Julius, was anxious to leave in his native city of Florence, of which he was the first Pope, some great memorial of himself, and of that divine artist who was his fellow citizen. At a word, he desired to complete some one of those admirable constructions which only a great prince, such as he was, can attempt. And as he therefore commissioned Michelangelo to execute the façade of the church of San Lorenzo in

Florence, which had been built by the house of Medici, the tomb of
Pope Julius was of necessity left unfinished, Leo not contenting himself
with the counsels or even the designs of Michelangelo, but requiring him
to act as superintendent of the works. Yet the master did not yield with-
out such resistance as was possible to him, alleging his engagements with
the Cardinals Santi Quattro and Aginense, to whom he was already
pledged in respect of the tomb. But His Holiness replied that he was not
to think of them, he (the Holy Father) having provided for that matter,
and in effect he did procure the release of Michelangelo by those
prelates, promising them that he should continue his preparations for the
sepulchre, by working at the figures destined for it in Florence, as he had
previously done. All this was, nevertheless, much to the dissatisfaction of
the Cardinals, as well as Michelangelo, who left Rome with tears in his
eyes.

Much talk, nay, innumerable discussions, arose on the subject of the
works to be executed in Florence also, seeing that an undertaking like
that of the façade of San Lorenzo ought certainly to have been divided
among many persons. In regard to the architecture more especially, sev-
eral artists repaired to Rome, applying to the Pope for the direction
thereof. Baccio d'Agnolo, Antonio da Sangallo,[16] Andrea and Jacopo
Sansovino, with the graceful Raphael, having all made designs for that
building. The latter did indeed afterwards visit Florence for a similar
purpose.

But Michelangelo determined to prepare the model himself, and not
to accept any guide, or permit any superior in the matter of the archi-
tecture. This refusal of all aid was nevertheless the occasion of such
delays that neither by himself nor by others was the work put into op-
eration, and the masters above-named returned, hopeless of a satisfactory
conclusion, to their accustomed avocations. Michelangelo then repaired
to Carrara, but first he was empowered to receive a thousand crowns
from Jacopo Salviati, and presented himself for that purpose accordingly.
Now it chanced that Jacopo was at that moment shut up in his room, en-
gaged on matters of importance with certain of the citizens; but
Michelangelo would not wait for an audience, and departed, without
saying a word, for Carrara. Hearing of the master's arrival in Florence, but
not seeing him, Salviati sent the thousand crowns after him to Carrara,
the messenger requiring that a receipt should be given to him. But
Michelangelo replied that the money was for expenses on the Pope's ac-
count and not his own, adding that the messenger might carry it back if
he chose to do so, but that he, Michelangelo, was not in the habit of giv-
ing receipts and acquittances for others; whereupon the man became
alarmed, and returned to Jacopo Salviati without any receipt.

While Michelangelo was at Carrara, where he was causing marbles to

be excavated for the tomb of Pope Julius, which he proposed ultimately to complete, as well as for the façade of San Lorenzo, he received from Pope Leo a letter to the effect that there were marbles, of equal beauty and excellence with those of Carrara, to be found in the Florentine dominions, at Serravezza namely, on the summit of the highest mountain in the Pietra Santa, called Monte Altissimo. Now Michelangelo was already aware of that circumstance; but it seems he would not attend to it, perhaps because he was the friend of the Marchese Alberigo, Lord of Carrara, or it might have been because he thought the great distance to be passed over would cause loss of time, as indeed it did. He was nevertheless compelled to go to Serravezza, although protesting that the difficulty and expense would be greatly increased thereby, as proved to be the case in the beginning. But the Pope would not hear a word of objection.

A road had then to be constructed for many miles through the mountains, and for this rocks were to be hewn away, while it was needful to drive piles, in marshy places, many of which intervened. Michelangelo thus lost several years in fulfilling the Pope's desire. But finally he procured five columns of fine proportion from these quarries, one of them being now on the Piazza of San Lorenzo, in Florence, the others lie on the shore. Another result of the matter was to make the Marchese Alberigo a bitter enemy of Michelangelo, although the latter was so little to blame.

Other marbles, besides the columns above-named, were subsequently procured at Serravezza, where they have been now lying more than thirty years. But Duke Cosimo has given orders for the completion of the road, of which there are still two miles to make, over ground very difficult to manage, when the transport of marbles is in question. But there is also another quarry, which was discovered at that time by Michelangelo, and which yields excellent marble, proper for the completion of many a noble undertaking. He has likewise found a mountain of excessively hard and very beautiful varicolored marble in the same place of Serravezza, and situate beneath Stazema, a villa constructed amidst those hills, where Duke Cosimo has formed a paved road more than four miles long, for the purpose of bringing the marbles to the sea-shore.

But to return to Michelangelo, who had now again repaired to Florence. Losing much time, first in one thing and then in another, he made a model, among other things, for those projecting and grated windows with which are furnished the rooms at the angle of the Palazzo Vecchio, in one of which Giovanni da Udine executed the paintings and stucco-work which are so much and so deservedly extolled. He also caused blinds, in perforated copper, to be made by the goldsmith Piloto, but after his own designs, and very admirable they certainly are. Michelangelo consumed many years as we have said, in the excavation

of marbles. It is true that he prepared models in wax and other requisites for the great undertakings with which he was engaged at the same time but the execution of these was delayed until the monies appropriated by the Pontiff for that purpose had been expended in the wars of Lombardy. And at the death of Leo, the works thus remained incomplete, nothing having been accomplished but the foundations of the façade, and the transport of a great column from Carrara to the Piazza di San Lorenzo.

The death of Pope Leo X completely astounded the arts and artists, both in Rome and Florence; and while Adrian VI ruled, Michelangelo employed himself in the last-named city with the sepulchre of Julius. But when Adrian was dead, and Clement VII elected in his place, the latter proved himself equally desirous of establishing memorials to his fame in the arts of sculpture, painting, and architecture, as had been Leo and his other predecessors. It was at this time, 1525, that Giorgio Vasari, then a boy, was taken to Florence by the Cardinal of Cortona, and there placed to study art with Michelangelo. But the latter having been summoned to Rome by Pope Clement, who had commenced the library of San Lorenzo, with the new sacristy, wherein he proposed to erect the marble tombs of his forefathers, it was determined that Giorgio should go to Andrea del Sarto, before Michelangelo's departure, the master himself repairing to the workshop of Andrea, for the purpose of recommending the boy to his care.

Michelangelo then proceeded to Rome without delay, being much harassed by the repeated remonstrances of Francesco Maria, Duke of Urbino,[17] who complained of the artist greatly, saying that he had received sixteen thousand crowns for the tomb, yet was loitering for his own pleasure in Florence without completing the same. He added threats to the effect that, if Michelangelo did not finish his work, he, the Duke, would bring him to an evil end. Arrived in Rome, Pope Clement, who would gladly have had the master's time at his own command, advised him to require the regulation of his accounts from the agents of the Duke, when it seemed probable that they would be found his debtors rather than he theirs. Thus then did that matter remain; but the Pope and Michelangelo taking counsel together of other affairs, it was agreed between them that the sacristy and new library of San Lorenzo in Florence should be entirely completed.

The master thereupon, leaving Rome, returned to Florence, and there erected the Cupola[18] which we now see, and which he caused to be constructed in various orders. He then made the goldsmith Piloto prepare a very beautiful ball of seventy-two facets. While he was erecting his cupola, certain of his friends remarked to him that he must be careful to have his lantern very different from that of Filippo Brunelleschi. To

which Michelangelo replied, "I can make a different one easily; but as to making a better, that I cannot do."

He decorated the inside of the sacristy with four tombs, to enclose the remains of the fathers of the two Popes, Lorenzo the elder and Giuliano his brother, with those of Giuliano the brother of Leo, and of Lorenzo his nephew.[19] Desiring to imitate the old sacristy by Filippo Brunelleschi, but with new ornaments, he composed a decoration of a richer and more varied character than had ever before been adopted, either by ancient or modern masters. The beautiful cornices, the capitals, the bases, the doors, the niches, and the tombs themselves were all very different from those in common use, and from what was considered measure, rule, and order by Vitruvius and the ancients, to whose rules he would not restrict himself. But this boldness on his part has encouraged other artists to an injudicious imitation, and new fancies are continually seen, many of which belong to *grottesche* rather than to the wholesome rules of ornamentation.

Artists are nevertheless under great obligations to Michelangelo, seeing that he has thus broken the barriers and chains whereby they were perpetually compelled to walk in a beaten path, while he still more effectually completed this liberation and made known his own views in the library of San Lorenzo, erected at the same place. The admirable distribution of the windows, the construction of the ceiling, and the fine entrance of the vestibule can never be sufficiently extolled. Boldness and grace are equally conspicuous in the work as a whole, and in every part; in the cornices, corbels, the niches for statues, the commodious staircase, and its fanciful divisions—in all the building, at a word, which is so unlike the common fashion of treatment, that every one stands amazed at the sight thereof.

About this time Michelangelo sent his disciple, Pietro Urbino of Pistoia, to Rome, there to execute a figure of Christ on the Cross, which is indeed a most admirable work. It was afterwards erected beside the principal chapel in the Minerva by M. Antonio Metelli.

Then followed the sack of Rome and the exile of the Medici from Florence; and in this change, those who governed the city, resolving to rebuilt the fortifications, made Michelangelo commissary-general of the whole work.

In that capacity he prepared numerous designs, adding much to the defences of the city, and more especially surrounding the hill of San Miniato with bastions. These he did not form in the usual manner, of turf, wood, and bundles of faggots, but first constructed a basement of oak, chestnut, and other strong materials, using rough bricks very carefully levelled. He had previously been despatched by the Signoria of Florence to Ferrara, there to inspect the fortifications of artillery and mu-

nitions of Duke Alfonso I, when he received many proofs of favor from that noble, who begged the master to execute some work for him at his leisure; which Michelangelo promised to do.

Having returned to Florence, he proceeded with the fortifications of the city, and although impeded by numerous engagements, he yet contrived to paint the picture of a Leda for the Duke of Ferrara. This work, which was in tempera, proved to be a divine performance, as will be related in due time. He also continued secretly to labor at the statues for the tombs in San Lorenzo. Michelangelo remained about six months at San Miniato, hastening forward the defences of the heights, seeing that the city would have been lost, had the enemy made himself master of that point; he consequently devoted the most zealous attention to the works. The before-mentioned sacristy was also making progress, and Michelangelo occupied a portion of his time in the execution of seven statues for that place, some of which he completed wholly, others only in part. In these, as well as in the architecture of the tombs, all are compelled to admit that he has surpassed every artist in all the three vocations. Among the statues, either rough-hewn, or finished in marble, by Michelangelo for that sacristy, is one of Our Lady. This is a seated figure with the limbs crossed, the Infant Christ being placed astride on the uppermost, and turning with an expression of ineffable sweetness towards the mother, as if entreating for the breast; while the Virgin, holding him with one hand and supporting herself with the other, is bending forward to give it him. The figures are not finished in every part, yet, in the imperfection of what is merely sketched, there clearly appears the perfection which is to be the final result.

But still more did he surprise all beholders by the tombs of the Dukes Giuliano and Lorenzo de' Medici, in which he appears to have proceeded on the conviction that earth alone would not suffice to give an appropriate burial-place to their greatness. He would therefore have other powers of the world to take part, and caused the statues to be placed over the sarcophagus in such rich sort as to overshadow the same, giving to the one Day and Night namely, and to the other the Dawn and the Twilight. All these statues are beautiful, whether in form or attitude, while the muscular development is treated with so much judgment that, if the Art of Sculpture were lost, it might by their means be restored to all its pristine lustre.

The statues of those princes, in their armor, also make part of the ornaments; Duke Lorenzo, thoughtful and reflective, with a form of so much beauty that eyes of mortal could see nothing better; and Duke Giuliano, haughty of aspect, but with the head, the throat, the setting of the eyes, the profile of the nose, the chiseling of the mouth, and the hair so truly divine, as are also the hands, arms, knees and feet, with all be-

sides, indeed, accomplished by our artist in this place, that the spectator can never be satisfied with gazing, and finds it difficult to detach his eyes from these groups. And, of a truth, he who shall examine the beauty of the buskins and cuirass must believe it to be celestial rather than of this world.

But what shall I say of the Aurora?—a nude female form, well calculated to awake deep melancholy in the soul, and to make the Art of Sculpture cast down her chisel. Her attitude shows her to have hastily risen from her bed, while she is still heavy with sleep. But in thus awakening, she had found the eyes of that great prince closed in death; wherefore she turns in bitter sorrow, bewailing, as an evidence of the great suffering she endures, her own unchangeable beauty. Or what shall I say of the Night?—a statue not rare but unique. Who, in any period of the world's history, has ever seen statues, ancient or modern, exhibiting equal art? Not only is there here the repose of one who sleeps, but the grief and regret of one who has lost a great and valued possession. This is the Night that obscures all those who for a certain time expected, I will not say to surpass, but to equal Michelangelo. In this figure is all that somnolency which one remarks in the sleeping form, as moulded by nature herself; wherefore many verses, both in Latin and the vulgar tongue, were made in praise of our artist's work by most learned persons, as, for example, those which follow, and of which the author is not known.[20]

> The Night that here thou seest, in graceful guise
> Thus sleeping, by an Angel's hand was carved
> In this pure stone; but sleeping, still she lives.
> Awake her if thou doubtest, and she'll speak.

To these words Michelangelo, speaking in the name of Night, replied as below:

> Happy am I to sleep, and still more blest
> To be of stone, while grief and shame endure;
> To see, nor feel, is now my utmost hope,
> Wherefore speak softly, and awake me not.

Certain it is that, if the enmity which constantly exists between Fortune and Genius had suffered this work to attain completion, Art might have proved to Nature that she is capable of far surpassing her on every point.

While Michelangelo was thus laboring with the utmost zeal and love at such works came the siege of Florence, which too effectually impeded the completion thereof; this took place in 1529, when he could do little or nothing more, the citizens having charged him with the care of the fortifications, as we have said. He had lent the Republic a thousand

crowns; and, as he made one of the Council of War called the Nine, he turned all his mind and thoughts to the perfecting and strengthening of the defences. But at length, and when the enemy's troops had closed round the city, while all hope of aid was gradually disappearing, and the difficulties of maintaining the place increased, Michelangelo, who felt himself to be in a position not suited to him, resolved, for the safety of his person, to leave Florence and repair to Venice, without making himself known to any one by the way. He departed secretly, therefore, by the road of Monte Miniato, no one being informed of his purpose, and having with him only his disciple Antonio Mini, and the goldsmith Piloto, his faithful friend. They all bore a sum of money, each having fastened his portion into his doublet; and having reached Ferrara, the master halted to refresh himself.

Here the suspicions usual in time of war, and the league of the Emperor and Pope against Florence, caused the Duke Alfonso of Ferrara to keep strict watch, and he required to be secretly informed every day, by the hosts, of all the strangers whom they lodged; a list of all foreigners, with the countries to which they belonged, being carried to him daily. It thus happened that although Michelangelo desired to remain unknown, yet the Duke, made aware of his arrival by this means, greatly rejoiced thereat, because he had become his friend.

That prince was a man of a high mind, and delighted in works of genius all his life long. He instantly despatched some of the principal persons of his court to invite Michelangelo, in the name of his Excellency, to the palace, where the Duke then was; these Signori being ordered to conduct him thither with his horse and all his baggage, and to give him commodious apartments in the palace. Michelangelo, thus finding that he was no longer master of his movements, put a good face on the matter, and accompanied the Ferrarese nobles to the presence of their lord, but without removing his baggage from the hostelry. The Duke received him graciously, but complained of his reserve and secrecy. Subsequently making him rich gifts, he did his utmost to prevail on him to settle in Ferrara; but to this, Michelangelo could not agree, when the Duke requested that he would at least not depart while the war continued, and again offered to serve him to the utmost of his power.

Unwilling to be outdone in courtesy, our artist thanked the Duke with the utmost gratitude, and turning to his two travelling companions, he remarked that he had brought 12,000 crowns with him to Ferrara, and that if these could be of any service to the Duke, they were to consider his Excellency as much master of them as himself. The Duke then led the master through the palace to amuse him, as he had previously done at an earlier visit, showing him all the fine works in his possession, among others his own portrait by the hand of Titian, which Michelangelo

greatly extolled. But the latter could not be prevailed on to accept rooms in the palace, and insisted on returning to his inn. The host then received various supplies, secretly sent from the Duke for the better accommodation of our artist, and was forbidden to accept any remuneration when his guest should depart.

From Ferrara, Michelangelo repaired to Venice, where many of the most distinguished inhabitants desired to make his acquaintance. But he, who had never any very high opinion of their judgment in matters concerning his vocation, left the Giudecca, where he had taken up his abode, and where, as it is said, he prepared a design, at the entreaty of the Doge Gritti, for the bridge of the Rialto, which was declared to be one of original invention and extraordinary beauty. He was meanwhile earnestly entreated to return to his native city, and not to abandon his works there. A safe conduct was likewise sent him, and, moved by love of his native place, he did eventually return, but not without danger to his life.

At this time, Michelangelo finished the Leda, which he was painting, as I have said, at the request of the Duke Alfonso, and which was afterwards taken into France by his disciple Antonio Mini. He also repaired the campanile of San Miniato, a tower which effectually harassed the enemy during the siege with its two pieces of artillery. The Imperialists then assailed it with heavy cannon, and, having all but effected a breach, would soon have destroyed it utterly, had not Michelangelo found means to oppose sacks of wool and thick mattresses to the artillery; but he did eventually defend it with success, and it is standing to this day.

We find it furthermore related that Michelangelo at that time obtained the block of marble, nine braccia high, which Pope Clement, in the contention between Baccio Bandinelli and himself, had promised to the former. This being now the property of the Commonwealth, he demanded it from the Gonfaloniere, who granted his request, although Baccio had already made his model and diminished the stone considerably by the commencement of his rough-hewn sketch. Michelangelo now prepared a model on his part, which was considered a very fine one; but on the return of the Medici, the marble was restored to Bandinelli. The war having been brought to an end, Baccio Valori, commissioner of the Pope, received orders to arrest and imprison some of the more zealous among the citizens, the court itself causing Michelangelo to be sought in his dwelling; but he, doubtful of their intentions, concealed himself in the house of a trusted friend, where he remained several days.

But when the first bitterness of resentment had subsided, Pope Clement, remembering the ability of Michelangelo, commanded that he should be sought anew, but with orders that no reproaches should be addressed to him; nay, rather that he should have all his early appointments restored, and should proceed with the works of San Lorenzo, M.

Giovambattista Figiovanni, an ancient servant of the house of Medici, and prior of San Lorenzo, being named superintendent of the work. Thus reassured, Michelangelo, to make a friend of Baccio Valori, commenced a figure in marble of three braccia high, an Apollo namely, drawing an arrow from his quiver, but did not quite finish it. It is now in the apartments of the Prince of Florence, and although, as I have said, not entirely finished, is a work of extraordinary merit.

About this time there came to Michelangelo a gentleman of the Duke Alfonso of Ferrara, who, having heard that the master had completed a beautiful work of him, and being unwilling to lose such a jewel, had sent the gentleman in question to secure it, who had no sooner arrived in Florence than he sought out our artist, to whom he presented the letters of his lord. Having received him courteously, the master then showed him the Leda; her arm thrown around the swan, and with Castor and Pollux proceeding from the egg; a large picture in tempera. The Duke's messenger, expecting, from what he had heard of Michelangelo, to see some great thing, but who was incapable of comprehending the excellence and power of art displayed in that figure, remarked to the master, "Oh, this is but a very trifling affair." Whereupon our artist, knowing that none have better judgment in a matter than those who had long experience therein, inquired of him what his vocation might be. To which the gentleman, secretly smiling and believing himself not to be known for such to Michelangelo, replied, "I am a merchant," at the same time making a sort of jest of the question, and speaking with contemptuous lightness of the industry of the Florentines. "Aye, indeed," replied Michelangelo, who had thoroughly understood the sense of his words, "then you will make a bad bargain for your master this time; be pleased to take yourself out of my sight."

In those days Antonio Mini, the disciple of Michelangelo, had two sisters to marry, when the master presented the Leda to him, some few days after the conversation just related, with the greater part of the designs and cartoons which he had made, a most noble gift indeed. When Antonio afterwards took it into his head to go to France, therefore, he carried with him two chests of models, with a vast number of cartoons finished for making pictures, some of which had been painted, while others still remained to be executed. The Leda he there sold, by the intermission of certain merchants, to Francis, the King of France; and it is now at Fontainebleau. But the cartoons and designs were lost, seeing that Antonio died before he had been long in France, when those treasures were stolen, and our country was thus deprived, to her incalculable injury, of those admirable works of art. The cartoon of the Leda has, however, returned to Florence, and is in the possession of Bernardo Vecchietti. There are four pieces of the cartoons

of the chapel also, which have been brought back by the sculptor Benvenuto Cellini, and are now held by the heirs of Girolamo degli Albizzi.

Michelangelo now thought it fitting and proper that he should repair to Rome, there to take the commands of Pope Clement, who, though much displeased, was yet the friend of distinguished men; His Holiness accordingly forgave all, and ordered him to return to Florence with a commission to give the ultimate completion to the library and the sacristy of San Lorenzo. By way of facilitating the progress of the work moreover, the large number of statues required for it were distributed among other masters. Tribolo received two; one was given to Raffaello da Montelupo; and another to the Servite monk, Fra Giovan Agnolo, all sculptors; but Michelangelo assisted each of them, making rough models in clay for them all.

While these masters, therefore, were zealously occupied with their works, Michelangelo proceeded with the library, the ceiling of which was finished after his models by the Florentines Caroto and Tasso, both excellent carvers and masters in wood-work; the shelves for the books being executed at the same time by Battista del Cinque and Ciapino his friend, also good masters in their vocation. While, to give the work its final perfection, the famous Giovanni da Udine was invited to Florence, when he, assisted by his disciples and certain Florentine masters, adorned the tribune with stucco-work. All these artists laboring zealously to bring the edifice to completion.

Michelangelo, on his part, was anxious to have his statues also in readiness, but the Pope then summoned him to Rome for the purpose of adorning the walls of the chapel of Sixtus with pictures, as he had already done the ceiling for Pope Julius II. On the first of these walls, or that behind the altar, Pope Clement commanded him to paint the Last Judgment, proposing that in this picture he should display all that the art of design is capable of effecting. While on the opposite wall, and over the principal door, the Pontiff directed that the Fall of Lucifer, and that of the Angels who sinned with him, should be depicted, with their Expulsion from Heaven and Precipitation to the center of Hell. Of these subjects, it was found that Michelangelo had long before made sketches and designs, one of them being afterwards put into execution in the church of the Trinità in Rome by a Sicilian painter, who had been many months with Michelangelo, and had served him in the grinding of his colors. The picture, which is in fresco, is in the transept of the church, at the chapel of San Gregorio namely. And although badly executed, there is nevertheless a certain force and variety in the attitudes and groups of those nude figures raining down from heaven, and of the others, which having fallen to the center, are then turned into frightful and horrible

forms of Demons, which certainly give evidence of extraordinary power of fancy and invention.

While Michelangelo was thus busied with his painting of the Last Judgment, no day passed that he did not have contentions with the agents of the Duke of Urbino, who accused him of having received sixteen thousand crowns for the tomb of Pope Julius II. He was much grieved at this charge, and, though now become old, wished to finish the tomb, since so unlooked-for an opportunity had been presented to him of returning to Rome, whence indeed he desired never to depart, not being willing to remain in Florence, because he greatly feared the Duke Alessandro de' Medici, whom he knew to be no friend of his. Nay, when the latter had intimated to him, through the Signor Alessandro Vitelli, that he must repair to Florence, there to select a better site for the forts and citadel, Michelangelo replied that he would not go thither unless compelled to do so by Pope Clement.

An agreement being finally arrived at in respect to the tomb of Julius, the matter was arranged on this wise: the edifice was no longer to be an isolated fabric, but merely a single façade, executed as Michelangelo should think best, he being held nevertheless to supply to it six statues by his own hand. By this contract the Duke of Urbino allowed Michelangelo to work during four months of the year for Pope Clement, whether in Florence or wherever else it might please the Pontiff to employ him. Michelangelo now believed himself to have obtained quiet, but he was not allowed to continue his work of the tomb in peace, because Pope Clement, eager to behold the ultimate effort and force of his art in the chapel, kept him perpetually occupied with those paintings. Yet, while giving the Pontiff reason to suppose him fully employed with them, he did secretly work on the statues for the sepulchre.

In the year 1534, Pope Clement died, when the works proceeding at the library and sacristy in Florence, which, notwithstanding all the efforts made, were not yet finished, were at once laid aside. Michelangelo then believed himself to be free and at liberty to give all his attention to the tomb of Pope Julius, but Paul III being created High Pontiff, no long time elapsed before our artist was summoned by His Holiness, who received him with great favor, declaring that he wished the master to enter his service and remain near his person. Michelangelo excused himself, saying he was engaged by contract to the Duke of Urbino until the tomb should be completed. But Paul, much displeased, replied, "For thirty years have I had this wish, and now that I am Pope will you disappoint me? That contract shall be torn up, for I will have you work for me, come what may." Hearing this, Michelangelo was tempted to leave Rome and find means for the completion of the tomb elsewhere. Yet, prudent as he was, and fearing the power of the Pontiff, he resolved to

try if he could not content him with words, and so keep him quiet (seeing that he was already so old) until some new change might ensue.

Pope Paul meanwhile, determined to have some important work executed by Michelangelo, went one day to his house with ten Cardinals, and then demanded to see all the statues for the tomb of Julius; they appeared to him to be most admirable, more particularly the Moses, which, as the Cardinal of Mantua remarked, was sufficient of itself to do honor to the late Pontiff. The cartoons and designs for the walls of the chapel were next examined. These also amazed the Pope with their beauty, and he again pressed Michelangelo to enter his service, promising to persuade the Duke of Urbino to content himself with three statues by the hand of Michelangelo, who might cause the remaining three to be executed after his own models by other good artists. And His Holiness did accordingly so arrange with the Duke's agents that a new contract was signed by that prince. But Michelangelo proposed, of his own free will, to pay for the three statues wanting, as well as for the masonry of the sepulchre, depositing one thousand five hundred and eighty ducats in the bank of the Strozzi for that purpose. This he might have avoided, had it pleased him to do so; but having done that, he thought he had made sufficient sacrifices for so laborious and vexatious an undertaking as this tomb had proved to be, and he then caused it to be erected, at San Pietro in Vincoli, in the following manner.

The lower basement, with its carved decorations, has four pedestals, which project forwards to the extent required for giving room to a figure representing a Captive, which was originally to have been placed on each, but for which a terminal figure was now substituted. The lower part had thus a poor appearance, and a reversed corbel was therefore added at the feet of each. Between the termini are three niches, of which the two outermost have a circular form, and were to have received figures of Victory. Instead of which, the one had now Leah, the daughter of Laban, as the representative of Active Life; in one hand she holds a mirror, to denote the circumspection which we should give to our actions; and in the other a garland, to intimate the virtues which adorn our lives while in this world, and render them glorious after death. The opposite niche received Rebecca, the sister of Leah, as denoting Life in Contemplation; her hands are joined, her knees are bent, and her face is turned upwards as in ecstasy of spirit. These statues were executed by Michelangelo himself in less than a year.

In the center is the third niche, but this is of a square form, having been originally intended to serve as the entrance to the oval temple, wherein the quadrangular sarcophagus was to have been erected. In this niche there is now placed the beautiful and majestic statue of Moses, of which we have said enough. Over the heads of the terminal figures,

which serve as capitals, there are the architrave, frieze, and cornice, which project over the termini and are richly carved in foliage, ovoli, denticulations, and other ornaments. Above the cornice is a second compartment without carving of any kind, but with termini of a different form, and other figures, standing immediately over those below; they stand in the place of pilasters with varied cornices. In the center of this compartment, which is similar to and accompanies that below in all its parts, is an opening corresponding with the niche wherein is the Moses; and here, supported by the ressauts of the cornice, is a marble sarcophagus on which is the recumbent statue of Pope Julius II executed by the sculptor Maso dal Bosco.[21] Immediately over this and within a niche is the figure of Our Lady holding the Divine Child in her arms, and executed, after the model of Michelangelo, by the sculptor Scherano da Settignano. These are tolerably good statues; and in two other niches, also of a square form, are two larger statues, a Prophet and a Sibyl namely, both seated; they are placed immediately over the figures representing Active Life and Life in Contemplation. These were made by Raffaello da Montelupo, but did not give satisfaction to Michelangelo.

This part of the tomb was surmounted by a richly decorated cornice, which formed the summit of the whole, and projected considerably over the whole front of the work. At the ends of the same, and above the termini, stand candelabra of marble; and in the center, or over the Prophet and Sibyl, are the arms of Julius II. Within each of the niches, however, it has been necessary to make a window for the convenience of the monks who serve the church. The choir being behind this monument, these windows permit the voices to be heard in the church, and allow the divine offices to be seen. Upon the whole, then, the work has turned out to be a very good one, although wanting much of the magnificence promised by the first design.

Michelangelo had now resolved, since he could not do otherwise, to enter the service of Pope Paul III, who commanded him to continue the paintings ordered by Pope Clement, without departing in any manner from the earlier plans and inventions, which had been laid before His Holiness; for the latter held the genius of Michelangelo in great respect; nay, the love and admiration which he felt for him were such that he desired nothing more earnestly than to do him pleasure. Of this there was a proof in the fact that Pope Paul desired to have his own arms placed beneath the statue of the Prophet Jonas, where those of Julius II had previously been. But when the master, not wishing to do wrong to Julius and Clement, declined to execute them there, saying that it would not be well to do so, His Holiness yielded at once, that he might not give Michelangelo pain, acknowledging at the same time the excellence of that man who followed the right and just alone, without flattery or

undue respect of persons; a thing to which the great are but little accustomed.

Michelangelo now caused an addition to be made to the wall of the chapel, a sort of escarpment, carefully built of well-burnt and nicely chosen bricks, and projecting half a braccio at the summit, in such sort that no dust or other soil could lodge on the work. But I do not propose to enter into details as regards the compositions or inventions of this story, because there have been so many prints, great and small, made from it that I need not waste my time in describing the same. Let it suffice to say that the purpose of this extraordinary master was no other than the representation by the pencil of the human form, in the absolute perfection of its proportions, and the greatest possible variety of attitude, with the passions, emotions, and affections of the soul, expressed with equal force and truth.

It was sufficient to him to treat that branch of art wherein he was superior to all, and to lay open to others the grandeur of manner that might be attained in the nude form, by the display of what he could himself effect in the difficulties of design, thus facilitating the practice of art in its principal object, which is the human form. Keeping this end in view, he gave but slight attention to the attractions of coloring, or to the caprices and new fantasies of certain delicate minutiæ, which some painters, and not perhaps without good show of reason, have been especially careful to cultivate. Many, indeed, who have not possessed Michelangelo's distinction in design, have sought by the variety of their tints and shades of coloring, by many fanciful and varied inventions, or, in short, by some other method of proceeding, to make their way to a place beside the first masters. But Michelangelo, taking firm ground on the most recondite principles of art, has made manifest, to all who know enough to profit by his teaching, the means by which they may attain perfection.

But to return to the story. Michelangelo had brought three-fourths of the work to completion, when Pope Paul went to see it; and Messer Biagio da Cesena, the master of ceremonies, a very punctilious man, being in the chapel with the Pontiff, was asked what he thought of the performance. To this he replied that it was a very improper thing to paint so many nude forms, all showing their nakedness in that shameless fashion, in so highly honored a place; adding that such pictures were better suited to a bathroom, or a roadside wine shop, than to the chapel of a Pope. Displeased with these remarks, Michelangelo resolved to be avenged. And Messer Biagio had no sooner departed than our artist drew his portrait from memory, without requiring a further sitting, and placed him in Hell under the figure of Minos, with a great serpent wound round his limbs, and standing in the midst of a troop of devils. Nor did

the entreaties of Messer Biagio to the Pope and Michelangelo that this portrait might be removed suffice to prevail on the master to consent; it was left as first depicted, a memorial of that event, and may still be seen.

It chanced about this time that Michelangelo fell from a no inconsiderable height of the scaffolding around this work and hurt his leg, yet in the pain and anger this caused him he would suffer no surgeon to approach his bed. Wherefore, the Florentine physician, Maestro Baccio Rontini, the friend of Michelangelo, and a great admirer of his genius, who was a very eccentric person, taking compassion on his state, went one day to knock at the door of the house. Obtaining no reply, either from his neighbors or himself, he strove to make his way in by a secret entrance, and from room to room at length arrived at that wherein the master lay. He found him in a desperate state, but from that moment he would not leave his bed-side, and never lost sight of the patient until he had effectually cured the injured leg.

His malady overcome, and having returned to his work, the master labored thereat continually for some months, when he brought it to an end, giving so much force to the figures of the same that they verified the description of Dante: "Dead are the dead, the living seem to live." The sufferings of the condemned and the joys of the blessed are exhibited with equal truth. Wherefore, this painting being given to view, Michelangelo was found to have surpassed not only all the early masters who had painted in that chapel, but himself also, having resolved, as respected the ceiling which had rendered him so celebrated, to be his own conqueror; here, therefore, he had by very far exceeded that work, having imagined to himself all the terrors of the last day with the most vivid force of reality.

For the greater pain of those who have not passed their lives well, he has represented all the Passion of Our Savior Christ, as presenting itself to their view: the cross, the column, the lance, the sponge, the nails, and the crown of thorns being all borne in the air by nude figures, whose difficult and varied movements are executed with infinite facility. The seated figure of Our Lord, with a countenance terrible in anger, is turned towards the condemned, on whom he thunders anathema, not without great horror on the part of Our Lady, who, wrapt in her mantle, is the witness of that destruction.

There are, besides, a vast number of figures, Prophets, and Apostles, surrounding the Savior. Those of Adam and St. Peter are more especially conspicuous, and they are believed to have been made so; the one as the first parent of those thus brought to judgment, the other as being the founder of the Christian religion. At the feet of Christ is a most beautiful figure of San Bartolommeo, holding forth the skin of which he was deprived, with a nude figure of San Lorenzo, and those of other saints,

male and female, to say nothing of the many other forms of men and women, some near and some at greater distance, who embrace each other and express their joy; they, by the grace of God and as the reward of their good works, having secured eternal blessedness.

Beneath the feet of Our Savior are the seven Angels with the seven trumpets, described by St. John the Evangelist; and as they summon all to judgment, the terrible expression of their faces causes the hair to stand on end. Among the angels, there are two holding the Book of Life; while near them on one side, and not without admirable forethought, are the seven mortal sins in the form of demons. They are struggling to drag down to hell the souls which are flying, with beautiful attitudes and admirable foreshortenings, towards heaven.

Nor has our artist hesitated to show the world how, in the resurrection of the dead, these forms retake their flesh and bones from the earth itself, and how, assisted by others, already risen to life, they are soaring into the heavens, the blessed spirits above also lending them aid. Every part exhibits the peculiarities that may be supposed best suited to such a work, the master having made sketches and endured fatigues of all kinds, as indeed may be clearly perceived throughout the whole. This is, perhaps, more particularly manifest in the bark of Charon, who stands in an attitude of furious anger, striking with his oars at the souls which are dragged into the boat by the devils, as Michelangelo's most beloved author, Dante, has described him, when he says,

> Charon, the demon, with the eyes of brass,
> Calls the sad troops, and having gathered all,
> Smites with raised oar the wretch that dares delay.

Nor would it be easy adequately to describe the variety displayed in the heads of those devils, which are truly monsters of hell. In the sinners also, the crimes they have committed, with their fear of eternal punishment for the same, are equally manifest. And, to say nothing of the beauty of this work, the harmony with which it is executed is so extraordinary that the pictures appear as if all painted in the same day, while the delicacy of their finish surpasses that of any miniature. But of a truth the number of the figures, with the grandeur and dignity of the composition, are such, while the expression of every passion proper to humanity is so fully and so wonderfully expressed, that no words could do the work justice. The proud, the envious, the avaricious, or the luxurious are easily distinguished by one who examines with judgment, the master having given his attention to every point, and maintained the truth of nature in each expression, attitude, and circumstance, of whatever kind; a thing which, however great and admirable, was not impossible to Michelangelo, who was ever prudent and observing. He had seen many

men and lived much in the world, thereby acquiring the knowledge which philosophers seek to obtain from books and reflection.

The man of judgment and one well versed in Art will here perceive the latter in all its force, and will discover thoughts and emotions in these figures such as were never depicted by any other than Michelangelo himself. Here we may learn how the attitude may be varied even in the most extraordinary gestures of young men and old, male and female. And who can fail to perceive herein the greatness of his art, as well as the grace which had been imparted to him by nature, when they move the hearts of the ignorant almost as they do those of men well versed in the matter? Foreshortenings are here seen which give the appearance of the most perfect relief, with a softness and delicacy of every part, showing what paintings may be when executed by good and true masters; but in some of these figures there are outlines turned by Michelangelo in a manner that could have been effected by no other than himself.

At a word, we have here the true Last Judgment, the real Condemnation, the effectual Resurrection. For our arts this work is, in short, the example of a great picture sent by God to men, thereby to show them how Fate proceeds, when spirits of the highest order are permitted to descend to this our earth, bearing within them the grace and divinity of knowledge as innate, or a part of themselves. Those who had before believed themselves acquainted with Art are led bound and captive by the work before us; and, gazing on the evidence of power in these contours, they tremble and fear as if some great Spirit had possessed himself of the art of design. Examining these labors, their senses are bewildered at the mere thought of what other paintings executed, or to be executed, must needs appear, when brought into comparison with this paragon.

Truly fortunate may that man be esteemed, and happy are his recollections, who had been privileged to behold this wonder of our age. Thrice blessed and fortunate art thou, O Paul III, since God has permitted that under thy protection was sheltered that renown which the pens of writers shall give to his memory and thine own! How highly are thy merits enhanced by his art! A great happiness, moreover, has most assuredly been his birth for the artists of our time; since by the hand of Michelangelo has been removed the veil of all those difficulties which had previously concealed the features of Painting, Sculpture, and Architecture, seeing that in his works he has given the solution of every difficulty in each one of those arts.

At this work Michelangelo labored eight years. He gave it to public view on Christmas Day, and (as I think) in the year 1541. This he did to the amazement and delight, not of Rome only, but of the whole world. For myself, I, who was at Venice that year, and went to Rome to see it, was utterly astounded thereby.

Now Pope Paul had caused a chapel, called the Pauline, to be built by Antonio da Sangallo, as we have before related, in imitation of that erected by Nicholas V, and he now resolved that Michelangelo should there paint two large stories. In one of them our artist accordingly depicted the Conversion of St. Paul; Our Savior Christ is seen in the air above, with a multitude of angels, nude figures exhibiting the most graceful movements. On the earth beneath them lies Paul, fallen from his horse, stunned and bewildered. Some of the soldiers standing around are about to raise him up, while others, terrified by the voice and the majesty of Christ, are betaking themselves to flight. Their movements and attitudes are of singular beauty. The horse likewise, endeavoring to fly from the place, appears to hurry after him the servant who is seeking to restrain the velocity of his course. The whole story indeed offers evidence of extraordinary power and design. In the second picture is the Crucifixion of St. Peter, a most beautiful figure bound naked to the cross. The executioners have made a hole in the earth wherein they are about to fix the cross, that the martyr may remain crucified with his feet in the air; a picture full of fine thought and consideration.

The attention of Michelangelo was constantly directed towards the highest perfection of art, as we have said elsewhere. We are therefore not here to look for landscapes, trees, buildings, or any other variety of attraction, for these he never regarded; perhaps because he would not abase his great genius to such matters. These were his last pictures. They were painted in his seventy-fifth year, and as he told me himself, at great cost of fatigue, seeing that painting, and more especially fresco, is not the work of those who have passed a certain age. Michelangelo now arranged that Perino del Vaga, a most excellent painter, should decorate the ceiling with stucco-work and painting after his designs, and to this Pope Paul III consented. But the work being delayed, nothing more was done, as indeed has been the case with many undertakings, which the irresolution of artists or the indifference of princes has caused to be left unfinished.

Pope Paul had begun to fortify the Borgo, and had called Antonio Sangallo, with many of the Roman nobles, to counsel in that matter; but knowing that Michelangelo had directed the fortifications of San Miniato at Florence, he determined, after many disputes, to ask his opinion also. Thinking differently to Sangallo and most of the others, Michelangelo nevertheless uttered his thoughts plainly, when Sangallo told him that sculpture and painting were his arts, and not fortification. To this Michelangelo replied that of sculpture and painting he knew but little; of fortification, on the contrary, the much he had thought of it, with what he had accomplished, had taught him more than had ever been known by Sangallo and all his house put together. He then proceeded, in the presence of all, to point out the errors that had been

committed. One word calling forth another, the Pope was compelled to impose silence on every one. But no long time afterwards, Michelangelo brought the whole fortification of the Borgo, designed in such sort as to throw light over all that remained to be done; and this, opening the eyes of each person concerned, caused the great gate of Santo Spirito, designed by Sangallo, and then near its conclusion, to be discontinued and to remain unfinished.

The active spirit of Michelangelo could not endure to continue unoccupied. And not being able to paint any longer, he set himself to work on a piece of marble, whence he proposed to extract a Pietà, consisting of four figures larger than life, doing this for his amusement and pastime as he said, and because the use of the hammer kept him in health. Our Savior Christ, as taken from the Cross, is supported by the Virgin Mother, who is powerfully aided by Nicodemus, a figure standing beneath, with the feet firmly fixed on the earth. One of the Maries also, perceiving that the powers of Our Lady are about to fail, comes also to her aid, as, overcome by her grief, she can no longer support the form of her Son. A dead body equal to this of Christ could not possibly be found; sinking with the limbs in perfect abandonment, the attitude is different from that of any other, not of Michelangelo's own execution only, but of any that has ever been made.

The work is such as has rarely been extracted from a single stone. It is a truly beautiful as well as laborious one, but, as will be related hereafter, it suffered many mishaps, and ultimately remained unfinished, although Michelangelo had intended this group to serve as his own monument, and to be placed at the altar near which he hoped to be laid to his final rest.

In the year 1546, it chanced that Antonio da Sangallo died. A director for the fabric of San Pietro was required, and there were various opinions as to who should be entrusted with the office; at length, and, as I believe, inspired by God, His Holiness resolved to send for Michelangelo. Being asked if he would undertake the work, the master replied that he would not, architecture not being his vocation; but when entreaties were found useless, the Pope commanded him to accept the trust, and to his infinite regret he was compelled to obey. One day among others that he had gone to the building accordingly, to see the model in wood prepared by Sangallo, and to examine the fabric, the whole party of the Sangallicans came to meet him, and in the best terms they could find, expressed their satisfaction at his appointment, remarking that the model before them was a field on which he need never want pasture. "You speak well," replied Michelangelo, intending to imply (as he declared to one who was his friend) that the pasture was good for sheep and oxen and other animals who know nothing of art. Nay, he would

often publicly declare that Sangallo had left the building without lights, and had heaped too many ranges of columns, one above the other on the outside; adding that, with its innumerable projections, pinnacles, and divisions of members, it was more like a work of the Teutons than of the good antique manner, or of the cheerful and beautiful modern style. He furthermore affirmed that fifty years of time, with more than 300,000 crowns in the cost, might very well be spared, while the work might be completed with increased majesty, grandeur, and lightness, to say nothing of better design, more perfect beauty, and superior convenience.

He made a model also, to prove the truth of his words, and this was of the form wherein we now see the work to have been conducted. It cost twenty-five crowns, and was finished in a fortnight; that of Sangallo having exceeded four thousand, as we have said, and occupied several years in the making. From this and other circumstances, it was indeed easy to see that the church had become an object of traffic and a means of gain, rather than a building to be completed; being considered, by those who undertook the work, as a kind of bargain to be turned to the best account. Such a state of things could not fail to displease so upright a man as Michelangelo; and, as the Pope had made him superintendent against his will, he determined to be rid of them all. He therefore one day told them openly that he knew well they had done and were doing all they could, by means of their friends, to prevent him from entering on this office, but that if he were to undertake the charge, he would not suffer one of them to remain about the building. These words, thus publicly spoken, were taken very ill, as may readily be supposed, and awakened so much hatred against Michelangelo that this, increasing daily as the whole arrangement of the work was seen to be changed both within and without, permitted Michelangelo to have no peace, his adversaries constantly inventing new methods of tormenting him, as will hereafter be seen.

At length the Pontiff issued a *Motu-proprio*,[22] by which he appointed him superintendent of the fabric, with full authority to do or undo, decrease, extend, or change as it should seem good to him, and furthermore commanding that the whole government of those who were employed should be in his hands. Thereupon Michelangelo, seeing the confidence which the Pope placed in him, desired to prove himself worthy thereof, and had a clause inserted in the *Motu-proprio* to the effect that he performed his office for the love of God, and would accept no reward, although the ferry of the river at Parma,[23] which had formerly been given to him by the Pope, had been lost to him by the death of the Duke Pier-Luigi, and he had received only a Chancery of Rimini, which brought him in but a small revenue, in its stead. But that circumstance he did not regard; and although Pope Paul more than once sent him money as a stipend, he would never accept any, a fact to which Messer Alessandro

Ruffini, then Chancellor of the Pope, and Messer Pier Giovanni Aliotti, Bishop of Forlì, have borne witness.

The model of the church made by Michelangelo was finally approved by the Pope; and this, although it decreased the circumference of the building, yet did in fact give it greater space, to the satisfaction of all who have judgment, although some, who profess to be judges, but in reality are not, are far from being pleased therewith. It was now found that the four principal piers constructed by Bramante, and left unaltered by Antonio da Sangallo, which had to support the weight of the tribune, were too weak. Michelangelo therefore partly filled them up. And near them he made two spiral staircases, with steps of ascent so easy and so slightly inclined that the asses used for carrying the materials to the summit could mount and descend them, while men could go up on horseback to the platform of the arches. He formed the first cornice over the arches of travertine in a circular form, a beautiful work, of the most graceful effect, and quite different from the others; nor could there be anything better of that kind.

He then commenced the two great recesses of the transept; but whereas, by the order of Bramante, Baldassare,[24] and Raphael, there were to be eight niches or tabernacles on the side towards the Campo Santo, as we have said, an arrangement followed by Sangallo, Michelangelo reduced them to three, with three chapels, raising over them a vaulting of travertine, and a range of windows, giving full light, varied in their form, and of very magnificent effect. But as these are finished, and are besides to be published by engravings, as are all the designs of Michelangelo and of Sangallo likewise, I will not give myself the trouble of describing them, which is indeed unnecessary. Let it suffice to say, that where our artist made changes he caused all to be constructed with the utmost exactitude, adding a degree of strength which should leave no pretext for any other to disturb his plans. And this was the foresight of a prudent man, for it does not always suffice to do well, unless further precaution be taken; seeing that the presumption and boldness of such as might be supposed—if you regard their words rather than their works—to know something, may cause many inconvenient changes.

Now the Roman people desired, under the favor of Pope Paul, to give some more decorous, beautiful, and convenient form to their Capitol, proposing to adorn it with columns, and flights of steps, having balustrades and broad stairs; to say nothing of the ancient statues wherewith it was to be further decorated. For this the advice of Michelangelo was requested, and he made them a rich and beautiful design. This comprised a fine front in travertine, on the side of the Senate-house, towards the east namely, with a double flight of steps, ascending to a platform, whence you enter the middle of the Great Hall, the rich and varied

balustrades of those steps serving at once as a support and a bulwark. And, for the further decoration of the same, he added antique figures of recumbent River-gods, nine braccia high, the Tiber and the Nile namely. These he has raised on pedestals, and between them there is to be the statue, in a large niche, of Jupiter.

On the south side, where is the palace of the Conservators, and by way of bringing the building to a square form, there followed a rich and varied façade, with a loggia of columns, and niches beneath, and here many antique statues are to be placed. Doors, windows, and numerous ornaments are likewise in preparation, many of which are finished. A similar façade is to be erected opposite to this, on the north side beneath the Ara Cœli; and on the west, there is to be a flight of steps of very easy ascent, the whole surrounded by a balustrade. And here will be the principal entrance, which is further to be adorned by a range of pedestals, whereon the magnificence of those statues, in which the Capital is now so rich, will be displayed.

In the center of the Piazza, and on a pedestal of an oval form, is erected the Horse of bronze so much talked of, whereon there sits the figure of Marcus Aurelius, which Pope Paul III caused to be removed from the Piazza of the Lateran, where it had been placed by Sixtus IV. By all these alterations and additions, the edifice has now been rendered so beautiful that it merits to be accounted among the finest of Michelangelo's works, although it is at present only in course of completion, not by himself, but by M. Tommaso de Cavalieri, a Roman gentleman, who has been and is one of the most faithful friends of Michelangelo, as will be related hereafter.

While Antonio da Sangallo lived, Pope Paul had permitted him to continue the building of the Farnese Palace; but the upper cornice on the outside was still wanting, and His Holiness now desired that this should be added by Michelangelo, after his own design, and under his direction. That master, therefore, not wishing to disoblige the Pope, who esteemed and favored him so much, made a model in wood, seven braccia long, and of the exact size which the cornice was to be. This he caused to be fixed on one of the angles of the palace that the effect might be seen; when, as the Pontiff and all Rome with him were much pleased therewith, it was put into execution; and so much of it as we now see was completed, proving to be the most beautiful and varied cornice ever erected, either by the ancients or moderns. On the death of Sangallo, Pope Paul desired, as we have said, that Michelangelo should undertake the charge of the whole palace, where he constructed the great window with its beautiful columns of varicolored marble, which is over the principal entrance, adding a large escutcheon, also in marble, and bearing the arms of Paul III, the founder of that edifice.

He continued the great court also, constructing two ranges of columns over those first erected, with the most beautiful windows, and a great variety of rich ornaments, ending with the great cornice; all of these works being so beautiful, that this court, by the labor of Michelangelo, has now become the finest in all Europe. Our artist likewise enlarged the Great Hall, and made arrangements for the vestibule, which he vaulted after a new manner, in the form of a half oval. It chanced that in this year an antique group of Hercules, in marble, standing on a mountain, and holding a bull by the horns, was discovered at the warm baths of Antoninus. A second figure is assisting Hercules. The group is seven braccia square. Around the hill are nymphs, herdsmen, and different animals. The whole work is certainly one of great beauty, the figures being in full relief. It was adjudged to have been intended for a fountain, and Michelangelo advised that it should be placed in the second court, where, being restored, it might be used for the same purpose. This advice pleased every one, and by command of the Signori Farnese, the group is now receiving the most careful restoration to that effect.

It was at this time that Michelangelo proposed the erection of a bridge to cross the Tiber at the point where it would form a road from the Farnese Palace in the Trastevere to another palace belonging to the same family; when a view might be obtained from the principal entrance on the Campo di Fiori across the court, and comprising the fountain, the Strada Julia, this bridge, and the beautiful gardens, even to the opposite gate which opens on the road of the Trastevere; a magnificent idea, and one fully worthy of that Pontiff, as well as of the genius and judgment of Michelangelo.

In the year 1547, Bastiano Veniziano, the monk of the leaden seal,[25] departed this life. And as the Pope was then proposing to have the antique statues of the Vatican restored, Michelangelo favored the Milanese sculptor, Guglielmo della Porta, a youth of great promise, who had been recommended to him by Fra Bastiano, and with whom Michelangelo was himself much pleased. He presented him to Pope Paul, therefore, from whom Guglielmo received a commission to restore two of the statues in question; and Michelangelo afterwards caused the office of the leaden seal to be conferred on Della Porta, who continued the restoration of the statues also, as we now see them in the palace. But, forgetful of all these benefits, Fra Guglielmo subsequently became one of the master's most eager opponents.

The death of Pope Paul took place in the year 1549, when Julius III was elected High Pontiff; and Cardinal Farnese then commissioned Fra Guglielmo to construct a vast sepulchre for his kinsman, Paul III. That artist proposed to erect it under the first arch of the new church beneath the tribune. But this interfered with the plans of the architect, and was in

effect not the proper place for the tomb. Wherefore, Michelangelo judiciously advised that it should not be constructed there. This caused Fra Guglielmo, who thought our artist acted from envious motives, to conceive a bitter hatred against him. But time has proved Michelangelo right, and the fault was all with Guglielmo, who, having the opportunity for producing a fine work, failed to make use of it, as I shall mention further elsewhere, and can here plainly show.

For it chanced that, in the year 1550, I had gone to Rome by order of Pope Julius III, there to enter the service of that Pontiff, and the more gladly as I could thus be near Michelangelo, when I took part in the council held respecting that matter of the tomb, which Michelangelo wished to have placed within one of those niches where now stands the Column of the Possessed, and which was indeed its proper position. I had also labored to secure from Pope Julius the selection of the opposite niche as the place of his own sepulchre, which was to correspond in manner with that of Paul III. But the opposition of Fra Guglielmo caused his own work to remain unfinished, while the construction of that of Pope Julius was likewise prevented; results which had all been predicted by Michelangelo.

In the same year Pope Julius resolved to erect a marble chapel in San Pietro-a-Montorio, with two sepulchral monuments, the one for his uncle, Antonio Cardinal di Monte, and the other for Messer Fabiano, his grandfather, who had laid the foundation of greatness for that illustrious house. For these works Vasari made the designs and models, when Pope Julius, who admired the genius of Michelangelo and loved Vasari, commanded that the former should fix the price to be paid for those labors, and Vasari entreated the Pontiff to prevail on Michelangelo to take the work under his protection. Now Vasari had proposed that Simon Mosca should be employed to prepare carvings for this chapel, and that Raffaello da Montelupo should execute statues. But Michelangelo advised that no carving of foliage should be added, nor any decorations of that kind used among the architectural portions of the monuments, remarking that where there are marble statues there should be no other ornament. Vasari meanwhile was afraid the work would look poor; but when he afterwards saw it completed, he confessed that Michelangelo had displayed judgment, nay, great judgment.

The master was also unwilling that Raffaello da Montelupo should have the commission for the statues, remembering that he had not acquitted himself well in those which he had executed under his own guidance for the tomb of Pope Julius II. He therefore preferred to see them confided to Bartolommeo Ammanati, whom Vasari was likewise seeking to put forward for that occasion, although Michelangelo had a touch of personal dislike against him, as well as against Nanni di Baccio

Bigio. But this displeasure, if we consider all things, had arisen from slight causes, these artists having offended from love of art rather than from a desire to wrong him. Being youths, that is to say, they had taken several drawings by Michelangelo from his disciple Antonio Mini, but these were afterwards restored by the intervention of the Council of Eight; and the master himself had employed the intercession of his friend Messer Giovanni Norchiati, Canon of San Lorenzo, to save the boys from any further punishment. Michelangelo was once talking to Vasari about this matter when the latter told him laughingly that he did not consider the young men so very blamable, and would himself have taken, not some drawings only, but all that he could have laid hands on, acting from the love of art and in the hope of improvement only, seeing that those who would make progress must proceed with force of will, and should be rewarded for their zeal rather than punished as are those who steal money or property of that kind. The matter was thus turned into a jest, and the work being commenced that year, Ammanati went with Vasari to Carrara, to prepare the marbles.

Vasari was at this time in the company of Michelangelo daily, and one morning in the Jubilee year, the Pope in his kindness gave them both a holiday, to the effect that they might accompany a cavalcade which was riding forth to visit the Seven Churches, and might thus receive the absolution together. In doing this they had much useful and pleasing discourse, while going from one church to another, respecting the arts and other vocations, and Vasari wrote the whole dialogue, which he intends to publish at some future day, with other matters concerning art.

In the same year, Pope Julius confirmed the *Motu-proprio* of Paul III in respect to the fabric of San Pietro. And although the Sangallican faction found great fault with what Michelangelo had ordered for the building, the Pontiff would at that time hear nothing of all they could say, Vasari having assured him that Michelangelo had given life to the edifice (as was the truth), and persuading His Holiness to do nothing in respect to his design for San Pietro without the full concurrence of the master, a promise to which Pope Julius, having once given it, constantly adhered. Nor would he suffer anything to be done without Michelangelo's advice either at the Vigna Julia or the Belvedere. The flight of steps now used was at that time constructed at the last-mentioned palace in place of the semicircular staircase previously existing there, and which, having ascended eight steps, turned inwards and ascended eight more, as designed by Bramante. This was erected in the great recess in the center of the Belvedere, but Michelangelo now designed the beautiful quadrangular staircase with a balustrade of peperino marble, as we still see it.

It was in this same year that Vasari completed the printing of his book, comprising the Biography of the Painters, Sculptors, and Architects; but

he had written the life of no surviving artist (although many were very old), Michelangelo alone excepted. He now presented his work to that master, who received it very gladly, many facts derived from his own lips having been recorded therein, for he, being of so advanced an age, and having so much judgment as well as experience, was well able to afford much information. No long time afterwards, having read the book, Michelangelo sent Vasari the following sonnet, which he had written, and which, in memory of his affection, I think it well to add in this place:

> If with the chisel and the colors, thou
> Hast made Art equal Nature, now thy hand
> Hath e'en surpassed her, giving us her beauties
> Rendered more beautiful. For with sage thought
> Now hast thou set thyself to worthier toils,
> And what was wanting still, hast now supplied,
> In giving life to others; thus depriving
> Her boast of its last claim to rise above thee.
> Is there an age whose labors may not hope
> To reach the highest point? yet by thy word
> All gain the limit to their toils prescribed.
> The else extinguished memories thus revived
> To new and radiant life, by thee, shall now
> Endure, with thine own fame, throughout all time.

Vasari, having soon afterwards returned to Florence, remitted the charge of laying the foundations at San Pietro-a-Montorio to Michelangelo. But to Messer Bindo Altoviti, then Consul of the Florentines and a great friend of Vasari, the latter remarked that it would have been much better if the tomb of Pope Julius had been erected in the church of San Giovanni de' Fiorentini. Giorgio added that he had already spoken on the subject to Michelangelo, who wished to promote the change, seeing that this would be a good opportunity for completing that church. The proposal pleased Messer Bindo, who, being admitted to much familiarity by the Pope, pressed it zealously on His Holiness, urging that it would be much better to construct the chapel and tomb in the church of San Giovanni than at Montorio, because the Florentines, impelled by the motive for action thus presented, would at length be induced to supply the monies needful for the completion of the church; seeing that, if His Holiness would make the principal chapel, there were merchants who would make six more, and so on by degrees, until all should be finished. The Pope changed his mind accordingly, although the model had been made and the price of the work agreed on; and going to Montorio, he sent for Michelangelo. Thereupon Vasari, who was daily writing to the latter and obtaining intelligence of all that was going on there, in reply,

received the following, dated August 1, 1550, wherein he notifies the Pontiff's change of purpose, and these are the words themselves as they came from his own hand:

"MY DEAR MESSER GIORGIO,—With respect to the foundations of San Pietro Montorio, I write you nothing, seeing that the Pope will not hear of them, and I know you are well advised thereof by your man that is here. But I desire to tell you what follows, and that is that yesterday morning the Pope, having repaired to the said Montorio, sent for me. I met him on the bridge as he was returning, and had a long conversation with him in regard to the tombs confided to you. At length he told me that he had determined not to construct them on the mount, but in the church of the Florentines, desiring to have my opinion and designs for the same; whereupon I encouraged him in that purpose, considering that the church would thus be finished. Respecting your last three letters, I have no pen that can reply to such high matters; but if I should rejoice to be what you make me, it would be principally that you might have a servant who should be worth something. Yet why should I marvel that you, being the restorer to life of dead men, should add life to those who are still living? But to shorten my words, such as I am, I am wholly yours,
MICHELANGELO. *Rome.*"

While these affairs were in course of arrangement and the Florentines in Rome were laboring to raise money, certain difficulties arose; there was nothing concluded and the matter began to cool. But Vasari and Ammanati had now caused all the marbles to be excavated at Carrara, whereupon they were sent to Rome, and Ammanati with them, Vasari writing by him to Buonarroti, desiring the latter to get an order from the Pope as to where the work was to be executed, and having received it, to let the foundations be laid. As soon as Michelangelo had read this letter, he spoke to our Lord the Pope, and wrote to Vasari as follows:

"MY DEAR MESSER GIORGIO,—As soon as Bartolommeo had arrived, I went to speak to the Pope, and seeing that he wished the tombs to be at Montorio, I began to look out for a builder from San Pietro. But when Tantecose[26] heard of it, he desired to choose one after his own mind; whereupon I withdrew, not wishing to struggle with one who commands the winds, and who is so light-minded a man that I think it better not to involve myself in any question with him. At all events, the church of the Florentines is no longer to be thought of. Return as soon as you can; and, meanwhile, fare you well. Nothing further remains to say, 15th Oct., 1556."

Michelangelo called the Bishop of Forlì *Tantecose,* because he liked to meddle with every kind of matter. Being principal chamberlain to the

Pope, he had under his care all the medals, jewels, cameos, small figures in bronze, and other things of similar kind, but he would fain have had everything depend on himself. Michelangelo avoided him carefully, finding the Bishop's meddling always unfriendly to himself, and fearing lest the ambition of the prelate should involve him in some trouble. Be this as it may, the Florentines in Rome lost an excellent occasion for completing their church. God knows when they may have such another, and the failure gave me indescribable vexation. I would not omit the mention of the matter, desiring to show how constantly Michelangelo sought to benefit those of his country as well as to assist his friends and brother artists.

Scarcely had Vasari returned to Rome, and the year 1551 had not well commenced before the Sangallican faction had formed a plot against Michelangelo, making interest to prevail on the Pope to assemble all concerned in the building of San Pietro, declaring with false calumnies that they could show His Holiness how Michelangelo was spoiling the edifice. He had constructed the recess of the king, where the three chapels are, that is to say, and had placed three windows in the upper part. But these people, not knowing what he was proposing to do in the vaulting, with their feeble judgment had given the old Cardinal Salviati and Marcello Cervino, who was afterwards Pope, to understand that San Pietro would be left with insufficient light. All being assembled accordingly, the Pope told Michelangelo that the deputies declared that part of the church to be unduly deprived of light, when the master replied that he would like to hear those deputies speak.

"We are the deputies," replied Cardinal Marcello; and Michelangelo rejoined, "Monsignore, in the vaulting above, and which is to be of travertine, there are to go three other windows." "You have never told us so," returned the Cardinal; to which Michelangelo responded, "I neither am nor will be obliged to tell either your lordship or any other person what I intend or ought to do for this work; your office is to procure money, and to take care that thieves do not get the same; the designs for the building you are to leave to my care." Then turning to the Pope, he said, "Holy Father, if the labors I endure do not benefit my soul, I am losing my time vainly for this work"; to which the Pope, who loved him, replied, laying his hands on the shoulders of the master, "You will be a gainer both for your soul and in the body; do not doubt it."

Having rid himself of those who desired to unseat Michelangelo, the love of the Pope for that master increased daily, and he commanded that Vasari, as well as himself, should repair to the Vigna Julia, on the very day following that of the assembly above described. Here the Pontiff had much conversation with them, discussing all the admirable improvements since effected there, nor did he meditate or decide on any work of de-

sign without the opinion and judgment of Michelangelo. And among other occasions, that artist once going thither, as he frequently did, with Vasari, they found the Pope, with twelve Cardinals, by the fountain of the Acqua Vergine, when His Holiness would compel Michelangelo to be seated near him, however humbly he excused himself, the Pontiff always doing every possible honor to his genius.

Pope Julius likewise made him prepare the model for a palace, which His Holiness wished to build near San Rocco, proposing to make the mausoleum of Augustus serve as a part of the masonry. Nor would it be possible to find the design of a façade more varied, original, rich or beautiful than is this, seeing that Michelangelo, as may be remarked in all his works, would never restrict himself to any laws, whether ancient or modern, as regarded architecture, he being one who had ever the power to invent things no less beautiful than varied and original. This model is now in the possession of the Duke Cosimo de' Medici, to whom, when he went to Rome, it was given by Pope Pius IV, and who has deposited it among his most valued possessions. This Pontiff regarded Michelangelo so highly that he constantly defended him against all the Cardinals and others who sought to do him injury. He also required every other artist, however able or distinguished, to wait on Michelangelo at his own house. Nay, his consideration for our artist was so great that, fearing to demand too much, he refrained from asking many a work, which the master, notwithstanding his age, might very well have performed.

In the time of Pope Paul III, Michelangelo had received a commission from that Pontiff to repair the foundations of the bridge of Santa Maria, which had been weakened by time and the perpetual flow of the waters. The piers had been carefully repaired, or rather refounded, by means of coffer-dams, and a great portion of the work had been concluded, at a great expense for timber and travertine. Under the pontificate of Julius III, there was question in the Council of bringing this bridge to an end; certain among those present proposing that the architect, Nanni di Baccio Bigio, should finish it by contract, they alleging that it would thus be done in a short time and at small cost. The Clerks of the Chamber pretended, moreover, that this would be a relief to Michelangelo, who was now old, and cared so little for the matter that the work, at the rate it then proceeded, could never be brought to an end. The Pope was no lover of disputes, and not thinking of the consequences that might ensue, he gave the desired authorization, bidding them manage the matter as an affair of their own. The fabric, with all the materials collected, was then committed, without Michelangelo knowing anything of what was going forward, to Nanni, who had full power to treat it as he pleased; when he not only neglected the precautions needful to the security of the foun-

dations, but even removed and sold a great part of the blocks of traver-
tine with which the bridge had been anciently strengthened and paved
(a thing which greatly added to the stability and duration of the struc-
ture), supplying the place of those blocks with gravel, and materials of
similar kind, so that there was no want of solidity in appearance. Nanni
also made bulwarks and other external defences, causing the bridge to be
seemingly well restored, while in fact it had been much weakened and
deteriorated.

Five years afterwards, however, and when the flood of 1557 came
down, the whole fabric fell to ruin, in such a manner as to prove the
error of judgment which the Clerks of the Chamber had committed and
the injury which Rome had suffered from their disregard of
Michelangelo's advice. He had indeed frequently predicted the ruin of
the bridge to his friends. And I remember that when we were one day
crossing it on horseback, he said, "Giorgio, this bridge shakes beneath us;
let us be gone, that it may not fall while we are on it."

But to return to a subject before touched on. When the work of
Montorio was, to my great satisfaction, completed, I returned to Florence
to the service of Duke Cosimo; this was in the year 1554. The departure
of Vasari grieved Michelangelo, as indeed it did Giorgio; and as no day
passed wherein the adversaries of the master did not labor to vex him,
now in one way and now in another, so did these two not fail to write
to each other daily. In the April of the same year, Vasari gave Michel-
angelo notice that a son had been born to his nephew Lionardo; the
child, whom Giorgio had accompanied to his baptism, having been at-
tended by a most honorable train of noble ladies, and receiving the name
of Buonarroti. To this letter Michelangelo replied by the following:

"MY DEAR FRIEND GIORGIO,—I have felt much pleasure in reading
your last, seeing that you still remember the poor old man, and because
you were present at the triumph of which you write, and have seen the
birth of another Buonarroti. For this intelligence I thank you as much as
I can or may, although I am displeased by so much pomp, seeing that no
man should laugh when the whole world is in tears. I think too, that
Lionardo should not rejoice so much over the birth of one who is but
beginning to live; such joy should be reserved for the death of one who
has lived well. Do not be surprised if I have not replied immediately; and
for the many praises you send me, if I could only deserve one of them,
I should then think that in giving myself to you, soul and body, I might
perhaps have given you something that might, in some small measure,
repay the much wherein I am your debtor. But I must acknowledge you
my creditor for more than I can ever pay, and being old I have now no
hope of acquitting myself. In the next life we may nevertheless regulate

our account, wherefore I pray you to take patience, and am wholly yours. Things here stand much as before."

So early as the time of Paul III, Duke Cosimo had sent Tribolo to Rome to try if he could persuade Michelangelo to return to Florence, there to finish the sacristy of San Lorenzo; but the master had excused himself, saying that he was become old, might no longer endure the fatigue of labor, and could not leave Rome. Tribolo then inquired as to the steps for the library of San Lorenzo, for which Michelangelo had caused many of the stones to be prepared, but for which no model, nor any certain indication of the form in which they were to be constructed, could be found. It is true that there were some few sketches of a pavement and other things in clay, yet the correct and final design of the work could not be ascertained. But not all the entreaties of Tribolo, although he brought in the name of the Duke, could move Michelangelo to say more than that he did not remember.

The Duke then commanded Vasari to write to the master, since it was hoped that for love of him Michelangelo would perhaps say something which might enable them to bring the work to conclusion. Vasari wrote to him accordingly as the Duke desired, adding that, of all which had to be done, Vasari was to be the director, and would do everything with the utmost fidelity, taking care of every minutia, as of a work of his own. To this Michelangelo replied by sending the plans for the work in a letter written by his own hand on the 28th of September, 1555.

"MESSER GIORGIO, MY DEAR FRIEND,—About the staircase whereof there has been so much said, believe that if I could remember how I had arranged it I should not require so many entreaties. There is a certain stair that comes into my thoughts like a dream; but I do not think it is exactly the one which I had planned at that time, seeing that it appears to be but a clumsy affair. I will describe it for you here nevertheless. I took a number of oval boxes, each about one palm deep, but not of equal length and breadth. The first and largest I placed on the pavement at such distance from the wall of the door as seemed to be required by the greater or lesser degree of steepness you may wish to give to the stair. Over this was placed another, smaller in all directions, and leaving sufficient room on that beneath for the foot to rest on in ascending, thus diminishing each step as it gradually retires towards the door; the uppermost step being exactly of the width required for the door itself. This part of the oval steps must have two wings, one right, the other left. The steps of the wings to rise by similar degrees, but not to be oval in form. The ascent by the middle flight, from the center to the upper part, shall be for the Signore. The turn of the wings must be towards the wall. But from the center downwards to the pavement, they shall be kept at the dis-

tance of about three palms, in such sort that the basement of the vestibule shall not be infringed upon in any part. What I am writing is a thing to be laughed at, but I know well that you will find something suitable to your purpose."

In those days Michelangelo wrote to Vasari, to the effect that, Julius III being dead, and Marcello being elected in his place, the faction adverse to himself was beginning to torment him anew. The Duke hearing this, and being displeased by those proceedings, made Giorgio write to Michelangelo, bidding him leave Rome and come to Florence, where his Excellency would ask nothing more from him than occasional advice respecting his buildings and other works of art, but was ready to grant him whatever he might desire without wishing him to lay a hand upon anything. Messer Leonardo Marinozzi, private secretary to the Duke, was also the bearer of a letter to that effect from his Excellency, as well as of one from Vasari. But Marcello having died, and Pope Paul IV being elected High Pontiff, Michelangelo, who had gone to kiss the feet of the new Pope, had received the most amicable offers from His Holiness; and desiring to see the completion of San Pietro, while he also thought himself bound in a certain sort to that employment, the master wrote to the Duke, excusing himself for that he could not then enter his service. And to Vasari he sent the following words:

"MESSER GIORGIO, MY DEAR FRIEND,—I call God to witness how much against my will it was that I was put into the fabric of San Pietro ten years since by Paul III; had they subsequently continued to work at that edifice, as they then did, I should have now brought it to such a state that I might be permitted to think of returning home. But for want of money the work has been retarded, and that at a time when the most laborious and difficult part of it has come to be executed, insomuch, that to abandon it now would be no other than a great shame and sin, whereby I should lose the reward of all those toils which for the love of God I have endured for the last ten years. I make you this discourse in reply to your letter, and because I have a letter from the Duke which makes me not a little to marvel that his Lordship should write with so much kindness. I thank God and his Excellency so much as I may and can. But I depart from my subject, I have indeed lost my memory and understanding; writing is besides a great trouble to me, seeing that it is not my vocation. The conclusion is this: to make you comprehend what would follow if I were to abandon the above-named building and depart hence. Firstly, I should rejoice many a worthless scoundrel; and lastly, I should cause the ruin, or perhaps indeed the final suspension, of the edifice."

Michelangelo furthermore wrote to Vasari, telling him, for his excuse with the Duke, that having a house and many other comforts in Rome, worth some thousands of crowns, and suffering besides from many infirmities of age, he was unfit for the fatigues of travelling, as Messer Eraldo his physician, to whom, after God, he owed it that he was yet in life, could testify. He added that for all these causes he was unable to leave Rome and had, indeed, courage for nothing more than to die and be at rest. In other letters from his hand, which Vasari has kept, he begs the latter to excuse him to the Duke; and did himself also write to his Excellency, as I have said. Nay, had he been in a condition to travel, he would have repaired instantly to Florence; and the kindness shown to him by Duke Cosimo had moved him so deeply that I do not believe he would in that case have found resolution to depart again.

Meanwhile he pressed forward the works of San Pietro in various parts of the building, desiring to bring it to such a state that the arrangement thereof could no more be changed. About this time he was told that Pope Paul IV bethought himself of having certain parts of the paintings in the chapel altered, His Holiness considering that the figures in the Last Judgment were shamefully nude. When Michelangelo, therefore, received a message from the Pope to that effect, he replied: "Tell His Holiness that this is a mere trifle, and can be easily done; let him mend the world, paintings are easily mended."

The office of the Chancery at Rimini was now taken from our artist, but he would not speak of the matter to His Holiness, who knew nothing about it, his Cupbearer having withdrawn it from Michelangelo, with the intention of paying him a hundred crowns per month instead, by way of stipend, for his services at San Pietro. But when the first month of that stipend was sent to the master's house, he refused to receive the money. In the same year there happened to Michelangelo the death of Urbino, his servant, or rather his companion, for such he had become.[27] This man had entered his master's service at Florence, in the year of the siege, and after Antonio Mini, his disciple, had gone to France. He was a most zealous servant, and in the twenty-six years of his abode with his master, the latter had made him rich, and had loved him so much that, although so old, he had nursed him in his sickness, and slept at night in his clothes beside him, the better to watch for his comforts. When Urbino died, therefore, Vasari wrote to Michelangelo to console him, and the master replied in these words:

"MY DEAR MESSER GIORGIO,—I can but ill write at this time, yet to reply to your letter I will try to say something. You know that Urbino is dead, and herein have I received a great mercy from God, but to my heavy grief and infinite loss. The mercy is this, that whereas in his life he

has kept me living, so in his death he has taught me to die, not only without regret, but with the desire to depart. I have had him twenty-six years, have ever found him singularly faithful; and now that I had made him rich, and hoped to have in him the staff and support of my old age, he has disappeared from my sight. Nor have I now left any other hope than that of rejoining him in Paradise. But of this God has given me a foretaste in the most blessed death that he has died; his own departure did not grieve him, as did the leaving me in this treacherous world, with so many troubles. Truly is the best part of my being gone with him, nor is anything now left me except an infinite sorrow. And herewith I bid you farewell."

Under Paul IV, Michelangelo was much employed in many parts of the fortifications of Rome; and for Sallustio Peruzzi, to whom that Pontiff had entrusted the construction of the great gate of the Castello Sant'Angelo, now half ruined, as we have related elsewhere, he undertook to distribute the statues required for that work, as well as to see and correct the models of the sculptors. At this time the French army approached Rome, and Michelangelo, believing that he might himself come to an evil end, together with the city, resolved to depart with Antonio Franzese, of Castel Durante, whom Urbino had left him at his death to serve him. He fled secretly from Rome accordingly, retiring into the mountains of Spoleto, where he visited several abodes of the Hermits. At that time Vasari wrote to him, sending him a little work which the Florentine citizen, Carlo Lenzoni, had left at his death to Messer Cosimo Bartoli, who was to have it printed, and dedicated to Michelangelo.[28] It was just then finished, and Vasari, who despatched it to Michelangelo, received the following in reply:

"MESSER GIORGIO, MY DEAR FRIEND,—I have received Messer Cosimo's little book, and in this shall be an acknowledgment, which I beg you to present to him with my service.

"I have in these last days undertaken a visit in the mountains of Spoleto, to the Hermits abiding there, at great cost of labor and money, but also to my great pleasure, insomuch that I have returned to Rome with but half my heart, for of a truth one finds no peace or quiet like that of those woods. More I have not to tell you. I rejoice that you are well and happy, and recommend myself to your friendly remembrance. This 18th day of Sept., 1556."

Michelangelo worked for his amusement almost every day at the group of four figures, of which we have before made mention. But he broke up the block at last, either because it was found to have numerous veins, was excessively hard, and often caused the chisel to strike fire, or

because the judgment of this artist was so severe that he could never content himself with anything that he did, a truth of which there is proof in
the fact that few of his works, undertaken in manhood, were ever completed; those entirely finished having been the productions of his youth.
Such for example were the Bacchus, the Pietà of the Madonna della
Febbre, the Colossal Statue at Florence, and the Christ of the Minerva,
which are finished to such perfection that a single grain could not be
taken from them without injury; while the statues of the Dukes Giuliano
and Lorenzo, with those of Night, Aaron, Moses, and the two figures belonging to the latter, altogether not amounting to eleven statues, have still
remained incomplete. The same may be said of many others. Nay,
Michelangelo would often remark that, if he were compelled really to
satisfy himself in the works to be produced, he should give little or nothing to public view. And the reason of this is obvious: he had proceeded
to such an extent of knowledge in art that the very slightest error could
not exist in any figure without his immediate discovery thereof. But having found such after the work had been given to view, he would never
attempt to correct it, and would commence some other production, believing that the like failure would not happen again. This then was, as he
often declared, the cause wherefore the number of pictures and statues
finished by his hand was so small.

When he had broken the Pietà, as related above, he gave it to
Francesco Bandini. And this happened about the time when the
Florentine sculptor, Tiberio Calcagni, had been made known to Michelangelo by the intervention of that Bandini, and of Messer Donato
Giannotti. For he, being one day in the house of the master, where the
broken Pietà still remained, inquired after a long discussion wherefore he
had destroyed so admirable a performance? To this our artist replied that
he had been moved thereto by the importunities of Urbino his servant,
who was daily entreating him to finish that work. There had, besides,
been a piece broken off the arm of the Madonna. And these things, with
a vein which had appeared in the marble and had caused him infinite
trouble, had deprived him of patience, insomuch that he not only broke
the group, but would have dashed it to pieces, if his servant Antonio had
not advised him to refrain, and to give it to some one even as it was.
Hearing this, Tiberio spoke to Bandini, who desired to have something
from his hand. And by means of the latter, Antonio received the offer of
two hundred crowns in gold on condition that he should prevail on
Michelangelo to permit that Tiberio, aided by the models of the master,
should complete the group for Bandini, by which means the labor already expended on it would cease to be lost.

Michelangelo presented them with the broken marbles accordingly,
and they instantly carried them away; when the parts were put together

by Tiberio, certain portions, I know not what, being added. But the death of Bandini, of Michelangelo, and of Tiberio himself caused the work to remain unfinished after all. It is now in the possession of Pierantonio Bandini, son of Francesco, and may be seen at his villa of Montecavallo.[29] But to return to Michelangelo, it now became needful to find some other block of marble that he might daily have opportunity for amusing himself with his chisel. He took a much smaller piece therefore, wherein he commenced another Pietà, but in a different manner.

Now the architect, Piero Ligorio, had entered the service of Pope Paul IV, and, busying himself with the fabric of San Pietro, he disturbed Michelangelo anew, going about declaring that the latter had fallen into second childhood. This offended our artist exceedingly. He would fain have then returned to Florence, and was much pressed to do so by Giorgio. But feeling that he had become old, for he had then attained his eighty-first year, he excused himself to Vasari, to whom, writing in his ordinary manner, he sent several spirited sonnets, setting forth that the end of his days was nearly come, that he must now be careful to direct his thoughts to suitable objects, that his letters must prove him to be at his eleventh hour, and that no thought arose in his mind which did not bear the impress of approaching death.

He added in one of his letters, "God has willed that the burden of my life must be endured for some time longer. I know you will tell me that, being old, I am unwise to attempt the making of sonnets, but since they say I am in my dotage, I do but perform my proper office. I see well the love you bear me, and do you, on your part, know to a certainty that I would gladly rest my weak frame by the bones of my father, as you exhort me to. But if I departed hence I should cause great injury to the fabric of San Pietro, which would be a shame as well as heavy sin. Yet when all is so far completed that nothing can be changed, I hope still to do as you desire, if indeed it be not sinful to disappoint a set of rogues who are expecting me daily to leave the world."

With this letter there came the following sonnet:

> Now in frail bark, and on the storm-tossed wave,
> Doth this my life approach the common port,
> Whither all haste to render up account
> Of every act,—the erring and the just.
> Wherefore I now do see, that by the love
> Which rendered Art mine idol and my lord,
> I did much err. Vain are the loves of man,
> And error lurks within his every thought.
> Light hours of this my life, where are ye now, /
> When towards a twofold death my foot draws near?

The one well-known, the other threatening loud.
Not the erst worshipped Art can now give peace
To him whose soul turns to that love divine,
Whose arms shall lift him from the Cross to Heaven.

From this we see that Michelangelo was drawing towards God and casting from him the cares of art, persecuted as he was by those malignant rivals, and by certain among the Commissioners for San Pietro, who would fain, as he said himself, be making themselves more than rightfully busy in the matter. Vasari replied to Michelangelo's letter, by order of Duke Cosimo, in few words, but still encouraging him to return to his own country. To his verses Giorgio replied by a sonnet of similar character. And Michelangelo would now without doubt have left Rome very gladly, but he had become so weak that, although he had determined on doing so, as will be related hereafter, yet the spirit was more willing than the frame, and his debility kept him in Rome. Now it happened in June, 1557, that in the construction of the vaulting over the apse (which was in travertine, and after Michelangelo's own designs) there was found to be an error, he not being able to visit San Pietro so frequently as before, and the principal builder having constructed the entire vaulting on one center, instead of using several as he ought to have done. Thereupon Michelangelo, as being the friend and confidant of Vasari, sent him the designs for the vaulting as made by himself, and with the words beneath written at the foot of two of them.

"The chief builder took the measure of the arch, which you will find marked in red, for that of the whole vaulting, but when he came to the center of the half-circle, which is at the summit of the same, he perceived his error as here seen in the design marked in black. But with this error it is that the work has been proceeding, insomuch that a large number of the stones will have to be displaced; for in the whole vaulting there is no masonry of bricks, all is in travertine, and the diameter of the arch, exclusive of the cornice which borders it, is twenty-two palms. This mistake has been committed because my advanced age prevents me from visiting the building so frequently as I could wish, although I had prepared an exact model of the work, as I do of every thing; and whereas I thought that part of the fabric was finished, it will now not be completed during the whole winter. If a man could ever die of shame and grief, I should not be living now. I beg you to account to the Duke for my not being at this moment in Florence."

On another of the designs, wherein Michelangelo had drawn the plan of the building, he wrote as follows:

"MESSER GIORGIO,—To the end that the difficulty of the vaulting

may be the more clearly comprehended, it becomes needful to describe the construction from the ground upwards. It was necessary to divide it into three sections, corresponding with the windows beneath, which are separated by piers; and these sections you see proceeding in the form of pyramids towards the inner center of the highest point of the vaulting, being in perfect harmony with the basement and sides thereof. But it was needful that the work should be regulated by a large number of centers for supporting the arches, which should have been constantly changed on all sides, and from point to point, for all which no fixed rule could be given; the circles and squares approaching the center of their deepest part having to be diminished, and to cross each other in so many directions, and to proceed to so many points, that it is without doubt exceedingly difficult to find the true proportions for bringing all to perfection. Yet, having the model—which I make for all things—they ought not to have committed so great an error as to attempt constructing all those three sections with one center for the arches; a mistake which has compelled the removal of many stones, which we have still the shame and expense of taking down. The entire vaulting, with its various sections and orna- ments, are, like the lowermost part of the chapel, wholly of travertine, a thing not customary in Rome."

The Duke Cosimo, perceiving all these hindrances, no longer pressed Michelangelo to return to Florence, declaring that the satisfaction of the master, and the continuation of San Pietro, were matters of greater in- terest to him than any other consideration, and begging that Michel- angelo would give himself no further anxiety. Whereupon, the latter wrote to Vasari, telling him that he thanked the Duke with all his heart for that great kindness, and adding, "God give me grace to serve him with this my poor person, for my memory and understanding are gone to await him elsewhere." The date of this letter was August, of the year 1557. Thus Michelangelo perceived that the Duke esteemed his life and honor more than his presence, which was nevertheless so highly accept- able to him: all these things, with many others which it is not necessary to repeat, we learned from letters written by his own hand.

Our artist was now much pressed to make his final arrangements known, and as he saw that little was done at the building (although he had partly advanced the internal frieze of the windows, and the double columns outside, which form the circle above the round cornice whereon the Cupola is to be placed, as will be related hereafter), he was encouraged by his best friends, as the Cardinal di Carpi, Messer Donato Giannotti, Francesco Bandini, Tommaso de' Cavalieri, and Lottino, nay, he was even constrained by them, to make at least a model of the Cupola; since, as he might perceive, the erection of the same was suffering delay.

Several months elapsed, nevertheless, before he could resolve on any-
thing. At length he made a beginning, and by degrees produced a small
model in clay, to the end that after this, and by the aid of the plans and
sections which he had likewise prepared, there might eventually be made
a much larger one in wood. Such a model was accordingly constructed
in somewhat less than a year, and under Michelangelo's guidance, by
Maestro Giovanni Franzese, who worked at the same with much zeal and
care. The dimensions and minute proportions of this smaller structure,
measured by the ancient Roman palm, corresponded in every particular
with those of the great Cupola, all the parts being executed with extreme
nicety; the members of the columns, the bases, capitals, doors, windows,
cornices, ressauts, and every other minutia, being represented in such sort
that no better work of the kind could be effected. It may indeed be af-
firmed that not in all Christendom, nor indeed through the whole
world, is there a grander or more richly decorated structure than will be
that now in question.

And since we have taken the time to note objects of so much less im-
portance, I think it will be our duty, as well as profitable to our readers,
to describe the design according to which Michelangelo proposed to
construct this church and Cupola. Wherefore, with such brevity as we
may, we will give a simple narration thereof, to the intent that if, which
may God not permit, this undertaking should continue to be impeded in
the lifetime of the master, as it has hitherto been, and should have a sim-
ilar fate after his death, so shall my writings, such as they may be, avail to
assist the faithful executors of his designs, and restrain the malignity of
those presuming persons who may desire to alter them. They may also
enlighten and give pleasure as well as aid to those who love and delight
in these vocations.

To commence then, I say that, according to the model made under the
directions of Michelangelo, the internal diameter will be a hundred and
eighty-six palms from wall to wall, reckoning above the great circular
cornice in travertine, which passes around the inside and rests on the four
double piers, or pilasters. These rise from the floor with their carved cap-
itals of the Corinthian order, being with their architrave, frieze, and cor-
nice also in travertine. This cornice, turning around the great recesses,
reposes on the four large arches, those of the three niches, and that of the
entrance namely, which form the cross of the church. From that point
upwards commences the Cupola itself, which springs from a basement of
travertine, with a platform six palms broad, forming a wall or passage
around the building.

That basement presents a circle in the manner of a well, the thickness
thereof being thirty-three palms eleven inches, the height to the upper
cornice eleven palms ten inches. The upper cornice is about eight palms,

and it projects about six palms and a half. Through this basement there are made four entrances by which the ascent to the Cupola is commenced, and these are placed above the arches of the tribunes, the thickness of the basement being divided into three parts. The innermost division measures fifteen palms, the outermost eleven palms, and that in the middle seven palms eleven inches, which make the thirty-three palms eleven inches before mentioned.

The middle portion of the basement is uncncumbered and serves as a passage. Its height is equal to twice its breadth. It has a coved ceiling, and in the line of the four entrances it has eight doors, each joined by four steps; one leads to the level of the cornice of the first basement, which is six and a half palms broad; another conducts to the inner cornice, eight and three-quarters palms broad, which encircles the Cupola. These doors give commodious access to the inside as well as outside of the edifice. The distance from one to another forms the segment of a circle of two hundred and one palms, and these being four, the entire circle is one of eight hundred and four palms. This basement, whereon repose the columns and pilasters, and which forms the interior frieze of the windows, is fourteen palms one inch high; and on the outside there is a slight cornice above and below, which does not project more than ten inches and is entirely of travertine.

In the thickness of the third part, above that of the interior, and which we have described as being fifteen palms broad, there is a staircase four and a quarter palms broad in each quarter of the circle. It has two branches, the one turning one way, and the other in the opposite direction. These staircases lead to the level of the columns, above which, and immediately over the center of the basement, there rise sixteen large piers entirely of travertine, each adorned with two columns on the outside and two pilasters within, as will be mentioned hereafter, and between these the whole space is left for the windows which are to give light to the Cupola.

On the side looking towards the center of the Cupola these great piers present a surface of thirty-six palms, but on the other side of nineteen and a half palms only. Each has two columns on the exterior side, the dado at the foot of these measuring eight palms and three-quarters, and eight and a half palms in height. The base is five palms eight inches broad, and . . . palms eleven inches high. The shaft of the columns has forty-three and a half palms in height; the diameter is five palms six inches at the base; and above four palms nine inches. The Corinthian capital is six and a half palms high, or with the mouldings nine palms. Three-quarters only of these columns are seen, the fourth being let into the corner; but in the center there projects a pilaster, which forms an acute angle. Between the pilasters is an entrance forming an arched door-

way, five palms broad and thirteen palms five inches high; but above this
level it is filled in with solid masonry even to the capitals of the columns
and pilasters, being united with two other pilasters similar to those which
form the acute angle beside the columns, and these decorate the sides of
the sixteen windows constructed around the circle of the tribune, each
window having a clear light twelve and a half palms wide, and about
twenty-two palms high.

The windows are adorned on the outside by an architrave of varied
character two palms and three-quarters broad, and on the inside they are
in like manner decorated with a similarly varied range of pediments and
arches intermingled, being broader without and narrower within, for the
purpose of increasing the light. They are lower also inside than out, to
the end that they may throw light on the frieze and cornice. Each win-
dow is enclosed between pilasters corresponding in height to the
columns on the outside, so that there are thirty-two columns without
and thirty-two pilasters within. Over the pilasters on the inside is the ar-
chitrave, which is four palms five inches high, while the frieze is four
palms and a half, the cornice being four palms and two-thirds, with a
projection of five palms. And over this is a range of balusters, to the end
that one may walk around in security.

For the more commodious ascent to the platform whence the
columns ascend, there is another flight of steps, with two branches, which
rise to the summit of the columns, capitals, architrave, frieze, and cornice;
so that this staircase, without interrupting the light of the windows,
passes at the upper end into a spiral stair of the same breadth until it at-
tains to the platform, whence the Cupola begins to turn.

All these arrangements, divisions and decorations are so varied, com-
modious, strong, and rich, the base gives such effectual support to the
two vaults of the Cupola which are turned upon it, the whole work is
so admirably conceived and so ably executed that the eyes of one who
understands and is capable of judging can see nothing more graceful,
more beautiful, or more ingenious. As to the masonry, and all that re-
spects the stability of the work, every part has received the utmost
strength and power of duration, while infinite judgment is displayed in
the conduits for carrying off water by concealed channels, and in every
other minutia.

At a word, the whole work, so far as it has hitherto proceeded, is
brought to such perfection that all other edifices shrink into nothing
when compared therewith. Very deeply it is to be regretted that those in
power have not put everything into Michelangelo's hands, to the end that
before the death of this extraordinary man we might have had this im-
mense and beautiful erection completed. Up to this point Michelangelo
has finished the masonry of the building. It now remains that we com-

mence the vaulting of the Cupola, of which, since we have the model, we will continue to describe the arrangement as he has left it to us. The centers of the arches are directed on three points which form a triangle as below.

A B

C

The lowermost, or point C, determines the form, height, and width of the first half-circle of the tribune,[30] which Michelangelo has ordered to be constructed of well-baked bricks, the thickness given to the wall being four palms and a half above as well as below, leaving a space in the middle which is four palms and a half wide at the foot; and this is to be occupied by the stairs leading from the cornice, whereon are the balustrades, to the lantern. The arch of the interior of the second vaulting, which is broader below and narrower above, proceeds from the point B, which gives four palms and a half as the thickness of the lower part.

The last arch, which represents the outer side, and is also enlarged below while it is restricted above, departs from the point A. At the upper part this arch gives the entire space in which are the stairs, whose height is of eight palms, so that men can walk upright therein, the thickness of the vault being gradually diminished to the extent that, while it has four palms and a half at the foot, it has three palms and a half only at the head. The vaultings, exterior and interior, are so well conjoined and connected that one supports the other; of the eight parts into which it is divided at the base, four are left hollow above the arches, to diminish the weight, while the four others are bound and secured to the piers in such sort that their durability may well extend to all time.

The central stairs between the two vaultings are made in the following manner. Those which start from the point whence the vault springs have each two branches, and proceeding through one of the sections they cross each other in the form of the letter X, until they attain the summit of the vaulting over the center of the arch C. Having thus ascended the half of this arch by a direct line, the remainder is commodiously surrounded by a flight which turns easily, until the summit, whence the lantern commences, is attained; around this there is a smaller range of double pilasters and windows similar to those in the interior, all corresponding with that diminution of the compartments which takes place above the piers, as will be described below.

Over the first great cornice within the tribune commence those concave compartments into which the vaulting is divided and which are formed by sixteen projecting ribs. These have the width of two of those pilasters which separate the windows placed under the vault of the Cupola at their base, but they constantly diminish up to the opening for the lantern. They rest on a pedestal of breadth equal to their

own and twelve palms high, based on the platform of the cornice which passes around the tribune. Over this and between the ribs are eight large ovals, each twenty-nine palms high, while above them is a range of rectangular compartments twenty-four palms high and somewhat broader at the lower than the upper edge. But where the ribs approach each other more nearly, then come circles, fourteen palms high, over each square, so that there are eight ovals, eight squares, and eighth circles; each range being less deeply concave, as well as smaller, than that beneath it: a most rich and beautiful design. Michelangelo proposing to form the ribs, and frame-work of all these compartments in carved work of travertine.

There remains that we mention the superficies and ornaments of the exterior vaulting, which rises from a basement twenty-five palms and a half high, reposing on a socle which has a projection of two palms, as have the mouldings at the head. The master proposed to cover the whole roof with lead, as was done for the old church of San Pietro. He divided it into sixteen spaces, which commence at the point where the double columns end, and are placed between them. In the center of each space he formed two windows, making thirty-two in all, and serving to light the staircases between the two vaultings. To these he added projecting corbels supporting the segment of a circle, the whole forming a kind of roof which serves to throw off the rain.

In the line of the columns and in the center of the space between them, the ribs were made to spring from that point where the cornice ends; they were broader at the base and narrower at the summit, sixteen in all, and of five palms in width. In the center of each there was a channel formed, a palm and a half broad; and in this were stairs of about a palm high, by which an ascent can be made to the opening left for the lantern. These are to be of travertine, constructed in such sort as shall defend them from the effects of the frost and rain.

The design for the lantern makes that structure diminish in the same proportion with all the other parts of the work, becoming gradually smaller in exact measure, and ultimately closing with a small temple having round columns, which stand in pairs, as do those below. They have pilasters behind them, and rest on a socle, so that one can pass around from pilaster to pilaster, looking down upon the windows, the interior of the Cupola, and the church. An architrave with frieze and cornice surrounds the whole, and projects over the two columns, immediately above which are spiral shafts and niches, rising together to the summit of the coping, which begins to contract at about one-third of their height in the manner of a circular pyramid, until it reaches to where the ball and cross are to form the completion of the structure.

I might here add numerous details, such as the precautions taken

against earthquakes, the conduits for water, the various lights and other commodious arrangements, but I refrain, since the work is not yet finished, and it shall suffice me to have touched on the principal parts. All the details, moreover, are within reach of the reader's eyes, and can be seen. This slight sketch will therefore be sufficient to inform such as know nothing of the building.

The completion of this model was a great satisfaction, not only to the friends of Michelangelo but to all Rome. He continued to direct the works until the death of Pope Paul IV; and when Pius IV was chosen in his place, that Pontiff, although employing Piero Ligorio, who was architect of the Vatican, to construct the little Casino in the wood of the Belvedere, yet made many offers of service and showed much kindness to Michelangelo. The *Motu-proprio* of Paul III, Julius III, and Paul IV in respect to the fabric of San Pietro was confirmed by His Holiness, who likewise restored a portion of those allowances which our artist had lost during the pontificate of Paul IV. He employed him in many of his own buildings, and during his reign the works of San Pietro likewise proceeded busily.

Among other things, Michelangelo was required to prepare the design for a monument to the memory of the Pope's brother, the Marquis of Marignano, which the Cavaliere Lione Lioni of Arezzo, an excellent sculptor and the friend of Michelangelo, was commissioned to construct in the Cathedral of Milan, as will be related in its due place.

About the same time the Cavaliere Lioni made the portrait of Michelangelo (a very close resemblance) in a medal; on the reverse of which, and in compliment to the master, was a blind man led by a dog, with the following legend:

DOCEBO INIQUOS VIAS TVAS, ET IMPII AD TE CONVERTENTUR.[31]

This pleased Michelangelo greatly, and he presented Lioni with a model in wax of Hercules killing Antæus, accompanied by several of his designs. Of Michelangelo we have no other portrait except two in painting, one of which is by Bugiardino, and the other by Jacopo del Conte, with an alto-relievo in bronze by Daniello Ricciarelli.[32] But from that of the Cavaliere Lioni there have been made so many copies that I have myself seen a vast number both in Italy and other countries.

In the same year, Giovanni Cardinal de' Medici, son of Duke Cosimo, went to Rome to receive the Hat from Pope Pius IV, when Vasari, who was his friend and servant, determined to go with him, remaining there willingly for a month to enjoy the society of Michelangelo, whom he held very dear, and visited constantly. Vasari had taken with him, by order of his Excellency, the model in wood of the Ducal Palace of Florence, together with the designs for the new apartments, which had been built

and painted by himself. These models and designs Michelangelo desired to see, since, being old, he could not visit the works themselves.

They were extensive, varied, and replete with divers inventions and fantasies, exhibiting stories of Uranus, Saturn, Ops, Ceres, Jupiter, Juno, and Hercules; each apartment being adorned with histories, in numerous compartments, of one of those gods. The apartments beneath these were decorated with stories from the lives of heroes belonging to the house of Medici, beginning with Cosimo the Elder, and proceeding through the times of Lorenzo, Leo X, Clement VII; the Signor Giovanni,[33] the Duke Alessandro, and, finally, of Duke Cosimo. There were portraits of these personages moreover, with those of their sons, and of many among the renowned of old times, whether distinguished for statesmanship, in arms, or for their learning, and being almost all portraits taken from the life.

A Dialogue written by Vasari, in which the whole of these paintings were explained, and the connexion of the fables in the upper rooms with the histories in the lower apartments set forth, was read by Annibale Caro to Michelangelo, who was much pleased with the same. This Dialogue, Vasari proposes to publish, when he shall find time to do so.

These things caused a discussion to arise respecting the Great Hall, which Vasari had desired to alter, because the ceiling thereof was too low, giving it a stunted appearance, and it had besides too little light. For these causes Vasari wished to raise it, but the Duke had not yet given him leave to do so. It was not that his Excellency feared the cost, but he dreaded the danger that there might be in lifting a roof thirteen braccia, yet, judicious as he was, he now agreed to have the opinion of Michelangelo on the subject. The model of the hall in its early condition was then laid before the master, as was also that of its improved state, with all the stories designed as they were to be painted therein. Having examined all this, Michelangelo was so much pleased that he became rather the partisan than the judge of the work, the rather as all the precautions taken for the security and promptitude of its execution were also apparent to his perceptions. And when Vasari returned to Florence, Michelangelo wrote by him to the Duke, declaring that his Excellency ought to execute that undertaking, which he affirmed to be worthy of his greatness.

Now Duke Cosimo himself also repaired that same year to Rome with his consort, the Duchess Leonora, when Michelangelo went to see his Excellency, who received him with much favor, causing him, from respect to his great genius, to be seated near himself, and conversing with him very familiarly of all the works in painting and sculpture which he had commanded to be performed, and still proposed to execute in Florence, more especially of the hall above mentioned. Michelangelo then encouraged Cosimo anew to that undertaking, expressing his regret that he was himself no longer young enough to do him service, for he

did truly love that Prince. Among other things, the Duke told him how he had discovered the method of working porphyry, and as Michelangelo did not believe that possible, his Excellency sent him the Head of Christ, executed in porphyry by the sculptor Francesco del Tadda (as we have said in the first chapter of our *Theories*), which astonished him greatly.

Michelangelo visited the Duke several times afterwards, during the stay of the latter in Rome, to the great satisfaction of both; and when the most illustrious Don Francesco de' Medici, son of Duke Cosimo, was in Rome a short time afterwards, the master visited him likewise; being much pleased with the respect and affection shown to him by the noble Prince, who always spoke to him with uncovered head, so great was his reverence for that extraordinary man. To Vasari, Michelangelo wrote, declaring that it grieved him to be so old and infirm that he could do nothing for his Excellency; and he went about Rome looking for some fine piece of antiquity that he might send the same to Florence as a present for that Signore.

About this time Pope Pius required from Michelangelo a design for the Portia Pia, and the master made him three, all singularly beautiful. Of these the Pontiff chose the least costly, and this has been erected to the great credit of the artist. Finding, moreover, that His Holiness would gladly have the other gates of Rome restored, he made numerous designs for the same, as he also did one, at the request of Pope Pius, for the new church of Santa Maria degli Angeli, constructed in the Baths of Diocletian when that building was brought into the service of Christians. The design of Michelangelo surpassed those of many other excellent architects by the singular consideration displayed therein for the requirements of the Carthusian monks, who have now nearly completed the edifice.

His Holiness, with all the prelates and those of the court who have seen it, have indeed been amazed at the judgment with which he has availed himself of the whole skeleton of those Baths, whereof he has made a church with so beautiful an entrance that the expectation of the architects has been much surpassed, to the infinite honor of the master. He designed a ciborium for the Sacrament also, which the Pope desired to have made for this church. It has been executed, for the most part, by Jacopo Ciciliano, an excellent artist in bronze, whose castings succeed so well and are so delicately fine that they require but little chiseling, for in this respect Jacopo is a distinguished artist, and greatly pleased Michelangelo.

Now the Florentines in Rome had often talked of beginning in good earnest to set about the church of San Giovanni in the Strada Giulia. All the heads of the richest families among them assembled with that view, promising to contribute according to their means for that purpose; and a

good sum of money was got together. A discussion then arose as to whether it were better to pursue the old plans or to have something newer and better; when it was at length determined that a new edifice should be raised on the old foundations, the care of the whole being committed to three persons, Francesco Bandini, Uberto Ubaldini, and Tommaso de' Bardi.

By these persons an application for a design was made to Michelangelo, to whom they represented that it was a disgrace for the Florentines to have spent so much money without any profit, adding that, if his genius did not avail to finish the work, they should be wholly without resource. The master assured them, with the utmost kindness, that the design they required should be the first thing he would lay hand on; remarking, moreover, that in this his old age he was glad to be occupied with things sacred, and such as might contribute to the honor of God. He furthermore declared that it rejoiced him to do something for his own people, to whom his heart was ever true.

At this time Michelangelo had with him the Florentine sculptor Tiberio Calcagni, a youth who greatly desired to improve in his art, and who, having gone to Rome, had also given his attention to architecture. Being pleased with his manners, Michelangelo had given him the Pietà which he had broken, as we have said, with a head of Brutus in marble, larger than life, which he had copied, at the request of his friend Messer Donato Giannotti, for the Cardinal Ridolfi, from a carnelian of the highest antiquity belonging to Messer Giuliano Cesarino; a beautiful thing it is, and this he now desired that Tiberio should finish. He could, indeed, no longer execute the more delicate parts of his architectural designs, and therefore employed Tiberio, who was a modest and well-conducted youth, to complete them under his direction. For this church, therefore, he now required him to take the ground plan of the original foundation, which he brought to Michelangelo. The latter instantly caused him to inform the Commissioners, who did not expect to find anything yet accomplished, that he had fulfilled their wishes, showing them at the same time five plans of beautiful churches, which surprised them greatly. He then bade them choose one; but they refused, preferring to abide by his own decision. Yet, the master insisting that they should make a selection, they all with one accord declared for the richest; whereupon Michelangelo is reported to have told them that, if they brought that design to completion, they would do more than either Romans or Greeks had ever done in their best of times; words which certainly never proceeded from his mouth, neither at that time nor at any other, seeing that he was always most reserved and modest.

It was finally determined that Michelangelo should direct the work, while Tiberio should execute it, and the Commissioners, to whom our

artist promised his best services for the church, were entirely satisfied with that arrangement. The plan was then given to Tiberio, that he might copy it in all parts, with due order; and the master commanded that a model in clay should be prepared, which he showed Tiberio how to fix up firmly. This, which was of eight palms, Tiberio completed in ten days, and it pleased all the Florentine community. Wherefore they caused him afterwards to make one in wood, which is now in their Consulate, and a beautiful church it is as ever man beheld, grand, rich, and varied. The building was commenced accordingly; but when five thousand crowns had been expended thereon, the works ceased for lack of funds to Michelangelo's infinite vexation. He then procured for Tiberio the commission to finish, under his direction, a chapel which the Cardinal of Santa Fiore had commenced in the church of Santa Maria Maggiore. But this also remained unfinished at the death of the Cardinal, of Michelangelo, and of Tiberio himself; the early demise of the latter being an event much to be regretted.

Michelangelo had been seventeen years in the fabric of San Pietro, and the Commissioners had more than once attempted to remove him, but not succeeding, they labored continually to throw obstacles in his way, hoping to weary his patience, seeing that he was now old, and could endure but little. At this time it chanced that Cesare da Castel Durante, overseer of the works, died; when Michelangelo, to the end that the building should not suffer, and until he could find a successor after his own heart, sent Luigi Gaeta thither in his place, a very young man certainly, but not without experience. Some of the Commissioners had, however, been frequently trying to bring Nanni di Baccio Bigio into that undertaking, he having urged them much to do so, and promising great things. They now, therefore, thinking of managing everything in their own fashion, sent away Luigi Gaeta, when Michelangelo, much displeased by this, would no longer go to San Pietro; and they, the Commissioners, then began to give out that a substitute must be provided, he being able to do no more, and having himself declared, as they said, that he would no longer trouble himself with that work.

These things coming to Michelangelo's ears, he sent Daniello Ricciarelli of Volterra to the Bishop Ferratino, one of the Commissioners, who had told Cardinal Carpi that Michelangelo had assured a servant of his that he would have no more to do with the building. Daniello now informed the Bishop that it was not Michelangelo's wish to give it up. But Ferratino replied that he was sorry the master had not made his purpose known, adding nevertheless that a substitute was needful, and that he would have gladly accepted Daniello himself, a reply with which Michelangelo appeared to be satisfied. The Bishop then gave the rest of the Commissioners to understand, in the name of Michelangelo, that a

substitute was to be appointed. But instead of presenting Daniello, he put forward Nanni Bigio in his place. The latter was accordingly accepted and installed, nor had any long time elapsed before he caused a scaffolding to be raised from the Pope's stables, which are on the side of the hill, to the great apse which looks towards that side, declaring that too many ropes were consumed in drawing up the materials, and that it would be better to raise them by means of his scaffolding.

Being made acquainted with this proceeding, Michelangelo repaired to the Pope, whom he found on the piazza of the Capitol, and speaking somewhat loudly, His Holiness made him enter a room, when the master exclaimed, "Holy Father! a man of whom I know nothing has been placed by the Commissioners in San Pietro as my substitute, but if they and Your Holiness are persuaded that I can no longer fulfil my office, I will return to take my rest in Florence, where I shall be near that great Prince who has so often desired my presence, and can finish my life in my own house; wherefore I beg the good leave of Your Holiness to depart." The Pope, whom that proposal did not please, sought to pacify the master with kind words, and bade him come to Araceli on the following day to talk of the matter. Having there assembled the Commissioners, His Holiness inquired the cause of these things. And they, declaring that the building was in danger of being ruined by the errors committed therein, which he knew was not the case, the Pope commanded Signor Gabrio Scierbellone to examine the structure, and require Nanni, who had made these assertions, to show where the errors might be found.

The master being examined accordingly, and Signor Gabrio finding all the reports to be false and malignant, Nanni was dismissed with few compliments, and in the presence of many nobles, being reproached at the same time with the destruction of the bridge of Santa Maria, and with having promised to clean the harbor of Ancona at small cost, whereas he had injured that port more in one year than the sea had ever done in ten. And this was the end of Nanni Bigio's employment in San Pietro, where Michelangelo had employed seventeen years merely in the care of so fixing the arrangement of all its parts that they should not be altered; the envious persecutions to which he was subjected making him fear that changes in the building might be effected after his death. But he has thus brought things to such a state that the work has now a fair prospect of being securely completed.

By all this we see that God, who protects the good, has defended him while he lived, having extended his hand over the fabric and the master even to his death. Then Pope Pius IV, who survived him, commanded the superintendents to alter nothing that Michelangelo had arranged; while Pius V, his successor, continued with even greater authority to command that the designs of Michelangelo should be followed with un-

varying exactitude. Nay, when the architects Piero Ligorio and Jacopo Vignola were directing the fabric, he caused the former, who presumptuously proposed certain changes, to be dismissed with little honor, and the whole charge was then made over to Vignola.

That Pontiff was indeed as zealous for the honor of the edifice as for the glory of the Christian faith; and in the year 1565, when Vasari went to pay his respects to His Holiness—as well as in the next year, when he was again summoned to Rome—the Pontiff spoke of nothing but the regard that was to be paid to the designs left by Michelangelo. And, to obviate all disorder, he commanded Vasari to repair to the Bishop Ferratino, in company with Messer Guglielmo Sangalletti, the private treasurer of His Holiness, on the part of Pope Pius, and to direct that prelate, who was chief of the builders, on all occasions to guide himself by the important records and memoranda which Vasari would give him; to the end that no malignant or presumptuous person should ever prevail to alter a single point of those arrangements made by the admirable genius of Michelangelo. On this occasion, Messer Giovambattista Altoviti, a good friend of Vasari and of these arts, was also present; and when Ferratino had heard the discourse made to him by Vasari, he solemnly promised to observe, and see observed, every order and arrangement left by Michelangelo, adding that he would himself be the protector, defender, and preserver of the labors performed by that great man.

Returning to Michelangelo himself, I have to relate that, about a year before his death, Vasari secretly prevailed on Duke Cosimo to move the Pope, through Messer Averardo his Ambassador, to the end that, since Michelangelo was now much debilitated, His Holiness should keep a careful eye on those by whom he was surrounded, and should cause him to be visited at his house for the due preservation of his designs, cartoons, models, and other property, taking measures, in the event of any sudden accident, such as may well happen to the very old; and this, in order that whatever might belong to, or be needful for, the fabric of San Pietro, the sacristy and library of San Lorenzo, or the façade of the last-named church might not be taken away, as so frequently happens. Nor were these precautions, which were all duly attended to, without a satisfactory result.

In the Lent of this year, Lionardo, the nephew of Michelangelo, resolved to go to Rome, as though divining that his kinsman was now near the end of his life. And the promise of this visit was all the more welcome to the latter, as he was already suffering from a slow fever. He caused his physician, Messer Federigo Donato, to write to Lionardo, hastening his arrival; but his malady increased, notwithstanding the cares of those around him. Still, retaining perfect self-possession, the master at

length made his will in three words, saying he left his soul to God, his body to the earth, and his goods to his nearest relations. He recommended his attendants to bethink themselves, in the passage from this life, of the sufferings endured by Our Savior Christ; and on the 17th of February, in the year 1563, and at 23 o'clock, according to the Florentine computation (in 1564 after that of Rome) he departed to a better life.

Michelangelo found his chief pleasure in the labors of art. All that he attempted, however difficult, proving successful, because nature had imparted to him the most admirable genius, and his application to those excellent studies of design was unremitting. For the greater exactitude, he made numerous dissections of the human frame, examining the anatomy of each part, the articulations of the joints, the various muscles, the nerves, the veins, and all the different minutiæ of the human form. Nor of this only, but of animals, and more particularly of horses, which he much delighted in, and kept for his pleasure, examining them so minutely in all their relations to art that he knew more of them than do many whose sole business is the care of those animals. These labors enabled him to complete his works, whether of the pencil or chisel, with inimitable perfection, and to give them a grace, a beauty, and an animation wherein (be it said without offence to any) he has surpassed even the antique. In his works he has overcome the difficulties of art with so much facility that no trace of labor appears in them, however great may be that which those who copy them find in the imitation of the same.

The genius of Michelangelo was acknowledged in his lifetime and not, as happens in many cases, after his death only. And he was favored, as we have seen, by Julius II, Leo X, Clement VII, Paul III, Julius III, Paul IV, and Pius IV. These Pontiffs having always desired to keep him near them, as indeed would Soliman, Emperor of the Turks, Francis, King of France, the Emperor Charles V, the Signoria of Venice, and lastly Duke Cosimo de' Medici all very gladly have done, each of those monarchs and potentates having offered him the most honorable appointments for the love of his great abilities. These things do not happen to any except men of the highest distinction; but in him all the three arts were found in such perfection as God hath vouchsafed to no other master, ancient or modern, in all the many years that the sun has been turning round.

His powers of imagination were such that he was frequently compelled to abandon his purpose, because he could not express by the hand those grand and sublime ideas which he had conceived in his mind; nay, he has spoiled and destroyed many works for this cause. And I know too that some short time before his death he burnt a large number of his designs, sketches, and cartoons that none might see the labors he had endured, and the trials to which he had subjected his spirit, in his resolve not to fall short of perfection. I have myself secured some drawings by

his hand, which were found in Florence, and are now in my book of designs. And these, although they give evidence of his great genius, yet prove also that the hammer of Vulcan was necessary to bring Minerva from the head of Jupiter. He would make his figures of nine, ten, and even twelve heads long, for no other purpose than the research of a certain grace in putting the parts together which is not to be found in the natural form, and would say that the artist must have his measuring tools, not in the hand but in the eye, because the hands do but operate, it is the eye that judges. He pursued the same idea in architecture also.

None will marvel that Michelangelo should be a lover of solitude, devoted as he was to Art, which demands the whole man, with all his thoughts, for herself. He who resigns his life to her may well disregard society, seeing that he is never alone nor without food for contemplation. And whoever shall attribute this love of solitude to caprice or eccentricity does wrong. The man who would produce works of merit should be free from cares and anxieties, seeing that Art demands earnest consideration, loneliness, and quietude; she cannot permit wandering of the mind. Our artist did nevertheless greatly prize the friendship of distinguished and learned men. He enjoyed the society of such at all convenient seasons, maintaining close intercourse with them, more especially with the illustrious Cardinal Ippolito de' Medici, who loved him greatly. Having heard that an Arab horse which he possessed was much admired for its beauty by Michelangelo, the Cardinal sent it to him as a present, with ten mules, all laden with corn, and a servant to take care of those animals, which the master accepted very willingly.

The most illustrious Cardinal Pole was also a very intimate friend of Michelangelo, who delighted in the talents and virtues of that prelate. The Cardinals Farnese and Santa Croce, the latter afterwards Pope Marcello, with the Cardinals Ridolfi and Maffeo, Monsignore Bembo, Carpi, and many other Cardinals and Prelates were in like manner among his associates, but need not all be named here. Monsignore Claudio Tolomei was one of his intimates, and the magnificent Messer Ottaviano de' Medici was his gossip, Michelangelo having been godfather to one of his sons. Another of his friends was Messer Bindo Altoviti, to whom he gave that cartoon of the chapel, wherein Noah is represented as inebriated and derided by one of his sons, while the other two compassionately seek to veil the degradation of their father.

Messer Lorenzo Ridolfi, Messer Annibale Caro, and Messer Giovan Francesco Lottini, of Volterra, were likewise among the friends of Michelangelo. But more then all the rest did he love Messer Tommaso de' Cavalieri, a Roman gentleman, still young and much inclined to these arts. For him, and to promote his acquirement of drawing, he made superb cartoons, beautiful heads in red and black chalks, with a Gany-

mede carried to heaven by the Bird of Jove, a Tityas with the Vulture devouring his heart, the Chariot of the Sun with Phaeton therein falling into the river Po, and a Bacchanalia of Children, each and all of which are most admirable.

Michelangelo also made the portrait of Messer Tommaso in a cartoon the size of life; he, who never painted the likeness of any one either before or after, seeing that he hated to take anything from the life, unless it presented the very perfection of beauty. These drawings were afterwards increased by those which Michelangelo made for Sebastiano del Piombo, to the end that he might put them into colors; and which were obtained by Messer Tommaso, who has a great delight in these works, which are indeed most admirable, and well merit to be kept as he keep them in the manner of relics; but he very liberally permits artists to use them at their pleasure.

The friendships of Michelangelo were all for deserving and noble persons, he having much judgment in all things. Messer Tommaso induced him to execute numerous drawings for his friends, among others an Annunciation in a new manner for the Cardinal di Cesis. This was afterwards painted by Marcello of Mantua, and placed in the marble chapel constructed by that Cardinal in the church of the Pace at Rome. Another Annunciation, also painted by Marcello, is in the church of San Giovanni Laterano, and the design for this is in the possession of Duke Cosimo, given by Lionardo Buonarroti, after the death of his uncle, to his Excellency, who keeps it like a jewel, with a figure of Christ in the Garden, and other cartoons and sketches from the hand of Michelangelo. The Duke also possesses a statue five braccia high, representing the Goddess of Victory, with a captive lying beneath her. He has besides a group of four Captives, merely rough-hewn, but which may well serve to teach all men how statues may be extracted from marble without injury to the stone.

The method of proceeding is to take a figure of wax, or other firm material, and lay it in a vessel of water, which is of its nature level at the surface. The figure, being then gradually raised, first displays the more salient parts, while the less elevated still lie hidden, until, as the form rises, the whole comes by degrees into view. In the same manner are figures to be extracted by the chisel from the marble, the highest parts being first brought forth, till by degrees all the lowest parts appear. And this was the method pursued by Michelangelo in these figures of the Captives, which his Excellency would fain see adopted as models by his academicians.

Michelangelo loved the society of artists, and held much intercourse with many among them, as, for example, with Jacopo Sansovino, Il Rosso, Pontormo, Daniello da Volterra, and the Aretine Giorgio Vasari, to whom he showed infinite kindness. It was by him indeed that Vasari

was led to the study of architecture, Michelangelo intending some day to make use of his services, and gladly conferring with him on matters connected with art. Those who affirm that he was not willing to instruct others are wrong. He would assist all with whom he was intimate or who asked his counsels. I have been present many times when this has happened, but I say no more, not desiring to proclaim the defects of others. It is true that he was not fortunate with those whom he took into his house, having chanced upon disciples wholly incapable of imitating their master. The Pistolese, Pietro Urbino, had ability but would never give himself the trouble to work. Antonio Mini was sufficiently willing, but had not quickness of perception, and when the wax is hard it does not take a good impression. Ascanio della Ripa took great pains, but no results have been displayed, whether in designs or finished works. He spent several years over a picture of which Michelangelo had given him the cartoon, and, at a word, the hopes conceived of him have vanished in smoke. I remember that Michelangelo, having compassion on Ripa's hard labors, would sometimes help him with his own hand, but it was all to little purpose.

Had he found a disciple to his mind, he would have made studies of anatomy, and written a treatise on that subject, even in his old age, as he often said to me, desiring to do this for the benefit of artists, who are frequently misled by want of knowledge in anatomy. But he distrusted his power of doing justice to his conceptions with the pen, having little practice in speaking, although in his letter he expressed his thoughts well and in few words. He delighted in the reading of our Italian poets, more especially of Dante, whom he honored greatly and imitated in his thoughts as well as copied in his inventions.

Like Petrarch also, he was fond of writing madrigals and making sonnets, many of which are very serious, and have since been made subjects of commentary. Messer Benedetto Varchi, for example, has read an admirable lecture before the Florentine Academy, on that beginning:

> Non ha l'ottimo artista alcun concetto
> Ch'un marmo solo in se non circonscriva.[34]

Michelangelo sent a large number of these verses to the most illustrious Marchesana di Pescara, receiving replies both in verse and prose from that lady, of whose genius he was as much enamored as she of his. She went more than once from Viterbo to Rome to see him, and Michelangelo designed for her a Pietà, with two Angels of infinite beauty; an admirable work, as is also a figure of Christ on the Cross, raising his head to heaven, and commending his spirit to his Father, and one of Our Savior at the Well with the Woman of Samaria, both executed for the Marchesana. He delighted in the reading of scripture, like a good

Christian as he was, and greatly honored the writings of Fra Girolamo Savonarola, whom he had heard in the pulpit.

He was an ardent admirer of beauty for the purposes of art; and from the beautiful he knew how to select the most beautiful, a quality without which no master can produce perfection. But he was not liable to the undue influence of beauty, as his whole life has proved. In all things Michelangelo was exceedingly moderate. Ever intent upon his work during the period of youth, he contented himself with a little bread and wine, and at a later period, until he had finished the chapel namely, it was his habit to take but a frugal refreshment at the close of his day's work. Although rich, he lived like a poor man; rarely did any friend or other person eat at his table. And he would accept no presents, considering that he would be bound to any one who offered him such. His temperance kept him in constant activity, and he slept very little, frequently rising in the night, because he could not sleep, and resuming his labors with the chisel.

For these occasions he had made himself a cap of pasteboard, in the center of which he placed his candle, which thus gave him light without encumbering his hands. Vasari had often seen this cap; and, remarking that Michelangelo did not use wax lights, but candles made of unmixed goat's tallow, which are excellent, he sent the master four packets of the same, weighing forty pounds. His own servant presented them respectfully in the evening, but Michelangelo refused to accept them. Whereupon the man replied, "Messere, I have nearly broken my arms in bringing them from the bridge hither, and have no mind to carry them back; now, there is a heap of mud before your door which is thick enough to hold them upright, so I'll e'en stick them up there, and set them all a-light." But, hearing that, the master bade him lay down the candles, declaring that no such pranks should be played before his house.

He has told me that, in his youth, he frequently slept in his clothes; being wearied with his labors he had no mind to undress merely that he might have to dress again. Many have accused him of being avaricious, but they are mistaken. He has proved himself the contrary, whether as regards his works in art or other possessions. He presented rich productions of various kinds, as we have seen, to Messer Tommaso de' Cavalieri and Messer Bindo, with designs of considerable value to Fra Bastiano. While to his disciple, Antonio Mini, he gave designs, cartoons, the picture of the Leda, and all the models in clay or wax that ever he had made, but which were left in France as we have said.

To Gherardo Perini, a Florentine gentleman and his friend, he gave three plates of most beautiful heads, which have fallen since his death into the hands of the most illustrious Don Francesco, Prince of Florence, by whom they are kept as the gems which they truly are. For Bartolom-

meo Bellini, he made the cartoon of a Cupid kissing his mother Venus; a beautiful thing, now at Florence, in the possession of Bellini's heirs. For the Marquis del Vasto, moreover, he made the cartoon of a *Noli me tangere;*[35] and these two last-mentioned works were admirably painted by Pontormo. The two Captives he gave to Signor Roberto Strozzi; and the Pietà, in marble, which he had broken, to Antonio, his servant, and Francesco Bandini.

Who is it then that shall tax this master with avarice, seeing that the gifts he thus made were of things for which he might have obtained thousands of crowns? To say nothing of a fact, which I well know, that he has made innumerable designs, and inspected buildings in great numbers without even gaining one scudo for the same. But to come to the money which he did gain: this was made, not by offices nor yet by trafficking or exchanges, but by the labor and thought of the master. I ask also, can he be called avaricious who assisted the poor as he did, who secretly paid the dowry of so many poor girls, and enriched those who served him? As witness, Urbino, whom he rendered very rich; this man, having been long his disciple, had served him many years when Michelangelo one day said to him, "When I die what wilt thou do?" "Serve some one else," replied Urbino. "Thou poor creature!" returned Michelangelo, "I must save thee from that." Whereupon he gave him two thousand crowns at one time, a mode of proceeding befitting the Cæsars and high princes of the world. To his nephew also, he has more than once given three and four thousand crowns at a time, and has finally left him ten thousand crowns, besides the property in Rome.

Michelangelo had remarkable strength of memory, insomuch that, after having once seen a work of any other artist he would remember it so perfectly that, if it pleased him to make use of any portion thereof, he could do so in such a manner that none could perceive it. In his youth he was once supping with some painters, his friends, when they amused themselves with trying who could best produce one of those figures, without design and of intense ugliness, such as those who know nothing are wont to scratch on the walls. Here his memory came to his aid. He remembered precisely the sort of absurdity required, and which he had seen on a wall. This he reproduced as exactly as if he had had it before his eyes, surpassing all the painters around him: a very difficult thing for a man so accomplished in design, and so exclusively accustomed to the most elevated and finished works of mastery as was Michelangelo.

He proved himself resentful, but with good reason, against those who had done him wrong; yet he never sought to avenge himself by any act of injury or violence. Very orderly in all his proceedings, modest in his deportment, prudent and reasonable in discourse, usually earnest and serious, yet sometimes amusing, ingenious, and quick in reply, many of his

remarks have been remembered and well merit to be repeated here. But I will add only a few of these recollections.

A friend, once speaking to him of death, remarked that Michelangelo's constant labors for art, leaving him no repose, must needs make him think of it with great regret. "By no means," replied Michelangelo, "for if life be a pleasure, yet, since death also is sent by the hand of the same master, neither should that displease us." To a citizen who observed him standing at Or San Michele, to look at the San Marco of Donatello, and who inquired what he thought of that statue, he replied that he had never seen a face looking more like that of a good man, adding: "If St. Mark looked thus we may safely believe what he has written." Being once shown the drawing of a boy who was recommended to his favor, and told, by way of excuse for defects, that he had not been long learning, he answered, "It is easy to perceive that." A similar remark escaped him when a painter who had depicted a Pietà was found to have succeeded badly. "It is indeed a pity," observed the master.

When Michelangelo heard that Sebastiano Veniziano was to paint a monk in the chapel of San Pietro-a-Montorio, he declared that this would spoil the work, and being asked wherefore, replied that "as the monks had spoiled the world, which was so large, it could not be surprising that they should spoil that chapel, which was so small." A painter had executed a work with great labor, and spent much time over it, but acquired a good sum when it was finished. Being asked what he thought of the artist, Michelangelo replied, "While he is laboring to become a rich man, he will always continue a poor painter."

A friend of his, who had taken orders, arrived in Rome wearing the garb of a pilgrim, and meeting Michelangelo, saluted him. But the latter pretended not to know him, compelling the monk to tell his name at length, when Michelangelo, feigning surprise at his dress, remarked, "Oh, you really have a fine aspect; if you were but as good within as you seem without, it would be well for your soul." The same monk had recommended a friend of his own to Michelangelo, who had given him a statue to execute, and the monk then begged him to give something more. This also our artist good-naturedly did, but it was now found that the pretended friend had made these requests only in the certainty that they would not be granted, and suffered his disappointment to be seen. Whereupon Michelangelo declared that such gutter-minded men were his abhorrence, and continuing to take his metaphors from architecture, he added, "channels that have two mouths rarely act well."

Being asked his opinion of an artist who, having copied the most renowned antique marble statues and imitated the same, then boasted that he had surpassed the ancients, he answered to this effect: "He who walks on the traces of another is but little likely to get before him; and

an artist who cannot do good of himself is but poorly able to make good use of the works of others."

A certain painter, I know not who, had produced a picture wherein there was an ox that was better than all besides, when, being asked why the artist had made that animal more life-like than the rest, Michelangelo replied, "Every painter draws himself well." Passing one day by San Giovanni, in Florence, he was asked his opinion of the doors, and said, "They are so beautiful that they deserve to be used as the gates of Paradise." Seeing a prince who changed his plans daily, and was never in one mind, he remarked to a friend, "The head of this Signore is like a weather-cock; it turns round with every wind that touches it."

Going to see a work in sculpture which was about to be fixed in its place, the sculptor took great pains to arrange the lights that the work might be seen well, when Michelangelo said: "Do not trouble yourself; the principal question is how it will bear the light of the Piazza"—meaning to imply that, when a work is given to public view, the people judge it, whether good or bad. There was a great prince in Rome who desired to pass for a good architect, and had caused certain niches to be made wherein he meant to place figures. Each recess was three times the height of its depth, with a ring at the summit; and here the prince had various statues placed, but they did not turn out well. He then asked Michelangelo what he could put into the niches. "Hang a bunch of eels in that ring," replied the master.

With the Commissioners of San Pietro, there was associated a gentleman who professed to understand Vitruvius, and to criticize the works accomplished. "You have now a man in the building who has great genius," remarked some one to Michelangelo. "True," replied our artist, "but he has a bad judgment." A painter had executed a story for which he had taken so many parts from drawings and other pictures that there was nothing in it which was not copied. This being shown to Michelangelo, and his opinion requested, he made answer, "It is very well; but at the day of Judgment, when every body shall retake its own limbs, what will this story do, for then it will have nothing remaining." A warning to those who would practice art that they should do something for themselves. Passing once through Modena, he saw many beautiful figures which the Modenese sculptor, Maestro Antonio Bigarino,[36] had made of terra-cotta, colored to look like marble, which appeared to him to be most excellent productions. And as that sculptor did not know how to work in marble, he said, "If this earth were to become marble, woe to the antiques."

Michelangelo was told that he ought to resent the perpetual competition of Nanni di Baccio Bigio, to which he replied, "He who strives with those who have nothing gains but little." A priest, who was his

friend, said to him, "'Tis a pity that you have not married, that you might have left children to inherit the fruit of these honorable toils"; when Michelangelo replied, "I have only too much of a wife in my art, and she has given me trouble enough. As to my children, they are the works that I shall leave; and if they are not worth much, they will at least live for some time. Woe to Lorenzo Ghiberti if he had not made the gates of San Giovanni, for his children and grandchildren have sold or squandered all that he left; but the gates are still in their place."

Vasari was sent one night by Pope Julius III to the house of Michelangelo for a design, and the master was then working at the Pietà in marble which he afterwards broke. Knowing by the knock who stood at the door, he descended with a lamp in his hand; and having ascertained what Vasari wanted, he sent Urbino for the drawing, and fell into conversation on other matters. Vasari meanwhile turned his eyes on a leg of the Christ on which Michelangelo was working and endeavoring to alter it. But to prevent Vasari from seeing this, he suffered the lamp to fall from his hand, and they remained in darkness. He then called to Urbino to bring a light, and stepping beyond the enclosure in which was the work, he remarked: "I am so old that death often pulls me by the cape, and bids me go with him; some day I shall fall myself, like this lamp, and the light of life will be extinguished."

With all this he took pleasure in the society of men like Menighella, a rude person and commonplace painter of Valdarno, but a pleasant fellow; he came sometimes to see Michelangelo, who made him a design of San Rocco and Sant'Antonio, which he had to paint for the country people. And this master, who would not work for kings without entreaty, often laid aside all other occupation to make designs of some simple matter for Menighella, "dressed after his own mind and fashion," as the latter would say. Among other things Menighella received from him the model of a Crucifix, which was most beautiful; he formed a mould from this also, whence Menighella made copies in various substances, and went about the country selling them. This man would sometimes make Michelangelo laugh till he cried, more especially when he related the adventures he met with; as, for example, how a peasant, who had ordered the figure of San Francesco, made complaints that the painter had given him a gray dress, he desiring to have a finer color, when Menighella put a pluvial of brocade on the back of the saint, which gladdened the peasant to his heart.

He favored, in like manner, the stone-cutter Topolino, who imagined himself an excellent sculptor, although, in fact, a very poor creature. He passed much time at the quarries of Carrara, sending marbles to Michelangelo, nor did he ever despatch a cargo without adding three or four little figures from his own hand, at the sight of which Michelangelo would

almost die of laughing. At length, and after his return, he had rough-hewn a figure of Mercury in marble, which he was on the point of fin-ishing, when he begged Michelangelo to go and see it, insisting earnestly that he should give his true opinion of the work. "Thou art a fool to at-tempt figures, Topolino," said the master; "for dost thou not see that, from the knee to the foot, this Mercury of thine wants a full third of a braccio of its due length? and thou hast made him a dwarf and a crip-ple?" "Oh, that is nothing," replied Topolino, "if it has no other fault I shall find a remedy for that, never fear me."

The master laughed again at his simplicity and departed; when Topolino, sawing his Mercury in two below the knee, fastened a piece of marble nicely between the parts, and having thus added the length re-quired, he gave the figure a pair of buskins, the fastenings of which passed beyond the junctures. He then summoned the master once more; and Michelangelo could not but wonder as well as laugh when he saw the resolutions of which those untaught persons are capable, when driven by their needs, and which would certainly never be taken by the best of masters.

While Michelangelo was concluding the tomb of Julius II, he permit-ted a stone-cutter to execute a terminal figure, which he desired to put up in San Pietro in Vincoli, directing him meanwhile by telling him daily, "Cut away here," "Level there," "Chisel this," "Polish that," until the stone-cutter had made a figure before he was aware of it. But when he saw what was done, he stood lost in admiration of his work. "What dost thou think of it?" inquired Michelangelo. "I think it very beautiful," returned the other, "and am much obliged to you." "And for what?" de-manded the artist. "For having been the means of making known to me a talent which I did not think I possessed."

But now, to bring the matter to a conclusion, I will only add that Michelangelo had an excellent constitution, a spare form, and strong nerves. He was not robust as a child, and as a man he had two serious at-tacks of illness, but he was subject to no disease, and could endure much fatigue. It is true that infirmities assailed him in his old age, but for these he was carefully treated by his friend and physician, Messer Realdo Colombo. He was of middle height, the shoulders broad, and the whole form well proportioned. In his latter years, he constantly wore stockings of dog-skin for months together, and when these were removed, the skin of the leg sometimes came with them. Over his stockings he had boots of Cordovan leather, as a protection against the swelling of those limbs, to which he then became liable.

His face was round, the brow square and ample, with seven direct lines in it; the temples projected much beyond the ears, which were somewhat large, and stood a little off from the cheeks; the nose was rather flattened,

having been broken with a blow of the fist by Torrigiano; the eyes were rather small than large, of a dark color, mingled with blue and yellowish points; the eyebrows had but few hairs; the lips were thin, the lower somewhat the larger, and slightly projecting; the chin well formed, and in fair proportion to the rest of the face; the hair black, mingled with grey, as was the beard, which was divided in the middle, and neither very thick nor very long.

This master, as I said at the beginning, was certainly sent on the earth by God as an example for the men of our arts, to the end that they might profit by his walk in life, as well as learn from his works what a true and excellent artist ought to be. I, who have to thank God for an infinite amount of happiness, such as is rarely granted to those of our vocation, account it among the greatest of my blessings that I was born while Michelangelo still lived; was found worthy to have him for my master; and being trusted by him, obtained him for my friend, as every one knows, and as the letters which he has written to me clearly prove. To his kindness for me I owe it that I have been able to write many things concerning him, which others could not have related, but which, being true, shall be recorded. Another privilege, and one of which he often reminded me, is that I have been in the service of Duke Cosimo. "Thank God for this, Giorgio," has Michelangelo said to me; "for to enable thee to build and paint, in execution of his thoughts and designs, he spares no expense; and this, as thou seest well, by the Lives thou hast written, is a thing which few artists have experienced."

Michelangelo was followed to his tomb by a concourse of all the artists, and by his numerous friends, receiving the most honorable sepulture from the Florentine nation, in the church of Sant'Apostolo, within a sepulchre of which church he was laid in the presence of all Rome, His Holiness expressing an intention to command that a monument should be erected to his memory in St. Peter's.

Lionardo, the nephew of Michelangelo, did not arrive in Rome until all was over, although he travelled post in the hope of doing so. When Duke Cosimo heard what had happened, he resolved that, as he had not been able to do the master honor in his life, he would cause his body to be brought to Florence, where his obsequies were to be solemnized with all possible splendor. But the remains of the artist had to be sent out of Rome in a kind of bale, such as is made by merchants, that no tumult might arise in the city, and so the departure of the corpse be prevented.

But before the body could arrive, the news of the master's death having been noised abroad, the principal painters, sculptors, and architects assembled in their Academy, on the requisition of their Prorector, who was at that time Don Vincenzio Borghini, they being obliged by their rules to solemnize the obsequies of all their brethren. They had done this

most affectionately, and to the satisfaction of every one, in the case of Fra Giovan-Agnolo Montorsoli, who was the first that had died after the creation of the Academy; and it was now fitting and proper that they should resolve on what was to be done for the due honoring of Buonarroti, who had been unanimously elected first Academician and head of them all. To this proposal all replied that, being obliged, as they were, to the genius of that great man, they desired that nothing should be omitted which could contribute to do him honor, but that everything should be accomplished in the best manner possible.

That decided, and to avoid the daily assemblage of so many men, which was very inconvenient to them, as well as for the more effectual arrangement of the preparations, four persons, all of eminent reputation and distinguished in their arts, were chosen to direct the same. These were the painters Agnolo Bronzino and Giorgio Vasari, with the sculptors Benvenuto Cellini and Bartolommeo Ammanati, who were appointed to consult among themselves, and with the Prorector, as to all the arrangements to be made, they being empowered to dispose of everything belonging to the Academy. This charge they undertook the more willingly as they saw that all the artists, young and old, came forward readily with offers to prepare, each in his several vocation, such pictures and statues as were needed for the ceremony.

It was first resolved that the Prorector and Syndics should lay all before the Duke in the name of the Academy, requesting from his Excellency such countenance and aid as they might require, the first thing to be asked being permission for the solemnization of those obsequies in the church of San Lorenzo, which belongs to the illustrious house of Medici, and where are the greater part of Michelangelo's works in Florence. His Excellency was also requested to permit Messer Benedetto Varchi to pronounce the funeral oration, to the end that the greatness and excellence of Michelangelo might be suitably set forth in the eloquence of so distinguished a man as was Varchi, but who, being in the particular service of his Excellency, could not undertake that office without his permission, although they were certain that he would not of himself refuse to do so, being most kindly of nature as well as much attached to the memory of Michelangelo. All this duly settled, and the Academicians having dispersed, the Prorector wrote to the Duke as follows:

"The Academy and Company of Painters and Sculptors having resolved, if it please your Excellency, to do honor in some sort to the memory of Michelangelo, not only from a consideration of what is due to the genius of him who was, perhaps, the greatest master that has ever lived, and one more particularly their own, he belonging to their com-

mon country, but also as being moved by a sense of the benefit accru-
ing to the arts from the perfection of his works, and by the obligation
laid upon them to prove their gratitude to his memory, do hereby re-
peat this their desire, expressed to your most illustrious Excellency in
their former epistle, and do entreat from you, as their sure resource, a
certain amount of assistance. I then, being requested by them and being
(as I think) bound thereto by the fact that, with your Excellency's good
pleasure, I am again of their company this year under the title of your
Prorector, am moved to compliance, as the undertaking appears to me
worthy of upright and grateful men; but still more as knowing the pro-
tection extended by your Excellency to the arts, and that in this age you
are the sole resource and shield of distinguished men. Insomuch that
you do herein surpass your illustrious ancestors, although they also con-
ferred innumerable favors on the men of these vocations; witness the
Magnificent Lorenzo, who, long before his death, caused a statue to be
erected in the Cathedral to Giotto,[37] with a monument in marble to Fra
Filippo, all at his own cost; to say nothing of many other great and noble
acts that might be named.

"Considering all these things, I have taken courage to recommend to
your illustrious Excellency the petition of this Academy to the effect that
they may duly honor the genius of Michelangelo, who was the disciple
and especial pupil of the School created by the Magnificent Lorenzo. For
this that they desire to do shall be not only to their great contentment,
but also to the infinite satisfaction of all men; it will, furthermore, be no
slight spur to the professors of these arts, and a proof to all Italy of the
high mind and great goodness of your most illustrious Excellency, whom
may God long preserve in happiness, for the advantage of your people
and for the good of art."

To this the Duke replied as follows:

"REVEREND AND WELL-BELOVED,—The promptitude which the
Academy has shown, and is showing, in its preparations to honor the
memory of Michelangelo Buonarroti, who has passed from this life to a
better, has consoled us much for the loss of so extraordinary a man; and
not only will we do as you request, but will endeavor to have his remains
brought to Florence, as, according to what we hear, was his own desire.
All this we write to the Academy to encourage the members in their
purpose of honoring the talents of that great man in the best manner
possible; and so may God keep you in joy."

Of the letter, or memorial, mentioned above, as addressed by the
Academy to the Duke, the following are the words:

"MOST ILLUSTRIOUS, &C.—The Academy and the Men belonging to

the Society of the Arts of Design, established under the grace and favor of your Most Illustrious Excellency, having heard with what care and zeal you have caused the body of Michelangelo Buonarroti to be claimed by your ambassador in Rome, have assembled and unanimously resolved to celebrate his obsequies in the best manner possible to them. Knowing therefore that your Excellency was honored by Michelangelo as much as he was favored by your Excellency, they pray you of your infinite goodness and liberality to be pleased to permit, first, that the solemnities shall be held in the church of San Lorenzo, which was built by your ancestors, wherein are so many fine works, both in architecture and sculpture, by his hand, and near which it is your purpose to erect an abode which, for the Academy and Company of Design, shall be as it were an abiding seat of study, whether in architecture, painting, or sculpture.

"Secondly, we beg that you will commit to Messer Benedetto Varchi the charge, not only of composing the funeral oration, but also of pronouncing it with his own lips, as at our entreaty he has freely promised to do, provided your Illustrious Excellency shall consent. Thirdly, we pray that you will be pleased, out of that same goodness and liberality, to assist the Academy in all which these obsequies may demand, beyond their own power, which is very small, to supply. All and every of these things have been discussed in the presence and with the consent of the very magnificent and reverend Monsignore, Messer Vincenzio Borghini, Prior of the Innocents, the Prorector of your Most Illustrious Excellency, for the said Academy and Company. And your petitioners, &c."

To this the Duke replied:

"OUR WELL-BELOVED,—We are well content fully to grant your petitions, for the great love that we have ever borne to the rare genius of Michelangelo Buonarroti, and which we still bear to all of your vocation. Do you therefore execute whatever you propose to do for his obsequies, and we, on our part, will not fail to supply what you may need. We have, meanwhile, written to Messer Benedetto respecting the oration, and to the Director concerning all else that occurs to us as needful in this matter. And herewith we bid you farewell. From Pisa."

The letter to Varchi was as follows:

"MESSER BENEDETTO, OUR WELL-BELOVED,—The affection we bear to the great genius of Michelangelo Buonarroti makes us desire that his memory shall be honored and celebrated in all ways, wherefore it will be pleasing to us, if, for our love, you will accept the care of the oration which is to be pronounced at his obsequies, according to the arrangements made by the deputies of the Academy: still more will it please us if this oration be spoken by yourself. Fare you well."

Messer Bernardino Grazzini also wrote to the above-named deputies, telling them that the Duke was displaying all the zeal that could be desired in that cause, and adding that they might assure themselves of all help and favor from his Most Illustrious Excellency.

While these arrangements were proceeding in Florence, Lionardo Buonarroti, the nephew of Michelangelo (who had departed post for Rome on hearing of his uncle's sickness, but had not found him living), had been told by Daniello da Volterra, the intimate friend of Michelangelo, as well as by others who had been about his person, that he had requested and even entreated them to have his body taken to Florence, his most noble country, to which he had ever borne the tenderest affection. Lionardo therefore had promptly and with great resolution, but also very cautiously, had the body taken out of Rome, and had sent it towards Florence in the form of a bale, as if it had been some kind of merchandise.

And here we are not to conceal the fact that this ultimate determination of Michelangelo confirmed what many did not believe, but which was nevertheless true, namely, that his having remained away from Florence for so many years had been caused by the effect of the air only, the sharpness of which, as experience had taught him, was injurious to his constitution. That of Rome, on the contrary, more temperate and mild, had kept him in health to nearly his ninetieth year, preserving all his faculties in perfection, and giving him so much strength, his age considered, that he had not been compelled to cease entirely from his labors till the very last.

The sudden and almost unexpected arrival of the body, not having permitted such dispositions for its reception as were afterwards made, it was placed, by desire of the deputies, in the vault of the company of the Assumption, which is beneath the steps at the back of the high altar in the church of San Pietro Maggiore. This was on the 11th of March, which was a Saturday, and for that day nothing more was done. The next day, which was the second Sunday in Lent, all the painters, sculptors, and architects assembled quietly around St. Peter's, whither they had taken nothing more than a pall of velvet, richly decorated and embroidered all over with gold, and this they placed over the bier as well as coffin, on which there lay a crucifix. At nightfall they gathered silently around the corpse, when the oldest and most distinguished masters each took one of a large number of torches, which had been brought for that purpose, the younger artists at the same moment raising the bier. This they did with so much promptitude that blessed was he who could approach near enough to get a shoulder under it, all desiring the glory of having to say in after years that they had borne to earth the remains of the greatest man ever known to their arts.

The sight of a certain number of persons assembling round San Pietro had caused others to stop, and the rather as a rumor had got abroad that the body of Michelangelo had come, and was to be carried to Santa Croce, although everything had been done to keep the matter secret, as I have said, that a great crowd might not be attracted, which could not fail to cause confusion; and also because it was desired that all then to be done should proceed with more quiet than pomp, all display being reserved to a more convenient time.

Yet the contrary happened in both these things. For as to the crowd, the news passing from mouth to mouth, the church was completely filled in the twinkling of an eye, so that at length it was not without the utmost difficulty that the corpse could be taken from the church to the sacristy, there to be freed from its wrappings, and placed in the receptacle destined to receive it. Then for the pomp—although the number of priests, wax lights, and mourners clothed in black are without doubt imposing and grand in funeral ceremonies, yet it cannot be denied that the sight of all the distinguished men, some of whom are now highly honored, and others promising to be still more so in the future, gathered in so much affection around that corpse, was also a very grand and imposing spectacle.

And of a truth the number of such artists (and they were all present) was at that time very great in Florence. The Arts have indeed ever flourished there in such sort that, without offence to other cities, I believe I may say that their first and principal abode is in Florence, as that of the Sciences was at Athens. But besides the number of artists, there were so many citizens following them, and such masses of people joined the procession in the streets through which it had to pass, that the place would hold no more, and what is greater than all, nothing was heard but the praise of Michelangelo. True art has indeed so much power that, after all hope of further honor or profit from a distinguished man has ceased, yet for its own merit and qualities it is ever beloved and admired. For all these causes, that demonstration was more precious and more truthful than all the pomp of gold and banners that could have been displayed.

When the remains, with this magnificent attendance, had been carried to Santa Croce, the monks performed the ceremonies customary for the dead; when the corpse was removed (but not without the greatest difficulty, because of the concourse of people) to the sacristy, where the above-named Prorector, who was there by virtue of his office, thinking to gratify many thereby, and also (as he afterwards confessed) desirous of seeing him dead whom he had not seen living, or at so early an age that he had lost all memory of him—the Prorector, I say, resolved to have the cerements taken off. This was done accordingly, and whereas he, and all of us who were present, expected to find the body decomposed, since

the master had been dead twenty-five days, and twenty-two in the coffin, we found it altogether perfect, and so totally free from odor that we were almost tempted to believe he lay in a sweet and quiet sleep. The features were exactly as in life, except that they showed the pallor of death; the limbs were unaltered, and the face and cheeks were firm to the touch, as though but a few days had elapsed since Michelangelo had passed away.

When the great press of people had departed, arrangements were made for placing the body in a tomb of the church which is near the altar of the Cavalcanti family, beside the door leading into the cloister of the chapter-house. But meanwhile the news had spread through the city, and so great a concourse hastened to look upon the corpse that the tomb was not closed without much difficulty, and if it had been day instead of night, we must have left it open many hours to satisfy the general wish. On the following morning, while the painters and sculptors were preparing the solemnities, many of those distinguished persons who have ever abounded in Florence began to append verses, both in Latin and the vulgar tongue, on the above-named tomb, and this was continued for some time. Many of these compositions were afterwards printed, yet these made only a small part of the number written.

But to come to the obsequies; these were not solemnized on St. John's day, as had been intended, but were deferred to the 14th of July, when the three deputies (for the fourth, Benvenuto Cellini, who had been indisposed from the first, had taken no part in the matter), having chosen the sculptor, Zanobi Lastricati, as their Proveditor, resolved to exhibit some ingenious invention worthy of their art, rather than a pompous and costly ceremonial. For, having to celebrate such a man as Michelangelo, and this having to be effected by men of those vocations which he exercised, who are always more amply furnished with the wealth of mind than with other riches, it was most appropriate, as the deputies and their Proveditor agreed, that he should be honored, not with regal pomp or superfluous vanities, but with ingenious inventions and works full of spirit and beauty, proceeding from the knowledge, ability, and promptitude of hand of our artists, thus honoring Art by Art.

It is true that we might have reasonably expected to obtain from his Excellency all the money we should require, seeing that he had already given whatever we had asked; but we were nevertheless convinced that from us was expected a preparation, rich from its ingenuity and art, rather than the grandeur and cost of a pompous display. But although this was the conviction of the deputies, the magnificence of the ceremonial was equal to that of any ever solemnized by those Academicians, and was no less remarkable for true splendor than for ingenious and praiseworthy inventions.

The arrangements finally made were as follows. In the central nave of San Lorenzo and between the two lateral doors, one of which opens on the street and the other on the cloister, was erected a catafalque of a square form, twenty-eight braccia high, eleven long, and nine broad, the whole surmounted by a figure of Fame. On the basement of the catafalque, and at two braccia from the floor, on that side which looks towards the principal door of the church, were two River-gods, the Arno and the Tiber. The first bore a cornucopia with its flowers and fruits, to signify that the labors of our vocations in the city of Florence are such and so rich in fruits as to fill the world, but more especially adorning Rome with their beauties; a thought well carried out by the attitude of the other River-god, for the Tiber, extending one arm had the hand full of the flowers and fruits poured forth from the horn of the Arno, which lay beside and opposite to the Tiber.

The enjoyment by this last of the Arno's fruits also implied that Michelangelo had spent much of his life in Rome, and there produced those works which astonish the world. The Arno had a Lion beside him as his device, and the Tiber a Wolf, with the infants Romulus and Remus, both the River-gods being colossal figures of extraordinary beauty and excellence, and having the appearance of marble. The artist who executed the Tiber was Giovanni di Benedetto of Castello,[38] a disciple of Baccio Bandinelli; the Arno was from the hand of Battista di Benedetto, a disciple of Ammanati, both young men of much promise.

From the basement there rose a structure five braccia high, having a cornice at the upper and lower parts as well as at the angles; space for the reception of pictures was left in the center of each side. The picture on the part where the River-gods were, and which, like all the others, was in chiaroscuro, represented the Magnificent Lorenzo, in his garden, an old man receiving Michelangelo as a child, having seen certain indications of his genius, which may be said to have intimated, in the manner of flowers, the rich fruits afterwards so largely produced by the grandeur and force of that genius. This story was painted by Mirabello, and by Girolamo del Crocifissaio, as they were called, and who, being companions and friends, undertook to do it together. The attitude of Lorenzo, whose figure was a portrait from the life, exhibited great animation; his reception of Michelangelo was most gracious. The boy stood before him with looks of reverence, and having been examined, was in the act of being passed over to the masters by whom he was to be instructed.

In the second story, or that on the side of the lateral door, which opens into the street, was Pope Clement, who, far from resenting the part taken by Michelangelo in the siege of Florence, as is commonly believed, was careful to assure his safety, gave evidence of much friendly feeling towards him, and employed him in the works of the new sacristy and library of

San Lorenzo, in which places how admirably he acquitted himself we
have already set forth. This picture was painted with much facility and
softness by the Fleming Federigo,[39] called the Paduan. Michelangelo was
showing the Pope the plan of the sacristy; and behind him, borne partly
by angels, and partly by other figures, were carried the models of the li-
brary, the sacristy, and the statues which have been completed, all well
composed and carefully executed. In the third picture, which faced the
high altar, was a long Latin inscription, composed by the very learned
Messer Pier Vettori, the meaning of which in the Italian tongue, was as
follows:

"The Academy of Painters, Sculptors, and Architects, by favor of the
Duke Cosimo de' Medici, their chief, and the supreme protector of these
arts, admiring the extraordinary genius of Michelangelo Buonarroti, and
acknowledging the benefits received from his divine works, have dedi-
cated this monument, erected by their own hands, and consecrated with
all the affection of their hearts, to the eminence and genius of the great-
est painter, sculptor, and architect that has ever existed."

The Latin words were these:

Collegium pictorum, statuariorum, architectorum, auspicio opique
sibi prompta Cosmi ducis auctoris suorum commodorum, suspiciens sin-
gularem virtutem Michaelis Angeli Bonarrotæ, intelligensque quanto
sibi auxilio semper fuerit præclara ipsius opera, studuit se gratum erga
illum ostendere summum omnium, qui unquam fuerint, P. S. A. ideoque
monumentum hoc suis manibus extructum magno animi ardore ipsius
memoriæ dedicavit.

This inscription was supported by two Angels weeping, and each ex-
tinguishing the torch which he held in his hand, as if lamenting the loss
of that great and extraordinary genius. In the picture of that side which
turned towards the door of the cloister was Michelangelo engaged in
constructing the fortifications of the heights of San Miniato, and which
were considered impregnable: this was by Lorenzo Sciorini, the disciple
of Bronzino, and a youth of much promise.

The lowermost part, or what may be called the base of the whole fab-
ric, had a projecting pedestal on each side; and on each pedestal was a
colossal figure, having another at its feet in the manner of a captive, and
of similar size, but in the most singular and abject attitude. The first, or
that on the right as you approach the high altar, was a youth of slender
form, and a countenance full of life and spirit, representing Genius, and
with two small wings on his temples, as Mercury is sometimes depicted.
Beneath his feet, and executed with remarkable ability, was a figure with
asinine ears, representing Ignorance, the mortal enemy of Genius. These

were both by Vincenzio Danti, of Perugia, whose works are much distinguished among the young sculptors of the day.

On the pedestal opposite to this, and facing the new sacristy, was a female figure representing Christian Love; for this, being made up of religion and every other excellence, is no less than an aggregate of all those qualities which we call the cardinal, and the Pagans the moral, virtues, and was thus appropriately placed in the monument of Michelangelo, since it beseems Christians to celebrate the Christian virtues, without which all other ornaments of body or mind are as nothing. This figure, which had Vice, or Impiety, trampled beneath its feet, was by Valerio Cioli, an excellent youth of much ability, and who well merits the name of a judicious and diligent sculptor.

Opposite to the above, and on the side of the old sacristy, was a figure of the goddess Minerva, or Art. And this was placed there with much judgment, since after a pure life and upright walk, which among the good are ever to be held the first, it was Art that gave to Michelangelo, not honor and riches only, but so much glory even in his life that he may with truth be said to have then enjoyed more than most of our illustrious artists obtain from their works even after death. Nay, to him it was given even to overcome envy, seeing that by common consent, and without any contradiction, the reputation of being the first and greatest has been accorded to his name. For this reason, the figure of Art had Envy beneath her feet; the latter an old woman, meagre, worn, and with viperous eyes, which, together with all her countenance and every feature, were breathing poison and bitterness; she wore a girdle of snakes about her waist, and had a serpent in her hand. These figures were executed by a youth of very tender age, called Lazzaro Calamec of Carrara, who, though still but a child, has given evidence of most distinguished talent, both in painting and sculpture.

It was by his uncle, Andrea Calamec, who was a disciple of Ammanati, that the two figures placed on the fourth pedestal were prepared; these were opposite the organ, and looked towards the principal door of the church. The first of the two represented Diligence; for those who act but feebly, and effect but little, cannot hope to attain the excellence of Michelangelo, who, from his fifteenth to his ninetieth year, never ceased to labor earnestly, as we have said above. This figure, most appropriate to the monument of such a man, exhibited the appearance of a bold, powerful youth, having small wings a little above the wrist, to intimate the promptitude and facility of his operations. Beneath him, as his captive, was Indolence, or Idleness, a heavy, weary-looking woman, bearing an impress of sleepy dulness over all her person.

These four groups, arranged as here described, formed a beautiful and magnificent composition, and had all the appearance of being in marble,

the clay having been covered with a coat of white, which had succeeded admirably. From the level platform on which they were placed, there rose another basement, also quadrangular, and about four braccia high, but neither so long nor so broad as that below, which surpassed it by all the space occupied by the figures above described. On each side of the second basement was a picture six and a half braccia wide and three high; and over these arose a platform, similar to but smaller than that beneath, on each angle of which was a projecting socle occupied by a seated figure, somewhat larger than life. These four statues, all of women, were readily perceived, by the instruments beside them, to be Painting, Sculpture, Architecture, and Poetry, and were judiciously placed here, as the life of Michelangelo, above written, may fully prove.

Proceeding from the principal door of the church towards the high altar, the first painting in the second range of the catafalque appeared; and referring to the statue of Architecture, it presented Michelangelo standing before Pope Pius IV, with the model of the wonderful Cupola of San Pietro in his hand. This story was over that in which Lorenzo receives Michelangelo in his garden, the invention and manner of which were highly commended; it was painted by the Florentine Piero Francia. And the statue of Architecture, which was to the left of the story, was by Giovanni di Benedetto, of Castello, who, so much to his credit, also executed the Tiber, one of the River-gods in front of the catafalque, as we have before said.

In the second picture, continuing towards the right and approaching the lateral door into the street, was a story to accompany the statue of Painting, and representing Michelangelo engaged in the execution of that so much, yet never sufficiently, lauded work, the Last Judgment; that, I say, which serves as the example to all in our vocation of foreshortening, and every other difficulty of the art. To the left of this painting, which was executed with much grace and diligence by the disciples of Michele di Ridolfo, was the statue of Painting, by Battista del Cavaliere, a youth no less distinguished as a sculptor than for the modesty and excellence of his life.

In the third picture, or that towards the high altar and above the inscription, was a story relating to Sculpture, and showing Michelangelo taking counsel with a female figure, known to the Sculpture by her accompaniments. The artist has around him certain of the works executed by his hand in that branch of art, and the figure holds a tablet, with the words of Boëthius: *Simili sub imagine formans*.[40] Beside this picture, which was painted in a very good manner by Andrea del Minga, was the statue of Sculpture, extremely well executed by Antonio di Gino Lorenzi.

The fourth of these pictures, or that towards the organ, related to the statue of Poetry, and exhibited the master intent on the writing of some

composition. Around him, in a graceful hand, robed as the poets describe them, were the Nine Muses, and before them Apollo, crowned with laurel, and bearing the lyre in one hand; while in the other he held a second crown of laurel, which he appeared about to place on the head of Michelangelo. Near to this graceful and beautiful story, which was painted in an admirable manner, with figures exhibiting attitudes of infinite animation, by Giovanmaria Butteri, was the statue of Poetry, the work of Domenico Poggini, a man of much experience in the casting of bronze, the making of dies for coin, and the execution of medals; nor was he less remarkable as a writer of poetry.

Thus it was then that the catafalque was adorned, and as it diminished at every stage there was a walk entirely around each platform; it was indeed not unlike the mausoleum of Augustus in Rome; or rather, being of square form, it was more like the Septizonium of Severus; not that near the Capitol, which is commonly called so by an error, but the true one, near the Baths of Antoninus, of which there is a plate in the *Nuove Rome*.

Up to this point the catafalque had three stages; the first on which were the River-gods, the second where were the groups, and the third on which stood the single figures. From the platform of the last stage there rose a base or socle, one braccio high, much smaller than the platform on which it was placed; and above the ressauts of which were seated the statues, as before mentioned, while around it were the words, *Sic ars extollitur arte*.[41] On the socle was a pyramid, nine braccia high, on two sides of which, that towards the principal door namely, and that towards the high altar, were two oval compartments, each bearing the head of Michelangelo in relief; a portrait from the life, and admirably executed by Santi Buglioni.

On the summit of the pyramid was a ball in due proportion with the same, and supposed to be placed there as representing one that might contain the ashes of him so highly honored; while above the ball was a figure, larger than life, with the appearance of marble, and representing Fame in the act of commencing her flight to cause the glory and praise of that greatest of masters to resound through the whole world; she being about to place to her lips a trumpet which terminated in three mouths for that purpose.

This figure of Fame was by the hand of Zanobi Lastricati, who, in addition to all his labors as Proveditor for the whole, would yet, to his great honor, assist with the force of his genius and the labor of his hand also. The height of the catafalque, from the floor to the head of the Fame, was twenty-eight braccia, as we have said. Besides the catafalque, the church was hung with baize and serge, not around the central columns only, as is customary, but about all the surrounding chapels also; nor was there

any space between the pilasters, which stand on each side of those chapels and correspond with the columns, which had not some ornament of painting, or which did not present a beautiful and imposing aspect.

To begin with one end, in the space of the first chapel, which is beside the high altar, and proceeding towards the old sacristy, there was a picture six braccia high and eight long, wherein, with a new and almost poetical invention, Michelangelo was displayed as having attained the Elysian fields. On his right hand were figures larger than life, representing the most renowned of the great painters and sculptors of antiquity, each made clearly manifest by some particular sign: Praxiteles, by the Satyr which is in the Vigna of Pope Julius III; Apelles, by the portrait of Alexander the Great; Zeuxis, by that picture with the grapes which deceived the birds; and Parrhasius with the pretended curtain covering the picture. The others, also, were in like manner made known by other signs.

On the left of Michelangelo were the masters of modern times, all those who have been most illustrious in these arts, from Cimabue downward, that is to say. Thus Giotto was known by a small portrait of Dante as a youth, depicted in the same manner as that by his hand which is still to be seen in the church of Santa Croce. Masaccio was a portrait from the life, as was also Donatello, who had, besides, his Zuccone of the Campanile beside him. Filippo Brunelleschi was made known by the copy of his Cupola of Santa Maria del Fiore. Then followed (portraits from the life and without any other sign) Fra Filippo, Taddeo Gaddi, Paolo Uccello, Fra Angelico, Jacopo Pontormo, Francesco Salviati, and others; all surrounding Michelangelo with a welcome similar to that offered by the masters of antiquity, and giving evidence in their looks of their love and admiration for him, no other than was done for Virgil when the other poets received him on his return, as feigned by the divine poet Dante, from whom the invention was taken, as was likewise the verse which was added and which was exhibited on a scroll held in the hand of the River-god Arno, which lay at the feet of Michelangelo in a most graceful attitude, and with features of singular beauty.

Tutti l'ammiran, Tutti amor gli fanno.[42]

This picture, which was by the hand of Alessandro Allori, the disciple of Bronzino, an excellent painter and most worthy scholar of so great a master, was very highly extolled by all who beheld it. In the space of the chapel of the Holy Sacrament, at the end of the cross aisle, was a picture five braccia long and four broad, wherein was Michelangelo surrounded by all the School of the Arts; little children, boys and young men of every age up to twenty-four, all offering to him, as to something sacred and di-

vine, the first-fruits of their labors, paintings, sculptures, models, &c. All which he was courteously receiving, instructing them at the same time in questions of Art, while they gave ear to his precepts with reverent attention, and were looking at him with exquisite expressions of countenance, and in attitudes truly beautiful and graceful.

In effect, the composition of this picture is such that it could not in a certain sense have been done better; nor, as respects some of the figures, could anything more beautiful be desired; for which cause, Battista, the disciple of Pontormo, by whom it was painted, received infinite praise. The verses at the foot of this picture were as follows:

> Tu pater et rerum inventor, tu patria nobis
> Suppeditas præcepta tuis ex, inclyte, chartis.[43]

Descending from this picture towards the principal door of the church, just before you arrived at the organ, was another, six braccia long and four broad, in the space of a chapel, and on this was depicted the extraordinary favor conferred by Julius III, when, desiring to avail himself of the great master's talents, he invited him to the Vigna Julia, and caused him to be seated beside himself. Here then, Michelangelo was seen in conversation with the Pontiff, while the Cardinals, Bishops, and other great personages of the court remained standing around them. This event, I say, was here depicted with such admirable composition and so much relief, the force and animation of the figures was so remarkable, that it could not perhaps have been much better had it proceeded from the hand of an old and experienced master. Wherefore, Jacopo Zucchi, a young disciple of Giorgio Vasari, by whom it was executed in so good a manner, was judged to have hereby proved that the best hopes of his future progress might reasonably be entertained.

Not far from this, and on the same side, a little beneath the organ, that is to say, the able Flemish painter, Giovanni Strada,[44] had painted a picture six braccia long and four high, wherein he depicted an event from the period of Michelangelo's visit to Venice, at the time of the siege of Florence. The master is in the Guidecca, a quarter of that most noble city so called, and is receiving a deputation of Venetian gentlemen, whom the Doge, Andrea Gritti, had sent to visit him and make him offers of service. In this work, the painter above named showed much knowledge and judgment, the whole composition and every part of it doing him much honor, seeing that the propriety and grace of the attitudes, the animation of the faces, and the life-like movement imparted to each figure gave proof of rich inventive power, great knowledge of design, and infinite grace.

We now return to the high altar, and looking towards the new sacristy. In the first picture exhibited there, which was that in the space of the first

chapel, was represented another signal favor enjoyed by Michelangelo, and which was here depicted by Santi di Tito, a young man of great judgment, and who had practiced painting extensively in Florence as well as in Rome. This favor, to which I think I have before alluded, was conferred at the visit paid by the master to the most illustrious Signor Don Francesco Medici, Prince of Florence, when the latter was in Rome about three years before Michelangelo died. No sooner did Buonarroti enter the room than the Prince rose from his seat; and to do honor to the truly venerable age of that great man, he would have him be seated in his own place, although Michelangelo, who was exceedingly modest, refused to accept that courtesy. Then, standing before him with the utmost respect, the Prince listened to his words with all the reverence and attention that could have been shown by a son to the best of fathers. At the feet of Don Francesco, in the painting of Santi di Tito, was a boy admirably depicted, who held the beretta, or ducal cap, of the Prince in his hand, and around the group stood soldiers dressed in the antique fashion, and executed in a very good manner. But best of all were the figures of Michelangelo and the Prince, which were so full of animation that the old man appeared to be truly speaking, and the youth to be attentively listening to his words.

In another picture, nine braccia high and twelve long, which was opposite to the tabernacle of the Sacrament, Bernardo Timante Buontalenti, a painter much favored by the most illustrious Prince, had painted the rivers of the three principal parts of the world, representing these River-gods as having all come, downcast and sorrowful, to lament and condole with the Arno for their common loss. These rivers were the Nile, the Ganges, and the Po; the first had the Crocodile for his symbol, with a sheaf of corn to intimate the fertility of his country: the Ganges had the Gryphon and a coronal of gems; and the Po a Swan, with a chaplet of black amber. The River-gods, conducted into Tuscany by Fame, whose figure was seen hovering above them, were standing around the Arno, who was crowned with cypress, and, holding aloft his exhausted urn in the one hand, had a branch of cypress in the other: beneath the feet of the Arno was a Lion.

Then, to intimate that the spirit of Michelangelo had ascended to the regions of bliss, the judicious painter had depicted a story of Splendor in Heaven, significant of the celestial light; and towards this the soul of Michelangelo, in the form of a little angel, was seen ascending, with the following verse:

Vivens orbe peto laudibus æthera.[45]

On each side of this picture were pedestals with statues holding back a curtain, within which those River-gods, the soul of Michelangelo, and

the figure of Fame appeared. The statues on the pedestals had figures beneath their feet, that on the right of the River-gods respecting Vulcan. He has a torch in one hand; and beneath him, in an attitude of much constraint, is Hatred, laboring to free himself from the weight imposed on his neck by the foot of his conqueror. The symbol of this group was a Vulture with the verse which follows:

Surgere quid properas Odium crudele? Jaceto.[46]

Signifying that supernatural, nay, almost divine excellence, should by no means be either envied or hated, the second statue, represented Aglaia, one of the Graces, and the wife of Vulcan. She was placed there to signify Proportion, and had a Lily in her hand, partly because flowers are dedicated to the Graces, and also because lilies are considered to be not inappropriately used in funeral ceremonies. The figure beneath this statue represented Disproportion (or Deformity); her symbol was an Ape, and over her was the following verse:

Vivus et extinctus, docuit sic sternere turpe.[47]

Beneath the River-gods were the two verses following:

Venimus Arne, tuo confixa ex vulnere mœsta
Flumina, ut ereptum mundo ploremus honorem.[48]

This picture also was considered very fine for its invention, for the composition of the story, the beauty of the figures and that of the verses, as also because the painter had not executed the work by commission as the others had done, but had spontaneously, and with the help of certain among the obliging and respectable friends which his abilities had gained him, thus done honor to the master by these his labors. For this cause, therefore, Bernardo both deserved and obtained the greater commendation.

In another picture, six braccia long and four high, which was near the side door opening on the street, Tommaso da San Friano, a young painter of much ability, had depicted Michelangelo when despatched by his country as Ambassador to Pope Julius II, as we have said that he was sent, and for what causes, by Soderini.

Not far distant from this picture, a little lower down than the side door that is to say, was one of similar size by Stefano Pieri, a disciple of Bronzino, and a very studious careful youth. He had paid several visits to Rome no long time previously, and now painted Michelangelo as seated in an apartment in conversation with Duke Cosimo, which he frequently did at that period, as we have sufficiently related in other places.

Above the black cloth with which, as we have said, the church was hung all round, in all the spaces where there were no pictures or stories

were placed images of Death, escutcheons, devices, and other objects of like sort, all differing from those usually seen, and exhibiting much ingenuity. Some of the figures of Death, as if lamenting that they had robbed the world of such a man, held a tablet with these words, *Cœgit dura necessitas,*[49] with a globe of the world, out of which was growing a Lily bearing three blossoms, but the stalk of which was broken, the ingenious invention of the above-named Alessandro Allori. Other figures of Death were represented with various peculiarities, but one among these was more especially commended. This was extended on the earth, and a figure of Eternity, holding a palm in the hand, stood over it with one foot planted on the neck; and looking disdainfully at Death, appeared to say that, whether acting by force or his own will, he had effected nothing, since, despite of him, Michelangelo must live to all eternity. The motto was *Vicit inclyta virtus.*[50] This was the invention of Vasari.

Nor will I omit to mention that between these figures of Death was mingled the device of Michelangelo, which was three coronals or circlets, interwoven in such sort that the circumference of one crossed alternately through the centers of the other two. This Michelangelo used either because he meant to signify that the three arts of Sculpture, Painting, and Architecture were so bound and united that each received benefit and ornament from the other, and neither can nor ought to be divided, or perhaps (he being a man of so high a genius), because he had some more subtle meaning in view. But the Academicians, considering the perfection to which he had attained in all three, one having aided and embellished the other, changed these three circlets into three crowns interwoven, with the motto, *Tergeminis tollit honoribus,*[51] to signify that the crown of perfection had been merited by him in all these arts.

On the pulpit whence Varchi pronounced the funeral oration, which was afterwards printed, there was no ornament placed, since, that being in bronze and marble, which had been executed in mezzo and bassorelievo by the excellent Donatello, whatever decoration had been attempted must have proved infinitely less beautiful than itself. But on the pulpit opposite to this, and which had not then been raised on its columns, there was placed a picture four braccia high, and somewhat more than two wide, on which a figure of admirable design and execution was painted by the Perugian sculptor, Vincenzio Danti, of whom we have already made mention. It represented Fame, or Honor, under the semblance of a youth in a fine attitude, and bearing a trumpet in the right hand, while his feet are planted on the figures of Time and Death, to show that Fame and Honor, in despite of Death and Time, maintain those who have powerfully acted in this life in the perpetual memory of their fellow men.

The church, being prepared in this manner, was furthermore adorned

by numerous lights, and was filled by an incalculable number of the peo-
ple, all of whom, abandoning every other care, had thronged to behold
that honorable solemnity. When the procession entered the building,
there first came the Prorector of the Academy, accompanied by the
Captain and Halberdiers of the Duke's Guard, and followed by the
Syndics, and Academicians, and all the Painters, Sculptors, and Architects
of Florence. These having taken their places between the catafalque and
the high altar, where they had for some time been awaited by a large
number of nobles and gentlemen, all seated according to their rank, a
solemn mass for the dead was begun, with music, and all the ceremonies
usual on the highest occasions. That finished, Varchi mounted the pul-
pit above mentioned to fulfil an office which he had last undertaken for
the most illustrious lady the Duchess of Ferrara, daughter of Duke
Cosimo, and had never accepted since. Then, with that elegance of man-
ner, those modes of utterance, and that tone of voice, which are indeed
peculiar to that distinguished man, he described the merits, life, and
works of the divine Michelangelo Buonarroti.

And assuredly it is to be reputed as a great happiness for Michelangelo
that he did not die before the creation of our Academy, seeing that his
funeral ceremonies were solemnized by that society with pomp so mag-
nificent and so honorable. Very fortunate was he, likewise, in having de-
parted before Varchi was removed from this life to that of eternal
blessedness, since he could not have been eulogized by a more eloquent
or more learned man. The funeral oration pronounced by Messer
Benedetto was printed no long time afterwards, as was also another
equally beautiful oration, made in praise of Michelangelo and of
Painting, by the most noble and most learned Messer Leonardo Salviati,
then a youth of but twenty-two years old, although distinguished by his
compositions of all kinds, both in Latin and the vulgar tongue, to the ex-
tent which we all know, and which will be further made manifest to the
world by his future efforts.

But what shall I say, or what can I say, that will not be too little, of the
ability, goodness, and foresight displayed by the very reverend Signor
Prorector, Don Vincenzio Borghini, if it be not that, with him for their
chief guide and counsellor, the highly distinguished men of that
Academy and Company succeeded to perfection in the solemnization of
those obsequies? For although each of them was capable of effecting
much more in his particular branch of art than he was called on to ac-
complish on that occasion, yet can no undertaking be brought to a suc-
cessful conclusion unless one sole head, in the manner of an experienced
pilot and captain, have the direction and government of the work.

Now the whole city could not sufficiently examine the above-named
preparations in one day. It was therefore decided, by command of the

Signor Duke, that the ornaments should remain, and the church contin-
ued thus adorned during several weeks, for the satisfaction of his people,
as well as for that of the strangers who came from the neighboring places
to see it. The multitude of epitaphs and verses in Latin and Italian com-
posed in honor of Michelangelo by many able men are not repeated
here, because they would fill a book of themselves, and have besides been
printed by others. But I will not omit to say that, after all the honors
above described, the Duke commanded that a place of sepulture should
be given to the master in Santa Croce, the church in which Michelangelo
had desired to be buried, that being the place of burial of his ancestors.
To Lionardo, the nephew of Michelangelo, his Excellency gave all the
marbles for the tomb of his uncle, which the able sculptor, Battista
Lorenzi, was commissioned to construct, after the designs of Giorgio
Vasari; the same artist having also to execute the bust of Michelangelo.

Three statues are to adorn this tomb, to be executed, one by Battista
Lorenzi, one by Giovanni dell'Opera, and the third by Valerio Cioli,
Florentine sculptors, who are now occupied with the same; and these fig-
ures, together with the tomb, will soon be finished and in their places.
The work is at the cost of Lionardo Buonarroti, with the exception of
the marbles. But his Excellency, that nothing may be wanting to the
honor of so great a man, proposes to place his bust with an inscription,
in the Cathedral, wherein there are the busts and names of many other
distinguished Florentines.

TITIAN OF CADORE
The Painter
[1477–1576]

TITIAN was born in the year 1480,[1] at Cadore, a small place distant about five miles from the foot of the Alps; he belonged to the family of the Vecelli, which is among the most noble of those parts. Giving early proof of much intelligence, he was sent at the age of ten to an uncle in Venice, an honorable citizen, who seeing the boy to be much inclined to painting placed him with the excellent painter Giovanni Bellini, then very famous, as we have said. Under his care the youth soon proved himself to be endowed by nature with all the gifts of judgment and genius required for the art of painting. Now Giovanni Bellini, and the other masters of that country, not having the habit of studying the antique, were accustomed to copy only what they saw before them, and that in a dry, hard, labored manner, which Titian also acquired.

But about the year 1507, Giorgione da Castelfranco, not being satisfied with that mode of proceeding, began to give to his works an unwonted softness and relief, painting them in a very beautiful manner; yet he by no means neglected to draw from the life, or to copy nature with his colors as closely as he could. And in doing the latter, he shaded with colder or warmer tints as the living object might demand, but without first making a drawing, since he held that to paint with the colors only, without any drawing on paper, was the best mode of proceeding and most perfectly in accord with the true principles of design.

But herein he failed to perceive that he who would give order to his compositions, and arrange his conceptions intelligibly, must first group them in different ways on the paper to ascertain how they may all go together; for the fancy cannot fully realize her own intentions unless these be to a certain extent submitted to the corporal eye, which then aids her to form a correct judgment. The nude form also demands much study before it can be well understood, nor can this ever be done without drawing the same on paper. To be compelled always to have nude or draped figures before the eyes while painting is no small restraint; but when the hand has been well practiced on paper, a certain facility both in designing and painting is gradually obtained, practice in art supervenes, the manner and the judgment are alike perfected, and that labored mode of execution mentioned above is no more perceived.

Another advantage resulting from drawing on paper is the store of valuable ideas which gradually fill the mind, enabling the artist to represent natural objects from his own thoughts, without being compelled to hold them constantly before him. Nor does he who can draw need labor to hide his want of design beneath the attractions of coloring, as many of the Venetian painters, Giorgione, Il Palma, Il Pordenone, and others, who never saw the treasures of art in Rome, or works of the highest perfection in any other place, have been compelled to do.

Having seen the manner of Giorgione, Titian early resolved to abandon that of Giovanni Bellini, although well grounded therein. He now therefore devoted himself to this purpose, and in a short time so closely imitated Giorgione that his pictures were sometimes taken for those of that master, as will be related below. Increasing in age, judgment, and facility of hand, our young artist executed numerous works in fresco which cannot here be named individually, having been dispersed in various places; let it suffice to say that they were such as to cause experienced men to anticipate the excellence to which he afterwards attained.

At the time when Titian began to adopt the manner of Giorgione, being then not more than eighteen, he took the portrait of a gentleman of the Barberigo family, who was his friend. And this was considered very beautiful, the coloring being true and natural, and the hair so distinctly painted that each one could be counted, as might also the stitches in a satin doublet, painted in the same work. At a word, it was so well and carefully done that it would have been taken for a picture by Giorgione, if Titian had not written his name on the dark ground.

Giorgione meanwhile had executed the façade of the German Exchange, when, by the intervention of Barberigo, Titian was appointed to paint certain stories in the same building, and over the Merceria. After which he executed a picture with figures the size of life, which is now in the hall of Messer Andrea Loredano, who dwells near San Marcuola; this work represents Our Lady in her flight into Egypt. She is in the midst of a great wood, and the landscape of this picture is well done, Titian having practiced that branch of art, and keeping certain Germans who were excellent masters therein for several months together in his own house. Within the wood he depicted various animals, all painted from the life, and so natural as to seem almost alive.

In the house of Messer Giovanni Danna, a Flemish gentleman and merchant, who was his gossip, he painted a portrait which appears to breathe, with an *Ecce Homo,* comprising numerous figures which, by Titian himself, as well as others, is considered to be a very good work. The same artist executed a picture of Our Lady, with other figures the size of life, men and children, being all taken from nature, and portraits of persons belonging to the Danna family.

In the year 1507, when the Emperor Maximilian was making war on the Venetians, Titian, as he relates himself, painted the Angel Raphael, with Tobit and a Dog, in the church of San Marziliano. There is a distant landscape in this picture, wherein San Giovanni Battista is seen at prayer in a wood; he is looking up to Heaven, and his face is illumined by a light descending thence. Some believe this picture to have been done before that on the Exchange of the Germans, mentioned above, was commenced.

Now it chanced that certain gentlemen, not knowing that Giorgione no longer worked at this façade, and that Titian was doing it (nay, had already given that part over the Merceria to public view), met the former, and began as friends to rejoice with him, declaring that he was acquitting himself better on the side of the Merceria than he had done on that of the Grand Canal; which remark caused Giorgione so much vexation that he would scarcely permit himself to be seen until the whole work was completed, and Titian had become generally known as the painter. Nor did he thenceforward hold any intercourse with the latter, and they were no longer friends.

In the year 1508, Titian published a wood engraving of the Triumph of Faith; it comprised a vast number of figures: our first Parents, the Patriarchs, the Prophets, the Sibyls, the Innocents, the Martyrs, the Apostles, and Our Savior Christ borne in triumph by the four Evangelists and the four Doctors, followed by the holy Confessors. Here Titian displayed much boldness, a fine manner, and improving facility. I remember that Fra Sebastiano del Piombo, speaking on this subject, told me that, if Titian had then gone to Rome and seen the works of Michelangelo with those of Raphael and the ancients, he was convinced, the admirable facility of his coloring considered, that he would have produced works of the most astonishing perfection, seeing that, as he well deserved to be called the most perfect imitator of nature of our times as regards coloring, he might thus have rendered himself equal to Raphael or Buonarroti as regarded design, the great foundation of all art.

At a later period, Titian repaired to Vicenza, where he painted the Judgment of Solomon on the Loggetta wherin the Courts of Justice are held; a very beautiful work. Returning to Venice, he then depicted the façade of the Grimani. At Padua he painted certain frescoes in the church of Sant'Antonio, the subjects taken from the life of that saint. And in the church of Santo Spirito he executed a small picture of San Marco seated in the midst of other saints whose faces are portraits painted in oil with the utmost care; this picture has been taken for a work of Giorgione.

Now the death of Giovanni Bellini had caused a story in the Hall of the Great Council to remain unfinished,[2] it was that which represents

Federigo Barbarossa kneeling before Pope Alessandro III, who plants his foot on the Emperor's neck. This was now finished by Titian, who altered many parts of it, introducing portraits of his friends and others. For this he received from the Senate an office in the Exchange of the Germans, called the Senseria, which brought him in three hundred crowns yearly, and which those Signori usually give to the most eminent painter of their city, on condition that from time to time he shall take the portrait of their Doge or Prince when such shall be created, at the price of eight crowns, which the Doge himself pays, the portrait being then preserved in the palace of San Marco as a memorial of that Doge.

In the year 1514, the Duke Alfonso of Ferrara had a small apartment decorated in certain of its compartments by the Ferrarese painter Dosso; the stories were of Æneas, Mars, and Venus; and in a Grotto was Vulcan with two Cyclops working at the forge. The Duke then wished to have some pictures by Giovanni Bellini, who painted on one of the walls a vat of red wine surrounded by Bacchantes, Satyrs, and other figures, male and female, all inebriated, with Silenus entirely nude mounted on his ass, a very beautiful figure. Around this group are crowds of figures with grapes and other fruits in their hands. And this work is so carefully colored that it may be called one of the finest ever executed by Giovanni Bellini, although there is a certain harshness and stiffness in the draperies, he having imitated a picture by the Fleming, Albert Dürer,[3] which had just then been brought to Venice. It was placed in the church of San Bartolommeo, an extraordinary work painted in oil, and comprising a crowd of figures. Within the vat above mentioned, Giovanni Bellini wrote the following words:

Joannes Bellinus Venetus, p. 1514.

This picture the great age of the master had prevented him from completing; and Titian, as being more eminent than any other artist, was sent for to finish it. Wherefore, desirous of progress and anxious to make himself known, he depicted two stories which were still wanting to that apartment. The first is a river of red wine, beside which are singers and players on instruments, half inebriated, females as well as men. There is one nude figure of a sleeping Woman which is very beautiful, and appears living as indeed do the other figures. To this work Titian affixed his name.

In the second picture, which is near the above, and is seen on first entering, there are numerous figures of Loves and beautiful Children in various attitudes: the most beautiful among these is one who is fishing in a river, and whose figure is reflected in the water. This greatly pleased the Duke, as did the first picture. These children surround an altar, on which

is a statue of Venus with a shell in her hand; she is attended by Grace and Beauty, exquisite figures, which are finished with indescribable care.

On the door of a press, Titian painted the figure of Christ, from the middle upwards, a most beautiful and admirable work; a wicked Hebrew is showing to Jesus the coin of Cæsar. Other pictures, executed in the same place, are declared by our artists to be among the best ever produced by Titian, and are indeed singularly fine. He was consequently rewarded very largely by the Duke, whose portrait he also took, representing him as leaning on a large piece of artillery. He portrayed the Signora Laura likewise, who was afterwards wife of the Duke; and this too is an admirable work. Nor is it to be denied that the labors of those who toil for art have great energy when stimulated by the liberality of princes.

About this time Titian formed a friendship with the divine Messer Ludovico Ariosto, and was by him acknowledged as an admirable painter, being celebrated as such in his *Orlando Furioso*:

> . . . e Tizian che onora
> Non men Cador che quei Venezia e Urbino.[4]

Having then returned to Venice, Titian painted a picture in oil for the brother-in-law of Giovanni da Castel Bolognese; a nude figure of a Shepherd, to whom a Peasant Girl offers a Flute; around the group is a beautiful Landscape. That work is now at Faenza, in the house of the above-named Giovanni. For the high altar in the church of the Minorite Friars, called the Ca' Grande, this artist painted a picture of Our Lady ascending into Heaven, with the Twelve Apostles beneath. But of that work, which was painted on cloth, and perhaps not carefully kept, little can now be seen. In the same church, and in the chapel of the Pesari family, Titian painted a Madonna with the Divine Child in her arms; San Piero and San Giorgio are beside her, and the owners of the chapel are kneeling around the group. These persons are all portraits from the life; among them are the Bishop of Baffo[5] and his brother, who had just then returned from the victory which that Bishop had obtained over the Turks.

At the little church of San Niccolò in the same convent, Titian also painted a picture, comprising figures of San Niccolò, San Francesco, Santa Caterina, and San Sebastiano; the latter is nude, and has been exactly copied from the life without the slightest admixture of art; on efforts for the sake of beauty have been sought in any part, trunk or limbs; all is as nature left it, so that it might seem to be a sort of cast from the life. It is nevertheless considered very fine, and the figure of Our Lady with the Infant in her arms, whom the other figures are looking at, is also accounted most beautiful. This picture was drawn on wood by Titian himself, and was then engraved and painted by others.

After the completion of these works, our artist painted for the church of San Rocco a figure of Christ bearing his Cross; the Savior has a rope round his neck, and is dragged forward by a Jew. Many have thought this a work of Giorgione. It has become an object of the utmost devotion in Venice, and has received more crowns as offerings than have been earned by Titian and Giorgione both, through the whole course of their lives.

Now Titian had taken the portrait of Bembo, then secretary of Pope Leo X, and was by him invited to Rome, that he might see the city, with Raphael of Urbino and other distinguished persons. But the artist, having delayed his journey until 1520, when the Pope and Raphael were both dead, put it off for that time altogether.

For the church of Santa Maria Maggiore he painted a picture of St. John the Baptist in the Wilderness; there is an Angel beside him that appears to be living; and a distant Landscape, with trees on the bank of a river, which are very graceful. He took portraits of the Princes Grimani and Loredano, which were considered admirable, and not long afterwards he painted the portrait of King Francis, who was then leaving Italy to return to France.

When Andrea Gritti was elected Doge, our artist made his portrait also; a beautiful thing it is, the likeness being in the figure of Sant'Andrea, who makes one of a group, consisting of Our Lady, San Marco, and himself. The picture is now in the Hall of the College. He painted other portraits of the Doges likewise, that being in his office, as we have said; and these were Pietro Lando, Francesco Donato, Marcantonio Trevisano, and Veniero; but in respect to the two Doges and brothers Pauli,[6] he was excused, because he had become very old at the time of their election.

The renowned poet, Pietro Aretino, having left Rome before the sack of that city and repaired to Venice, then became the intimate of Titian and Sansovino, which was both honorable and useful to the former, who was by that circumstance made known wherever the pen of the writer had reached, more especially to certain powerful princes, as will be related in due time.

To return, meanwhile, to the works of Titian. It was by him that the altarpiece of San Piero Martire, in the church of SS. Giovanni and Paolo, was painted. San Piero, a figure larger than life, is seen extended on the earth, in a wood of very large trees. He is fiercely assailed by a Soldier, who has already wounded him so grievously in the head that, although still living, the shadows of death are seen on his face. The countenance of another Monk, who is flying from the scene, exhibits the utmost terror. In the air are two nude figures of Angels descending from Heaven in a blaze of light, by which the picture is illumined. These are most beautiful, as is indeed the whole work, which is the best and most perfectly finished, as it is the most renowned of any that Titian has yet ex-

ecuted. This painting having been seen by Gritti, who was ever the friend of Titian as well as of Sansovino, he caused the former to receive a commission for the story of a great battle piece, to be painted in the Hall of the Grand Council, and representing the route of Chiaradadda. The soldiers are contending furiously, while heavy rain is falling on them. The work is wholly copied from the life, and is considered the best, most animated, and most beautiful picture in the hall. In the same palace, at the foot of one of the staircases, our artist depicted a Madonna in fresco.

No long time after, Titian painted a picture for a gentleman of the Contarini family; the subject was Our Savior at table with Cleophas and Luke. But the gentleman, considering that the beauty of the work rendered it worthy to be seen in public—as it certainly is—presented it, he being a lover of his country, as a gift to the Signoria, when it was kept for some time in the apartments of the Doge; but it is now placed in a more public position, and where it can be seen by all, over the door of the hall leading to that of the Council of Ten namely. About the same time our artist executed a picture of the Virgin ascending the steps of the Temple, for the Scuola of Santa Maria della Carità; the heads in this work are all portraits from the life. He also painted a small picture of St. Jerome doing Penance, for the Scuola of San Faustino; this was much commended by artists, but was destroyed by fire about two years since, together with the whole church.

In 1530, when the Emperor Charles V was in Bologna, Titian, by the intervention of Pietro Aretino, was invited to that city by the Cardinal Ippolito de' Medici, and there he made a magnificent portrait of his Majesty in full armor. This gave so much satisfaction that the artist received a present of a thousand crowns for the same. Out of these he had subsequently to give the half to Alfonso Lombardi, the sculptor, who had made a model of that monarch to be executed in marble.

Having returned to Venice, Titian there found that many gentlemen had begun to favor Pordenone, commending exceedingly the works executed by that artist in the ceiling of the Hall of the Pregai, and elsewhere. They had also procured him the commission for a small picture in the church of San Giovanni Elemosynario, which they intended him to paint, in competition with one representing that saint in his episcopal habit, which had previously been executed there by Titian. But whatever care and pains Pordenone took, he could not equal nor even approach the work of the former. Titian was then appointed to paint a picture of the Annunciation for the church of Santa Maria degli Angeli, at Murano. But those who gave the commission for the work, not wishing to pay so much as five hundred crowns, which Titian required as its price, he sent it, by the advice of Pietro Aretino, as a gift to Charles V,

who being greatly delighted with the work, made him a present of two thousand crowns. The place which the picture was to have occupied at Murano was then filled by one from the hand of Pordenone.

When the Emperor, some time after this, returned with his army from Hungary, and was again at Bologna, holding a conference with Clement VII, he desired to have another portrait taken of him by Titian, who, before he departed from the city, also painted that of the Cardinal Ippolito de' Medici in the Hungarian dress, with another of the same prelate fully armed, which is somewhat smaller than the first; these are both now in the Guardaroba of Duke Cosimo. He painted the portraits of Alfonso, Marquis of Davalos, and of Pietro Aretino, at the same period, and these things having made him known to Federigo Gonzaga, Duke of Mantua, he entered the service of the latter, and accompanied him to his states. At Mantua our artist made a portrait of the Duke which appears to breathe, and afterwards executed that of his brother, the Cardinal. These being finished, he painted twelve beautiful Heads of the Twelve Cæsars, to decorate one of the rooms erected by Giulio Romano, and when they were done, Giulio painted a story from the lives of the Emperors beneath each head.

In Cadore, the native place of Titian, that artist has painted a picture wherein is Our Lady, San Tiziano, the Bishop, and his own portrait in a kneeling position. In the year that Pope Paul III went to Bologna, and thence to Ferrara, Titian having gone to the court took the portrait of His Holiness, a very fine work. He also painted that of the Cardinal Santa Fiore. Both of these works, for which he was very well paid by the Pope, are now in Rome, one in the Guardaroba of Cardinal Farnese, the other in the hands of those who became heirs of the Cardinal Santa Fiore. Many copies have been taken from them, and these are dispersed throughout Italy. About the same time our artist made the portrait of Francesco Maria, Duke of Urbino; and this is so wonderfully beautiful that it was celebrated by Messer Pietro Aretino in a sonnet, which begins thus:

> Se il chiaro Apelle con la man dell'Arte
> Rassembrò d'Alessandro il volto e il petto.[7]

In the Guardaroba of the same Duke, there are two female heads by Titian, which are very pleasing, with a recumbent figure of Venus, partially covered with flowers, and transparent draperies, the whole exceedingly beautiful and finely finished. There is a half-length of Santa Maria Maddalena, with dishevelled hair, which is likewise very beautiful; with portraits of Charles V, King Francis as a youth, the Duke Guidobaldo II, Pope Sixtus IV, Julius II, Paul III, the old Cardinal of Lorraine, and Soliman, Emperor of the Turks; all from the hand of Titian, and ex-

ceedingly fine. In that same Guardaroba, among many other things, is an antique Head of the Carthaginian Hannibal, cut in a carnelian, with a beautiful bust in marble by Donatello.

In the year 1541, Titian painted the picture of the high altar in the church of the Santo Spirito in Venice, the subject being the Descent of the Holy Spirit on the Apostles; the Almighty is represented in fire, and the Spirit as a Dove. This picture having shown signs of deterioration in a very short time, Titian had much discussion with the monks of Santo Spirito respecting it, and was ultimately obliged to repaint the work, which is that now on the altar.

At Brescia Titian painted the picture of the high altar in the church of San Nazzaro, which he did in five divisions. The center has the Resurrection of Our Lord, with soldiers around the sepulchre; in the sides are San Nazzaro, San Sebastiano, the Angel Gabriel, and the Virgin receiving the Annunciation. In the Cathedral of Verona, he painted the Assumption of Our Lady into Heaven, with the Apostles standing beneath; this is held to be the best modern painting in that city.

In the same year, 1541, this master painted the portrait of Don Diego di Mendoza, then Ambassador from Charles V to Venice. That beautiful portrait is a full-length, standing upright, and from that time Titian began the custom, since become frequent, of painting portraits at full-length. In the same manner he made the likeness of the Cardinal of Trent, then a youth, and for Francesco Marcolini he took the portrait of Pietro Aretino. But this is not so fine a one as that which the same person caused to be taken, and sent himself as a present to the Duke Cosimo de' Medici, to whom he also sent the head of the Signor Giovanni de' Medici, father of the Duke. This last was taken from a cast made from the face of Giovanni after his death, at Mantua, which cast was in possession of Pietro. The portraits are both in the Guardaroba of the Duke with other noble pictures.

In the same year, Giorgio Vasari was in Venice, where he passed thirteen months, employed, as I have said, in the decoration of a ceiling for Messer Giovanni Cornaro, and certain works for the company of the Calza, when Sansovino, who was directing the construction of Santo Spirito, caused him to make designs for three large pictures in oil, which were to be executed in the ceiling of Santo Spirito, and which Vasari was to paint. But Giorgio having departed, the three pictures were given to Titian, who executed the same most admirably, having taken especial pains with the foreshortening of the figures. In one of these pictures is the Sacrifice of Isaac by his father Abraham; in the second, David taking off the head of Goliath; and in the third, Cain killing Abel. About the same time Titian painted his own portrait, that this memorial of himself might be left to his children; and in the year 1546, being invited to Rome

by the Cardinal Farnese, he repaired to that city accordingly. There he found Vasari, who had then returned from Naples, and was painting the Hall of the Chancery for the Cardinal Farnese, by whom Titian was recommended to his care, whereupon Giorgio kept him faithful company in his visit to the remarkable objects of Rome.

Having rested himself for a few days, Titian then received rooms in the Belvedere, and was commissioned to make another full-length portrait of Pope Paul III, with that of Farnese, and of the Duke Ottavio; all of which he executed to the great satisfaction of those Signori, who then prevailed on him to paint a half-length figure of Christ, in the manner of the *Ecce Homo,* as a present for the Pope. But this work, whether it were that the paintings of Michelangelo, of Raphael, of Polidoro, and of others had made him lose courage, or from some other cause, although a good picture, did not appear to the painters equal in excellence to others of his productions, more particularly his portraits.

Now it chanced that Michelangelo and Vasari, going one day to see Titian in the Belvedere, beheld a picture, which he had just then finished, of a nude figure representing Danæ, with Jupiter transformed into a shower of gold in her lap, many of those present beginning to extol the work (as people do when the artist stands by) praised it not a little. When, all having left the place, and talking of Titian's work, Buonarroti, declared that the manner and coloring of that artist pleased him greatly, but that it was a pity the Venetians did not study drawing more, "for if this artist," said he, "had been aided by Art and knowledge of design, as he is by nature, he would have produced works which none could surpass, more especially in imitating life, seeing that he has a fine genius, and a graceful animated manner." And it is certainly true that whoever has not practiced design extensively, and studied the best works, ancient and modern, can never attain to the perfection of adding what may be wanting to the copy which he makes from the life, giving to it that grace and completion whereby Art goes beyond the hand of nature, which very frequently produces parts that are not beautiful.

Titian left Rome enriched by many gifts from those Signori, more particularly by a benefice of good income for Pomponio his son. But first his second son, Orazio, had completed the portrait of Messer Battista Ceciliano, an excellent player of the violin, which is a good work, Titian himself having made certain portraits, besides, for Guidobaldo, Duke of Urbino. Arrived at Florence, he was amazed at the sight of the fine works in that city no less than he had been by those of Rome. He then visited Duke Cosimo, and offered to take his portrait; but the Duke did not give himself much trouble in the matter, perhaps because he had no mind to offer a slight to the many noble artists of his own city and dominions.

Having reached Venice, Titian then finished an Allocution (as they

call it) for the Marquis del Vasto, and which that Signore had made to his soldiers. He afterwards executed the portrait of Charles V, with that of the Catholic King, and of many other persons. These labors completed, Titian painted a small picture of the Annunciation for the church of Santa Maria Nuova, and afterwards, using the assistance of his disciples, he painted a Last Supper in the refectory of SS. Giovanni and Paolo, with a picture for the high altar of the church of San Salvatore, the subject of which was the Transfiguration; and an Annunciation for another altar in the same church. But these last works, though there are good qualities in them, were not much esteemed by the master himself, and have not the perfection seen in many of his other paintings.

The productions, but more especially the portraits of Titian, are so numerous that it would be almost impossible to make the record of them all. I will therefore speak of the principal only, and that without order of time, seeing that it does not much signify to tell which was painted earlier and which later.

He took the portrait of Charles V several times, as we have said, and was finally invited by that monarch to his court; there he painted him as he was in those last years; and so much was that most invincible Emperor pleased with the manner of Titian, that once he had been portrayed by him, he would never permit himself to be taken by any other person. Each time that Titian painted the Emperor, he received a present of a thousand crowns of gold, and the artist was made a Cavaliere, or Knight, by his Majesty, with a revenue of two hundred crowns yearly, secured on the Treasury of Naples, and attached to his title.

When Titian painted Filippo, King of Spain, the son of Charles, he received another annuity of two hundred crowns; so that these four hundred added to the three hundred from the German Exchange make him a fixed income of seven hundred crowns, which he possesses without the necessity of exerting himself in any manner. Titian presented the portraits of Charles V and his son Filippo to the Duke Cosimo, who has them now in his Guardaroba. He also took the portrait of Ferdinand, King of the Romans, who was afterwards Emperor, with those of his children, Maximilian, that is to say, now Emperor, and his brother. He likewise painted the Queen Maria. And at the command of the Emperor Charles, he portrayed the Duke of Saxony, when the latter was in prison.

But what a waste of time is this! when there has scarcely been a noble of high rank, scarcely a prince or lady of great name, whose portrait has not been taken by Titian, who in that branch of art is indeed an excellent painter.

He painted King Francis I of France, as we have said, Francesco Sforza, Duke of Milan, the Marquis of Pescara, Antonio da Leva, Massemiano Stampa, the Signor Giovambattista Castaldo, and other Signori in vast

numbers. He has, moreover, produced various works at different times, besides those above mentioned. At Venice, for example, and by command of Charles V, he painted a large altar-piece, the subject of which is the Triune God Enthroned; Our Lady is present with the Infant Christ, who has the Dove over his head, and the whole ground is of fire, to signify Eternal Love; while the Father is surrounded by glowing Cherubim. On one side of this picture is the Emperor, and on the other the Empress, clothed in linen garments; they are kneeling in prayer with folded hands, and are surrounded by numerous Saints. The composition of this work was in accordance with the orders of his Majesty, who was then giving evidence of his intention to retire, as he afterwards did, from mundane affairs, to the end that he might die in the manner of a true Christian, fearing God, and laboring for his own salvation. This picture the Emperor told Titian that he would have taken to the monastery, where his Majesty afterwards finished the course of his life; and being a work of extraordinary merit, it is expected that engravings thereof will be published in a short time.

The same master painted for the Queen Maria a figure of Prometheus bound to the Mount Caucasus and torn by the Eagle of Jupiter; with one of Sisyphus in Hell loaded with his stone, and Tityus devoured by the Vulture. All these were transmitted to her Majesty, with a figure of Tantalus of the same size, that of life namely, on cloth and in oil. He painted a Venus and Adonis also, which are admirable; the goddess is fainting as she sees herself abandoned by Adonis, who is accompanied by dogs, which are singularly natural. In a picture of the same size, Titian painted Andromeda bound to the Rock with Perseus delivering her from the Sea-monster; a more beautiful painting than this could not be imagined. And the same may be said of another, Diana Bathing with her Nymphs, and turning Actæon into a Stag. He painted a figure of Europa likewise, borne over the Sea by the Bull. These pictures are in the possession of the Catholic King, and are held in high esteem for the animation imparted to them by the master, whose colors have made them almost alive.

It is nevertheless true that his mode of proceeding in these last-mentioned works is very different from that pursued by him in those of his youth, the first being executed with a certain care and delicacy, which renders the work equally effective, whether seen at a distance or examined closely; while those of a later period, executed in bold strokes and with dashes, can scarcely be distinguished when the observer is near them, but if viewed from the proper distance they appear perfect. This mode of his, imitated by artists who have thought to show proof of facility, has given occasion to many wretched pictures, which probably comes from the fact that whereas many believe the works of Titian, done

in the manner above described, to have been executed without labor, that is not the truth, and these persons have been deceived. It is indeed well known that Titian went over them many times, nay, so frequently, that the labor expended on them is most obvious. And this method of proceeding is a judicious, beautiful, and admirable one, since it causes the paintings so treated to appear living, they being executed with profound art, while that art is nevertheless concealed.

In a picture three braccia high and four broad, Titian painted the Infant Christ in the arms of the Virgin, and receiving the Adoration of the Magi. The work comprises numerous figures one braccio high, and is a very good one, as is another which he copied himself from this and gave to the Cardinal of Ferrara (the elder). Another work by this master, representing Christ derided by the Jews, was placed in a chapel of the church of Santa Maria delle Grazie at Milan. For the Queen of Portugal he painted a picture of Christ scourged at the Column; this, which is somewhat less than life, is very beautiful. For the high altar in the church of San Domenico, in Ancona, he painted a picture of Christ on the Cross, with Our Lady, San Giovanni, and San Domenico at the foot of the same; this also is very beautiful, and in the bold manner described above.

The picture at the altar of San Lorenzo, in the church of the Crocicchieri at Venice, is by Titian; it represents the Martyrdom of San Lorenzo, with a building crowded with figures. In the midst of them lies the foreshortened figure of San Lorenzo on the Gridiron, beneath which is a great fire, and the executioners stand around it. The time being night, there are two servants with torches giving light to those parts of the picture that are beyond the reach of the fire beneath the gridiron, which is a large and fierce one. But the light it throws, as well as that of the torches, is overcome by a flash of lightning which descends from Heaven, and cleaving the clouds, shines brightly over the head of the Saint and the other principal figures. In addition to these three lights, there is that of lamps and candles, held by those at the windows of the building. All this produces a fine effect, and the whole work is, in short, executed with infinite art, genius, and judgment.

At the altar of San Niccolò, in the church of San Sebastiano, there is a small picture by Titian, representing St. Nicholas, so animated as to seem alive; he is seated in a chair painted to imitate marble, and an angel is holding the mitre; this was executed for the advocate Messer Niccolò Crasso. At a later period, our artist painted a half-length figure of Mary Magdalene for the Catholic King; her hair falls about her neck and shoulders; her head is raised and the eyes are fixed on Heaven, their redness and the tears still within them, giving evidence of her sorrow for the

sins of her past life. This picture, which is most beautiful, moves all who behold it to compassion. When it was finished, a Venetian gentleman, . . . Silvio, was so much pleased therewith, that, being a zealous lover of painting, he gave Titian a hundred crowns for the picture, and the master had to make another for the Catholic King, which was however no less beautiful.

Among the portraits by Titian is that of a Venetian citizen, his friend, called Sinistri, and of Messer Paolo da Ponte, whose daughter, called the Signora Giulia da Ponte, a most beautiful damsel, and a gossip of Titian, the latter also took; as he did the Signora Irene, another lovely maiden accomplished in music, in learning, and in design, who died about eight years since, and was celebrated by the pens of almost all the Italian writers.[8] Titian also made the likeness of Messer Francesco Filetto, an orator of happy memory, with that of his son in the same picture. The last appears to be living, and the portrait is now in the possession of Messer Matteo Giustiniani, a lover of these arts, who has had his own likeness taken by the painter Jacopo da Bassano, a fine work, as are many others dispersed through Venice, and also by Bassano, who is particularly excellent in small pictures, and in the painting of animals.

Titian made a second portrait of Bembo, when the latter had become a Cardinal, that is; he also took Fracastoro,[9] and the Cardinal Accosti of Ravenna, whose portrait the Duke Cosimo has in his Guardaroba. The sculptor Danese has the portrait of a gentleman of the Delfini family by this master in his possession. And Messer Niccolò Zono tells us that he saw the likeness of Rossa, the wife of the Grand Turk, a lady of sixteen, with that of Cameria her daughter, both by the hand of Titian, and wearing dresses and ornaments of great beauty.

In the house of the lawyer, Messer Francesco Sonica, a gossip of Titian, is the portrait of that Messer Francesco by the hand of our artist, with a large picture representing the Madonna in the Flight to Egypt. She appears to have just descended from the Ass, and has seated herself on a stone by the wayside; St. Joseph stands near, as does St. John, a little child who is offering to the Savior the flowers gathered by an angel from the branches of a tree which is in a wood, wherein are numerous animals; the ass is browsing near. This picture, a very graceful one, has been placed by the Signor Francesco in a palace which he has built near Santa Justina in Padua.

For the Florentine Monsignore Giovanni Della Casa, a man illustrious for learning as well as birth, our artist painted a beautiful portrait of a gentlewoman whom Della Cosa loved when he was in Venice, and by whom the master was honored for the same with the exquisite sonnet which begins thus:

> Ben veggo io, Tiziano, in forme nuove
> L'idolo mio, che i begli occhi apre e gira.[10]

As also with that which follows it.

This admirable painter likewise sent a picture of the Last Supper to the Catholic King; this work, which was seven braccia long, was a performance of extraordinary beauty. And besides these, with many others of minor importance which we omit, he has still in his house, among numerous sketches and pictures commenced, the Martyrdom of San Lorenzo, of size similar to the above, which he also proposes to send to the Catholic King. He has likewise a large canvas exhibiting Christ on the Cross, the thieves on each side, and the executioners beneath, which he is painting for Messer Giovanni d'Arna; and a picture which was begun for the Doge Grimani, father of the Patriarch of Aquileia.

For the hall of the Great Palace of Brescia, Titian has commenced three large pictures, which are to form part of the decorations of the ceiling, as we have said when speaking of the Brescian painters, Cristofano and his brother. He also began a picture many years since for Alfonso, first Duke of Ferrara. The subject is a nude figure of a woman bowing before the goddess Minerva; there is besides another figure; and in the distance is the Sea, with Neptune in his Chariot. But the death of Alfonso, according to whose fancy the work was composed, caused the picture to remain incomplete, and it is still in Titian's hands.

Another work, brought to a state of considerable advancement, but not finished, is Our Savior appearing to Mary Magdalen in the Garden; the figures are of the size of life, as are those of another of equal size where Christ is placed in the Sepulchre, while the Madonna and the other Maries stand around. And among other good things to be seen in his house is a picture of the Madonna, with, as it is said, a portrait of himself, finished four years since, and which is very beautiful and natural. There is, likewise, a figure of San Paolo reading, a half-length figure, which is so fine that it may well be that same which was filled with the Holy Spirit.

All these works, with many others which I omit, to avoid prolixity, have been executed up to the present age of our artist, which is above seventy-six years. Titian has been always healthy and happy; he has been favored beyond the lot of most men, and has received from heaven only favors and blessings. In his house he has been visited by whatever princes, literati, or men of distinction have gone to or dwelt in Venice; for, to say nothing of his excellence in art, he has always distinguished himself by courtesy, goodness, and rectitude.

Titian has had some rivals in Venice, but not of any great ability, wherefore he has easily overcome them by the superiority of his art;

while he has also rendered himself acceptable to the gentlemen of the city. He has gained a fair amount of wealth, his labors having always been well paid. And it would have been well if he had worked for his amusement alone during these latter years, that he might not have diminished the reputation gained in his best days by works of inferior merit and consequent imperfection, performed at a period of life when nature tends inevitably to decline.

In the year 1566, when Vasari, the writer of the present history, was at Venice, he went to visit Titian, as one who was his friend, and found him, although then very old, still with the pencils in his hand and painting busily. Great pleasure had Vasari in beholding his works and in conversing with the master. Titian then made known to Giorgio, Messer Gian Maria Verdezzotti, a young Venetian gentleman of great ability, the friend of Titian, and a man well versed in design as well as a tolerable colorist, which he has proved by some very beautiful landscapes from his own hand. This youth, by whom Titian is loved and revered as a father, has two figures painted in oil within two niches by that artist, an Apollo and a Diana, that is to say.

It may be affirmed, then, that Titian, having adorned Venice, or rather all Italy, and other parts of the world, with excellent paintings, well merits to be loved and respected by artists, and in many things to be admired and imitated also, as one who has produced, and is producing, works of infinite merit; nay, such as must endure while the memory of illustrious men shall remain.

Many young men have been with Titian for the purposes of learning; yet the number of those who may truly call themselves his disciples is not great, seeing that he has never given much instruction. Yet all may learn more or less from the works of a master, once they have acquired the power of comprehending them.

I must not here omit to mention that the art of mosaic, almost abandoned in all other places, is encouraged and kept in life by the most serene Senate of Venice; and of this Titian has been the principal cause, seeing that so far as in him lies, he has ever labored to promote the exercise thereof, and to procure respectable remuneration for those who practice the art. Various works have thus been undertaken in the church of San Marco, the old mosaics having been almost wholly restored. And this mode of delineation, being now brought to all the perfection of which it is susceptible, exhibits consequently a very different aspect from that displayed in Florence and Rome at the time of Giotto, Alesso Baldovinetti, Ghirlandaio, or the miniaturist Gherardo.

All that has been done in Venice has been executed after the designs of Titian and other excellent painters, who have made colored cartoons for the same; thus the works are brought to perfection, as may be seen in

the portico of San Marco, where there is a Judgment of Solomon so beautiful that it could scarcely be executed more delicately with the pencil and colors. In the same place is the Genealogical Tree of Our Lady, by Ludovico Rosso. The Sibyls and Prophets are admirably represented in this work, which is carefully conjoined, and displays excellent relief.

But in the art of mosaic there are none who have distinguished themselves more highly in our times than have Valerio and Vincenzio Zuccheri, natives of Treviso,[11] many stories by whom may be seen in San Marco; those from the Apocalypse may more particularly be specified. In this work the four Evangelists, under the form of various animals, are seen to surround the Throne of God; the Seven Candlesticks, and other things, are also represented so admirably well that, to him who looks at them from below, they appear to be paintings in oil. There are besides numerous small pictures by those artists, and these are filled with figures which look, I do not say like paintings only, but like miniatures, and yet they are made of stones joined together.

There are portraits, moreover, of various personages; the Emperor Charles V, that is to say, with Ferdinand his brother, who succeeded him in the empire, Maximilian, son of Ferdinand and now Emperor, the most illustrious Cardinal Bembo, the glory of our age, and the Magnifico . . . all executed so carefully, with so much harmony, so admirable a distribution of light and shadow, and such exquisite tints of the carnations (to say nothing of other qualities) that no better or more perfect works of the kind could possibly be conceived.

Bartolemmeo Bozzato has also worked on the church of San Marco. He is the rival of the Zuccheri, and has acquitted himself in a sufficiently praiseworthy manner. But that which has most effectually contributed to the success of all these artists has without doubt been the superintendence of Titian, with the designs prepared for these mosaics by his hand. In addition to the above-mentioned and others who have been disciples of Titian, there was besides a certain Girolamo,[12] of whom I know no other name than Girolamo di Tiziano.

NOTES

Giotto

1. This is a crucifix, from which proceeds the genealogical tree of the Savior, with the prophets and patriarchs on medallions.
2. Not the saints themselves, but living models.
3. Modern scholarship discusses at length whether or not Giotto ever went to Assisi.
4. Commander of the Ghibelline forces at the battle of Arbia.
5. Vasari evidently meant to say Benedict XI, but it was Boniface VIII who summoned Giotto to Rome.
6. "You are rounder than the O of Giotto."
7. "O!" I exclaimed,
 "Art thou not Oderigi? art not thou
 Agobbio's glory, glory of that art
 Which they of Paris call the limner's skill?"
 "Brother!" said he, "with tints that gayer smile,
 Bolognian Franco's pencil lines the leaves.
 His all the honor now; my light obscured."
 (H. F. Cary, trans.)
8. The church of St. Anthony of Padua.
9. It is now generally admitted that these paintings are not by Giotto, but of a later date.
10. Supposed to have been a pupil of Giotto, since Michelina lived twenty years after Giotto.
11. 1337.
12. "I pass now to the bequest of my other possessions. To the aforementioned lord of Padua, since by the grace of God he needs nothing for himself, I leave the only thing I have worthy of him, my picture—or rather representation—of the Blessed Virgin Mary. This, the work of the distinguished painter, Giotto, was sent to me by my friend Michele Vanni of Florence. Its beauty is incomprehensible to the layman, yet astounds professionals. I bequeath this to my lord with the prayer that the Blessed Virgin herself will intercede for him with her son Jesus Christ, etc. . . ."

13. "Now (if I may turn from old things to new, and from foreign to domestic) I have known two painters whose work is outstanding and not merely attractive: Giotto of Florence, who enjoys a huge reputation nowadays, and Simone of Siena. I have also known a number of sculptors, etc."
14. Lived 1454–1494.
15. "It was I who revived the extinct art of painting. My hallmarks were ease and control. What my art lacked was also missing in Nature. No one has ever painted more or better. Do you admire the remarkable tower that resounds with the sacred chime? Through my design that too reached toward the stars. In a word, I am Giotto. But why tell you all this? My very name will serve as well as an ode."

Masaccio

1. Fra Filippo Lippi, Donatello, Lorenzo Ghiberti.
2. The suffix -accio in Italian is augmentative; it may also carry the meaning of "awkward" or "pitiable."
3. These frescoes are generally ascribed to Masolino.
4. The Miracle of the Snow is attributed to Masolino.
5. None of the above chronology is possible. The work at St. John of the Lateran took place in 1431–32; Cosimo I was recalled in 1434; Masolino died in 1447, whereas Masaccio's untimely death occurred in 1428.
6. Wooden shoes, worn by penitents.
7. Felice Brancacci (d. 1422) was the founder of the chapel.
8. Although Fra Angelico was fourteen years older than Masaccio, his later works bear the influence of the younger man's style.
9. More correctly, twenty-seven.
10. Untrue.
11.
 I painted, and my picture was as life;
 Spirit and movement to my forms I gave—
 I gave them soul and being. He who taught
 All others—Michaelangelo—I taught:
 He deigned to learn of me. . . .
 (by Annibal Caro)
12. "Why, O envious Lachesis, must thy dread hand sever the thread of a youth in its first flower? With a single blow dost thou cut down a thousand Apelles. With this loss painting loses all its charm. With this sun's extinction all the stars are extinguished. Alas! all beauty perishes with his death."

Fra Filippo Lippi

1. Fra Filippo received holy orders in 1421 (at the age of fifteen), i.e., before Masaccio gained great eminence. The two painters probably knew each other personally.
2. That is, North Africa. It is highly unlikely that this and the following statements are true.
3. The Coronation of the Virgin.
4. The belt of the Madonna, which, according to legend, was dropped to the apostle Thomas, to prove the reality of her Assumption.
5. The father of Lucrezia Buti died in 1451, and after this event she became a nun. She and Fra Filippo met in 1456.
6. The son, Filippino Lippi, was one of two children born to the couple. Far from being in disgrace, Fra Filippo was relieved of his ecclesiastical duties and given dispensation by Pope Pius II to live with Lucrezia as man and wife.
7. Attributed to Sandro Botticelli.
8. Died at the age of sixty-three.
9. The boy was twelve when his father died.
10. Cosimo died in 1469, before Fra Filippo.
11. See note 6.
12. "Here I lie, Filippo, the glory of painting. My wondrous skill is known to everyone. When I mixed my paints they lived and breathed: you expected my images to speak. Even Nature was amazed at seeing herself mirrored in my work, and admitted that my arts rivalled hers. Lorenzo de' Medici had me placed in this marble tomb; earlier I had been buried in the humble ground."

Botticelli

1. Botticelli's famous paintings, the Birth of Venus and the Primavera, are rectangular in form.
2. The Sistine Chapel.
3. Literally, "weeper" or "mourner," as the followers of Savonarola were called.
4. Sixty-sixth year.
5. Lucrezia Tornabuoni was Lorenzo's mother; his wife was Clarice Orsini.
6. "'Incriminate no man of false testimony'—this is the warning given by my little picture to the kings of the earth. Apelles gave one like this to the King of Egypt; the king was worthy of the gift, and the gift of him."

Leonardo da Vinci

1. Vinci is a small castle in the lower Valdarno, near Lake Fucecchio.
2. This magnificent work was executed about 200 years after, by Vincenzo Viviani, a disciple of Galileo.
3. For thickening cloth.
4. "Virgil and Homer both depicted Neptune spurring on his horses through the surf of the booming sea. The poets' pictures of him are mental; Vinci's is visual—and truly he is superior to both."
5. This was Leonardo's second trip to Milan; his first was in 1482–1483.
6. Francis I, namely, who visited Milan in 1515.
7. These portraits were painted in oil on the wall.
8. Not of Ludovico himself, but of his father, Francesco Sforza.
9. See *Trionfo d'Amore*, cap. iii.
10. It has been suggested that N. N. was a painter, the son of one of Leonardo's pupils.
11. Andrea Salai, or Salaino, was the disciple and servant of Leonardo, in whose testament he is mentioned under the latter designation only.
12. After Ludovico il Moro had been deprived of the duchy in 1499.
13. September, 1514.
14. The truth of this statement is much disputed.
15. Sixty-seventh year.
16. Vasari does not make mention of Leonardo's talents in architecture, nor of his skill as an engineer. The *Trattato della Pittura* of Leonardo has been translated into English. The following are among the principal literary works of this master: a Treatise on Hydraulics; those on the Human Anatomy and that of the Horse, which have been mentioned in the text; a Treatise on Perspective, and one on Light and Shade; with a work on Architecture, already alluded to.
17. He alone
Vanquished all others. Phidias he surpassed,
Surpassed Apelles, and the conquering troop
Of their proud followers.
18. Or Uglone, but more commonly called Marco Oggione.

Raphael

1. Giovanni de' Santi (d. 1494) made important historical contributions with his monumental rhymed chronicle on the Duchy of Urbino (*Elogio Storico*).
2. This was Magia Ciarlo (d. 1491).

3. When Raphael was born, Giovanni de' Santi already had one son, but this child died in 1485. He afterwards had one or, as some authors say, two daughters.
4. Raphael was only eleven when his father died and therefore could have assisted him but very little.
5. Raphael probably studied with Luca Signorelli and Timoteo Viti before joining the Perugino shop.
6. This is the celebrated picture of the "Sposalizio," now in the Brera, Milan.
7. All the cartoons are now ascribed to Pinturicchio himself.
8. Raphael's first Florentine journey took place in 1504, whereas the Leonardo and Michelangelo cartoons were not complete until 1506.
9. The inscription was added after Raphael's death.
10. The School of Athens.
11. Geometrical and astronomical figures.
12. Vasari here mixes in some figures from the scene of the Disputa, on the opposite wall of the room.
13. Pythagoras.
14. The fresco is called the Disputa, or the Disputation on the Holy Sacrament. It was actually the first work Raphael did for the papal apartment.
15. Pope Gregory IX.
16. The Sistine Chapel was thrown open to the public about the time when this secret visit is said to have taken place.
17. Trastevere is a section of Rome on the far side of the river Tiber; the palace is known as the Farnesina.
18. Sigismondo Conti of Foligno, private secretary of Pope Julius, and a learned historian.
19. The miracle is said to have taken place in the year 1264, under the pontificate of Urban IV, who instituted the festival of the Corpus Domini in consequence thereof.
20. Raffaello Riario.
21. The subject is the Expulsion of Heliodorus.
22. See the second book of Maccabees, chap. III.
23. Historically, the meeting took place between Attila and Leo I on the river Mincio, near Mantua.
24. "Others may paint the face alone and reflect its coloring; but Raphael laid bare Cecilia's soul."
25. Marcantonio Raimondi (c. 1488–before 1534).
26. It was St. Felicitas who was boiled in oil.
27. Known as Lo Spasmo di Sicilia.
28. Mount Etna.
29. Vasari is correct in his identification of the personages depicted in

both scenes; but the historical events portrayed are (1) the Coronation of Charlemagne by Pope Leo III, and (2) the Justification of Leo III before Charlemagne.

30. Forty-eight subjects from the Old Testament, and four from the New Testament, known as "The Bible of Raphael."

31. Giovanni Francesco Penni and Bartolommeo Ramenghi, called also Il Bagnacavallo.

32. By this time Luca was dead; the pavement came from his nephew, Andrea della Robbia.

33. Called the Villa Madama.

34. The famous Sistine Madonna, now in Dresden.

35. The Farnesina.

36. The figures of Lorenzetti—Elisha and Jonas—are now in the Chigi chapel, along with the seventeenth-century figures of Daniel and Habakkuk by Gianlorenzo Bernini.

37. Sebastiano del Piombo.

38. The Vatican painting was placed in San Pietro in Montorio at Raphael's death.

39. That is, raise him to the dignity of a Cardinal. The truth of this statement has been much debated.

40. The Pantheon.

41. President of the Chancery.

42. D. O. M. [To God, the Best and Greatest]

"In memory of painter Raphael Sanzio, son of Giovanni of Urbino, eminent painter and rival of the ancients. Beholding his life-like forms you readily see nature and art united. In his painting and architecture he increased the glory of Popes Julius II and Leo X. He lived for thirty-seven years in perfectness, and died on the day of his birth, April 7, 1520.

"This is the great Raphael. The great Mother of Things was afraid that she would be surpassed by him while he lived and that she would die when he died."

43. "Because he dared to heal Hippolytus' mutilated body with his medicinal art and bring him back from the waters of the dead, Asclepius himself was snatched into the Styx. Death was this master's reward for restoring life.

"With your genius, Raphael, you healed Rome's mutilated city. It was a mere shell, destroyed by fire and the sword, and decayed through age, yet you restored it to life and brought back its ancient beauty. Thereby you aroused the envy of the gods; they exacted their penalty with your untimely and undeserved death. What long years had slowly eaten away you dared recreate in defiance of the law of

mortality. Your unfortunate passing in the bloom of youth is a warning to us all of death's dues."

Michelangelo

1. Hard, blue-gray sandstone.
2. Ascanio Condivi's *Life of Michelangelo* was published in the years between the first edition of Vasari's *Lives* and the second.
3. Martin Schöngauer.
4. The Casa Buonarroti in the Via Ghibellina.
5. Niccolò Pisano, and not Giovanni.
6. Not Cardinal Rohan, but Cardinal Grolaye de Villiers.
7. Where the temple of Mars had been.
8. Andrea Solari.
9. By Agostino di Duccio.
10. That is, the symbol of the Signoria.
11. The correct name is Mouscron, and the Madonna is not bronze but marble. It is still in the church of Notre Dame in Bruges, Belgium.
12. Other historical versions of this incident report it as considerably less physical in character.
13. This command was not obeyed.
14. Actually the artist worked some six years on the frescoes.
15. The Pope's surname *della Rovere* means "of the scrub oak."
16. Giuliano da Sangallo, and not Antonio.
17. A relative of Pope Julius II.
18. Or dome.
19. The two tombs executed by Michelangelo are those of Giuliano, Duke of Nemours, brother of Pope Leo X, and of Lorenzo, Duke of Urbino.
20. The author was Gio. Battista Strozzi.
21. This is believed to be Maso Boscoli, the disciple of Andrea Sansovino.
22. Papal decree.
23. It was instead Piacenza.
24. Baldassare Peruzzi.
25. Sebastiano del Piombo.
26. Mr. Busybody, Much-ado, or whatever may best express a meddling disposition. *Tante cose* means simply "many things."
27. This was Francesco di Bernardino dell'Amadori (d. 1555) of Castel Durante (near Urbino).
28. *Difesa della Lingua Toscana e di Dante.*

29. The group was placed in the Cathedral of Florence in 1722.
30. By tribune, in this description, Vasari means dome.
31. "I shall teach the wicked thy ways, and the impious shall be converted to thee."
32. Better known as Daniele da Volterra.
33. Giovanni delle Bande Nere, father of Cosimo I.
34. The best of artists hath no thought to show
 Which the rough stone in its superfluous shell . . .
 (Trans. J. A. Symonds)
35. "Touch me not."
36. Better known as Begarelli.
37. A bust and inscription, rather.
38. Giovanni Bandini.
39. Friedrich Lambert, a native of Amsterdam who settled in Florence.
40. "Creating in God's image."
41. "Thus art extols art."
42. "All admire him, all bring him love."
43. "You are our father, our teacher, and our guide. Your genius instructs us through your canvases."
44. Giovanni Stradano (1536–1605) of Bruges.
45. "As I ascend to Heaven, my praises still live on Earth."
46. "What is your hurry to rise, cruel Hatred? Lie there!"
47. "Alive and dead alike he has taught men to destroy ugliness."
48. "The river Arno runs sadly in the knowledge of your death. We too have come to bewail the departure of glory from the world."
49. "Dire necessity required this death."
50. "The fame of virtue conquers all."
51. "Glorified with triple honors."

Titian

1. This is one of the rather numerous inaccuracies of this Life.
2. The painting was left unfinished by Giorgione.
3. Dürer was German.
4. . . . And Titian who honors
 No less Cador than Venice and Urbino.
5. The Bishop of Paphos, Monsignore Jacopo da Pesaro.
6. Priuli.
7. If clear Apelles with the hand of Art
 Represents the face and breast of Alexander . . .
8. Irene di Spilembergo, the disciple of Titian.

9. An eminent physician and Latin poet of the time.
10. "Well do I see, Titian, my idol in new forms, who opens and turns beautiful eyes . . ."
11. These were Francesco and Valerio Zuccati of Da Ponte.
12. Girolamo Dante.